**POWERING
THE NATION**

POWERING
THE NATION

IMAGES OF THE SHANNON SCHEME AND
THE ELECTRIFICATION OF IRELAND

SORCHA O'BRIEN

IRISH ACADEMIC PRESS

First published in 2017 by
Irish Academic Press
10 George's Street
Newbridge
Co. Kildare
Ireland
www.iap.ie

© Sorcha O'Brien, 2017

9781911024675 (Paper)
9781788550000 (Kindle)
9781788550017 (epub)
9781788550024 (PDF)

British Library Cataloguing in Publication Data
An entry can be found on request

Library of Congress Cataloging in Publication Data
An entry can be found on request

Interior design by www.jminfotechindia.com
Typeset in Adobe Garamond Pro 11/15 pt

Cover design by edit+ www.stuartcoughlan.com

Cover front: 'Power house, view inside a penstock', silver gelatin print, 3 March 1929.
(Photograph courtesy of the Siemens Archive: Album A704, photograph No. 1151, p. 66.)

Cover back: Electricity Supply Board, '90,000 horses' newspaper advertisement, August
1928. (Image courtesy of the ESB Archives: MK.PA.1.42.)

Back flap: Brigid O'Brien (Ganly), *Ardnacrusha Power Station under Construction*,
watercolour, 1928. (This image is reproduced courtesy of the National Library
of Ireland: PD 4258 TF.)

Contents

Foreword
Powering The Nation

ESB was established in 1927 and was the first commercial semi–state company in Ireland. It was the world's first fully integrated national electricity utility, with a remit to generate, transmit, distribute, market and sell electricity on a national basis. By the late 1930s, as a result of the ESB's work in implementing The Shannon Scheme, all the major towns and most large villages in Ireland had an electricity supply.

Spurred on by an ambition to create a brighter future for Ireland and its citizens through the provision of affordable and reliable electricity, ESB continued to innovate over successive generations, bringing power to every corner of Ireland. By the late 1970s every home in the country had access to electricity.

The widespread availability of electricity led to rapid industrial development and increased productivity on farms. It transformed a way of life that had existed for generations, bringing comfort and convenience to both rural and urban dwellers and driving economic growth to stem the tide of national emigration.

This beautifully presented book provides an invaluable insight into how the initial steps in that journey had to be mapped out and planned. The Shannon Scheme is acclaimed nationally and internationally as a ground breaking engineering and social achievement. Dr Sorcha O'Brien's outstanding work tells the story of how these achievements were realised and how this important infrastructural project was promoted. She presents insights into the perspectives of the main protagonists: The Irish Government, the main contractor Siemens-Schuckert, ESB and the ordinary people of Ireland who witnessed and experienced the transformation it brought.

We are very grateful to Dr Sorcha O'Brien and Conor Graham from Irish Academic Press, as well as all the other contributors who have helped with the publication of this book. It has captured a unique chapter in Ireland's social, economic and political development, and is a wonderful tribute to the vision, ambition and commitment that were embodied in The Shannon Scheme.

This year, as we celebrate the 90th anniversary of ESB, we continue to innovate and adapt to ensure that electricity remains an agent of progress and positive change in society, particularly in the transition to a low carbon future. As this book shows, we have a deep well of inspiration to draw from in meeting the energy challenges ahead, as we look towards our 100th anniversary and beyond.

Pat O' Doherty
Chief Executive ESB.

Acknowledgements

Firstly, I would like to thank the staff of Ardnacrusha Power Station past and present, including Terry Cusack, Paddy Buckley, Senan Colleran and Michael Rock, and the Electricity Supply Board, guardians of both the station and much archival material associated with it, for their generous sponsorship of this book. This book would have literally not been possible without the enlightened collecting policies of both the ESB and Siemens, and I would like to thank Brendan Delany, Gerry Hampson, Pat Yeats, Deirdre McParland, Kirsten Mulrennan and Brian McManus of the ESB Archive for all of their help; Alexandra Kinter, Christophe Frank and Florian Kiuntke of the Siemens Archive, Munich, and Daniela Lehmann at Siemens Head Office, Berlin. I would also like to thank the Arts and Humanities Research Board, the Modern Interiors Research Centre at Kingston School of Art, Kingston University, the University of Brighton Faculty of Arts and Architecture, the Thomas Damman Junior Memorial Trust and the Society for the History of Technology for supporting my research, and thanks to Conor, Fiona, Myles and the staff of Irish Academic Press, for actually making the book into a real artefact.

I would like to thank the staff of the libraries and archives who have been so helpful in helping me find relevant material, sources and more than one insight on the project. These include the late Edward Murphy, Donna Romano and the staff of the NCAD Library and the National Irish Visual Arts Library; TCD library; IADT library; St. Peter's House Library at the University of Brighton; Raheny Public Library; UCD Architecture Library; the staff of the National Library of Ireland, Dublin, particularly Berni Metcalfe, Glenn Dunne and Elizabeth Harford; Brian Donnelly, Tom Quinlan and the staff of the National Archives of Ireland, Dublin; Anne Hodge and Sean Mooney at the National Gallery of Ireland; the Irish Architectural Archive; Brian Hodkinson and

Matthew Potter at the Limerick City Museum; Colleen O'Sullivan and Anne Boddaert at the Crawford Gallery in Cork; Elizabeth Forster at the Dublin City Gallery The Hugh Lane; RTÉ Stills Library; Hannah Josey at Gallery Oldham; Éimear O'Connor and the staff of TRIARC, TCD; Claudia Schmitt at the Kreisverwaltung Bernkastel-Wittlich, Germany; Fionnuala Carragher and Michelle Ashmore of the National Museums Northern Ireland; and the Irish Army Military Archives in Cathal Brugha Barracks, Dublin. I would particularly like to thank the families of the designers, artists and photographers for their generosity in answering my questions about parents and grandparents, including Berry Atkinson, Patrick John Boyd, Patricia Haselbeck Flynn, Lar Joye, Stan Mason, Antje, Annette and the late Thomas Scheuritzel, and Clodagh Wilkinson.

I would also like to thank the community of design and art historians in Ireland and the UK who have given their support, suggestions and critiques on this work as it developed. This particularly includes Louise Purbrick, Jonathan Woodham, Nicola Gordon-Bowe, Deborah Sugg Ryan and Jill Seddon, but also Mary Ann Bolger, Teresa Breathnach, Sarah Foster, Angela Griffith, Jane Hattrick, Torunn Kjolberg, Linda King, the late Knight of Glin, Yunah Lee, Silvia Löffler, Fiona Loughnane, the late Michael Mende, Anna Moran, Charlotte Nicklas, Katharina Pfützner, Ciarán Swan, John Turpin, Ann Wilson, and Wendy Williams. Sigrid Neugebauer, Nina Shiel, Christa Prusskij, Noora Corcoran and Agnieska Jarczok helped with translations and the staff of the Goethe Institute, Dublin improved my German, particularly Marlies McGuire and Beatrix Schlitzer.

On a personal level, I would like to thank all my students in Dublin and London who have provided me with inspiration and encouragement over the years. Thanks also to Deirdre Ruane, Joe and Breigeen Cosgrave, Rosaleen and Martin Waddell, Peter Orford and the staff and members of Limerick Printmakers for their help. I would particularly like to thank my family, especially Tom, Melissa, my father Joseph and my late mother Nell for their support throughout.

Introduction

A free Ireland would drain the bogs, would harness the rivers, would plant the wastes, would nationalise the railways and waterways, would improve agriculture, would protect fisheries, would foster industries, would promote commerce, would diminish extravagant expenditure (as on needless judges and policemen), would beautify the cities, would educate the workers (and also the non-workers, who stand in direr need of it), would, in short, govern herself as no external power – nay, not even a government of angels and archangels – could govern her.[1]

Great as are the material advantages of the 'Shannon Scheme' – as it is affectionately called throughout Ireland – the psychological benefit is incalculable … With the success of the Shannon enterprise a new mood of confidence has taken the place of the earlier pessimism. An era of electricity has superseded the Celtic twilight. The Shannon scheme gives concrete as well as symbolic expression to the new driving force which is revivifying Irish activities.[2]

In 1931, a number of American newspapers marked St Patrick's Day by publishing a cartoon entitled 'If St. Patrick Could Only See That' (see Fig. 1).[3] This cartoon showed a traditional Irish 'colleen' standing at the front door of a thatched cottage, happily looking up a broad road at a squared-off building labelled 'River Shannon Hydro Electric Power Plant'. The accompanying article situated this building within a broad description of Irish geography and climate, noting that 'for a year the great Shannon power station has been supplying the Irish Free State with electric current'.[4] With a number of soft pencil lines,

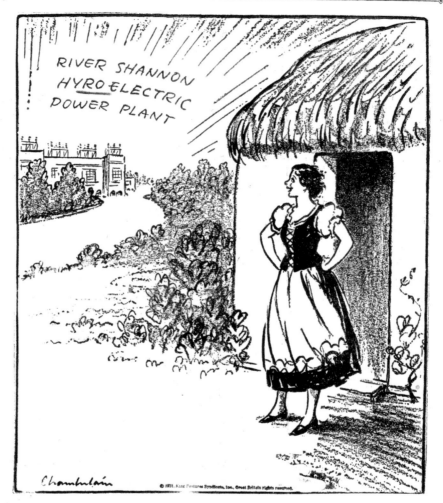

Figure 1 'If St. Patrick Could Only See That', cartoon, *Cincinnati Times-Star,* 17 March 1931. (Courtesy of the ESB Archives.)

the cartoonist succeeded in setting up a contrast between traditional Irish architecture, dress and custom, and the Modernist industrial forms of the Shannon Scheme building, while at the same time framing the Scheme as something noteworthy and desirable for the people of the nation.

Possibly the most un-'Irish' national project in the history of independent Ireland, the Shannon Scheme refers to the construction of a run-of-the-river hydro-electric power scheme on the River Shannon in the late 1920s, making use of the fall of the river from Lough Derg to the Shannon estuary (see Fig. 2).[5] Now known as Ardnacrusha power station after the nearby village, it was built under the aegis of the Cumann na nGaedheal government, which was in the process of stabilising the country after the War of Independence and the Civil War of the early 1920s.[6] The impetus for the project came from Irish engineer Thomas McLaughlin, who had spent most of the early 1920s working for the German engineering company Siemens in what is now Germany and Poland. McLaughlin convinced the Minister for Trade and Industry Patrick McGilligan of his plan for the Shannon, and played a central role in its execution.[7] Commissioned from Siemens within four years of the Anglo-Irish Treaty, it was developed in an unsettled political atmosphere, with the last of the anti-Treaty forces still taking violent action as late as 1927.[8] Siemens was particularly interested in overseas construction projects, partly as a way of expanding the company and partly as a way of earning hard currency outside economically depressed inter-war Germany. Construction work began in 1925 and the Electricity Supply Board (ESB), the first of the Irish semi-state companies, was set up in 1927 to manage the new power station. The ESB was then made solely responsible for power generation and distribution within the Free State, as well as for the construction and operation of several later hydro-, coal-, gas- and peat-powered electricity generating stations around the country.[9] This time period is also bracketed by the term of the first Government of the Irish Free State, which was in power from the signing of the Treaty in late 1921 until the victory of the anti-Treaty Fianna Fáil party in the 1932 general election.

The Shannon Scheme was considered state-of-the-art technology in the 1920s and was continually described in terms of superlatives, whether in relation to the amount of power it produced (a hugely over-specified 86MW), the number of labourers engaged on its construction (an estimated 4,000 Irishmen) or the amount of money being spent by the Irish Government on it (£5.5 million or 20 per cent of the national budget in 1925). It was also presented to the Irish public as a sublime spectacle, with thousands of visitors encouraged by the ESB to visit the construction site, taking photographs

and buying postcards. A measure of the overwhelming experience of the construction site, full of bucket excavators, churning mud and thousands of labourers can be deduced from the Fox Film Company crew which departed in despair in May 1929, stating that it was impossible to produce a sound film of the works.[10]

The Shannon Scheme was presented by the ESB and the Irish Government as an icon of the new Irish state of the late 1920s, downplaying the pivotal role of German engineers and skilled construction workers in its design and construction. This presentation of the Scheme as a great Irish project throws up issues about the construction of nationality and nationhood, as the dominant conception of Irish identity at that time was rural, traditional and Romantic, looking to the ancient past and the countryside for inspiration. The perception of electrical technology in the 1920s in Germany was very different to that in Ireland, as was the practice of engineering and architecture, all of which had immediate influence on the design of the Scheme buildings themselves. The importation of German ways of working into rural Ireland had its own difficulties, not least in terms of different approaches to technical drawings and construction practices, resulting in a set of buildings influenced by Cumann na nGaedheal financial policy as well as local geography and hydrology.

Images of this unashamedly industrial building were everywhere in 1920s and early 1930s Ireland – the paintings of Seán Keating were far from alone in their presentation of the Shannon Scheme as an addition to the mythology of the Irish Free State. The average Irish citizen could see images of the construction site and then the finished building in newspaper advertisements and illustrated articles on the Scheme, buy numerous different postcard and cigarette card views, and by the end of 1930, post them with a Shannon Scheme stamp. They could visit the Scheme themselves and take their own photographs of the works, or see prints exhibited by George Atkinson, the headmaster of the Dublin Metropolitan School of Art, and if they were very lucky, see the personal photographs of some of those construction workers, as well as those of other tourists.

Many of these images were based on photographs of the Scheme taken by Siemens, which were used as an internal company record of the project, but were also reprinted in German newspapers as evidence of the resurgence

of German engineering. In contrast to the presentation in Ireland, these photographs worked alongside lithographic prints commissioned by Siemens from German artist Anton Scheuritzel to promote national and corporate interests. This national split in the representation of the Scheme is crucially important in understanding the spread of images of the Shannon Scheme, particularly the appropriation of the building itself, but also the Siemens photographs, by the Irish nation. The Shannon Scheme images also provide a record of industrial work and labour in Ireland, at a time when the traditional dominance of manual and agricultural labour was challenged by the wholesale importation of industrial construction machinery. They record the struggle, not just to understand the rhythms and impact of industrialised work, but to deal with ideas about work and the male worker that centred around the figure of the hero and didn't sit easily with a landscape full of bucket excavators and dredgers, let alone turbines and penstocks.

The majority of writing about the Scheme to date has been from a non-visual point of view, with only Seán Keating's paintings (particularly *Night's Candles are Burnt Out*) receiving any sustained consideration.[11] It has been discussed from the point of view of a company history in Maurice Manning and Moore McDowell's history of the ESB, which devotes two chapters to the development of the Scheme and one to the early days of the ESB.[12] More recently, it has been the subject of historical sociology in Michael McCarthy's *High Tension: Life on the Shannon Scheme*, and *The Shannon Scheme*

Figure 2 Plan of the Shannon Scheme Works, 1925–9. (Courtesy of the ESB Archives.)

Plan of the Shannon Scheme, 1925-1929.

and the Electrification of the Irish Free State, an anthology of mostly company and engineering histories edited by Andy Bielenberg, which includes a chapter on Keating's paintings.[13] However, there are no sustained architectural studies of the Shannon Scheme buildings, despite its seminal place in the history of Irish architecture, and very little on the non-painting images of the Scheme.[14]

The visual significance of the Shannon Scheme raises issues about modernisation, technology and national identity, particularly when it is considered in the context of existing publications on Irish history and politics which focus on the contested nature of Irish identity during the twentieth century.[15] Apart from the facts and analysis of economic histories, there is a distinct lack of recognition of the forces of modernisation or the introduction of 'modern' technology which was evident throughout the rest of Europe, particularly in the early part of the century.[16] The impact and influence of such concepts were not unknown in the country and contribute an important and under-recognised element in the development of the nation, particularly in the first years after independence.

Today, Ardnacrusha station is a small part of the Irish power generation network, providing extra power during periods of peak demand, in addition to acting as an environmentally friendly backup to the larger coal- and gas-powered stations in Moneypoint, Aghada and Poolbeg.[17] Despite the fact that it now only provides a bare fraction of the electrical power generated in the Republic of Ireland (92MW out of roughly 7,500MW in 2017), it still holds an important place both in the history of power generation in Ireland and in the national consciousness, still providing a comparison for any new engineering project eighty years on.[18] It has retained its importance within engineering history, with the ESB and Siemens jointly awarded the Institute of Electrical and Electronics Engineers (IEEE) Historical Milestone Award on the seventy-fifth Anniversary of the Scheme in 2002, an honour which it shares with the Eiffel Tower and the space shuttle.[19]

Recognition of the importance of technology and modernisation to the early Free State may only be possible in the light of the developments of the last twenty years in Irish society and culture. Two important factors in twenty-first-century Ireland situate and influence this argument, in addition to the continued negotiation of identity within the province of Northern Ireland. The first is the development of a thriving Information Technology industry,

particularly near Dublin in the 1990s. This arose mostly as a result of tax breaks for large multi-national companies such as Microsoft, Hewlett Packard, Intel and Google, but it also created an impetus for small indigenous start-up software companies providing niche services such as e-learning and online mapping.[20] The second is the increased heterogeneity of Irish society, with the reversal of the historical trend of net emigration and increased levels of immigration from Eastern Europe, Africa and Asia, for both social and economic reasons.[21] Neither of these factors has been simple or straightforward, but they have produced a new subjectivity which has outlasted the Celtic Tiger: that it is possible to be Irish without being of Gaelic descent, and that it is possible to be Irish as well as technologically literate.[22] Neither of these new conceptions of Irishness is universally accepted, even within the current Republic, but they allow space for an alternative reading of the history of 'Irishness', which permits alternatives to the dominant interpretation of the formative years of nation-building in the 1920s and 1930s.[23]

1

National Identity and Electrical Technology in 1920s Ireland: Balancing Forces of Essentialism and Epochalism

The Shannon Scheme was begun primarily as an advertisement for the Free State Government. The desire to create cheap electricity for the people was secondary to the desire to create cheap publicity for our 'young Ministers'. A tree shall be known by its fruits and the mean inspiration which begot the Shannon scheme became apparent on the first day the work started. To develop the waterpower of Ireland, to win from it the white coal which will end our dependence on the British coal lords is a good and beneficial work.[1]

Ideas about national identity, modernisation and technology are central to understanding the political and social context of Ireland in the 1920s, particularly in relation to the Shannon Scheme. The imagined community of the Irish Free State was brought into being in 1922, but was built on a long history of ideas about what it meant to be Irish, not all of which tallied exactly with each other. The cultural and political climate of the 1920s and very early 1930s meant that the new Free State was engaged in a process of literal and figurative

'nation-building', as both politicians and ordinary people worked out what it meant to be a twenty-six-county state, and how that could be presented in a visual fashion. A central part of this process was the balancing, or rebalancing, of ideas about tradition, landscape, modernity and technology, and how they would relate to each other in this new State.

The ideas about modernisation in Ireland in the 1920s tied in with debates about the term 'modern', which has been used to mean everything from Renaissance thought to the current day, but is here used to refer to the wider condition of modernity in late-nineteenth and twentieth-century Western culture. The aesthetic response of particular artists, designers and architects provides only one aspect of this condition of living, but it is one that varies widely, particularly in terms of geography and in different nation–states such as America and Germany.

The importation of ideas about technology, progress and modernity into Ireland in the 1920s was affected by the existing positions of the Irish people on these ideas, particularly their associations with colonialisation. This chapter looks at how these ideas were read and understood by the ruling government for most of the 1920s, that of Cumann na nGaedheal, which challenged orthodox ideas about Irish national identity in its support for the large-scale technological project of the Shannon Scheme.

National identities: the imagined community

When writing on nationalism and national identity, Benedict Anderson points out three paradoxes in the way that nationalism has been discussed and understood by historians, politicians and nationalists themselves. The first of these is the subjective antiquity of their nation to nationalists, compared with the objective modernity of the idea of the nation in historical terms, evolving in nineteenth-century Europe to the point where it required nation-states, republican institutions, common citizenship, popular sovereignty, national flags and anthems, etc., and the liquidation of their opposites: dynastic empires, monarchical institutions, inherited nobilities, serfdoms, and so on.[2] The second is the assumption that everyone in the world has a nationality, despite the fact that individual nationalities are often highly contested – for example, it is entirely possible to talk about Greek nationalism, despite and because of

contested ideas of what it means to be 'Greek', 'Cypriot' or 'Macedonian' and the same goes for 'Irishness' where there is no agreed definition of the term. The third is the continuing political power of different nationalisms in comparison with their philosophical poverty.[3]

Anderson insists that nationalism is *not* an ideology, to be discussed in similar terms as neo-conservatism or socialism, but rather that it is much more important and culturally foundational, carrying structural similarities to wider anthropological concepts such as kinship or religion.[4] This definition of nationalism provides an explanation for the fragmented nature of nationalist thought, which, by definition, is splintered into a multitude of discrete conceptions, although each refers back to a concept of a sovereign nation, which may or may not be the same thing as an actual state. He talks about the idea of the nation as 'imagined community', where the members of a nation continually 'imagine' it into being. It is important to note that 'imagined' is used here in the sense of a creative endeavour, rather than in the sense of falsifying and fabricating, as those involved in imagining Greece or Ireland or America are generally doing in all good faith.[5]

Anderson's explanation of the roots of national identities is based heavily on the development of print technologies and their interplay with the spread of capitalism, particularly that of the newspaper.[6] This totally overlooks the visual dimension of national identity, where two- or three-dimensional symbols are used to communicate and express political ideals, whether through flags, stamps and coins, postcards sent from tourist sites or the paintings exhibited in a National Gallery.[7] However, the concept of the imagined community remains a useful one, particularly as it can be expanded into areas which Anderson did not consider himself.

The conceptual model of the imagined community has a corollary that Anderson himself does not point out – it allows for more than one interpretation of that community to exist at once and for the process of imagining to be a negotiated and heavily mediated one. This is particularly important in the context of the post-colonial state, where a withdrawal or defeat of the erstwhile power leaves a space to be filled with a new interpretation of the nation.[8] Or, in the case of a fragmented post-colonial moment such as that of Ireland, there is a contested and contentious flurry of interpretations, the validity of any of which depends entirely on the political stance of the viewer.[9]

Figure 3 Seaghan MacCathmhaoil, 'Fergus Goes to Meet Cucullin', 1909. Frontispiece illustration from Mary Ann Hutton, *The Táin* (2nd ed., Dublin: The Talbot Press, 1924). (This image is reproduced courtesy of the National Library of Ireland: Ir 89162 t 4.)

When Anderson discusses post-revolutionary governments taking over the reins of power, he is working on the assumption of a straightforward one-to-one handover of power. Given the partition of the island of Ireland and the contested nature of the six northern counties, more than ninety years later, each of the imagined communities of the Saorstát Éireann (Irish Free State), the Republic of Ireland, Ulster, the island of Ireland and Northern Ireland has had a different and sometimes mutually incompatible imagining, complete with varying flags, colours, regalia and invented traditions.[10]

The twentieth century saw a number of competing claims (and disclaims) to Irishness. In the 1920s, it saw Sinn Féin, the main political party of Irish independence, split over the Treaty question in classic post-colonial civil war fashion, resulting in the pro-Treaty establishment of the Saorstát Éireann (the 'Irish Free State') by the faction that would become the Cumann na nGaedheal party, shadowed by the phantom Republic of the anti-Treaty rump (later the Fianna Fáil party).[11] The performance and interaction of these profoundly antagonistic interpretations of the nation underpinned Irish post-revolutionary politics of the 1920s and has thrown a long shadow over the subsequent century.[12] According to Homi Bhabha, this performative aspect of the nation is particularly important, as the political is only possible in a discursive space where ideas can be discussed and debated, whether in written or visual form.[13] In addition, national identity cannot be considered in isolation from the rest of society, whether this encompasses positions of class, sexuality, gender or ethnicity and race, which also play a large role in the formation of identity. These issues are particularly entangled within post-revolutionary Ireland, as antagonisms between and within the Anglo-Irish upper-middle class, the urban working class and nascent political feminism complicated the simplistic picture of a split over the Treaty.[14] Each of these social positions was produced and performed through a series of 'enunciative moments' running in parallel and in competition with each other, striving to become the dominant hegemonic representation of Irishness.[15]

The importance of the nation as the 'apparatus of symbolic power' is what gives this struggle for political power its urgency.[16] Not only does political power bestow control of the economic and structural guidance of a nation-state, but also control of the signs and symbols that are used to represent the nation-state and the political ideology which they support. The cultural status quo can be bolstered and reinforced into a state of cultural hegemony and naturalisation through the medium of culture.[17] For example, the Russian Revolution of 1917 enabled the dominant symbolic language of a large part of the Eurasian landmass to move from a dynastic empire clad in national clothes to that of a workers' republic.[18] The change in symbolic power included the expected trappings of nationhood – flags, stamps, national anthem – but also precipitated profound changes in the administration and regulation of transport, agriculture, education and industry.

Essentialism and epochalism

In *The Interpretation of Cultures*, Clifford Geertz discusses the process through which the population of a nation forms (or imagines) itself into nationhood. He describes four stages, beginning with the formation of nationalist movements, moving into the achievement of (partial or total) national independence, the organisation of a new state and, finally, the definition and stabilisation of the new state, with respect to other states and the society from which it arose.[19] The first stage corresponds to the formation of nationalist movements in Ireland in the late nineteenth century and early twentieth century, with the second stage being achieved with partition and partial independence in 1922.[20] The third stage, that of the organisation of the new state, relates to the restructuring of the administrative, legal and organisational structures of the new Free State during the 1920s, including issues such as the formation of An Garda Siochána, the national schools, the court system, An Post and the civil service.[21] Geertz's phases of nationalism tie in easily with Irish history up until this point, but the fourth phase is rather more problematic, as it should include the Civil War of 1922–3, which happened simultaneously with the formation of these institutions. It could also, arguably, extend to the current day, as the relationship of the current Republic of Ireland with the six northern counties cannot be said to be definitively stabilised, despite the recent achievements of the Good Friday Agreement and the Northern Irish peace process.[22]

Geertz discusses the formation of identities in the first stage of nationalism as crucial, as this is where the 'dense assemblage of cultural, racial, local, and linguistic categories of self-identification and social loyalty that centuries of uninstructed history had produced' is constructed into a simplified, abstracted idea of nationality, which can function as a rallying point for revolutionaries and their supporters.[23] It is this idea of Irish identity which influenced not just the cultural production of Irish-Irelanders in the nineteenth century, but also the formative stages of cultural movements such as the Irish Arts and Crafts movement, which based its cultural production on the linguistic revival of the Irish language, music and surviving oral sagas, as well as medieval Christian manuscripts and metalwork. It is also the origin of the valorisation of peasant and traditional folk identities, particularly those of the West of Ireland, which formed an important basis for later imaginings of Free State identity.[24]

The final stage of Geertz's discussion looks at the attempts to define who 'we' are, once a nation-state has been formed and is beginning to function. He presents two different approaches to this, both of which exist to varying degrees in the cultural formation of different national identities. The first of these he calls 'The Indigenous Way of Life', which looks to 'local mores, established institutions, and the unities of common experience – to "tradition", "culture", "national character", or even "race"', whereas the other is described as 'The Spirit of the Age', which concerns 'the general outlines of the history of our time, and in particular to what one takes to be the overall direction and significance of that history'.[25] Both of these approaches have direct relevance to the conception of Irish national identity, particularly during the formative years of the Free State, although 'The Indigenous Way of Life', or essentialism, has had a far stronger influence overall compared to 'The Spirit of the Age', or epochalism. That is not to say that epochalism did not have an influence on Irish national identity; although the Irish language was used as a symbol and fortress of heritage and history, at the same time, the use of English acted as a passport to the outside world.[26] The tension between these two approaches also explains Anderson's first paradox of how a national identity can be ancient and modern at the same time, which 'gives new state nationalism its peculiar air of being at once hell-bent towards modernity and morally outraged by its manifestations'.[27] Geertz also makes the point that these two approaches are not eternally opposed forces, but are specific to the historical situation of a newly-formed nation-state in the modern world, a point echoed by Sparke in her discussion of the overlap of the design strategies used by newly formed nations.[28] The negotiation of a relationship between Geertz's two forces is particularly important, as they both played an influential role during a period in which a stable national identity was still being worked out, compared to such concepts in a long-established state in which they would have settled into a stable configuration, not susceptible to radical change in the same manner.[29]

National identities: the creation of Irish histories

Eric Hobsbawm, in his introduction to *The Invention of Tradition*, discusses essentialist attempts in various historical periods to present certain parts of social life as unchanging and eternal, within the context of a changing society.

He describes this as:

> a set of practices normally governed by overtly or tacitly accepted rules and of a ritual or symbolic nature, which seek to inculcate certain values and norms of behaviour by repetition which automatically implies continuity with the past. In fact, where possible, they normally attempt to establish continuity with a suitable historic past.[30]

Such practices are different from traditional customs or behaviour, and are the main mechanism by which the subjective antiquity of nations is formed, as 'an elaborate language of symbolic practice and communication', borrowed 'from the well-supplied warehouses of official ritual, symbolism and moral exhortation – religion and princely pomp, folklore and freemasonry'.[31] In the same book, Trevor-Roper describes the way in which the tartan kilt was 'invented' as Scottish national dress in the eighteenth century, after the traditional belted plaid had died out.[32] This idea also plays a vital role in the construction of the essentialist concept of a national history or a national narrative that is told and retold in both historical and fictive forms.[33]

This invention of tradition applies directly to the Irish obsession with the Celtic and Gaelic past in the nineteenth and early twentieth century, particularly demonstrated by the Neo-Celtic movement. During this period, an up-swelling of interest in disappearing Irish traditions of earlier centuries resulted in attempts to record oral tales and legends at the last possible opportunity.[34] The characters and settings from these oral tales were used both as proof of a timeless oral tradition, stretching back to the mists of the 'Celtic Twilight', and as examples of indigenous 'Irish' nationhood.[35] This 'highly selective construction of nationality' worked alongside (and was often conflated with) the decorative detailing from antiquarian discoveries of early medieval Insular Christian art such as the Tara Brooch and the Book of Kells, and was seen as an alternative to the late-nineteenth-century British imagining of Irish people as servile, undeveloped and monkey-like.[36] This essentialist imagining of Ireland provided an inspiring pantheon of 'heroic Celtic warriors and skilled and beautiful queens' who increasingly appeared in both written and visual form from the 1880s to the 1920s.[37] The visual interpretation of these legends involved large amounts of extrapolation from the surviving oral tales,

liberally interspersed with anachronistic Christian detailing and large doses of sheer invention, particularly noticeable in the use of Celtic interlace patterns from various Insular manuscripts in graphic design and the 'revived' handcraft industries (see Fig. 3).[38]

The Romantic roots of these interpretations are clear, with conceptions of the Irish nation retaining a historical dependence on nineteenth-century German Romanticism, influenced by Thomas Davis' visit to Germany in the late 1830s. This had the effect of influencing a rather straightforward 'pre-political' radicalism that 'national culture, national history and national language were not merely ornamental, but integral, to national identity'.[39] This emphasis on cultural difference, emotion, group rights and a subjective and creative definition of nationality, as well as on the cornerstones of race and language, served to influence Irish nationalist thinking well into the twentieth century, privileging the essential over the epochal. Irish nationalism was tightly tied to an oppositional stance to Britain and the British administration had not seriously tried to industrialise the island, instead relying on it as a regional source of food products.[40] Therefore, the idea of the rural and the primitive in late-nineteenth-century Ireland was cultivated by national romantics as a position of opposition to the colonial power.[41] The 'experiments in social engineering' of the Gaelic League, the Gaelic Athletic Association, the *Feiseanna Cheoil*, the *Aonach Tailteann* and the 'rescue' of the Irish wolfhound all played a role in reinventing the ancient Irish past in an essentialist form which could foster a psychologically immediate sense of Irish national culture.[42]

These ideas were given particular impetus in the creative arts, where the ideas of the 'romantic and visionary writers, revolutionaries, poets, archaeologists and Utopian socialists' of the Arts and Crafts Movement were imported by Anglo-Irish artists such as the Yeats sisters.[43] These found a new urgency in this atmosphere of cultural nationalism, replacing the Arthurian and medievalist forms of the English Arts and Crafts with those of Early Christian saints and legendary heroes such as Queen Tailtiu. This period of invention of 'Irish' tradition overlaps with that described by Hobsbawm as the heyday of 'mass-producing traditions' in Europe, and it had a large influence on the more overt political movements of the period, whether campaigns for Home Rule or for a separate Republic.

The invention of tradition has acted as 'a crucial legitimizer' of populist nationalist interpretations of the Irish past.[44] The absence of a strong socialist or feminist movement throughout most of the twentieth century has resulted in a lack of challenges to the orthodox essentialist interpretation of historical events, leaving an emphasis on the teleological passing of the torch from martyr to martyr.[45] This situation has been challenged from within the discipline of history itself, with historians such as Roy Foster and J.J. Lee disputing nationalist interpretations of the past, as well as from socialist and feminist directions in recent years.[46] In addition, the practice of art history and, latterly, design history has been involved in attempts to analyse the symbols of Irish imagery, to discuss, understand and unpack the visual symbols of the nation (or competing imaginings thereof).[47] The analysis of different visualisations of nationhood can provide an illuminating insight into the competing sets of meanings, metaphors and rhetorical strategies by which the Irish nation has been imagined, attempting to create persuasive arguments embodied in material form.[48] The dependence of both Anderson and Hobsbawm on the analysis of print culture and formal ritual has been criticised by Tim Edensor for failing to consider the role of everyday cultural production which continually reinforces the idea of the nation in the imagination of the people. Anderson's focus on the institutions of colonial power in 'Census, Map, Museum', for example, retains a concern for the role of governmental structures in promulgating and promoting an official view of a nation, but does not move outside the realm of official cultural production.[49] As Edensor points out, both Anderson and Hobsbawm fail to consider the development of middle-class or working-class cultural forms of production, such as cinema, radio or popular music, let alone the vernacular, the mundane and the everyday, missing the point that advertisements and postcards can be just as powerful in shaping national identity as fine art and newspapers.[50]

National identities: alternative Irelands in the 1920s

The political history of Ireland in the 1920s was the outcome of more than a decade of overt political turmoil, arising from a long history of cultural division and fragmentation on the island. Despite the myth-making surrounding the formation of the Irish Free State and the Civil War, these events had the effect

of division and separation, rather than the united and idyllic Ireland aspired to during the late nineteenth century. It should not be surprising then that the formulation of an 'official history' of the period did not appear in school books in the Republic of Ireland until much later on.[51]

In contrast, a range of alternative Irelands were being imagined in the early years of the century, particularly in the decade after independence. The great political schism of Fianna Fáil and Cumann na nGaedheal was not the only defining factor of the Free State in the 1920s, and a reliance on this definition would over-simplify the roles played by organised labour, the Anglo-Irish and business interests, as well as a developing feminist awareness within the State. These cultural positions played just as large a role (if not larger in some cases) as political affiliation in identity formation in this period, despite the loose affiliation of Irish-Ireland to the nationalist movement in its entirety. The construction of national identities was more than able to include trade unionists, businessmen, the Ascendancy and suffragettes within either side of the Treaty split. For a short time in the late 1920s, the existence of a potential technological Ireland was only made possible by the fact that several other alternative imaginings also competed with the 'official' Ireland in the eyes of the people.

The existence of a 'phantom Republic' as an alternative 'imagined community' of Irishness is of central importance here.[52] The possibility of multiple interpretations of 'Ireland' allowed the continuation of the more romantically-inspired end of Irish nationalism past independence, particularly recalcitrant and unrepentant Republicanism. It also legitimised the continued use of armed force by the IRA throughout the 1920s, as well as the repudiation of the Oath and the pre-1927 boycotting of the Dáil by Fianna Fáil.[53] The rhetoric of the Republican newspaper *An Phoblacht* during the late 1920s retained a consistent emphasis on the continuity of the republican ideal with those of pre-independence patriots, as well as continual reference to 'the fraudulent Government'.[54] From a visual point of view, it is distinctive for its inclusion of an Irish language column throughout the period, set in an uncial font, as well as overt visual and textual references to the ancient sagas, intended to establish continuity with both the late-nineteenth-century imagining of Ireland and the source of that invented tradition (see Fig. 4).

Cumann na nGaedheal: state building and nation building

The motivation behind the acceptance of the Anglo-Irish Treaty by Sinn Féin negotiators in London in 1921 is generally seen as the recognition that dominion status was the maximum concession that they could wring from the British Government, in their attempts to create an independent Irish state. However, Michael Collins' stance that it allowed 'the freedom to achieve freedom' was not accepted by numbers of his Sinn Féin colleagues, and this is generally seen as the root cause of the Irish Civil War of 1922–3.[55] After the deaths of Collins and fellow-negotiator Arthur Griffith in August 1922, the reins of the pro-Treaty wing were taken up by W.T. Cosgrave, who had been a minor revolutionary with a background in administration in Dublin Corporation.[56] The pro-Treaty faction then reorganised into a distinct new party, Cumann na nGaedheal, at the end of 1922, which contested and won the elections of April 1923, with the anti-Treaty forces under Éamon de Valera refusing to sit in the fourth Dáil.[57]

The composition of Cumann na nGaedheal at the start of their nine years in power was that of the more pragmatic members of old Sinn Féin, and 'pragmatism' is a term which comes up again and again in the discussion about the early years of the party.[58] Finally, a measure of independence had been achieved from Britain and the business of actually running the fledgling Free State took priority. The damage of seven years of unrest had taken its toll on the country, from both a psychological and physical point of view, with burnt-out houses and blown-up bridges, as well as continuing action by IRA irregulars remaining as a physical reminder of the shaky condition of the new state. Despite the inheritance of a fairly sophisticated public infrastructure, the Free State also bore the classic features of an underdeveloped colonial economy, heavily agricultural and dependent on its industrialised neighbour for processed and industrial goods and as a destination for its exports.[59] The approach of 'probably the most conservative-minded revolutionaries that ever put through a successful revolution' was not the nineteenth-century goal of self-sufficiency, but to focus on stamping out any remaining IRA activity and rebuild both the physical structure and infrastructure of the state.[60] Budgets were tightly controlled by Ernest Blythe's Department of Finance, which soon garnered a reputation for balancing the annual returns with an iron fist. The professional civil service inherited from Britain had transferred

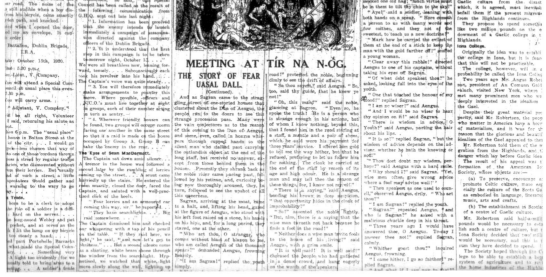

Figure 4 'The Children's Camp Fire: Meeting at Tír na n-Óg' (*An Phoblacht*, 22 October 1926, p. 4). (This image is reproduced courtesy of the National Library of Ireland: Newspaper Collection.)

almost en masse to the new State and enjoyed almost autonomous control over financial matters, setting the tone for government policy.[61] The lack of industry also made a direct move to self-sufficiency unfeasible, so a policy of free trade was adopted throughout the lifetime of the Cumann na nGaedheal administration.[62] This basis in orthodox economic theory also reflected the centre–right position of the party, with a strong support base shared between the urban middle class and the larger farmers.[63] Previous imaginings of Ireland proved inadequate to the task of the day-to-day running of a nation–state, with the emphasis continually on pragmatic decisions, as it focused on what Meehan describes as 'the ordinary, mundane but vital work of building the Free State'.[64] This state building work does not seem to have extended to a focused industrial policy, with any intervention being carried out in 'a haphazard and apologetic fashion'.[65] This overall approach to the generation of

industry may seem at odds with the development of the Shannon Scheme and the project of electrification. However, this is due to the fact that the Shannon Scheme project developed from earlier ideas put forward by an individual Irish engineer Thomas McLaughlin.[66] Cumann na nGaedheal would take on an electrification project when it was presented to them as a fully-worked out plan, but were exceedingly unlikely to have taken the initiative on such a departure.

Tom Garvin argues that 'the central problem facing the creators of a new state is that of creating a new sense of community' and it is this need for a sense of national solidarity that underpinned the visual activities of the new Free State.[67] The state may be separate from civil society and culture, but it can only be understood and imagined by its own citizens using the symbols current and understandable in that culture, including both Hobsbawm's invented traditions and Edensor's everyday nationality. In the case of the new Cumann na nGaedheal government, they also had the difficulty of competition from the phantom Republic appropriated by Fianna Fáil. The identification of the Irish nation as purely Gaelic, Catholic and Republican proved contentious, as the Free State was not entirely any of these. As Garvin points out, any perceived 'natural affinity' between Gaelic culture and a thirty-two-county Republic tended to insinuate that the twenty-six-county Free State was also insufficiently Irish.[68] This can be seen as an underlying principle in any of the Free State's visual manifestations, as they continually reasserted the essentialist 'Irishness' of the State and protected it from misappropriation.

It was imperative that the community of the twenty-six counties begin to imagine themselves as a functional political community, without ruling out the possibility of being joined by their northern neighbours. Assembling the trappings of a modern state began with the notorious step of painting the British red post-boxes green, a step which cemented the symbolic importance of the colour green for this new conception of Ireland. The design of definitive stamps, coinage and the State Seal emphasised the connection with nineteenth-century imaginings of Ireland, with a focus on the agricultural and antiquarian.[69]

Although these early Free State symbols offered a far from unified front, they form a distinct demonstration of the complex web of associations suggested by Irish national symbols, combining symbolic defacement,

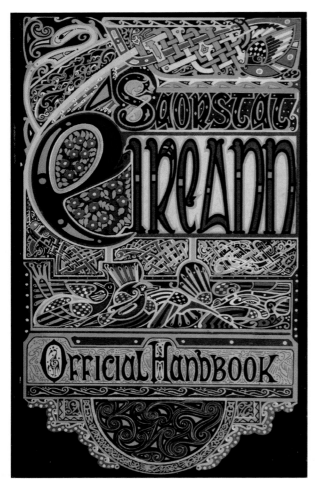

Figure 5 Art O'Murnaghan, Cover of the *Saorstát Éireann Irish Free State Official Handbook* (Dublin: The Talbot Press, 1932). (Image courtesy of the author, photograph courtesy of Peter Orford.)

symbolic use of colour, antiquarian references, geographical challenge, linguistic and typographical assertions, as well as allusions to both ancient legends and agricultural practice.[70] They work to reinforce the idea of the nation, allowing the population to continually imagine their nation by everyday contact with its physical manifestations. The majority of these symbols, however, are taken from the patrimony of essentialist symbols of the nation's past, with any epochal resonances restricted to the up-to-date production processes used to create the paraphernalia of a modern state. The Cumann na nGaedheal Government may not have been as deeply essentialist as later Fianna Fáil governments, but it managed to balance the essentialist leanings of the country at large with an eye for the current, epochal necessities for the creation of a new state.

This balance between the epochal and the essentialist can be seen in the publication of the *Saorstát Éireann Irish Free State Handbook*, which was published by Cumann na nGaedheal as they were leaving government in 1932, self-consciously commemorating a new epoch in Irish history and self-determination.[71] This elaborate publication had a cover designed by the illuminator Art O'Murnaghan (see Fig. 5), combining uncial textual elements with strongly coloured interlace and natural motifs highly reminiscent of Celtic manuscripts, all of which were intended to reinforce the position of the

POWER SUPPLY IN THE IRISH FREE STATE

ONE of the first economic problems dealt with after the establishment of the Irish Free State was that of power supply. By the hydro-electric development of the River Shannon, power derived from water as distinct from imported fuel, which until then was practically the sole source, was made available on a large scale. The distribution of this power throughout the country was provided for by the construction of a national network. The control and administration of the system was by the Electricity (Supply) Act, 1927, entrusted to a Board nominated by the Executive Council. The monies for the enterprise (over £10,000,000) are provided on loan to the Board from the State Exchequer.

The construction of the Shannon Power Station at Ardnacrusha near Limerick city began in August, 1925, and was completed towards the end of 1929. This power station is situated at the end of a 7½-mile head race canal which conveys the water from a weir situated near O'Brien's Bridge on the River Shannon. A tail race of 1½ miles long returns the water used in the power station back to the Shannon at the village of Parteen, near Limerick.

The head race is about 300 feet wide at water level and 35 feet deep, and ships' locks are provided in the power station dam to allow shipping

Illustrations—I. New Transformer Station at Fleet Street, Dublin. II. Interior of Turbine Spiral, Ardnacrusha Power Station, from drawings by Sean O'Sullivan, R.H.A.

Figure 6 Page from the *Saorstát Éireann Irish Free State Official Handbook* showing a terminal letter based on drawings by Sean O'Sullivan (Dublin: The Talbot Press, 1932, p. 157). (Image courtesy of the author, photograph courtesy of Peter Orford.)

Figure 7 Reproduction of a Mauri[ce] MacGonigal landscape painting of Lou[gh] Corrib, from the *Saorstát Éireann Ir[ish] Free State Official Handbook* chapter [on] industry (Dublin: The Talbot Press, 193[2] p. 146). (Image courtesy of the auth[or], photograph courtesy of Peter Orford.)

Free State as the legitimate inheritor of Ancient Ireland.[72] The interior contained chapters on the flora, fauna, art, industry and architecture of Ireland, as well as the constitution, judiciary, transport and trade.[73] The visual language of these chapters was heavily based on antiquarian ideas of Irishness, as they were decorated with terminal letters based on Celtic manuscripts and illustrated with lithographs of pages from those manuscripts and medieval metalwork, as well as reproductions of paintings of Irish landscapes by artists such as Maurice MacGonigal and Sean O'Sullivan (see Figs 6 and 7). However, the essentialist celebration of romantic and ancient Ireland closed with a substantial section of advertisements (many photographic) extolling the virtues of the most up-to-date hotels and transport connections, as well as businesses from shoemakers to department stores, convincing the reader that the visitor to Ireland has access to all conveniences of the modern epoch (see Fig. 8). This inclusion of modernised, commercial Ireland demonstrates a distinct awareness of the epochal context of the book, which was purposefully created with a view to the historical record and the creation of Irish history.

Modernities: modernisation and the Modern Movement

The specific development of Irish national identity in the early twentieth century owes a largely unacknowledged debt to conditions in the wider world. Particularly in the inter-war period,

events, ideas and ideologies outside the country set the context for what Graham includes in 'the numerous examples of failed nation-state building that litter Europe'.[74] One of the greatest influences on nation-states was that of the development of the idea of 'the modern age'. Described in *New Keywords* as 'one of the most politically charged keywords circulating', 'modern' is generally used to mean a recent period of time, although its historical association with the idea of progress means that it can be used to describe a range of phenomena, including science and technology, urban living, and a number of historical cultural avant-gardes.[75] Greenhalgh identifies five interconnected factors which must all be in place before modernisation can occur: the existence of a nation-state and the presence of advanced technology and financial capital, alongside a rise in consumption and in urbanisation.[76] MacCannell describes the features of the modernised world as 'advanced urbanization, expanded literacy, generalized health care, rationalized work arrangements, geographical and economic mobility and the

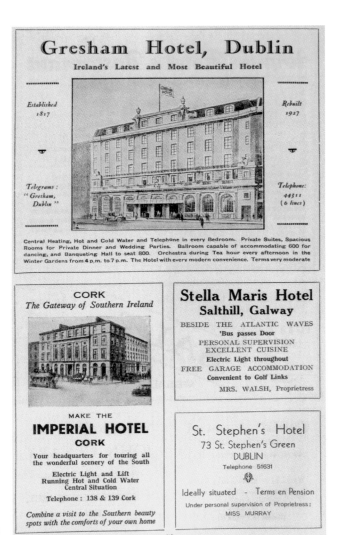

Figure 8 Advertisements for Irish hotels in the *Saorstát Éireann Irish Free State Official Handbook* (Dublin: The Talbot Press, 1932, p. 78 of advertisements). (Image courtesy of the author, photograph courtesy of Peter Orford.)

emergence of the nation-state as the most important socio-political unit', most of which increasingly applied to Ireland in the 1920s.[77] He argues that the condition of modernity becomes initially apparent in urban centres, before

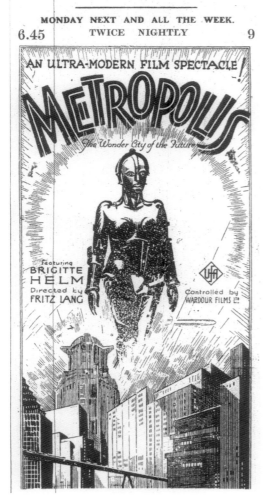

ATHENÆUM.

MONDAY NEXT AND ALL THE WEEK.

6.45 TWICE NIGHTLY 9

AN ULTRA-MODERN FILM SPECTACLE!

METROPOLIS

The Wonder City of the Future

featuring
BRIGITTE
HELM

Directed by
FRITZ LANG

Controlled by
WARDOUR FILMS L?

Figure 9 Advertisement for *Metropolis* in the Athenæum cinema, Limerick, 1927. (This image is reproduced courtesy of the National Library of Ireland: Newspaper Collection and the *Limerick Leader*.)

spreading in an uneven manner to more rural locations.[78] The spread of a modernised way of life to the Limerick city area in the late 1920s was evident by its location on the extensive railway network, the increasing number of motor cars, industrial work and exposure to occasional imports from industrialised Germany, as in this advertisement for the futuristic science fiction film *Metropolis*, screened in a Limerick city cinema (see Fig. 9). The film is labelled as 'an ultra-modern film spectacle!', and presented the figure of the robot Maria and the urban landscape as symbols of a modernised future based on science and industrial labour.

The development of Ireland as a modernised state created a society furnished with railways, motor cars, telephones, cinemas and daily newspapers. This spread of an ahistorical, epochal consciousness happened at a crucial moment in the development of the industrial world, moving from the earlier nineteenth-century model of mechanical industry, towards a model that incorporated distributed systems of power and consumption (e.g. electricity systems, car factories and management structures).[79] This is the modernised world described by Marshall Berman in his discussion of Baudelaire and Benjamin, where electric light took its place as a central symbol of the modern world, along with the fashionable parade, the *flâneur* and the constant movement of the big city.[80] It is these 'deep fundamental sociological structures and more lasting views and modes of thought and comprehension' which shape the culture of any particular time

and place.[81] Modernisation carries important associations with the universal, the rational, the systemic and the technological, all of which represented an influential epochal complex of ideas in the early twentieth century, particularly in the development of mechanical and then electrical technologies and their complex systems of control and administration.[82]

It is important here to separate out the epochal desire for modernisation from the specific manner in which artists and designers responded to this cultural context. The concept of a new age, structured by the values of 'order, regularity, system, and control' associated with Taylor and Ford inspired a whole generation of European artists, designers and architects.[83] Figures and groups such as the Futurists, Le Corbusier, Ludwig Mies van der Rohe and Walter Gropius were influential in developing aesthetic responses to the structural changes that were going on around them, despite representing a tiny fraction of creative practice.[84] They were involved in a collection of avant-garde aesthetic and ideological movements, which sought to reject history, tradition and applied ornament, and to express the power of machine and industrial production. As Wilk points out, although artistic Modernism was not a singular movement, modernists generally came from a common position that art, design and architecture had a moral imperative to transform society, to dispose of the vestiges of the past and to create a new, utopian world.[85] As well as this main group of idealists, Greenhalgh identifies two other tendencies within the Modern Movement: smaller groups involved in neutral reportage of life in the modern world, or radical critique of the changes brought by modernisation, such as the German Expressionist plays staged by the avant-garde Dublin Drama League in the late 1920s.[86] The slippery nature of the term 'modern' has meant that the enthusiastic responses to systemic technologies often allowed for confusion of the Modern Movement with the condition of modernity, as described above.[87] To reduce this confusion, I will refer to the wider cultural condition as the condition of modernity or modernisation, while specifying the aesthetic response as Modernism or Modernist.

Modernisation: multiple modernities

The concept that the condition of 'modernity' is singular, universal and indivisible is a logical follow-through from the common usage of the term, but

it is one that has since been shown to be impossible to apply to the variety of different modernities which developed in different nation-states and political structures during the twentieth century.[88] The differences in rate and direction of development of various 'modern' nations during this period (e.g. Germany, India, Russia) mean that it is very easy to see different expressions of modernity as levels of backwardness, compared to the United States.[89] This homogenising tendency also has the effect of masking the specific and particular ways in which each nation interprets the concept. For example, Sabatino writes about the relationship of Italian designers to the vernacular furniture and architecture of Capri and the Amalfi Coast, which they appropriated to form a modernist synthesis of collective expression and individual identity from the 1920s to the 1950s.[90] This works in a very different way to the symbolism of modern furniture in post-war Turkey discussed by Gürel, where it represented a level of class distinction, as well as an adoption of a pro-American stance in the Cold War and a rejection of local artisan traditions.[91] Both of these types of furniture are seen as 'modern', but they are designed to be 'modern' in very different ways, with another particularly Irish interpretation of 'modern' at work in the Irish Free State.

Technologies: technology and the technical

The regional variation in interpretation of the modern is hugely influential in how specific nation-states conceived of, used and manipulated the introduction and development of 'modern' technologies, depending on their interpretation of epochal issues. As the values of system and order were understood to be instilled through technological means, this makes national attitudes to technology of primary importance. The concept of 'technology' is open to interpretation and re-interpretation, to suit local social, political and economic conditions. For example, Schatzberg discusses the introduction and mis-translation of German concepts of technology into American debates in the early twentieth century. German terminology retained a difference between *Technologie*, meaning the ideas or concepts behind the industrial arts, and *Technik*, the practical methods and practices used to create industrial artefacts. *Technik* is closer in meaning to the English 'technique', specifying the purely practical and mechanical, rather than the social or organisational aspects of technological practice. The main route of transfer of this idea into English was from German to American economists,

most notably through the work of Thorstein Veblen. Veblen conflated both terms into the English 'technology', losing the sense of a difference between the purely practical aspects of technology and its wider social context.[92]

This interpretation of the idea of 'technology' as a loaded concept proved very influential in the period under discussion. While the precise meanings differed from person to person, in overall terms it marked a difference from 'the relatively limited capacity of the merely *useful* (or *mechanic* or *practical* or *industrial*) *arts* to generate social change'.[93] It brought the area of engineering out of the mere *Technik* (or technical), allowed it access to the realms of the higher arts and associated it with science, business and the creation of wealth. Importantly, it became inextricably entwined with the idea of progress, to become 'a concept that did not merely signify, like the useful arts, a means of achieving progress, but rather one that signified a discrete entity that, in itself, virtually constituted progress'.[94]

The close association of technology with progress was influential in both the United States and Europe, as it propelled the agent of technology from mechanic to technician and improved the status of the engineer. It also had the effect of associating technology with specially trained experts and university research programmes, transforming it into an elite, exclusive activity, and segregating it from the more common body of knowledge. This segregation then had the effect of mystifying the processes, artefacts and components of technology, so that both the specialised knowledge required to deal with technology and the objects themselves became 'black boxes'.[95] This encouraged the view that technology has an objective power of its own, as if it exists independent of its human creators and mediators, as well as encouraging determinist ways of thinking, as if technology alone is driving human history, outside of human control.[96]

The potential for the development of a technological Ireland in the 1920s depended on how these concepts were transferred into the State from outside. The English-speaking nature of industry and construction in the country tended to encourage the importation of British and American ideas, particularly in the sphere of engineering. Irish engineering education was heavily based on that of the British system, with numbers of Irish-trained engineers emigrating to work on projects throughout the Empire before Independence.[97] The importation of German ideas about *Technik* and

Technologie also suffered in translation here, as any importation of the concepts in the 1920s would have already found Veblen's conflated term 'technology' in existence, confusing the two terms.

Technologies: progress, *Technik* und *Kultur* in the United States and Germany

The underlying concepts of progress and modernisation are crucial to understanding the attitude to electrical technology in the 1920s, in Ireland as well as in the wider world. While German ideas of modernisation and technology were introduced into Ireland during this period by Siemens, American notions of technology were also very influential, given historical ties between the nations.[98] The American attitude to electrical technology was heavily influenced by determinist narratives, with a new 'age of electricity' being posited as part of an epochal narrative of progression into a technologically improved future. The approach to technology can be seen in the response to the efforts of, first, Frederick Taylor in the rationalisation of work, and later, Henry Ford in his systematisation of the factory workforce. Both of these methods of organisation had a profound effect on the use of advanced technology, as they were integrated with the more sophisticated 'second industrial revolution' of electrically-driven machinery and products. Coupled with an emergent mass culture, the unprecedented prosperity of the United States by the early 1920s was seen by many as a vindication of technological methods, as well as the result of the 'march of progress'.[99] This became an underlying rhetoric in much of American culture, with technology replacing economics as the prime motor of progress, and the engineer taking on the role of solver of social as well as technical problems.[100] The link with the modern, or specifically modernisation, is important in this context, as it plays an important role in the development of ideas about a single deterministic path from a traditional society to a modern one, which the first Irish government could view as an important state-building tool.[101] Nye identifies this as an important element in the formation of national identity in the United States of the period, with the embracing of technology and progress playing a central role in the frontier myth, an essential element of the imagined American community.[102] In addition, a common reaction to new technology seems to be uncritical acceptance of it and the projection of

desires for the future onto it, allowing the human imagination to express faith in itself, with one technological artefact standing symbolically for the entirety of the system.[103] The symbolic presentation of technology can be seen in the nineteenth-century American concept of the United States as a sort of Second Creation, or the earthly equivalent of Paradise, giving particular impetus to an enthusiastic acceptance of technology within the country.[104]

Similar debates were taking place in Germany during the 1920s, on the role and interplay of technology, modernisation and the nation. The early part of the period under discussion coincides with the Stresemann period of the Weimar Republic, consisting of six years of stability between the introduction of the Rentenmark in 1923 and the Wall Street Crash of 1929. A keen interest in American developments in the area of rationalisation of industry and work has been noted throughout the 1920s in Germany, as part of a search for possible models of economic success. The techniques pioneered by Frederick Taylor and Henry Ford formed a case study in economic modernity founded on industrial restructuring and provided a terminology with which to discuss Germany's future.[105] The interest in Fordist techniques, in particular, formed the logic underpinning the efforts of German industrialists, engineers, sociologists and psychologists during the 1920s who read Ford's autobiography, visited American factories with notebooks in hand, and returned eager to try out ideas of *Rationalisierung* at home. Books such as *Economic America*, published in 1925 by Carl Köttgen (the general director of Siemens), pointed out which aspects of the American experience could be applied to Germany, particularly in the light of German emphasis on quality handwork and intensive labour processes.[106]

The desire for a reimagined German national identity that could incorporate second revolution technology can be seen as a result of the historical circumstance in which the German nation was first imagined. The swift incorporation of industrial manufacturing into German society in the late nineteenth century was not accompanied by an embracement of Enlightenment thought amongst industrialists, nor by a parallel development of political liberalism.[107] This development within the German Empire of the *fin de siècle*, therefore, allowed the essentialist romantic legacy of the state to influence attitudes and approaches to technology in the early twentieth century.

These approaches to national identity and the imagined community had a central influence on the debate within the engineering profession about

the place of technology alongside the 'cultured society' of Germany. Within this cultural context, the German engineer was presented with a paradoxical problem. Was he (and exclusively he) to work as an agent of rationalisation and civilisation, embracing liberal economic doctrines, which meant turning his back on the opposed ideological formation of *Kultur*, with its cultural context of essentialist nation, blood and soil, the soul and the people? The emerging technological style evident in American industry of the 1910s was seen as being soulless and materialistic, unsuited to German local conditions and the German local '*Geist*'.[108] While ethnic, essentialist conceptions of national identity are definitely at play here, there is some basis to the idea that American technological models could not be directly transferred wholesale to Germany. The American model was based on much larger physical areas, both in terms of factory space and distribution for products, whereas German industry had historically operated on a smaller scale, using labour-intensive methods and models, partly based on developments of existing craft industries.[109]

Within the world of the professional engineer, an interesting realignment of the idea of technology took place, played out in the pages of German engineering journals and books considering '*der Streit um die Technik*' or 'the technical dispute', starting in the early years of the twentieth century. The main points of this discourse involved a repositioning of the engineer towards the dominant essentialist ideals of selfhood and authenticity, placing the creative labour of technology on a continuum with the craft worker and the artisan.[110] This technological romanticism posited the engineer as the modern hero, working within and for German society, balanced between the essential and the epochal.[111] A central role was played in this debate by figures such as Carl Köttgen, who was an activist in both the RKW (*Reichskuratorium für Wirtschaftlichkeit* [National Productivity Board]) and the VDI (*Verein Deutscher Ingenieure* [Association of German Engineers]) in the late 1920s, as well as a general director of Siemens from 1921.[112] Instead of simply accepting or rejecting American technological methods, Germany had managed to transfer and absorb certain elements of the American experience, while discarding others as being incompatible with local conditions. They had managed to create a balance between an efficient implementation of technological solutions and a distinct national culture, in a manner enviable to the Irish nationalist.[113] Although the choice of Siemens as contractor for the Shannon Scheme was

initially prompted by a set of personal circumstances and friendships, I would argue that this successful reinterpretation of engineering technology as an essentially German characteristic provided an attractive vision of technology to the Irish Government, which was involved in its own difficult negotiations between the forces of the epochal and the essential in the 1920s.[114]

Electrical technology and the technological sublime

The cultural associations surrounding technology were particularly marked in the area of electrical technology. The strength of these associations can be explained by the comparative newness of electrical technology, when compared with mechanical or steam technology. Indeed, the epochal associations of electrical technology were strong enough for it to be considered the defining technology of the age, as well as the foundational technology of a second Industrial Revolution.[115] This was particularly attractive in the early twentieth century, as industrialised parts of Europe were plagued by the effects of decades of coal smoke on the local environment, as well as the health of the local population. Both the AEG (Allgemeine Elektricitäts-Gesellschaft or 'General Electricity Company') in Germany and the Electrical Development Association (EDA) in the United Kingdom were involved in electrification programmes, in conjunction with education programmes designed to educate the people about how clean and safe the new form of power was.[116] For example, this poster from the EDA shows a leaping figure over a city skyline and the slogan 'For Health's Sake Use Electricity', emphasising the positive effects on health of living in a household free from gaslight or candles (see Fig. 10). The image is completely laid out in black-and-white: the slim silhouette and the sans-serif font combine to create a clean, sleek effect, with the aim of associating these values with electricity. The leaping movement of the figure, who is bearing a globe on a cable, presumably an electrical light, emphasises the simplicity of the new technology, as well as the textual link with healthy movement. An intensely epochal image, it also reinforces the Irish association of technology with the urban and the English, as the silhouetted city background locates electrical technology in a resolutely urban setting, specifically that of London, showing Battersea Power Station and St Paul's Cathedral.

Some of the British writing in the 1920s is almost evangelical on the subject, seeing electricity as the key to a clean and modern society. An example

FOR HEALTH'S SAKE
USE ELECTRICITY

Figure 10 British Electrical Development Association poster promoting the use of electricity, 1927. (A. Forty, *Objects of Desire: Design and Society since 1750*, London: Thames & Hudson, 1986, p. 191.)

from 1922 in *The All-Electric Age* by A.G. Whyte demonstrates this enthusiasm for technological solutions and their associated modernity:

> Of all the gifts that electricity brings, almost the greatest is the relief from the burden of mechanical, monotonous, everlasting toil. Just as our factories have become organised to turn out their product rapidly

and efficiently by electrical machinery controlled by man, our homes will be transformed to operate smoothly with the aid of electricity, so that the labour involved in cleaning, in heating, in cooking and in washing and other domestic tasks will be performed by an electric deputy.[117]

Electricity has been particularly associated with the idea of the technological sublime. Edmund Burke's idea of the sublime describes a human reaction to the natural world, such as the vast magnificence of the Matterhorn or other grand landscapes, which dwarf and terrorise the viewer into a kind of ecstasy of admiration.[118] But, whereas sublime reactions may be evoked by natural phenomena such as Niagara Falls, or by the ancient magnificence of a medieval cathedral, the technological sublime develops the idea for an industrial world into the awe-inspiring technical undertaking acting as witness to the achievements of Man (or the American people).[119] In the late nineteenth century, it was often associated with spectacular lighting displays, either as part of civic pageants or international exhibitions, as well as technological 'enhancements' of natural wonders such as Niagara Falls, illuminated by powerful electrically-powered searchlights from the 1920s.[120] Indeed, the experience of the technological sublime seems have been particularly associated with large projects or installations like dams and turbines, both of which are combined in the hydro-electric power station.[121] The American historian Henry Adams describes his reaction of awe and wonder on encountering a forty-foot high dynamo on exhibition in the French International exposition of 1900, comparing it to the response of a medieval peasant to a statue of the Virgin Mary.[122] Contemporary descriptions of the Shannon Scheme works heavily emphasise the size and scale of the work.[123] Even the Irish engineering press were not immune from this reaction, with several articles focusing on lengthy descriptions of the construction machinery.[124] They also focused on the speed of the work as a result of electric power:

> The first thing that strikes one is the vastness of the works, and the most outstanding feature is the wonderful machinery … The excavations, not yet near their full depth, are immense. The mechanical excavators, part steam driven, part electric power supplied

from one temporary power house, are wonderful. Forming the sides of the banks, excavating at the same time, they deposit the spoil in heaps to form embankments, or load it into waiting wagons of a train alongside, filling about ten wagons in about twelve minutes.[125]

The continual reference to the size and scale of the Shannon Scheme means that it could be considered as a manifestation of the technological sublime, particularly in the context of the unindustrialised Irish countryside. This type of epochal association surrounded the electrical technology which McLaughlin wished to import into Ireland, providing a direct contrast to the dominant essentialist tone of the country in the 1920s.

Technology in Ireland: Cumann na nGaedheal and the idea of progress

In contrast with its near neighbour Britain, the lack of nineteenth-century industrialisation within the island of Ireland resulted in a heavily agricultural society in the early twentieth century. Girvin argues that it would be more accurate to describe the new State as an agrarian region within the United Kingdom for quite some time after independence.[126] It remained a relatively poor region within a more prosperous area, depending on the industrialised North of England and Wales for manufactured goods and industrial products, and Cumann na nGaedheal retained a policy of free trade for this very reason. This location, geographically close to a large industrialised area, contributed to the continuing low level of industry in the Free State, along with the loss through partition of Belfast, the only industrial city on the island. Any remaining industries were small and low-technology, mostly comprising processing operations for foodstuffs such as beer and biscuits.[127] In addition to this lack of a strong industrial base which could influence Irish attitudes towards epochal ideas, a historic attitude towards heavy industry as something 'British' and associated with the conqueror can be discerned. The Irish experience of industrialisation and urban life was heavily mediated through London, Liverpool and Manchester, cities which provided a striking contrast to the undeveloped rural nature of the home island, so that an easy dichotomy of 'British = urban' and 'Irish = rural' could be set up and propagated.[128]

Nonetheless, a certain appreciation for the American idea of 'progress' can be discerned among Cumann na nGaedheal members and supporters during the period. The conservative nature of the new Government outlined above meant that no policy was carried through without careful consideration, as party political culture emphasised stability and caution.[129] However, the pressure was on the new Government to provide an improved standard of living for its people, meaning that the status quo could not just simply be maintained. The development of a programme for electrification in the mid-1920s can be seen in this light – as a way of providing improved services to the population, in line with or better than the rest of the world.[130] Again, the pragmatic nature of the Cumann na nGaedheal Government has to be taken into account, recognising the practical and economic effect that the Scheme would have on the country.

> Sir Thomas Esmonde: This scheme is going to do an immensity of good for the moral upliftment of the nation. You are going to bring light into the homes of the people. You are going to improve the sanitation of the country. You are going to improve the housing of the country. Most important of all, you are going to make it worth while for the rising generation of Ireland to live in their own homes.[131]

Cumann na nGaedheal demonstrated a distinct consciousness that it would not be possible for the new state to retreat totally into insularity and encouraged a policy of free trade throughout the period. This view was coupled with recognition of the dominant economic approaches of the day, positing a continual development of countries along a linear scale of 'progress'. This teleological approach underpinned much of the American discussion of industry and electricity and can be seen in the debates on the Shannon Scheme in the Dáil.

> Mr. McCullough: But we cannot afford to allow any interests to stand in the way of national progress and consequently, though there may be a certain amount of hardship involved for the interests which are behind the other schemes, I think that we will have to disregard it and give the Minister a backing to go ahead with the

greater scheme that will, in my opinion, revolutionise the whole face of the country.[132]

During the discussion on the explanatory statements made to the Dáil by Patrick McGilligan in 1924, it is notable that a number of TDs, not just members of Cumann na nGaedheal, were positive about the benefits of the Shannon Scheme, with TDs across the political spectrum couching their arguments in similar teleological and epochal terms.

> Professor Thrift: I only add one remark: that is, that I venture to hope this marks a very big day in Irish history, that we may from this turn our attention – taking our position here as a fixed position – to the most important thing in this country, and that is the practical question of how the country is to be advanced and brought into a real state of prosperity. It needs very little imagination to see in the scheme which the Minister has laid before us possibilities of progress and of a future for the country which may be indeed quite beyond the highest hopes of many of those who have very high hopes for it.[133]

However, the future Ireland envisaged in the 1920s was not to go down the route of the industrial north of England, with dark, smoky mills and factories in dirty industrial cities, but a development of existing small industry on a widespread, national scale. Electricity was an important part of this vision, providing clean energy and power to a modernised, but culturally authentic, Gaelic countryside.[134]

This imagining of a nation which was modernised and somewhat progressive was always leavened by the awareness of national identity, however. For example, just one month before the 1932 general election, in which Cumann na nGaedheal was to lose power, the party issued a fifty-page supplement to *The Irish Times* entitled 'Saorstát Éireann Irish Free State 1921– 1931: A Decade of Progress', which included a full-page article on the Shannon Scheme and its benefits to industry.[135] The front cover of this supplement (see Fig. 11) shows a facsimile of the signatures on the Treaty document with a stylised seal, surrounded by Celtic knot-work and the title in green uncial lettering, appropriating the signifiers of Ireland's past and marrying them to recent political developments and hopes for the future.

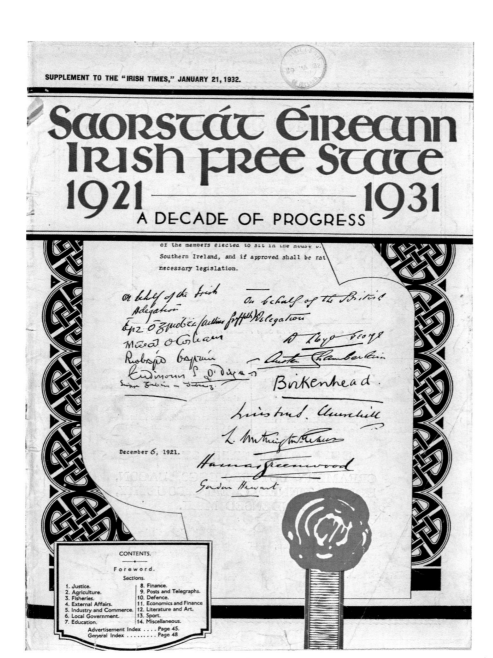

Saorstát Éireann
Irish Free State
1921 ———————— 1931
A DECADE OF PROGRESS

of the members elected to sit in the house of
Southern Ireland, and if approved shall be rat
necessary legislation.

December 6, 1921.

CONTENTS.

Foreword.

Sections.

Figure 11 Cover of *The Irish Times* 'Saorstát Éireann Irish Free State 1921–1931 Supplement' (21 January 1932, p. A1). (This image is reproduced courtesy of the National Library of Ireland: Newspaper Collection and *The Irish Times*.)

The Irish imagined community: finding a balance

The idea of the imagined community is an important one in the study of national identity, particularly in Ireland. It provides an explanation for the subjective antiquity and validity of the idea of the nation, as well as its enormous political power, despite the shakiness of any theoretical underpinnings. The imagined community allows the nation to be a performative creation, as it is only the sustained belief of its people which keeps the nation alive. The visual manifestations of a state also play an important role in sustaining national identity. The corollary, that different, competing interpretations of the one nation can exist simultaneously, is played out in the imagining of the Cumann na nGaedheal Free State and the phantom Republic, as well as a number of alternative Irelands which existed in the formative years of the Free State. The first years of the first Free State government were largely involved in establishing their imagining of Ireland as the official one, at the expense of any others. While the heavy dependence of this imagining of Ireland on previous essentialist imaginings ensured that the official symbols of the Free State were based on antiquarian and rural symbols, it was less essentialist than that of the competing phantom Republic. The 'pragmatic' attitude of Cumann na nGaedheal to economic and fiscal matters actually demonstrates an epochal awareness, which was not as developed in the main opposition party. This epochal awareness allowed a consideration of Ireland's state of progress in comparison to the rest of the world and fostered a desire to improve the country as much as possible, while still holding onto its essentialist heritage. The transfer of the teleological concept of progress from an American origin to Germany provided an attractive combination of epochal and essentialist forces, with the role of German engineering balanced between the two forces of *Zivilisation* and *Kultur*. It is this successful balancing act between the two forces which made German engineering so attractive to an Irish audience, providing a template for a technological romanticism, which was focused on the technological sublime and with the engineer as hero. In relation to the Shannon Scheme, the creation of the Scheme was an expression of the epochal tendencies of the Cumann na nGaedheal government, which allowed this German model to inspire the production of a technological artefact which would be able to stand for the whole system of Irish national identity at that point, both epochal and essential.

2

The Power Station: A German-Irish Industrial Building

The Shannon Works, needless to say, have not been built with a view to artistic effect. We do not suppose that aspect ever entered into the thoughts of the designers, but in their present state, anterior to the flooding of the canal ... the various constructions present a very imposing appearance, thus, once again, demonstrating that strong, honest construction, if boldly designed as construction, free from applied architecture, will always possess its own effect of grandeur and aesthetic character.[1]

Written shortly after the opening ceremony in August 1929, this *Irish Builder and Engineer* editorial presents the Shannon Scheme building as a triumph of engineering, a radical departure from the intense scepticism expressed by the Irish engineering and architecture community throughout the construction of the Scheme. The article, however, completely neglects to mention the German source of that very technological and engineering expertise, or the power station's aesthetic relationships with both other Siemens power stations and local vernacular architecture. The financial difficulties involved in financing the Scheme are alluded to later in the article, but it speaks of the power station as 'well thought out, carefully executed, and without undue interference on the part of the promoters', also conveniently ignoring the negotiations between the

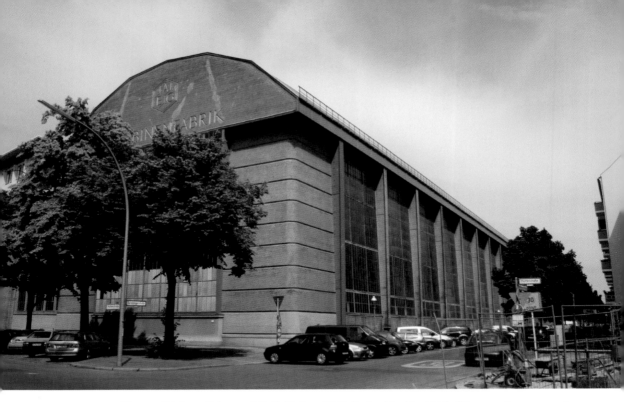

Figure 12 Peter Behrens, A.E.G. Turbine Hall, Berlin-Moabit, 1910. (Photograph courtesy of the author, 2009.)

German contractors and the Irish Government throughout the construction of the Scheme.[2]

Most recent discussions of the Shannon Scheme architecture focus on a view of the Scheme as a symbol of the new Irish Free State, a view that continues to leave out the central role of Siemens in designing and constructing the project.[3] This approach not only leaves out the hundreds of German staff who worked on the Scheme, but it also downplays the importance of both German industrial architecture and the specific style developed by Siemens for its own industrial construction. It also neglects the influence of the Irish location on the German architectural staff, as they tried to reconcile their views of *Technik* with local Irish *Kultur* and forms of vernacular building.

At first glance, it seems that the construction of the Shannon Scheme was carried out by the German engineering contractor Siemens on behalf of the Irish Government. However, the actual structure of negotiations was

POWERING THE NATION

not quite so simple, as the Department of Trade and Industry of the Free State Government retained ultimate financial control of the project, but were themselves beholden to the notoriously tightly held national budget of the Department of Finance. In order to exercise competent technical oversight of the process of construction, Trade and Industry set up Shannon Power Development to manage the project. Shannon Power Development had offices in Dublin and Limerick and employed what few Irish engineers with experience of large hydro-electric or water systems could be found, including Professor Frank Sharman Rishworth of University College Galway as Chief Civil Engineer, and then recruiting Peter Sothmann, a Dane with American citizenship, from the United States as Chief Electrical Engineer. There were also a small number of Swiss and Norwegian electrical engineers, as recommended by the Experts Report, but the majority of the Shannon Power Development staff were Irish, as were those of the later ESB.[4]

The fractured nature of Siemens' involvement with the Scheme reflected the complicated network of subsidiary companies grouped under the Siemens umbrella in the late 1920s, with the Siemens offices in Limerick and on site at Ardnacrusha hosting electrical engineering staff from Siemens Schuckertwerke and civil engineering staff from Siemens BauUnion, with overall control exercised from Berlin by Siemens Head Office. Siemens Head Office also took care of the negotiation with the German engineering firms of Escher Wyss and Voith for the production of turbines, and Louis Eilers for the production of the steel frames for the power house. While the negotiations surrounding the construction of the power house were nominally between Shannon Power Development and Siemens-Schuckertwerke, each side was part of a larger organisation, which heavily constrained and influenced their freedom to negotiate.

German industrial building (*Bedürfnisbau*)

The design and construction of the Shannon Scheme buildings were heavily influenced by the development of industrial buildings in Germany in the early years of the twentieth century. As with engineering practice and ideas, German architecture during this period took some basic American ideas about the structure and management of industrial work and adjusted them to suit

a particular national context. Members of the Deutsche Werkbund disagreed loudly and often with each other on how *zivilisiert* progress could be reconciled with German *Kultur*, but figures such as Muthesius, Behne, Gropius and Behrens were instrumental in creating a self-aware dialogue within the German manufacturing sector, including the development of a new type of construction, the *Bedürfnisbau* or industrial building.[5] Werkbund architects were focused on working out the specific functional constraints and demands of industrial buildings in terms of lighting, materials and the layout of machinery and equipment. At the same time, they wished to express and echo the industrial processes being carried out within the buildings, as well as the efficiency and stability of German industry, and relied on their shared Neo-Classical influences to underpin their stripped-down approach with regular, harmonic compositions.[6]

Peter Behrens' Turbine Hall in Berlin–Moabit designed for AEG (*Allgemeine Elektricitäts-Gesellschaft* [General Electricity Company]) (see Fig. 12) works as a negotiation between *Zeitgeist* and *Volksgeist*, the broad spirit of the age and the romantic spirit of the people, in a recasting of the debate between *Technik* and *Kultur* going on within the German engineering community at the time, as well as the forces of essentialism and epochalism within broader German culture.[7] While based on an overall structure heavily influenced by Neo-Classical handling of form, it is a resolutely modern building in its materials and detailing, with the 'pilasters' constructed of concrete and laminated iron and the 'bays' of plate glass.[8] The interior of the building continues this focus on the rhythmic, as the support structure for the travelling crane is embedded into the iron structure of the building itself, both literally and figuratively creating and controlling the dimensions of the physical space.[9] Behrens worked out the technical requirements of these support structures with AEG engineer Karl Bernhard and the functional constraints, such as the need for extensive natural lighting, were proscribed by Oskar Lasche, AEG's chief production engineer, allowing the building to retain both a strong sensitivity to the functional requirements of turbine construction work flow and the semantic message of an AEG landmark factory.[10] The large vertical windows are particularly notable, as they represented the easiest way of providing natural light in a tall space before the later adoption of glass curtain walls by Modernist architects such as Walter Gropius. The building was received by the

Werkbund as a shining example of embodied *Kultur*, particularly as a means of avoiding the alienation of workers who spent their working lives in the building, as they were provided with a light, airy workplace.[11]

Although Deutsche Edison Gesellschaft (later AEG) had been building power stations on contract from the 1880s, the majority of their early stations were decorated in a historical, often Neo-Classical style.[12] The new wave of industrial buildings in the 1910s started to influence German power station architects and engineers, inspiring them to apply these general ideas about the construction of general factory buildings to the more specific design problems of both fuel-burning and hydro-electric power stations. George Klingenberg, the head of the AEG Department of Power Stations had voiced the opinion that 'One should never forget … that a power station is nothing but an electricity factory and that, just as with other factory buildings, its industrial character should not be concealed.'[13] One such example, the Laufenburg

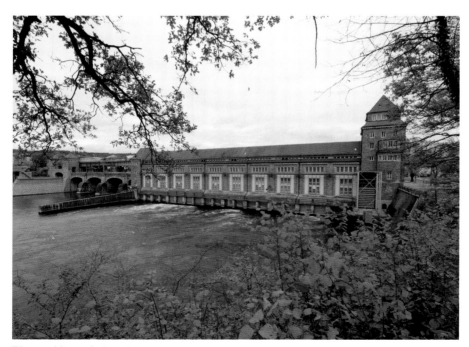

Figure 13 Laufenburg hydro-electric power station on the Upper Rhine, 1908–14. (Photograph courtesy of Wikimedia contributor Bobo11, CC-BY-SA-3.0,2.5,2.0,1.0.)

run-of-the-river power station on the Upper Rhine, was finished in 1914 (see Fig. 13).[14] This station was constructed with ten Kaplan turbines and a four-sectioned weir to control the level of the Rhine river and was the largest power station of its type when it was built.[15] The design of the power station buildings owed a great debt to existing *Bedürfnisbau*, based around a solid, rhythmic turbine hall whose ten turbine bays stretched halfway across the river. This repeated visual motif was strengthened by the repetition of the window elements, as each bay contains three tall windows, topped by four smaller ones above the level of the cable crane. The station was built from local stone and red slate, with a pitched roof typical of the area, intentionally tapping into the *Volksgeist* of southern Germany. The administration building (the right-hand section of the building in Fig. 13) continued this regular geometric pattern, with a grid of windows inset into each of the rectangular facades. The roof of this building, as well as the control towers on the weir, continued the simplified geometric aesthetic of the station, forming pyramidal caps at either end of the horizontal complex. This type of formal composition was endorsed by Adolf Ludin, one of Germany's foremost hydro-electric engineers of the period, who recommended that the architectural style of the power house be continued onto the weir and all other buildings within the complex. He also recommended that the turbine hall should be roomy, high and light, with floor-to-ceiling windows, if possible, to allow for a maximum of natural light.[16] Again, the functional requirements were a central concern, although in this case, tempered with local materials and styles of detailing related to the architecture of the surrounding area. Power stations such as Laufenburg were not without their critics, particularly classicists such as Paul Schultze-Naumburg, who saw in the lack of historical detail a total lack of concern for *Kultur*, but they did differ from the large projects taking place in the USA and the USSR at the time, in their emphasis on incorporating the cultural context of their location along with the formal requirements of the technology.[17]

The background of German industrial building had a large influence on the specific design style developed for Siemens industrial buildings in the 1920s, as the company expanded its

production and its identification as a leading light of German industry. The development of 'Siemens style' had its roots in the early-twentieth-century work of Karl Janisch, whose work as Siemens chief architect had seen him develop the industrial suburb of Siemensstadt, creating a core of buildings and courtyards which interpreted monumental late Classical forms in red Berlin brick (see Fig. 14).[18] The role of Siemens chief architect was taken over in 1915 by Hans Hertlein, who, under Werkbund influence, built on Janisch's work to develop 'Siemens style'.[19] His buildings exemplified the developing

Figure 14 Karl Janisch, Administration Building on the Nonnendammallee, Siemensstadt, 1913. (Photograph courtesy of the Siemens Archive, 1959.)

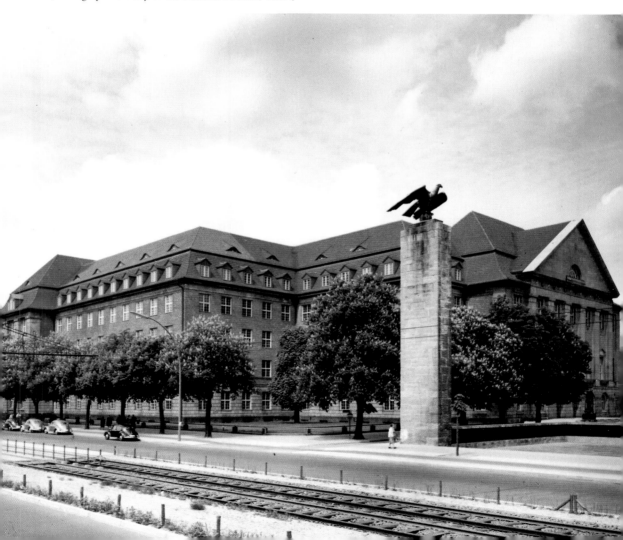

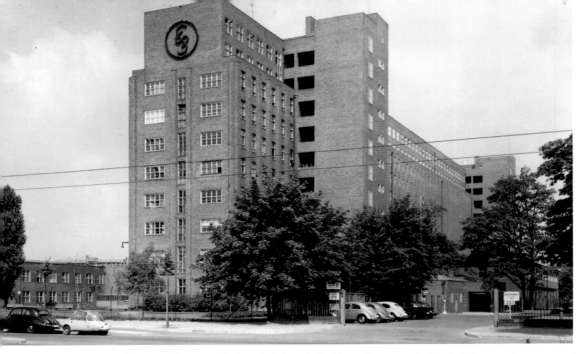

Figure 15 Hans Hertlein, Schaltwerk Building, Siemensstadt, 1928. (Photograph courtesy of the Siemens Archive, 1950s.)

tendency towards functionalism in Werkbund architecture during the late 1920s, which became heavily identified with the *Neue Sachlichkeit* or 'New Objectivity' movement, with its emphasis on 'formal simplicity, rationality of design, and machine technology'.[20] He constructed numerous buildings in the Siemensstadt area, including the Schaltwerk or control unit works (see Fig. 15), continuing the idea of the flexibility and interchangeability of manufacturing spaces, while developing the courtyard model of planning to include smooth cubic buildings with multiple wings at different heights.[21] The Schaltwerk housed the development and manufacture of high-tension plant and switch devices centrally important to Siemens inter-war expansion and was constructed at the same time as the Shannon Scheme, between 1926 and 1928.[22] Hertlein worked with engineer Carl Köttgen, who was, at that time, the chairman of the VDE (*Verband der Elektrotechnik* [Association for Electrical Technology]) and on the Board of Management of the company, to create a building with no concessions to historical style, but retaining the rhythmic layout and concern for balance which characterised earlier Siemens buildings. The cubic forms of the building sit solidly beside the flat manufacturing sheds,

construction. The pitched roof of the Shannon Scheme is similar in form to the Bielkowo roof, particularly in its use of eyebrow dormer windows, although triangular, rather than curved. The windows are all steel framed and were originally painted in a dark olive green, some of which can still be seen at the rear of the power house buildings (see Fig. 21). This olive colour and the treatment of the concrete architraves were recommended by Siemens architect Wilhelm Dohme, who advised that they be plastered smoothly and in a paler colour than the wall plaster, an interior effect used throughout Siemens interiors, including the control room depicted in a 1925 Siemens publication (see Figure 22).[40] The use of local dark grey Killaloe slate for the roof tiles creates a connection with the local styles of building, along with the grey concrete finish.[41] This is very much in keeping with the German approach of consideration for the *Volksgeist* of the surrounding countryside and appreciation for the local *Kultur*.

Figure 20 Rear of Ardnacrusha administration building, with turbine hall and 10kV switch house extending to the left. (Photograph courtesy of the author and the ESB Archives.)

Figure 21 Detail of window frames with original paintwork, rear of Ardnacrusha power house. (Photograph courtesy of the author and the ESB Archives.)

The intake building lies behind and above the power station and is almost invisible from the tail race, due to its flat roof. It is finished in a similar manner to the main station buildings, with a row of triple windows on either side allowing light into the interior, from where the penstocks and water intake could be adjusted (see Fig. 23). The flat roof on this building is completely different from the main building, however, and was the source of much debate during the construction, which will be discussed in the next chapter. The structure of the main complex and the exterior treatment of the buildings are so similar to German industrial buildings of the period, as well as to Siemens corporate architecture, that it leaves no doubt that this is a German-designed power station of the 1920s, albeit with a sensitivity to the local vernacular *Kultur*.

The interior of the turbine hall continued the emphasis on function, regularity and rhythm, with the original eight bays housing three turbines, although an additional turbine was installed in the mid-1930s into an identical two-bay extension (see Fig. 24). It is a typical German steel-framed industrial hall of the period, with the Eilers iron framework left proud of the concrete walls. The vertical steel frames were linked by a horizontal gantry and travelling crane, a functional arrangement for moving heavy equipment which went back to the earlier layout of Behrens' AEG Turbine Hall. This framework is currently painted pale teal blue, although there is no mention of the original colour in the Shannon Power Development file covering the design of the power house.[42] Each of the bays contained one tall exterior window on the tail race or west side and a set of smaller interior windows opposite, with the bottom two rows faced into the 10kV switch house and the top clerestory row opened out into daylight. This functional arrangement allowed the extraction

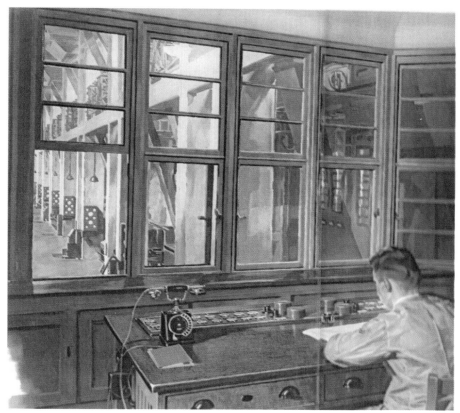

Figure 22 F. Schickert, illustration of 'Waermewarte in einem neuzeitlichen Grosskraftwerke [Heat exchange in a large modern power plant]' from *Der Siemens-Konzern im Bilde: Siemens & Halske Aktien-Gesellschaft* (Berlin: Siemens-Schuckertwerke Aktien-Gesellschaft, 1925). (Image courtesy of the Siemens Archive.)

of power from the turbines, whilst emphasising the rhythmic nature of the interior and adhering to Ludin's maxim about the importance of natural light in the turbine hall.

The materials of the turbine hall were also in line with Ludin's *Bedürfnisbau*-influenced ideas about functionality, with tiled floors, light coloured interior walls and an almost Classical attention to proportions and balance within the room.[43] The hall itself, however, was just a stage set for the central installation of the hydro-electric turbines, which were recognised as the centre pieces

of the entire complex and the reason and rationale for its existence. As early as 1900, non-engineers such as Henry Adams were recognising the power, both figurative and literal, encased in electrical generators and recognising them as artefacts of the technological sublime.[44] The monolithic forms of the Shannon turbines are over twenty feet high and march in a row down the centre of the hall, providing a central focus for the space. However, they manage not to dominate it entirely, mostly because their outer casings have also been painted in a similar pale colour to the whitewashed walls. The far end of the turbine hall was altered in the 1990s with the installation of a new digital control room, although the original analogue clock still hangs over the new construction, providing a symbol of efficiency and precision engineering, as well as the accurate timekeeping necessary for the manual load balancing carried out in the 1920s.[45]

This concern with efficiency and precision continued in the original control room of the station, which was placed at the top level of the administration building, directly underneath the pyramidal glass roof. The control room is horseshoe-shaped, with the curved wall bearing sets of circular dials, readouts

Figure 23 South side of Ardnacrusha intake building showing clerestory windows. (Photograph courtesy of the author and the ESB Archives.)

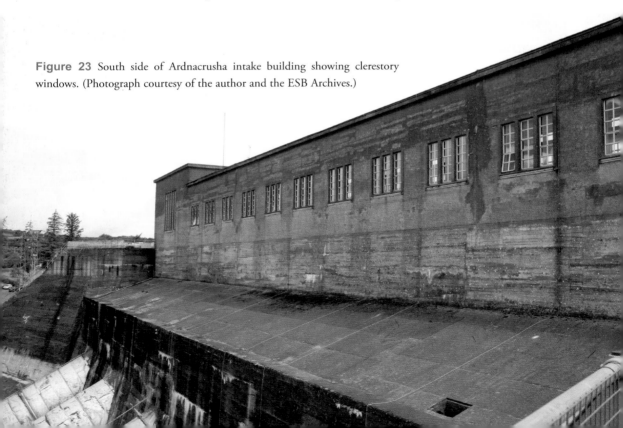

and a long curved bank of switches and controls, later described by a visitor as having 'an exquisite sense of order and simplicity about it'.[46] This was the original nerve centre of the station, manned twenty-four hours a day, where the duty engineer would monitor the flow of water through the turbines and the subsequent flow of electricity out through the 36kV and 10kV switch houses to the nation. The interior was, again, designed with efficiency in mind, as the engineer's large wooden desk in the centre of the floor allowed him to have an unimpeded 180-degree view of the readouts mounted on the semi-circular wall (see Fig. 25). The fourteen panels of circular dials were arranged in patterns on a three by four grid, with the layout of each panel dictated by its functional requirements. Each of the dials was surrounded by a dark lip to make it stand out from the pale cream panel, but had a slightly different colour background, in order to allow the operator to differentiate one dial from another. The impression of efficiency and precision was notable to visitors in

Figure 24 Interior of Ardnacrusha turbine hall. (Photograph courtesy of the author and the ESB Archives.)

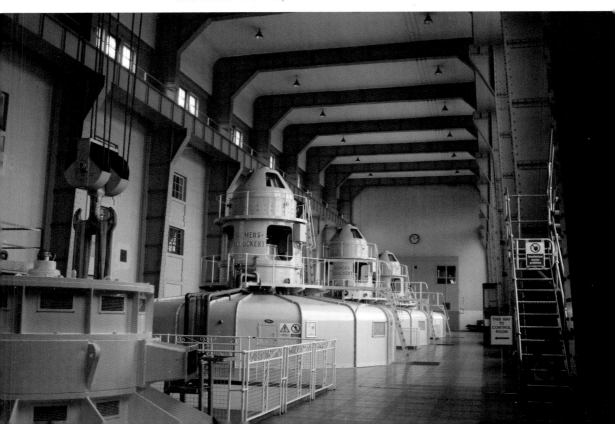

Figure 25 Original Ardnacrusha control room showing glass ceiling. (Photograph courtesy of the author and the ESB Archives.)

the 1920s, with one newspaper report comparing the arrangement to a counter in a jeweller's shop.[47] The ceiling of this room is taken up with an unusual glass skylight, which, again, was intended to allow maximum natural light into the interior. Constructed of custom obscure glass panels in a steel frame, it echoes the horseshoe shape of the room.[48] This glass ceiling was placed directly under the glass pyramid on the roof of the administration building, to allow light into the control room despite its windowless position in the centre of the building. In this case, Siemens produced a room which is balanced in proportions and geometric in form, although highly unusual in its horseshoe composition.

The Shannon power house was a unique building for the Ireland of the time and its development was watched with interest by Irish architects and engineers, as demonstrated by the continuous stream of articles in *The Irish Builder and Engineer*, which published an almost yearly progress report based on site visits by its writers.[49] Early objections to the Scheme from engineering and architectural circles focused on the lack of open competition in the organisation of the contract, which precluded the involvement of qualified Irish engineers and architects.[50] However, the general approach to the project seems to have been very positive from an engineering point of view, if rather cautious from an architectural one, with descriptions of it as 'an epoch-making event in the commercial history of Ireland' balanced against statements that the works 'have not been built with a view to artistic effect'.[51]

Overall, the buildings of the Shannon Scheme complex show undoubted evidence of their German origin. The concern for the technical issues of power generation is evident, ensuring that the plant is well-specified, well-lit and easy to clean. In addition, the design of the power station also demonstrates the specific concern with the expression of power and cleanliness unique to electricity, heavily influenced by the expressive quality of industrial buildings common in Germany in this period. It is a combination of these techniques and ideas about technology, specific to the German background of Siemens, which provided the major influence for the design and layout of the Shannon Scheme.

A German building in an Irish context

Overall, the initial impression given by the Shannon Scheme power station buildings is that they were directly influenced by industrial building in 1920s

Germany, from the initial innovations of Peter Behrens to the more developed structures of Siemensstadt, for which the functionality of steel-framed industrial buildings was used by Siemens to construct a large complex of buildings with some very detailed technical requirements. However, the Shannon Scheme buildings are not purely Germanic, as the Siemens engineers and architects retained a desire to balance the technical requirements with the cultural context of the development. German industrial building of the time did not involve completely bare or stripped forms, but a distinct awareness of the expressive potential of factory buildings, housing the most advanced technology of the time. It is this concern for the expression of technological form, the epochal spirit of the age, which underpins the design of the Shannon Scheme buildings, with their balanced and rhythmic interpretation of technical form. However, their concern for the local context demonstrates the German technical staff's sophisticated awareness of universal *Technik* and local *Kultur* with some concessions made to the essentialist nature of the rural Irish location. However, it is notable that these concessions are not made in the form of any applied neo-Celtic decoration or Neo-Classical forms, but in the use of typical Irish building material to relate to other buildings in the locality, as well as the insistence on a style of roofing suitable to the climate, regardless of cost.

3

Negotiating Building: Technical Drawings and Illustrations

The construction drawings and the steel structures for the Power House have been made in accordance with this decision (of a 45° slanted roof), and we were much surprised to hear that during the visit of Mr. Dohme to Ireland the Government revised its decision and gave instructions to alter the construction of the sloping roof, which was already finished, into that of a flat roof. We have made a drawing AZ 719467 representing this proposition, but the latter had to be abandoned, because the alteration would have caused a considerable delay in the completion of the plant and you therefore definitely decided for a sloping roof for the Power House.[1]

The development of the Shannon Scheme as a dynamic process of construction, rather than purely a fixed, finished object, can be drawn out through an analysis of the surviving technical drawings of the Scheme, which provide a visual dimension to the controversy about the pitch of the power station roof which came to a head in late 1928.[2] When analysed alongside the written historical evidence, the technical drawings provide an insight into the power struggles between contractor and client, as well as how technical drawings themselves can be used within both professional architectural and engineering practice as a tool for design and negotiation. This demonstrates the similarities and differences in working practices between architects

and engineers, as well as the different approaches of German and British-trained professionals to the deployment of technical drawings as the ultimate authority on determining form.

The role of technical drawings in building the power station

The interaction of German engineering influences and ideas about *Technik* and *Kultur* as Siemens worked within Irish power structures can be most clearly seen from an analysis of the construction process of the station. The greater or lesser influence of various actors, both human and non-human can be demonstrated by tracking a number of the technical drawings used to express ideas and communicate plans for the station throughout the process of design and construction, using them alongside the memos, letters and other textual evidence as a type of thick description of events. Tracking this historical debate through the surviving evidence allows the analysis to move beyond the final 'finished' state of the building today, but to consider the dynamics of how it developed throughout the initial planning and construction phases, as various groups negotiated in their own best interests, and non-human influences such as the Irish climate and the Free State finances proved controllable to a greater or lesser degree.

Technical drawing is an often overlooked area of visual representation, generally reproduced without interrogation or discussion, usually as a symbol or shorthand for production or construction of objects or buildings.[3] Even more than paintings or advertisements, technical drawings are heavily ideological in character, as they are devised using a very specific method to communicate kinaesthetic knowledge between specialists in a precise, detailed, but non-verbal manner.[4] Because of this specialist role, they form a standardised vocabulary of representation, dependent on a common visual language and method of interpretation impenetrable to the general public, leaving them with a solely pictorial function to the uninitiated, as a general sign or symbol of a technological undertaking.[5] This apparent ideological neutrality may be most noticeable when technical drawings are taken out of their original working context, but within the process of designing, making and constructing artefacts, they are used as tools and as a way of delimiting authority within the design and production process.[6] They are particularly used as markers of status

for engineers and architects, as control of the drawings separates them and their professional knowledge from builders, manufacturers and construction workers, whose status in the hierarchy of the building site only involves the reading and interpretation of drawings, if even that.[7]

Within the structure of the drawing office and the lifecycle of a particular project, a number of different types of drawing will be produced, which span both architectural and engineering production. Indeed, both types of drawing are based on the same geometric principles and requirements for presenting an artefact to the viewer before it exists, and as a way of making it come into being.[8] By the 1920s, drawing office practice in Germany and Ireland shared a set of drawing tools and techniques based on Gaspard Monge's technique of descriptive geometry, carried out on the drawing board with T-squares, pencils, pens and ink washes.[9] That is not to say that there were no cultural differences in the practice of engineering and architecture, given that Irish engineers such as McLaughlin and Rishworth had been trained in the British engineering education system, with its emphasis on craft-based practicality, flexibility and self-regulation, whereas the German engineers included graduates of technical institutes (e.g. *Technisches Hochschulen* or *Fachhochschulen*) with rigorous training in concrete and practical engineering solutions.[10] The types of drawing range from original conceptual sketches, through development and production/construction drawings, to the final stages of contract drawings, presentation drawings and technical illustrations.[11] Development, production/construction and contract drawings are generally standardised views conforming to the Mongean layout of plan, elevation (or front view) and side view, embodying a European world-view based on scientific methodology (see Fig. 26), radically different from presentation drawings and technical illustrations, which are not as geometrically constrained, more closely approaching the view from the human eye.[12]

Looking at the development of the Shannon Scheme power station building, a complex set of negotiations was carried out between the numerous actors during the planning and construction period in the mid and late 1920s. The controversy about the final form of the power station complex was not carried out through newspapers or external media, but was played out in a tightly constrained manner between Irish consulting engineer Rishworth of Shannon Power Development, the financial backers in the Department of Trade and Industry in Dublin, Siemens Schuckertwerke engineers on site,

Side elevation Front elevation Section AA

Floor plan

Axonometric Isometric

Figure 26 Standard orthographic projections used in architectural drawing. (Photograph courtesy of Wikimedia contributor ProfDEH CC-BY-SA-3.0.)

Siemens Head Office engineering and architectural staff in Berlin, as well as German sub-contractor Louis Eilers, who was building the steel frames for the turbine hall. The controversy can be traced through the production, circulation and approval of various technical drawings during the period, alongside memos, letters and other internal Siemens and Shannon Power Development correspondence, although interpreting the drawings allows a more nuanced understanding of the changes proposed and rejected. A number of technical drawings have survived in various archives, although, significantly, not in any central location and forming only a small number of the total number of drawings referred to in this correspondence.[13]

The interpretation of projects for a non-technical audience is mostly the preserve of technical illustrations, a small number of which survive as illustrations in contemporary texts about the Scheme. One of these, in particular, demonstrates the role played by technical illustrations in providing easily readable visualisations before the actual project is underway, popularised by nineteenth-century architectural competitions.[14] Often they were also used as illustrations in product advertisements or educational texts, as is the case with the view of the power station published in an extended article in *The Engineer* in 1927, which was reprinted as a booklet by the ESB in 1928 (see Fig. 27).[15] Despite the late date of the illustration in the development of the Scheme, it shows an early version of the power station buildings, identifiable from the slightly sloping roofs on the turbine hall and the three-part arrangement of the switch houses and middle building. It is most notable for the deep vertical pilasters between the windows on the power house, which give the complex a much more aggressively Modernist aspect than was actually built. The size of the originally proposed ship lift is noticeable in this drawing, which may be due to the fact that the drawing is constructed using rather exaggerated two-point perspective, which was commonly used in architectural illustrations, but doesn't provide a photorealistic view of what the finished scheme would look like to the naked eye.[16] It is also noticeable that the viewer is apparently sitting in thin air, or possibly in an airplane or helicopter, as there is no physical vantage point near the Scheme which would provide this view. However, the tenuous connection of such architectural visualisations to

66

the final built reality is not the point of their existence; rather, it is to excite the imagination of the viewer about the striking and ambitious Scheme proposed for the Shannon, including the readers of *The Engineer*. A similar drawing, this time in colour, was included in the printed version of a 1925 speech by Wilhelm Dohme, the Siemens head architect, this time from a perspective on the tail race canal (see Fig. 28).[17] This angle emphasises the repetitive nature of the turbine hall pilasters, and colours the whole complex in a dull red, implying that Siemens had initially intended to construct the complex from brick, rather than the local concrete eventually used.

The earliest drawings are in the Siemens Archive and consist of a set of development drawings produced by Siemens-Schuckertwerke in August of 1924, as part of the detailed scheme worked out by that company for the Irish Government during the summer of 1924.[18] After the initial negotiations between Thomas McLaughlin, Siemens and the Free State Government, and

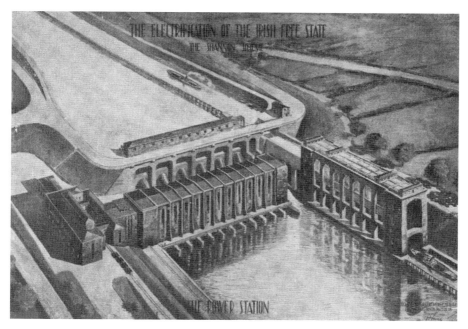

Figure 27 Technical illustration of original Ardnacrusha power station design from the 'Experts Report' (*The Electrification of the Irish Free State: The Shannon Scheme,* Dublin: The Stationary Office, 1925). (Image courtesy of the ESB Archives.)

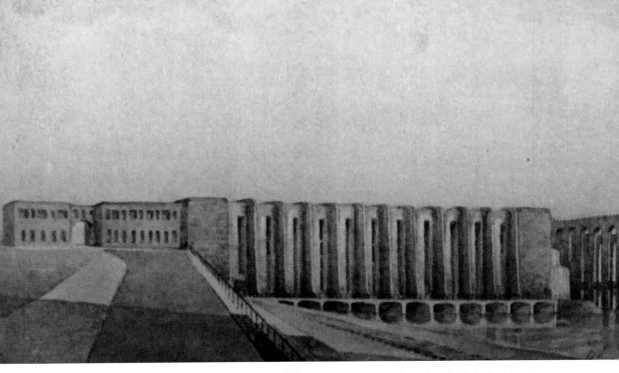

Figure 28 Wilhelm Dohme, perspective drawing of the power house complex of an Irish hydro-electric power station, 1925 (*Kraftswerkhochbauten [Power Station Structural Engineering]*, Berlin: Siemens-Schuckertwerke, 1925). (Image courtesy of the Siemens Archive: SSW 2056.)

the publication of a White Paper in March 1924, Siemens was given twelve months to produce an overall design for the Scheme.[19] The fifty-five drawings include numerous cross-sections of the River Shannon and the proposed canals, but two in particular are relevant to the design of the power station building itself. The first of these is an overall plan of the power station site which shows a number of notable differences from the building as finally built, the most notable being the inclusion of six turbines, rather than the three initially built (see Fig. 29). In addition, the switch houses are housed in a wing attached to the turbine building in three separate places (one of these being the 10kV switch house), rather than as a continuous building, highlighting the predictive nature of technical drawings, visualising something not yet physically in existence and liable to change.[20] This is evident in the case of the missing turbines, as these initial drawings were based on calculations carried out by the Siemens Design Engineering team, using the

1919 Shannon flow measurements of Irish engineer John Chaloner Smith, which suggested six turbines as the optimum. The International Experts did not agree, so only three were initially installed, and the Siemens engineers later made more detailed readings and realised that the fall was sufficient for four turbines, which led to the installation of a further Kaplan Turbine in 1934.[21] The drawing is also notable in that it has a mixture of text in both German and English, demonstrating which parts of the drawing were for internal use by Siemens and which were for communication to the English-speaking clients. For example, the labelling on the drawing itself is in English, as is the title and indication of scale, all required for the interpretation of the content of the drawing. On the other hand, the title block itself follows a standard layout in German, and would have been common to all drawings produced in the Berlin drawing office. The title block routinely contains information about who has drawn, edited or checked a drawing, all part of how technical drawings are used to track the internal division of labour within the office. In this case, the drawing was originally produced on 1 August 1924 by 'KG', probably a drawing technician, traced on the sixth of that month by 'Gu', which refers to the initial hand pencil drawing, which was then contact printed to produce a positive blueprint.[22] As blueprints can only reproduce monochrome lines, the colours to indicate water, earth and roof have been added by hand in pencil at the same time.[23] The drawing was then checked on 18 August by 'Ui', presumably Herr Uitting, a senior Siemens engineer on the project, exercising his professional authority over the plans to be sent to the client.[24]

The second drawing is a more detailed development plan of the power station building itself, also from 1924, which includes three cross-sections through the building (see Fig. 30). This drawing demonstrates the hierarchies within the drawing office, as it was drawn by the same person (KG), checked by the same person (Ui), but traced by a different tracer (Trh), as tracing was the least skilled task of the three tasks, usually reserved for 'bright working-class boys', rather than middle-class professionals.[25] This drawing also shows the initial layout of the switch houses and administration building in more detail, showing the initial plan for a gently canted roof on the turbine hall and intake house (see Fig. 31) and flat roofs on the complex of buildings between the turbine hall and the 100kV switch house. As compared to the

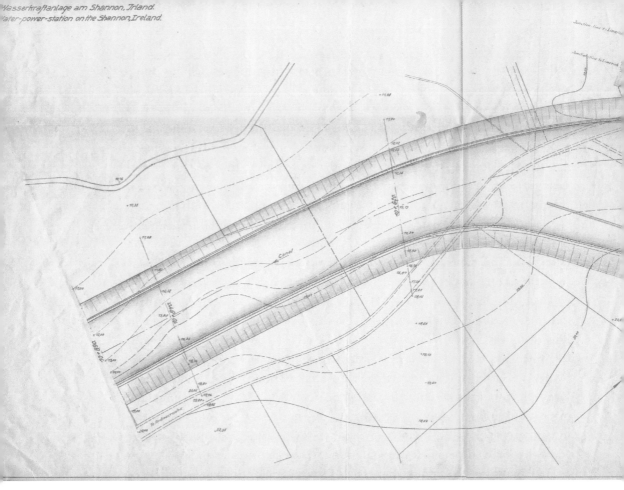

Figure 29 Detail of Siemens technical drawing AZ.710455, showing the original plan of the turbine house with six turbines, 1924. (Image courtesy of the Siemens Archive: 11139.)

final iteration of the built complex, this design has a number of much smaller architectural elements, rather than the single articulated building which was actually built.

Once the project got underway, Siemens located a small technical staff in the Limerick office of J.K. Prendergast, the Shannon Power Development Resident Engineer, although any final plans for the power house were to be prepared in Berlin.[26] However, a controversy erupted on the architectural style of the station between Siemens-Schuckert in Ireland and the Government's Civil Engineer Frank Sharman Rishworth, with both parties referring to the

POWERING THE NATION

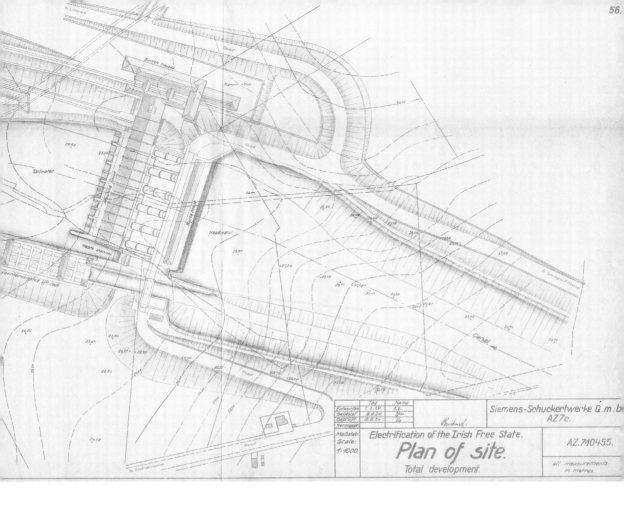

Entworfen	Tag	Name		
Entworfen	1.8.24	Kb.		
Geprüft	8.8.24	Die.	*Reichard.*	*Siemens-Schuckertwerke G.m.b*
Geprüft	18.8.24	Li.		*AZ7c.*
Normteer				
Maßstab: Scale: 1:1000.		*Electrification of the Irish Free State.* *Plan of site.* *Total development.*		*AZ.710455.*
				all measurements in metres.

respective authorities of Siemens architect Wilhelm Dohme in Berlin and the
Minister for Industry and Commerce Patrick McGilligan to provide weight
to their arguments. This controversy began with a request by Rishworth in
November 1926 for designs for the façade of the power house 'as we are
anxious that it will fit in with its Irish environment'.[27] Rishworth saw the
flat roofs and heavily rusticated façade of Olidan power station in Sweden as
a suitable model, demonstrating a similar Scandinavian influence to his Irish
architect contemporaries, despite the climatically unsuitable flat roofs and the
colonial connotations of a 'castle' in rural Ireland (see Fig. 32). Rishworth's

somewhat inconsistent concern for the appearance of the station is emphasised in a later letter, in which Siemens Head Office quotes Rishworth as requiring sloped roofs 'in consideration of the character of Irish buildings and of the local climatic conditions'.[28]

A set of drawings (AZ.716590 to 94), referred to as 'architectural sketches', were sent to Rishworth by the following February and four photographs of a clay model in March.[29] Although they have not survived, they were clearly being used to communicate the intention of Siemens architects and engineers as to the physical qualities of the proposed power station. Rishworth wrote to the Minister in September 1927, discussing these drawings, rejecting 'various alternative arrangements of the windows, attempts at a Romanesque façade, etc' due to the great height of the building and expressing his dissatisfaction with the depicted forty-five degree slope of the roof.[30] He had asked Siemens to provide an altered set of drawings, which they did in November 1927, although expressing the unhappiness of the unnamed Siemens architect with Rishworth's proposed roof slope of thirty-seven degrees.[31] The original proposals for the ventilation units are reconsidered and two alternative arrangements for the glass roof over the control room are proposed (drawings AZ.717401/1 and AZ.717402/1).[32] There is no further reference to these drawings in the files, as they are superseded by two new drawings (AZ.717142 and AZ.719021) the following May, when discussions about the roof and façade resume, with particular attention being paid to the arrangements for the glass roof over the control room.[33] The number of working drawings produced and discarded during this phase is entirely typical of the numerous iterations of a building project, particularly with a demanding client such as Shannon Power Development.

The discussions about the roof of the power station take an unusual turn in May 1928, when Siemens BauUnion requested information about a verbally proposed change to flat roofs.[34] A number of letters between Prendergast

POWERING THE NATION

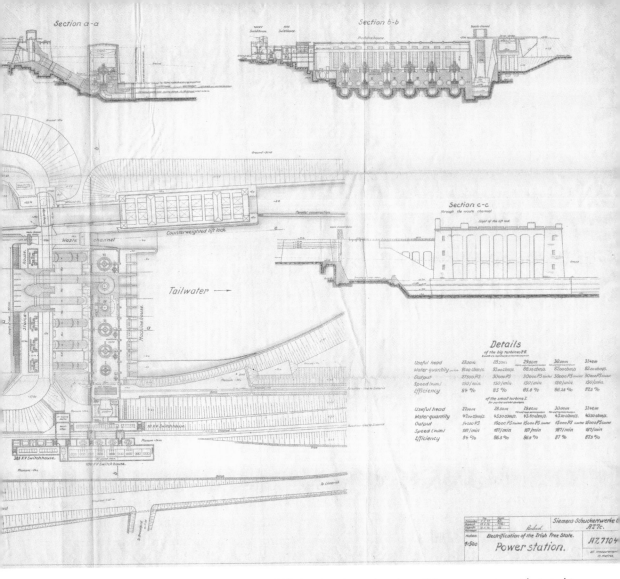

Figure 30 Siemens technical drawing AZ.710456, showing plan and sections of the power station with six turbines, 1924. (Image courtesy of the Siemens Archive: 11139.)

in Limerick, Rishworth in Dublin and Siemens in both Berlin and Dublin over the following weeks demonstrated a real concern on Siemens' behalf that Rishworth had side-stepped proper procedure of negotiation through drawings, with Siemens and Eilers both producing drawings in response to each requested change. This concern seems to stem not only from the fact that

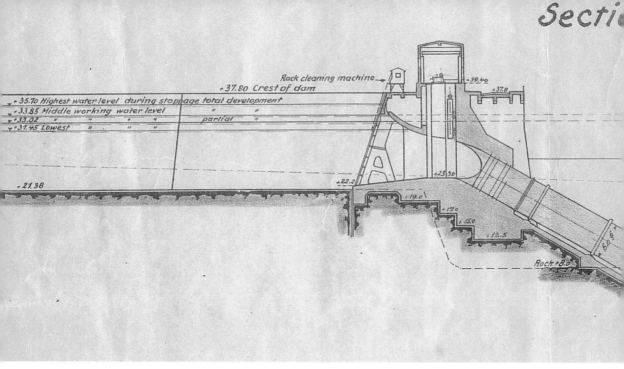

Rack cleaning machine ·39.40
·37.80 Crest of dam ·37.8
·35.70 Highest water level during stoppage total development
·33.85 Middle working water level " "
·33.02 " " · " partial "
·31.45 Lowest " . " "
·21.38
·22.2
·23.30
·19.0
·17.0
·15.0
·12.5
Rock +8.0

Figure 31 Detail of Siemens technical drawing AZ.710456, with Section A-A through the power house showing the intake from the head race canal, penstock, turbine and outflow to the tail race canal, 1924. (Image courtesy of the Siemens Archive: 11139.)

Rishworth was operating outside agreed standards of professional behaviour in both architectural and engineering practice, but from the fact that the procedure of design by drawing had ensured that Louis Eilers had already been engaged in producing the steel frames for the building in Hannover for some months, with the first three frames already on site in Limerick at the time of this discussion.[35] The motive for the sudden decision to radically alter the profile of the station to include flat roofs seems to be Rishworth's anxiety about the mounting cost of the project, overriding his previous concern for a contextually sensitive building. Despite concerns voiced by Prendergast and Professor Meyer Peters, one of the original group of European experts, Rishworth estimated that the change in roofs could save the Government £10,000 to £12,000 off an estimated bill of £97,550, which was nearly twice the original estimated cost for the buildings.[36] He received backing from the Minister for Industry and Commerce, through his secretary Gordon Campbell, although this seems to have been based on purely financial considerations,

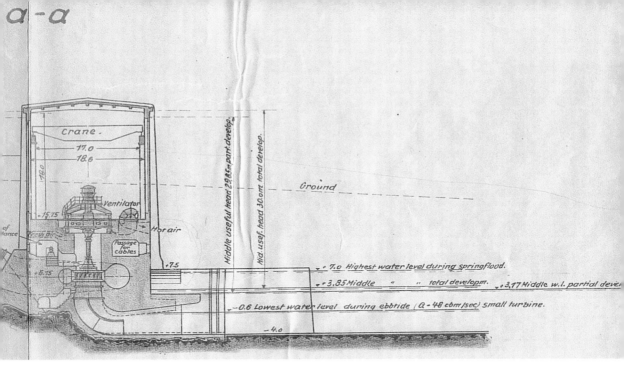

rather than aesthetic.[37] The only aesthetic comment which is recorded from the Department of Industry and Commerce on the proposed flat roofs (of which no drawings have survived) is a reference to an 'encsclule [*sic*]' on the top of the main building, presumably the glass lantern which apparently looked out of place alongside a flat roof, although Rishworth assured Campbell that it could be replaced by a flat glass roof.[38]

In the end, it was the physicality and complexity of the construction which determined the shape of the power station roof, as dictated by the inflexibility of Eilers' production schedule. As the steel construction was already far advanced when the controversy over the roof erupted, it appears that the production of a new roof frame suitable for supporting a flat roof (particularly one which could be walked on) would have set back the project by a minimum of six weeks, which was deemed financially unacceptable by the Government. The roof of the power station was returned to a sloped design in August 1928.[39] The level of personal feeling surrounding this controversy is evident in a later letter from Rishworth to the Minister, where he states that 'I do not claim to be an architect and am prepared to give way to their views, but in this case I cannot help feeling that they rather resent an engineer putting forward an

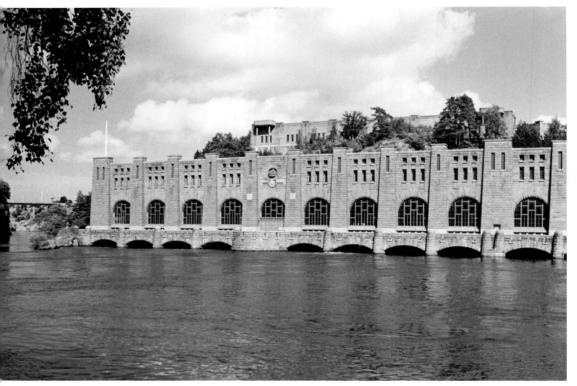

Figure 32 Olidan power station, Trollhätten, Sweden, 1910. (Image courtesy of Vattenfall.)

alternative proposal.'[40] Given the similarity in working method between civil engineers and architects, however, it is likely that it was the method by which Rishworth's alternative was proposed that was resented by Siemens, rather than an objection to his professional views on building design, particularly as Dohme certainly viewed construction plans as equal in importance to the legal documents.[41] In addition, both Rishworth's engineering training and experience had taken place in the British Empire, in an engineering culture that did not rely on such a detailed level of drawings as other countries, which would have allowed for a greater level of off-drawing negotiation in the actual construction and a less reverential attitude to the drawings themselves.[42]

It is this sloped roof design, along with the refinements of ventilation and pyramidal lantern, which is represented in Siemens BauUnion drawing

L.719 (see Fig. 33). This construction drawing consists of a plan and a number of sections of the power house building including the switch houses, again drawn on a sheet with a title block in German and the rest of the text in English. Unusually, the 'drawn' box is empty, whereas the 'traced' date is 12 March 1928 by 'J. Davids' and the drawing has been edited by 'Fe' on 24 August 1928. The dates are significant here, as the original drawing and tracing took place before the roof controversy broke out and it was later edited in August 1928, once controversy was settled, although the edited drawing does not show a simple reset to earlier plans. The overall design of the station has been simplified, with the 38kV switch house now completely attached to the middle building, leading directly into the turbine hall. The rear line of the station has been simplified into the form which was actually built, with the 10kV switch house sitting behind the turbine hall, but on top of the intake turbines. The edits include an indication of where the level on the foundations differ from the original drawings and a number of other small, but pertinent, engineering details, which would be needed for the final resolution of the financial side of the contract. Rather than using the colouring to indicate different materials, this drawing colour codes the turbine hall in blue and the switch houses in brown. This is significant in the light of the fact that this drawing has ended up in the Shannon Power Development files, rather than in Siemens' own archive, as it has been coloured to help the client understand the relation of the various sections to each other, as well as recording changes to the design negotiated during the construction process.

The relative importance and power of Chief Civil Engineer Rishworth in the negotiations about the roof is also evident in a subsequent exchange of letters discussing the roofs of the intake building, navigation lock and auxiliary buildings, which he succeeded in retaining with flat roofs, despite Siemens Head Office's objections that:

> Different kinds of roof on the various buildings will, later on, make the impression as if the buildings had not been erected at the same time but at quite different periods with intervals of many years. As to be seen from the buildings of newly built power stations, for instance in America and Switzerland, the builders of such stations in the whole world attach great importance to giving the exterior of the

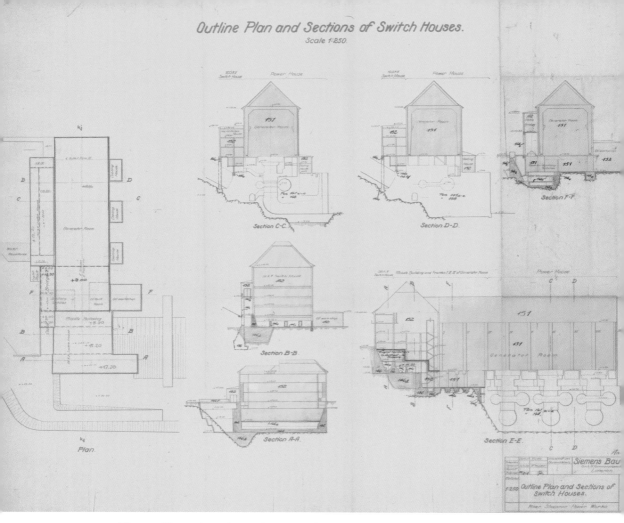

Figure 33 Outline Plan and Section of Switch Houses, Siemens BauUnion drawing L.719, 1928. (Image courtesy of the Director of the National Archives: NAI INDC/SS/495.)

building a dignified appearance. Nobody will, later on, understand, why just one of the largest and most modern power stations, which the Shannon Power Station certainly is, and which the Irish people may be proud of, was made to look like an accumulation of various styles joined to one another at different periods.[43]

Rishworth was confident enough of his position to dismiss this objection, due to the distance between the main complex and the auxiliary buildings. Significantly,

newspapers to illustrate articles, and later on to Irish postcard and cigarette card companies. In contrast to this popular circulation of photographs through the mass media, Siemens also commissioned a German printmaker of industrial landscapes, Anton Scheuritzel, to visit Ireland and produce a set of lithographic prints. These prints were then packaged in a prestige folder for distribution as a corporate gift, producing a high-profile, officially sanctioned view of the Scheme that Siemens could use as a way of promoting its status as a company ready for large-scale, high-profile engineering work.

Siemens industrial photography

In his discussion of the photographic archive, Sekula discusses the development of industrial photography as a tool of institutional and bureaucratic power.[3] The capacity of photography to provide a purportedly 'real', 'true' representation of events is utilised by corporate structures as a powerful tool to provide the most favourable representation of themselves to the outside world. This characteristic of photography can be seen at work within the series of photographs taken for Siemens during the period of construction of the Shannon Scheme, when the Siemens engineers on the Shannon felt it necessary to keep a photographic record of their work, documenting the site in its different forms, the ongoing work and some of the difficulties of constructing such a large project. These photographs start in early 1926, six months after construction began, with a number of small format photographs depicting the Shannon at Limerick, Strand Barracks and the arrival of the first German steamer transporting equipment for the Scheme, possibly taken with one of the engineers' own cameras (see Fig. 35).[4] In May 1927, Siemens-Schuckert Ireland sent a request to Siemens Head Office for permission to buy a set of photographic equipment, rather than tying up the official Siemens photographer in Ireland for a lengthy period of time.[5] The subsequent correspondence includes a request sent from the Head Office to three Berlin photographic workshops (Werkstätte für Chemie und Photographie [Workshop for Chemistry and Photography]; L.G. Kleffel & Son; Grass & Worff) for quotes for a large format camera of tropical quality, specifying Zeiss lenses, a four-legged tripod and a full set of developing equipment, which was fulfilled by L.G. Kleffel & Son with an ICA Tropica camera and dispatched by steamer to Ireland in late June 1927.[6] This exchange provides a revealing insight

Figure 35 Siemens photograph album A700, showing two sizes of photographs of trains unloading from the German steamer at Limerick docks, March 1926. (Photograph courtesy of the Siemens Archive: Album A700, p. 10.)

into Siemens' confidence in German *Technik*, as well as their constitution as a separate social group from the Irish engineers: there seems to be no consideration of buying a camera locally in Limerick, instead following their existing pattern of sending to Germany for complex technical equipment, to be delivered by the regular steamer service.[7]

Although the negatives do not seem to have survived, the resulting collection of prints in the Electricity Supply Board and Siemens Archives

forms a substantial body of photographic work, with some 1,762 silver gelatine contact prints 13 by 18 inch in size, covering most of the period of construction from March 1926 to January 1930.[8] Approximately 1,611 of these prints are dated and numbered in the bottom right-hand corner, with both a numbered and a shorter 'A' series, often duplicated, overlapping, with numbers missing from both sequences or with occasional un-numbered photographs. Although the numbered series starts much earlier, both series run until January 1930 and there is actually significant overlap from December 1928 onwards, as some photographs appear in both series under different numbers (e.g. photograph 1106 appears again as A9). The dating of photographs is very intermittent, following the pattern set in 1926 of small bursts of photographic activity over a long period of time, often with several photographs taken on one day and then none for a number of days. A larger set of prints was later mounted in six large photographic albums, which ended up in the Siemens Archive, while the ESB Archive collection contains six smaller albums and a number of loose prints. Unfortunately, the Siemens personnel records have not survived from this period, so it has not been possible to definitively identify the photographer, or photographers, although the original letter to Siemens Head Office is signed by Herr Dr Ott, one of the senior Siemens–Schuckert engineers.[9] Several of the Siemens staff are mentioned in the Archive files in connection with the Siemens photographs, including Friedrich Wechler, Siemens accountant on the Scheme, who subsequently worked for the ESB and whose name is written on the inside of three of the six albums in the ESB Archive.[10] Regardless of the exact identity of the photographer, he is very likely to have been a young male German engineer, part of a team of middle-class German professionals working away from home on a prestige project, with a professional interest in new technology and its construction.

The Siemens industrial photographs consist of a thorough documentation of the process of constructing the Scheme, and cover the civil engineering work of the canals, the construction of the power station and the installation of the turbines, as well as views of the accommodation of both workers and engineers and the installation of power lines in Cork and Dublin. They range from broad panoramas of the construction site (see Fig. 36) to close-ups of mechanical detail, particularly in the later stages of the work (see Fig. 37).

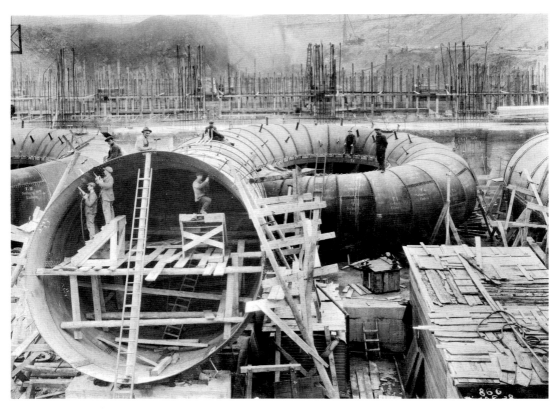

Figure 36 Workmen constructing the spiral casings, silver gelatin print, 18 June 1926. (Photograph courtesy of the Siemens Archive: Album A704, Photograph No. 866.)

A quantitative sampling of the photographs in Siemens albums reveals that the two main topics are views of the architecture or civil engineering works, closely followed by photographs of construction machinery (see Table 1). When the two categories are put together, they represent nearly half of all of the photographs (42 per cent), as compared to human workers, who appear in only 18 per cent of the photographs, which demonstrates the overwhelming emphasis on work, particularly the mechanisation of work. This is consistent with other examples of industrial photography in the early twentieth century, which draw on a tradition of European industrial photography dating back to the nineteenth century, particularly the launch of I.K. Brunel's Great Eastern ocean liner.[11] Robert Welch's photographs of the Harland and Wolff shipyards

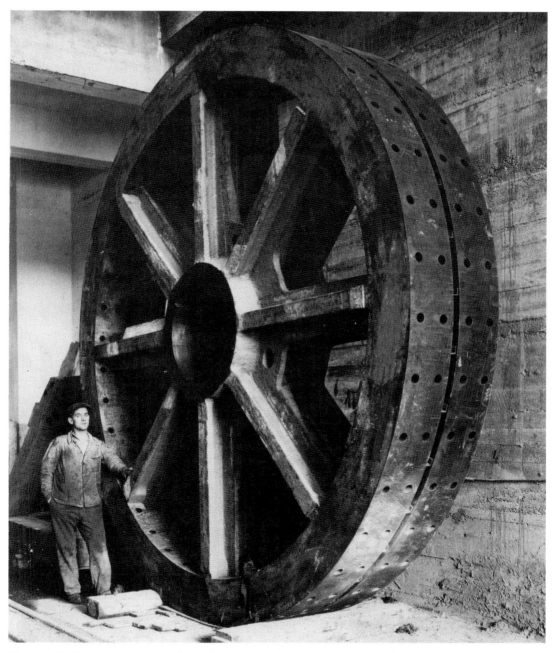

Figure 37 Workman posing with turbine rotor, silver gelatin print, 8 February 1929. (Photograph courtesy of the ESB Archives, Shannon Scheme Photograph No. A9.)

Table 1 Content analysis of Siemens industrial photographs, every 10th image sampled.

Content	No. of photographs	Percentage
General location (incl. Limerick and worker housing)	5	3%
Worker(s)	28	18%
Construction machinery (incl. trains and trucks)	46	29%
Power generation machinery	21	13%
Architectural views (incl. civil engineering and excavations)	57	35%
Maps or drawings	4	2%

share some of the qualities of the Siemens photographs in their focus on large pieces of obscure, but complicated fabrication, as well as the manner in which work is staged for the camera. This situation within a background of industrial photography situates the Siemens photographs as an 'official' record of industrial work, which focuses on the diligent recording of mechanical work, creating a record of construction over a period of time. This concern for a series of images of the same construction over a period of time is very much part of the condition of modernity, with its emphasis on time and movement.[12]

As the Shannon Scheme photographs were taken by one or more of the Siemens engineers, it is not surprising that the surviving industrial photographs should also show the influence of contemporary German photography. German *fotokultur* of the 1920s had been heavily influenced by experiments from within Russian constructivism and by the late 1920s, it was well on the way to developing 'the objective eye' as an alternative to art photography.[13] The proper subject of a mechanically-based art form such as photography was seen to be the modern world, but, rather than focusing on subjective human experience, the radical photography of the period was focused on wider, impersonal topics.[14] The photography of the New Objectivity or *Neue Sachlichkeit* formed a break from the pictorialist tradition in two ways, both in terms of composition and in choice of subject. Technical experimentation with viewpoints, perspectives, close-ups and serial images took advantage of the characteristics of the lens and the negative to frame images in a new and objective manner. In addition, the modern world was the appropriate subject matter for such a modern technology of seeing, with the specifically modern developments of the industrial world and urban life seen as uniquely appropriate subjects, harbingers of a technologised future.[15] Photography was

seen as a thoroughly modern effort, in its ability to bring both the new and the previously overlooked to prominence.[16] This emphasis on the industrial world can be seen in the photography of Albert Renger-Patzsch, who had exhibited in Germany through the 1920s and published a popular photo-book called *Die Welt ist Schön* [*The World is Beautiful*] in 1928, which concentrated on industrial machinery and mass-produced products.[17] Renger-Patzsch's interest in industrial buildings can be seen from his photograph of a blast furnace works in Lübeck, particularly in terms of how the formal qualities of the industrial landscape are framed to emphasise the repeated pattern of the intake pipes, angled symmetrically against the background of the works, devoid of any human intervention or agency (see Fig. 38). This type of photographic vision was not restricted to the German avant-garde, but extended out to the popular press, to advertising, photographic books and exhibitions.[18] Much of this expansion was based on the availability of smaller German cameras such as the Leica or the Rolleiflex, which used more practical 35mm or medium format film and was particularly noticeable in the area of *Sachphotographie* or the photography of the single object.[19] Renger-Patzsch was not alone in his focus on industrially mass-produced objects, which was enthusiastically taken up by the advertising industry.[20] A booming industry in photo-journalism and the expansion of the illustrated press engaged increasing numbers of graduates of photographic training schools; it also provided a readership for educational articles on photography and an audience for encyclopaedic photographic exhibitions such as *Film und Foto*, which took place in Stuttgart in 1929.[21]

This cultural background underpins the decision of the Siemens staff in Shannon to purchase their own camera and photograph the Scheme themselves, rather than engage a German professional for a short period of time, which was standard practice on other Siemens sites. Whether the Siemens photographs were taken by a single person or as a joint effort by more than one, they brought a Modernist sensibility to the practice of photography that was not evident in Irish work at the time.[22] Many of the photographs are of the turbine hall or the penstocks in various stages of construction, carrying out the task of 'recording for posterity'. But in addition to this, there is a certain fascination with the formal qualities of half-built structures similar to the work of Renger-Patzsch, as the giant turbines are assembled and the forms for pouring concrete are constructed (see Figs 39 and 40). This may be

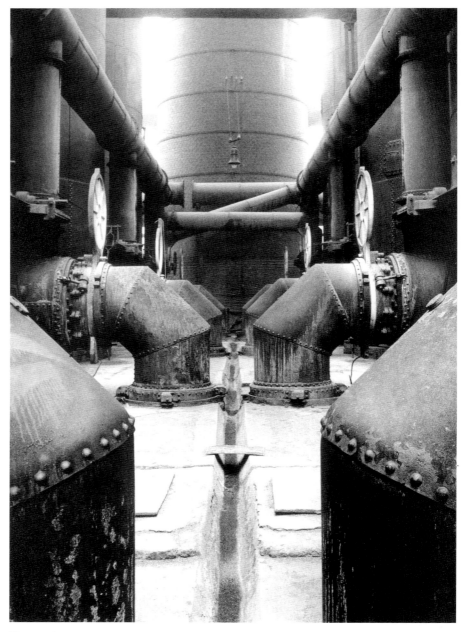

Figure 38 Albert Renger-Patzsch, 'Air Intake Pipes for a Blast Furnace, Lübeck', silver gelatin print, 1928. (Photograph courtesy of the Albert Renger-Patzsch Archiv – Ann and Jürgen Wilde, Zülpich / DACS 2017.)

partly due to the unique opportunity for an engineer with an interest, and possibly training, in photography to document the process of creation of form as well as the finished forms themselves. The later photographs, particularly, give a sense of an ordered endeavour both in terms of subject matter and their composition, a sense of construction, creation and great measured feats of engineering. This sense of controlled form also runs through the later interior photographs of the station. The photographer's eye has picked out physical details of the construction, some large, some small, with a continued focus on the physical and formal qualities of the industrial structure. There are many examples of this *Neue Sachlichkeit* 'metallic precision' within the series, for example, interior views of cables running down a wall and fanning out across a concrete floor (see Fig. 41).[23] The repeated lines created by the black cables

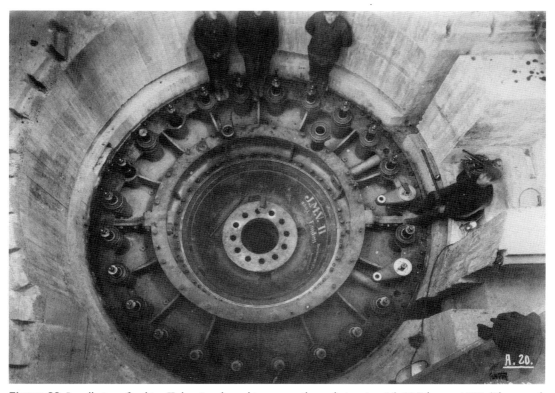

Figure 39 Installation of turbine II showing the turbine cover, silver gelatin print, 14–19 February 1929. (Photograph courtesy of the ESB Archives: Shannon Scheme Photograph No. A20.)

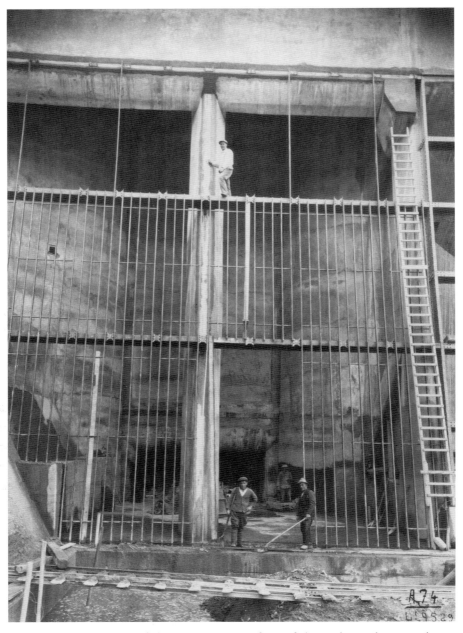

Figure 40 Construction of the coarse screen in front of the intake to the power house, silver gelatin print, 9 May 1929. (Photograph courtesy of the ESB Archives: Shannon Scheme Photograph No. A74.)

Figure 41 Branches of steering cables in the power house underneath the control room, silver gelatin print, 7 September 1929. (Photograph courtesy of the ESB Archives: Shannon Scheme Photograph No. A142.)

on the pale background are articulated into geometrically precise arcs as they travel throughout the station. The debt to the *Neue Sachlichkeit* is clear in this emphasis on the formal qualities of the industrial environment, presented for their abstract form, as well as their functional qualities as a record of work carried out.

In contrast to Renger-Patzsch's work, however, the labourers in the photographs are commonly included, either still working or stopped momentarily to stare at the camera (see Figs 39 and 40). The sense of agency of these anonymous workers is stronger, as they are not only present alongside their construction, but able to look out at the world through the lens, often quite proprietarily, even though they are dominated by the size of the giant construction. The resulting images show a sense of inclusion and pride in the work, as well as ownership of the project. The photographs of the testing of the power station lift are especially interesting in this respect, moving from a symmetric photograph of the empty lift (see Fig. 42), to the inclusion of a knickerbockered German engineer walking proprietarily across the lift compartment (see Fig. 43). The third image has thirty-two men squashed into the lift to demonstrate its carrying capacity (see Fig. 44), varying from formally dressed engineers to a number of manual workers who have been brought away from other tasks for this demonstration, to judge by their overalls, caps and goggle-marks. A certain stiffness can be detected in the novelty of their posing for the camera (as well as the remote possibility of the lift failing, it must be pointed out), along with expressions of deadly seriousness, embarrassment and amusement, but this photograph displays an active involvement with a collaborative piece of work. Not only do these photographs carry out the function of recording the check on the physical functioning of the lift, but they also record the participation of the workers in creating this building. Again, this is where these photographs differ from their German antecedents – the great building project of the Shannon Scheme is recorded as being the product of man's labour, rather than springing from the ground fully formed and shining, without human intervention.[24]

Although the relationship between the men and the product of their work is acknowledged in these photographs, it is decidedly uneven. The sheer size and scale of the work means that they generally show small groups of workers in conjunction with large, complicated pieces of machinery, often

tens of metres in size. The relationship is dominated by the technology and the photographs could be accused of showing the men in a subsidiary or occasionally decorative position, picking up the landscape tradition of using human figures to show scale and distance.[25] In examples such as Fig. 45, the worker is posed as part of the overall composition, providing a counterpoint to the rhythmic shapes of the penstock vanes. These photographs could be read as either displaying a narrative of man incorporated as a cog in the machine system, or as a representative of human creativity and effort which has produced this 'great work'.[26]

Figure 42 Empty lift at ground station, silver gelatin print, November 1929. (Photograph courtesy of the ESB Archives: Shannon Scheme Photograph No. A176.)

Figure 43 Inspection of lift at top level, entrance to control room, silver gelatin print, 4 November 1929. (Photograph courtesy of the ESB Archives: Shannon Scheme Photograph No. A177.)

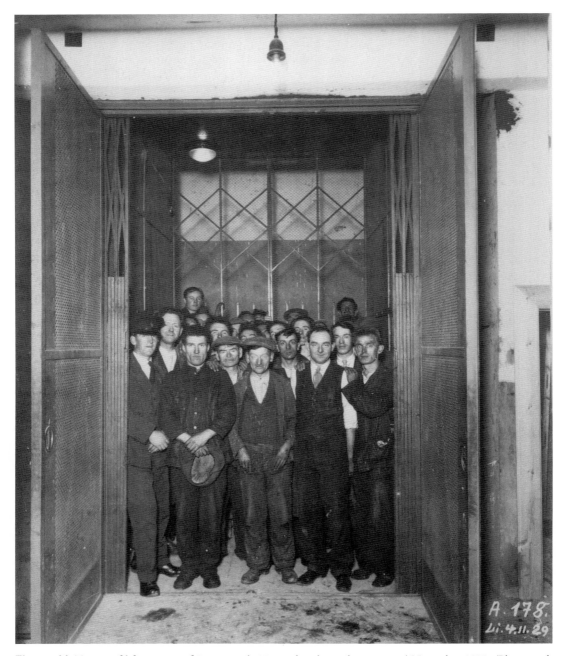

Figure 44 Testing of lift capacity of 3 tons, with 32 people, silver gelatin print, 4 November 1929. (Photograph courtesy of the ESB Archives: Shannon Scheme Photograph No. A178.)

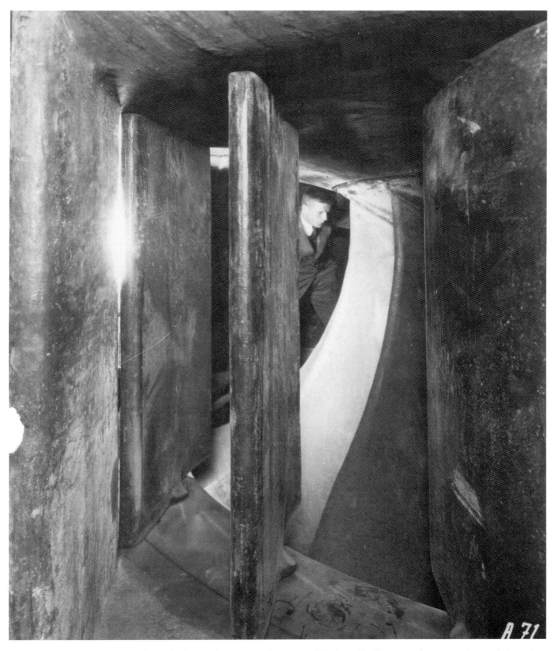

Figure 45 Workman seen through the guide vanes and runner of Turbine II, from spiral casing, silver gelatin print, 8 May 1929. (Photograph courtesy of the ESB Archives: Shannon Scheme Photograph No. A71.)

Newspaper circulation of industrial photographs

Outside their internal use to 'truthfully' document the construction process, selections from the Siemens industrial photographs were also reproduced in the mass media, both in Siemens' own publications and in local, national and specialist newspapers. They were used both as illustrations to written articles and as stand-alone captioned photographs, particularly as part of photographic essays in the picture posts, and were the main visual tool for promoting the Scheme to the German public, if not the Irish.[27]

The main vehicle for the publication of the Siemens industrial photographs was the Siemens internal monthly magazine *Siemens: Progress on the Shannon*, which was published during most of the duration of the project, from October 1926 to December 1929, and circulated to the Irish Government as well as within the Siemens group.[28] *Progress on the Shannon* shared a standardised layout with other Siemens' magazines, varying from four to twelve pages, but with a shared two-column layout in a serif font, including a standard format of banner title. This banner title incorporates a detailed pen-and-ink sketch of St John's Castle and Thomond Bridge in Limerick, with St Marys Cathedral in the background, initialled ZG (see Fig. 46). It closely resembles the initial smaller photographic prints from the first seven pages of the A700 photograph album discussed above, although the viewpoint is from Brown's Quay, rather than Clancy Strand.[29] The inclusion of this romantic hand-drawn image of medieval Limerick in what is otherwise a resolutely technical publication featuring articles on 'Rock Excavation on the Shannon' and 'Concrete Work at the Main Power Station' seems incongruous, as the lavishly illustrated magazines contain large numbers of reproduced photographs from both series of photographs.[30] The contrast of the hand-drawn banners can be seen as an attempt to visually locate the publication within the *Kultur* of Limerick and the mouth of the Shannon, although only succeeding in providing a superficial flavour of local colour, highlighting the contrast between the local essentialist emphasis on ancient history and the modernising epochal power of German industrial technology.

Unencumbered by any such gestures towards Irish culture and history, a surviving sample of German newspaper photographs from mid-1929 in the Siemens Archive tells a simpler story. The twenty-one newspaper clippings

Siemens=Schuckertwerke
Aktien=Gesellschaft

SIEMENS

Siemens=Bauunion GmbH.
Kommandit=Gesellschaft

PROGRESS ON THE SHANNON

2nd YEAR JUNE 1928 NUMBER 9

Concrete Work at the Main Power Station

All the excavation work at the site of the Main Power Station was completed towards the end of 1927 when approximately 200 000 cbm. of earth and 150 000 cbm. of rock had been removed down to the deepest foundation level of the underground portion of the Power Station. On account of the

Figure 46 Front cover of *Siemens: Progress on the Shannon*, Issue 2:9, June 1928. (Image courtesy of the ESB Archives.)

actually only reproduce seven different photographs, with an emphasis on wide angle shots of the entire power station complex taken from the far bank of the tail race and all corresponding to images from the set of Siemens industrial photographs taken between November 1928 and March 1929 (see Fig. 47).[31] The tendency of German newspapers to purchase photographs from picture agencies, rather than to employ photographers directly, would

Das deutsche Ingenieurwerk in Irland

Das gewaltige Shannon-Kraftwerk, über das unser Bild eine allgemeine Uebersicht gibt, ist in seinem baulichen Teil durch die Siemens-Bauunion bereits im wesentlichen fertiggestellt. Die Siemens-Schuckertwerke liefern die Maschinen und Apparate. Auf dem Bilde sieht man rechts die mächtige Staumauer mit 6 Durchlässen. Die an drei Durchlässen sichtbaren Rohre von je 6 Meter Durchmesser bringen das Wasser zu den Turbinen, die in dem noch unvollendeten mittleren Gebäude zur Aufstellung gelangen werden. Die anderen Gebäude werden die erforderlichen Schaltgeräte aufnehmen. Das Riesenkraftwerk (Gesamtleistung 250 000 PS) hat die Aufgabe, ganz Irland mit elektrischer Energie zu versorgen.

Figure 47 German newspaper article 'Das deutsche Ingenieurwerk in Irland [German Engineering Work in Ireland]' from *Deutsche Allgemeine Zeitung*, 24 March 1929. (Image courtesy of the Siemens Archive: 4086.)

indicate that Siemens was tightly controlling images of its work in Ireland in the German press, selecting photographs to present the Scheme in a specific fashion. The wide angle exteriors emphasised the monumental shapes of the construction while also reducing the subjective chaos of the building site to an ordered, controllable pattern and a landscape format familiar to the least avant-garde reader. The particularly German quality of this control of nature was continually emphasised throughout the clippings with numerous textual references to '*deutscher Technik* [German technology]' emphasising the national origin of the builders of the Scheme.[32] The range of publications from local and daily newspapers to the weekly picture posts and technical papers indicates interest in the Scheme from a wide cross-section of German society, from specialist technical interests to the broader general public.[33] These photographs presented a view of German technical achievements which would have framed the project in an appropriate way for German audiences keen for news of German technical advances.

In contrast to the German publications, the Irish newspapers focused on the name of the Scheme as the important term, emphasising its location on the Shannon river and the national importance of the Scheme, rather than the German origin of the technological expertise and technology, which is largely (and conveniently) ignored.[34] The ESB Publicity Department was diligent in collecting newspaper clippings on the Scheme from July 1928 onwards, with twenty clippings books covering the period from 1928 to 1932 in approximately 1,500 clippings, mostly from Irish newspapers, but including a small number of British and American titles. The Irish newspapers range from national newspapers such as *The Irish Times* and the *Irish Independent*, through a large number of local papers such as the *Cork Examiner* and the *Connacht Tribune* as well as engineering journals such as *Electrical Review* and *The Electrician*.[35] Roughly 250 original photographs of the Scheme were reproduced in these 406 images, forming a much wider range of images than those used in German newspapers. A large proportion of the photographs reproduced (179 or 44 per cent) are also wide-angle exterior shots of the powerhouse or of the weir, but the range of photographs includes a large number of portraits (119 or 30 per cent) (see Table 2). Apart from the *Irish Independent*, which sent its own photographer to the Scheme on a small number of occasions, the ESB Publicity Office released plentiful images and copy to

Table 2 Content analysis of Siemens industrial photographs reproduced in Irish newspapers, based on 406 photographs in ESB newspaper clippings books 1–20.

Content	No. of photographs	Percentage
General location (incl. Limerick and worker housing)	40	9%
Workers (incl. electrical demonstrators)	9	2%
Construction machinery (incl. trains and trucks)	7	2%
Power generation machinery (incl. turbine hall and other station interiors)	20	5%
Architectural views (incl. civil engineering and excavations)	179	44%
Maps or drawings	24	6%
Portraits (incl. opening)	119	30%
Misc. (incl. painting, stamp, models)	8	2%

the Irish press at regular intervals, which were particularly well received by the local newspapers.[36]

The reproduction of such diverse images of the Scheme functioned as an important channel of visual information for the Irish public for most of the project, particularly with the introduction of half-tone engraving in the mid-1920s and the enthusiastic development of the picture press and full page or double-page photographic spreads in the nationals.[37] The mass reproduction of photographs was used to bring 'true' representations of nationally important events to the attention of the reading public in a way that had not been possible before, literally opening an eye onto events that could not otherwise be witnessed. The choice of photographs for such spreads reflects the continuing importance of pictorialist conventions in Irish photography and newspaper illustration.[38] The thirteen photographs reproduced in Fig. 48 include two portraits, five photographs of 'men at work' and one of a man walking in the unfilled canal, along with one interior view of the turbine hall and four broad exterior views of the type discussed above. Unlike the German engagement with modernity which was carried out through Modernist experiments and promotion of technology, the interpretation and representation of the modern world was still carried out in Ireland largely using pre-modern aesthetic strategies such as portraits and landscapes. These newspaper photographs were concerned with the Shannon Scheme as an introduction to the modern world,

Figure 48 Shannon Scheme photographs printed in the *Daily Sketch*, 10 May 1929. (Image courtesy of the ESB Archives: Newspaper Clippings Book 5.)

but engaging with the condition of modernity represented by the picture press and electricity, rather than promoting Modernist aesthetic experimentation.

This selection of photographs has been chosen to emphasise two specific aspects of the Scheme: the scale of the construction, and the role played by Irish workers, which demonstrated an Irish concern for a specific set of issues. A similar domestication effect for the German newspapers can be observed, reducing the large scale of the Scheme to a manageable landscape image. The role of the worker is much more prominent than in any of the German publications, where they appear as tiny figures, if at all. This promotion of the worker demonstrates an Irish establishment desire to promote the Scheme as a productive working environment, given the labour disputes which had dogged its early days.[39] The *Daily Sketch* photographic essay also valorises the specifically *Irish* worker, highlighting the leadership roles of Patrick McGilligan and Ernest Blythe at ministerial levels, as well as 'Some of the sturdy Irishmen who have their backs into the Scheme with right good will' (see Fig. 48, under photograph of workers on left-hand page). Any German involvement

or agency is conveniently elided from both text and image, presenting a very different interpretation of the Scheme than in the German press.

Anton Scheuritzel: printmaking and German industry

The Siemens' imperative to create a visual record of its work on the Shannon Scheme also extended into the realm of fine art, with a set of commemorative etchings commissioned from a German printmaker, Anton Scheuritzel.[40] Although the subject matter of these prints is also the construction of the Shannon Scheme and they were created between 1927 and 1929, overlapping with the industrial photographs, their approach to the subject and practice of image-making is rather different indeed, springing from the uneasy fascination of a traditional essentialist art form with epoch-making technology and construction. Lithography was developed in Germany during the late eighteenth century, and was based on the reproduction of drawings in crayon or greasy pencil.[41] It became popular for book illustrations in the nineteenth century, as it allowed a much softer line and half-tone shading compared to the cut or scratched lines used in etching and the offset process allowed for much larger print runs.[42] Up until the First World War, the Romantic tradition in German art had focused on detailed, romantic landscapes, usually of the Mediterranean or the German countryside, particularly as symbols of a paradise in the process of being lost to technological development.[43] Printmakers such as Hermann Struck specialised in the use of lithography to produce romantic rural landscapes of Israel and small-town Germany, and Struck's 1908 book on printmaking, *Die Kunst des Radierens* [*The Art of Etching*], coincided with the young set designer Anton Scheuritzel taking up printmaking as a career and leaving the theatre behind for good.[44] Scheuritzel's printmaking work seems to have followed Struck's influence in a number of ways, taking regular study trips to Italy and into the German countryside to produce lithographic depictions of romantic rural landscapes such as 'Markischer Wald' (see Fig. 49).[45] His early work is documented in a 1920 exhibition catalogue of his work, in which German art historian Hans Singer praises Scheuritzel's continuation of a tradition of skilful, observant work, based on the economic handling of line and the creation of atmosphere, bringing out the romance and poetics of his landscapes.[46] His landscapes are compared to contemporary printmakers such

Figure 49 Anton Scheuritzel, *Markischer Wald*, etching, *c.*1913. (Image courtesy of the Scheuritzel family.)

as Ingwer Paulsen and Otto Fischer, as well as the Anglo-Belgian printmaker Frank Brangwyn, all of whom combined an emphasis on the technical skill of printmaking with a concern for the meaningful landscape.[47] Singer also situates these artists as providing an alternative to what he sees as the showy excesses of avant-garde Modernist art production, demonstrating the continuation of a German essentialist tradition based on respect for careful craftsmanship and attention to detail, rather than the more experimental work of the Modernists.[48]

Scheuritzel's printmaking career was interrupted by the First World War, during which he fought as a soldier, and it is not entirely clear why he moved to the production of industrial landscapes in the 1920s, although his family consider the uncertain economic circumstances of the 1920s to be the main reason that he focused on the more secure income of these commissions.[49] He carried out a number of commissions for industrial companies, mostly around the Berlin area, documenting the construction of their factories and large

engineering projects, mainly to produce offset lithographic illustrations for *Festschriften* or commemorative publications.[50] These publications emphasised the companies' achievements in the world of heavy industry, and were intended as a method of fostering pride in their work amongst the workforce, particularly during the literal and figurative reconstruction of inter-war Germany. Scheuritzel was only one of a number of artists who threw their considerable skills into this effort, and the industrial landscapes depicted in German artwork between the wars created a vision of technology tamed and controlled in the service of engineering and of the construction of great works, rather than being used for the destruction of land and human life, as it had been during the Great War.[51] It is a positive view of technology, which would have been supported by the developing cadre of German engineers, who would have shared the belief that progress and technology could improve the world.

Scheuritzel's relationship with the Siemens complex of companies is probably the most central of these commissions, ranging from illustrations for a 1925 book on the Siemens companies in Berlin, to his large painting of Siemensstadt in 1930, which still hangs in the Mosaic Hall of the Headquarters Building in Siemensstadt (see Fig. 50).[52] In his 1925 lithographs, the emphasis

Figure 50 Anton Scheuritzel, *Siemensstadt*, oil on canvas, 1930s. (Image courtesy of the Siemens Archive and the Scheuritzel family.)

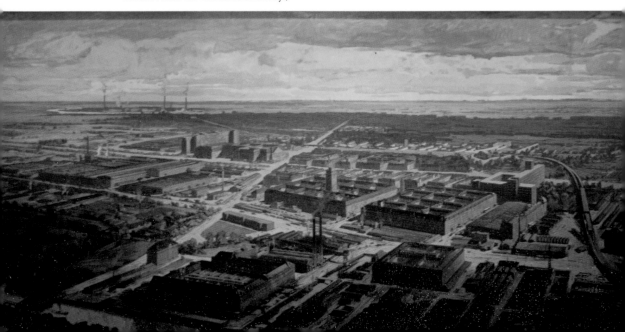

is on the monolithic gridded structure of the building itself, rather than the few tiny workers depicted in the foreground. Although the subject is radically different, the medium and techniques are a direct continuation of his earlier romantic landscapes, which lends emphasis to the impression of German industry itself as a monumental, romantic undertaking. It is particularly relevant that Scheuritzel continues to use romantic techniques of representing smoke and sky throughout his industrial landscapes, using his existing skills to emphasise the almost mythical dimension of the industrial enterprise, rather than the poetic marvel of nature; the industrial, rather than natural sublime landscape.[53]

Scheuritzel and the Shannon Scheme lithographs

Scheuritzel was sent by Siemens to Ireland in the late 1920s to create a set of sixteen offset lithographic prints documenting Siemens' first overseas project after the Great War. A lack of surviving documentation regarding this commission means that they can only be dated from internal evidence – seven prints are signed and dated as 1928, and of the remaining nine, four can be dated to July and August 1928 and five to 1929, based on internal evidence of the state of the works, which suggests that Scheuritzel made at least two visits to the Shannon.[54]

The lithographs cover the main points of the exterior construction work under way in 1928 and 1929, along with a view of the first turbine being installed in the turbine hall and one landscape view of the local area in Ardnacrusha. They are very detailed in their execution, with all the exterior scenes encompassing wide views of the power house construction site, the weir, the canals and bridges showing jumbles of machines, concrete forms, scaffolding and mounds of earth (see Fig. 51). While this devastated landscape is also somewhat reminiscent of the chaotic trench landscapes of the First World War, it is balanced by the positive, ordered construction to be seen in a number of the other prints, including a view of the shiplift end of the power station under construction (see Fig. 52). They replicate the conventions of traditional landscape art, where human figures only appear as tiny ciphers, included to allow the viewer a proper appreciation of the scale of the sublime, in this case industrial, landscape (see the figures on the lower levels of Fig.

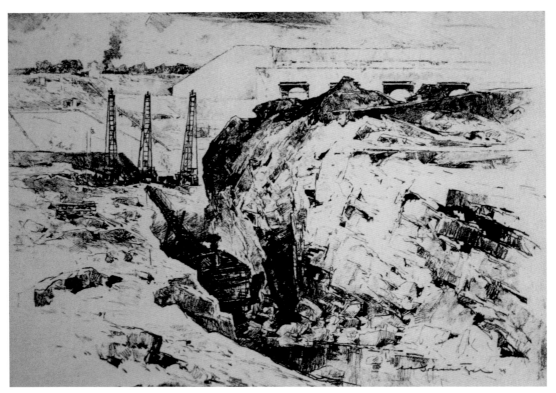

Figure 51 Anton Scheuritzel, 'Excavation in the tailrace, Löffelbagger and drilling machinery, with the water sluice in the background', *Images of the Development of the Shannon: The Electrification of Ireland,* Siemens Schuckert, lithograph, 1928. (Image courtesy of the author, Siemens and the Scheuritzel family.)

52).[55] The emphasis on machine, rather than human, work in the images also ties in quite closely with ideas about the industrial sublime, as the construction seems to be rising from the ground by itself, without human intervention. The way that the buildings are apparently springing up by themselves adds a level of mythologisation to the whole project and the use of traditional atmospheric effects throughout the series also serves to emphasise the romanticisation of technological effort. Fig. 53 represents an anomaly in the set of lithographs, depicting a picturesque rural scene with stone bridge and rural cottages, juxtaposed with an electrical pylon. This image depicts a momentary return to Scheuritzel's pre-War romantic landscapes, mostly depicted as a timeless rural

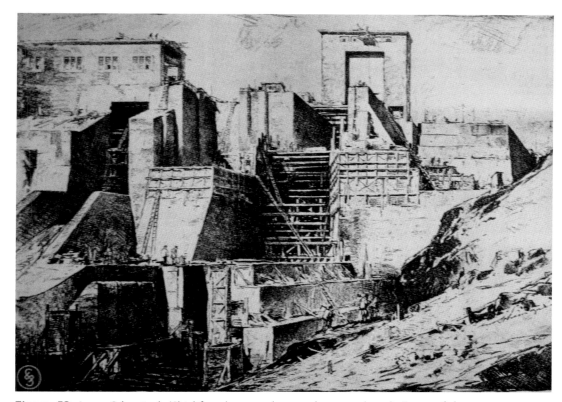

Figure 52 Anton Scheuritzel, 'Shiplift and empty chute at the power house', *Images of the Development of the Shannon: The Electrification of Ireland,* Siemens Schuckert, lithograph, *c.*1928. (Image courtesy of the author, Siemens and the Scheuritzel family.)

idyll. The message seems to be that electrified Ireland will differ very little from the existing romantic land, somewhat undercutting the depiction of immense machine work and effort in the other fifteen images. The representation of the Scheme using the same techniques and methods as Scheuritzel's earlier landscapes, as well as his industrial landscapes, firmly puts these images into a continuum of romantic depictions of the inhabited landscape, although in this case, it is the world being reshaped by the forces of engineering, rather than those of nature. It is not a representation of the sublime in nature, but the industrial sublime, with industrial technology naturalised as the motive force of the world. As Scheuritzel was engaged in a decade-long project of commemorating German industrial progress during the 1920s, these prints

Figure 53 *Images of the Development of the Shannon: The Electrification of Ireland, Siemens Schuckert,* lithograph, *c.*1929. (Image courtesy of the author, Siemens and the Scheuritzel family.)

position the Shannon Scheme as a great German engineering project, bringing electricity to the humble cottages of the Irish countryside.

The creation of Scheuritzel's Shannon Scheme prints as an unnumbered, uneditioned set in a prestige Siemens protective folder indicates that these prints were intentionally produced as an internal commemoration of the project, possibly for the German engineers and mechanics who worked on the Scheme, a practice which was common within German industry at this time.[56] The folders are not numbered or marked individually, but would have been produced in relatively small numbers, possibly a hundred or more.[57] Two of the lithographs were reproduced without comment in *Gebrauchsgraphik* in a 1930 article on advertising methods of large companies, which does suggest that they circulated outside the company, possibly as corporate gifts.[58]

Figure 54 Guest bedroom at Doonass House, silver gelatin print, 2 May 1929. (Photograph courtesy of the Siemens Archive: Album A700, Photograph No. 1172.)

surroundings in Doonass House (see Fig. 54), a Georgian mansion near Castleconnell which had a number of different owners during the early twentieth century.[7] The on-site accommodation was divided into three camps, at Ardnacrusha, Clonlara and at Parteen Weir, with a disused mill converted for accommodation at O'Briensbridge. The largest camp was at Ardnacrusha and was divided into German and Irish sections, both based around rows of pre-fabricated huts purpose-built by Siemens. The German camp also included a number of multi-occupancy timber houses inhabited by married staff, with a dedicated teacher working in an adjoining school building to provide a German education for their children.[8] These houses were designed

in a manner unfamiliar in Ireland at this time, but common in Germany, resembling two-storey apartment blocks, each accommodating four families (see Fig. 55). This would have reduced the culture shock of arriving in an unfamiliar culture for many of these workers and their families, as typical Irish house layout would have been very different, incorporating none of the rational advances in house planning being implemented in Germany at this time, either by Siemens or the wider German architectural community.[9] Unmarried or lone workers shared dormitories, with the Irish camp housing 750 men in 4 smaller timber huts and 7 larger concrete ones, each of which were divided into 3 rooms of 30 beds apiece (see Fig. 56). While these dormitories were cleaned regularly, lit with electric light, heated and furnished with indoor toilets, they were still fairly basic, with all baths and meals to be taken in separate dedicated buildings, a type of communal living unfamiliar to the Irish workers.[10] The size of the Irish camp also fell far short of the volume of accommodation required for the thousands of unskilled workers, which left large numbers renting rooms, sheds and, on occasion, pigsties, as the lack of wider infrastructure in the area failed to cope with the influx of men.[11] The

Figure 55 Timber houses for German employees with families, Ardnacrusha camp, silver gelatin print, 27 April 1926. (Photograph courtesy of the Siemens Archive: Album A700, Photograph No. 182.)

Figure 56 Interior of pre-fabricated Irish workman's hut, Ardnacrusha camp, silver gelatin print, 13 September 1926. (Photograph courtesy of the ESB Archives: Shannon Scheme Photograph No. 328 L.13.9.26.)

Siemens photographer was careful to document both German and Irish camps in 1926, where interior shots show that each man had a bed and a wardrobe, and some central communal space, and these somewhat staged photographs were used to illustrate an early issue of *Siemens: Progress on the Shannon* in January 1927, promoting the fair treatment and amenities provided to workers on the Scheme.[12] The class distinctions between engineers, skilled workers and unskilled workers are particularly notable when these photographs are compared with the furnishings of Doonass House, as well as the attitudes to family life – the provision of family accommodation and schooling was only extended to the ex-patriot German workers, with no provision for the families of Irish workers, who were expected to be alone, if not unmarried, despite moving long distances for work in many cases.

Worker photography: Otto Rampf

In contrast to this careful depiction of corporate paternalism, the small collection of photographic and other artefacts of Otto Rampf, a German excavator driver employed on the Scheme from 1928 to 1929, depicted a messier inside view of the life of a German worker on the Shannon Scheme. Consisting of thirteen annotated photographs, eight annotated postcards, a letter of reference from Siemens and a copy of the 1928 booklet *The Shannon Hydro-Electric Scheme*, this collection was donated to the ESB Archive by his daughter in the 1990s, with a letter attesting to the continued importance of the friendships made on the Shannon and their role in Rampf family lore.[13] The images focus around three main themes: Rampf's living situation, his workplace and machinery, and his workmates, with some overlap between the three. Several of the images are actually in the format of postcards, a process which used silver-gelatin emulsion on a postcard backing to provide instant, personalised postcards, with Rampf himself appearing in one (see Fig. 57) and his digging equipment in another (see Fig. 58).[14]

Figure 57 Otto Rampf, 'With my farmer after a Sunday walk. The son drove the train', with Rampf on far left, bespoke postcard, *c.*1928. (Image courtesy of the ESB Archives: Rampf Collection No. 17.)

The images in this small collection are entirely focused on the experience of living and working at the Ardnacrusha work site for an ex-patriot German worker, with an emphasis on enabling his family in Germany to visualise his everyday life. Crosses mark the window of the room he sleeps in, photographs are taken of his particular digger on site, excursions are noted and commented on and colleagues are celebrated, both living and dead. These images add texture and depth to the Shannon Scheme, personalising it and allowing it to play a background role in the personal narrative of a life, something that an official photograph is unable to do. The ability of photography to create 'snapshots' in space and time is fully brought into play here, as Rampf used his photographs to weave together a narrative of a significant episode in his life, in the sense of Alvarado's definition of narrative, constructing and reconstructing the order of events implied by the photograph.[15] Significantly, the annotations

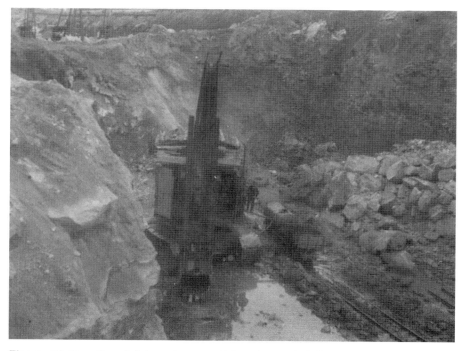

Figure 58 Otto Rampf, 'My equipment 1008 in the canal, difficult to excavate, only rocks, 11.8, Parteen site', bespoke postcard, *c.*1928. (Image courtesy of the ESB Archives: Rampf Collection No. 16.)

are clarified and expanded on by his daughter in the letter accompanying the donation, particularly in picking out her father for future readers, an act which ties in with her statement that 'my family still talk about his travels'.[16] The importance of these images to the family narrative and its connection to the official narrative of German engineering overseas has meant that they were seen as suitable candidates for inclusion into an 'official' archive, reinforcing the connection between Rampf's personal narrative of work and the Shannon Scheme project.[17] Unlike the mute gaze of the workers in the official photography, these images are drawn upon, corrected and annotated with the familiarity of the man on the ground, who is more concerned with the detailed narrative of his own experience, than the creation of any grand epochal narratives. These photographs can be used to puncture the visual rhetoric of the great undertaking of the Irish nation, pencilling in the detail of living and working conditions, the dangers and the colleagues lost to accidents, and the texture of life working on the Shannon Scheme.

The Rampf photographs illuminate the daily lives of the German semi-skilled and skilled workers in a way that the official photographs do not even attempt. They recognise the harshness of conditions on the canal-digging works, underpinning the textual narrative about the conditions of labour on the Scheme in a visceral manner (see Fig. 58). Rudi Volti emphasises the role of danger in forming a base for intense workplace socialisation, where 'strong interpersonal ties are essential for the effective operation of small groups working under dangerous circumstances', which was very much the case on the Shannon Scheme, where at least thirty-three workers were killed during the four years of the construction works.[18] The dangerous nature of Rampf's work is underpinned by the notation on a photograph of a digger, which is annotated 'In memory of Hans D.', with the implication that this was either the deceased's machinery or place of death.

The level of workplace socialisation is particularly intense when the community is isolated, either by geography or by unsocial working hours.[19] This is apparent in the photographs of Rampf with his co-workers taken in their living accommodation, recording the friendships and camaraderie of the overseas worker, cut off from both their place of origin and the local people by linguistic and cultural barriers. This can be seen in a pair of photographs taken on 3 January 1929 recording Rampf amongst a group of men in a wooden

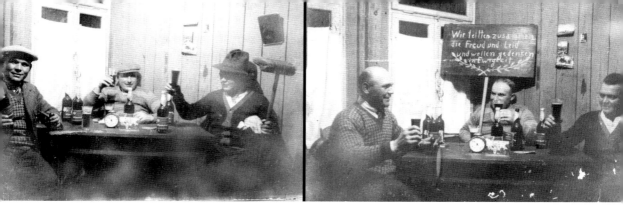

Figure 59 Otto Rampf, 'Ardnacrusha near Limerick, Ireland. 3.1.29', double photograph, 3 January 1929. (Photograph courtesy of the ESB Archives: Rampf Collection No. 20.)

accommodation hut, underneath a sign which translates as: 'We share good times and bad, in memory forever' (see Fig. 59). They are raising their glasses to the camera, acknowledging the supportive relationships built up among working men far from home, implicitly including the deceased members of the group as well as those who had returned home to Germany. The ritual nature of this unknown celebration is apparent from the sign and the salutations, but also from the hats and broomstick apparent in the upper photograph, which fit into Volti's description of workplace material culture encoding beliefs, values and norms in a symbolic manner, using common jokes, rituals, myths and stories to signify membership in a community.[20] This ties in closely with Etienne Wenger's ideas about 'communities of practice', where the shared competence and commitment of co-workers develops into a shared practice, forged into a community by the sharing of experiences, stories and tools over time.[21] The development of such communities of practice is very much about creating meaning within everyday life, participating in work as a social community and enterprise, as well as a means of earning a living.[22] It involves the training of new staff, but also rites of passage such as retirement or colleagues leaving, marked by ceremonies to ease the process of separation and transition such as the handshakes shown in Fig. 60 on the departure of his colleague Franz Engel.[23] That this community was extended in some ways to the mechanical equipment used every day by these men is demonstrated by Harry Alberry's observation of a posy of flowers tied to a German digger at the end of its time on the Shannon, marking the end of its service.[24] Wenger points out three dimensions of a community of practice – the use of a shared

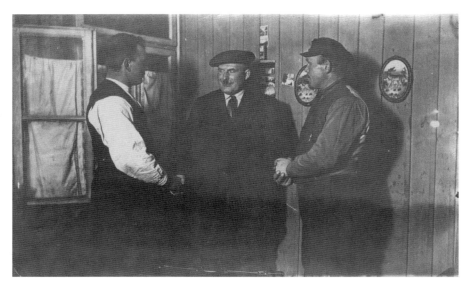

Figure 60 Otto Rampf, 'Farewell to my colleague Engel from Berlin with whom I shared a room! Now am living on my own', photograph, 22 March 1929. (Photograph courtesy of the ESB Archives: Rampf Collection No. 21.)

repertoire, for mutual engagement in a joint enterprise, all of which were present in the community of ex-patriot workers on the Shannon Scheme.[25] A similar, if less intense, community of practice presumably existed amongst the unskilled Irish workers on the Scheme, although their less secure financial status is probably responsible for the lack of photographic evidence.

Worker photography: Franz Haselbeck

The second set of images consists of glass negatives taken by Franz Haselbeck, who worked as an interpreter and stores-man on the Shannon Scheme from 1926 to 1930. Haselbeck was in an unusual and somewhat privileged position amongst Irish men seeking work on the Shannon Scheme, with a fluency in both English and German, as he had been born in Manchester to German parents and moved to Limerick as a child.[26] Haselbeck was also unusual amongst the Scheme workers in that he had attended the Dublin Metropolitan School of Art as an evening student and had worked as a photographic assistant in Killarney from 1909 to 1912.[27] He later set up a photographic studio in the Limerick area,

but the destruction of his initial premises during the Civil War in the 1920s and the general difficulty of finding work in Ireland meant that he took up non-photographic work on the Shannon Scheme in the late 1920s, where fluent German without the requirement for a work visa was a distinct advantage.[28]

This continued interest in and practice of photography can be demonstrated by the presence amongst the collection of glass negatives from Haselbeck's photographic practice of a number of images of the Shannon Scheme under construction.[29] These photographs are mostly of the extension work carried out in 1932/3 to install the final generator (see Fig. 61), but some show earlier construction work.[30] These photographs show a professional level of composition, in line with Haselbeck's training and, although they were not taken in an official capacity, they were stored with his professional work, and are produced using identical methods and materials. They only differ as to content, showing a professional's desire to continue practising, as well as a worker's desire to record his place of work.

Figure 61 Franz Haselbeck, Ardnacrusha power station, silver gelatin print, 14 September 1932. (Photograph courtesy of the ESB Archives and Patricia Haselbeck Flynn.)

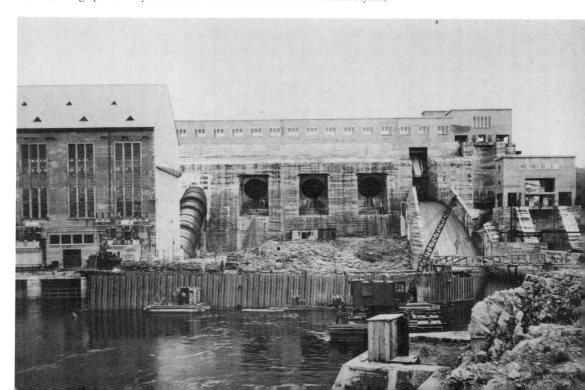

Haselbeck's background differentiates his work from that of amateur photographers such as Rampf, as he had both training and experience as a professional photographer. According to Stebbins, the post-professional is a professional who, for whatever reason, is no longer practising professionally within an area, but who retains ties and connections to it.[31] This can be clearly seen in Haselbeck's continued interest in photography, throughout an interlude in his life when there was little professional photographic work available. The intermittent availability of work has long been characteristic of the artistic job market, with the current definition of the 'portfolio career' having a long history within the arts. The scarcity of steady work outside art teaching has required artists to constantly shift and adapt to circumstances where 'the oversupply of aspirants, a predominance of project-based work, widely uneven rewards and rampant unpredictability' often require aspirant artists to take up working-class jobs in the interim, while retaining connections to their own communities of practice.[32] This continued identification with the photographic community of practice may have been important in combating any issues of alienation while unable to practice his skills in a professional setting, while also contributing to the overall sense that the Shannon Scheme was a worthwhile undertaking, for photographer and subjects alike.

Haselbeck was using a professional medium format camera, and it seems from the lack of workers in most of his photographs and his unofficial status that he was taking photographs outside working hours. His wide angle views of the power station building and the penstocks under construction hold a debt to the conventions of depiction of landscapes, which is not surprising, considering his conservative artistic education in the Metropolitan School of Art, which did not absorb the ideas of the German avant-garde until some decades later.[33]

Haselbeck's other interest in the Scheme is demonstrated in the occasional photographs of workers scattered among his photographs of the construction work. In Fig. 62, a mixed group of male German and Irish workers have posed outdoors for Haselbeck, complete with donkey and cart, babies (but no women), and musical instruments. The hand-lettered sign translates as 'Last Sunday in Ireland Whitsunday 1929', again commemorating the end of a group effort, and the splitting up of this community of practice. It is likely that Haselbeck was taking a semi-formal portrait of the last group of German

workers to leave the Scheme, with prints to be shared as a keepsake of their time in Ireland, as well as for the Irishmen who may have been leaving the area, if not the country. This is an entirely separate endeavour from the official Siemens photographs, which do include moments such as the 'topping out' ceremony, and which were taken by a company representative acting in an official capacity.[34] This photograph provided an alternative view of the Scheme to the official record, more like that of Rampf, emphasising cross-national camaraderie and the temporary community formed through hard physical labour and manual work Haselbeck may not have been a manual labourer on the project himself, but he was part of the joint enterprise building the Shannon Scheme, and this allowed his fellow workers to share their mutual engagement and pride in their work with a colleague.[35]

Figure 62 Franz Haselbeck, German and Irish Shannon Scheme workers on last Sunday in Ireland, silver gelatin print, Whitsunday (19 May) 1929. (Photograph courtesy of the ESB Archives and Patricia Haselbeck Flynn.)

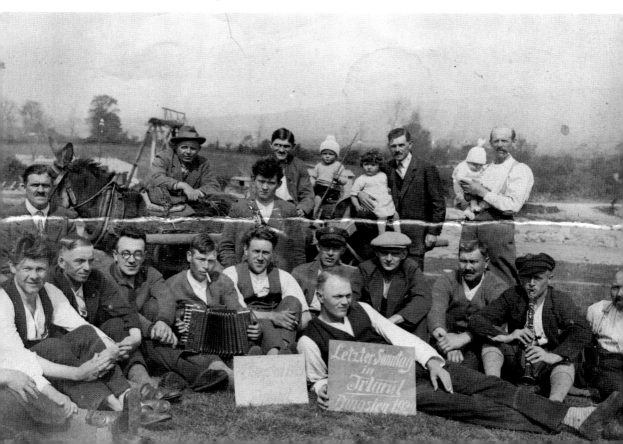

Photographing life on the Shannon Scheme

Both Haselbeck and Rampf share an emphasis on the work carried out on the Scheme, giving the actual workers themselves a level of agency that isn't seen in the official Siemens photographs. Rampf's photographs, in particular, show the Shannon Scheme workers, at least the German ones, as a community, working and living together in close and dangerous circumstances. The annotations, marks and crosses added by both Rampf and his daughter add a level of familiar familial narrative to the images, giving them a level of personal detail that grounds them in everyday life and shared concerns. They are not particularly interested in portraying the Scheme as a great national achievement, either Irish or German, or producing images for an initial audience wider than their family, although the later inclusion of the Rampf photographs in the ESB Archive points to a growing awareness of the importance of the project to Ireland and the ESB.

Haselbeck's perspective as a Limerickman and as a professional photographer meant that his conception of the Scheme as a national achievement must have informed his decision to bring his photographic equipment on site. He would have read the Irish local and national newspapers, talked to his family and neighbours in Limerick city, and retained a connection to the art world through his art college training. Haselbeck's photographs of the Shannon Scheme act as testimony to his professional training and ambitions, continuing to practice while not actually working as a photographer, but retaining a visual interest in the nature of the construction site around him.

6

An Irish Project:
ESB Advertisements

Every progressive country in the world to-day is looking ahead, planning and preparing for the future, and the key-note of all their proposals is electricity – the cheapest and most adaptable form of power. The immense natural cources [*sic*] of power which the Shannon provides are being harnessed for this country. The Irish people will have opportunities for development industrially, commercially and socially, that were undreamt of even ten years ago … The Shannon Scheme has not come one day too soon. It has been proved beyond all doubt that increased mechanical power does not mean less enjoyment. On the contrary it ensures greater employment, cheaper production, higher wages and greater profits. In a word, it means increased prosperity – for everyone.[1]

With the setting up of the Electricity Supply Board in May 1927, the responsibility for the generation and distribution of electricity with the Irish Free State was formally vested in the first Irish semi-state body, combining the agility of a private company with the national responsibility of a state department.[2] The creation of a publicity department allowed the ESB to embark on a campaign to familiarise the Irish public with the Shannon Scheme itself, and with the idea of electrical power, with a view to becoming subscribers themselves.

Unlike similar campaigns in countries like Britain, the continuing emphasis on Irish national identity as being rooted in the traditional, the rural and the antiquarian made this a rather complicated proposition to pitch, particularly to a national public not always familiar with electrical technology in the first place.[3]

The ESB Publicity Department

With the development of the Shannon Scheme well in hand by 1927, the newly formed ESB was surprisingly fast for a utility company in setting up a publicity department. The first Annual Report, covering the period August 1927 to March 1928, discussed the then Managing Director Thomas McLaughlin's trip to the United States to study American publicity and advertising techniques, as the Board realised early on that the success of the Scheme would require a large effort to 'create amongst the public an electrical consciousness'.[4] This was closely followed by the appointment of Edward (Ned) Lawler, the political correspondent of the *Irish Independent*, as the Public Relations Officer in late 1927.[5] Rather than the usual government approach of contracting out the advertising to an agency such as Wilson Hartnell or McConnells, Lawler organised the first ESB advertising campaign himself, writing the copy and contracting freelance artists to draw the images.[6] He states in *Advertising World* that the in-house arrangement 'suited our peculiar conditions better than doing it through an agency'.[7] These 'peculiar conditions' refer to the semi-state nature

Figure 63 ESB tour guide Laurence Joye conducting a group of tourists around the Scheme, *Irish Independent*, 18 June 1929. (Image courtesy of the *Irish Independent* and the ESB Archives: Newspaper Clippings Book 5.)

This Sketch shows Work in Progress at the great Power House at Ardnacrusha. Some idea of the magnitude of the scheme can be gained from the size of the Intake Sluices and the Foundation Pits below.

VISIT THE SHANNON WORKS

The most Stupendous Undertaking in the History of the Nation

SEE THIS MIGHTY PROJECT
IN THE MAKING

Next Summer it will be Too Late. Before next June the waters of the Shannon will be turned into the new canal, and the foundations on which this huge structure is reared will be hidden for ever.

HOW TO GET THERE

Take any early morning train to Limerick. A 'bus and official guides will meet the train and will take you over the works. The 'bus will carry you back in time to catch the evening mail home. 'Bus fare 4s.

The Great Southern Railway will issue return tickets at single fares—available for three days' stay—from any station to Limerick. Special arrangements made for parties.

For further information apply to :

ELECTRICITY SUPPLY BOARD
GUIDE BUREAU, STRAND BARRACKS, LIMERICK.

Figure 64 Electricity Supply Board, 'Visit the Shannon Works', newspaper advertisement with sketch of works, *The Irish Times*, 20 June 1928, p. 1. (Image courtesy of the National Library of Ireland, the ESB Archives and *The Irish Times*.)

of the Electricity Supply Board, which had a mandate to sell its services like a private company, but with a level of governmental oversight and national responsibility unheard of in the private sector. It is likely that Lawler felt the full weight of that responsibility to promote the Scheme and to ensure that the large amounts of money and effort spent on the Scheme were not wasted.

The 1927–8, the ESB Annual Report details the launch of the advertising campaign, a Pathé film of the construction and the establishment of the Guide Bureau to oversee the visits by the public to the construction works. The following year's report described the initial advertising campaign as having commenced on 1 September 1928, involving regular advertisements in the daily newspapers, forty provincial newspapers and a number of other periodicals.[8] The Publicity Department expanded rapidly in the initial years of the ESB, with a team of in-house artists led by Frank Brandt in place by the early 1930s, but the initial advertising campaign was led and coordinated by Lawler, relying on his existing connections within the newspaper industry.[9]

The focus of the ESB Publicity Department on newspapers and periodicals is not solely due to these newspaper contacts, but is typical of the Irish advertising industry's almost complete dependence on print periodicals in the late 1920s. Although small Dublin agencies such as Wilson Hartnell and McConnells had side-lines in both indoor cardboard showcards and outdoor poster advertising, Ireland was overwhelmingly a rural hinterland, lacking the big-budget mass media campaigns which were becoming a common feature of the industry in England at that time.[10] Newspapers still functioned as the central medium for the communication of advertising messages, with circulation figures taken as the main indicator of advertising success.[11] American ideas of market research and the psychological rationales behind buying decisions were slow to infiltrate the British Isles during the 1910s and 1920s, with the first British statistical studies based on the 1924 census used as advertising and marketing tools.[12] Several Irish agency figures regularly visited advertising conventions in London in the early 1920s and the resurrected Publicity Club sent a number of delegates to the London advertising conference in 1924, both of which provided routes into the country for new ideas, although take-up was slow.[13]

The main difference between British and Irish advertising was the extensive network of Irish provincial newspapers such as the *Limerick Leader* or *Meath Chronicle*, with small circulation numbers and overlapping readerships, but

Visit the Shannon Works!

See this Mighty Project in the making

Arrangements have been made with the Great Southern Railway to issue <u>Return Tickets at Single Fares</u> from all stations on its system to Limerick on week-days, available for return within three days including day of issue, from now on until the 29th of September inclusive.

Conducted Tours daily from the I. O. C. premises
Sarsfield Street, Limerick :—
1st Tour leaves at 10.30 a.m., returning 1.30 p.m.
2nd ,, ,, 2.30 p.m., ,, 6.30 p.m.
BUS FARE 4/- (Children Half-price)
Guide's services free.

Those not wishing to avail of these Conducted Tours should apply direct for a permit, giving date of proposed visit.
Conducted Tours on SUNDAYS for large excursion parties ONLY—

Apply to The ELECTRICITY SUPPLY BOARD

O'LOUGHLIN
PRINTER
FLEET STREET
DUBLIN

GUIDE BUREAU, STRAND BARRACKS, LIMERICK

Figure 65 Electricity Supply Board, 'Visit the Shannon Works' Newspaper advertisement with silhouette and thunderbolt, 1928. (Image courtesy of the ESB Archives: MK.PA.1.41.)

with multiple readers for each edition and a high level of trust from audiences in towns and their rural hinterlands.[14] This extensive network of provincial papers played as important a role in Irish advertising as daily papers such as the *Irish Independent* or *The Irish Times*, and Lawler was an experienced enough newspaper man to ensure that advertisements for the ESB were placed in both types of newspaper.

These advertisements must also be seen against the background of the Free State Government's extended efforts during the mid to late 1920s to encourage outside business and tourism to return to Ireland after the previous decade of turmoil. The moribund Tourist Organisation Society was revived in 1924, although its role was quickly taken over by the Irish Tourist Association, founded by Patrick McGilligan in 1925.[15] The new organisation was particularly concerned with the negative image of Ireland abroad after the Civil War, and it aimed to create an attractive post-independence identity to balance out portrayals such as 'the fighting Irish'.[16] The 'unspoilt' Irish countryside was promoted as the main attraction, particularly the traditional trinity of hunting, shooting and fishing, and large sums were spent on press advertisements attracting the English-speaking business class of Britain and America.[17] Often promoted by tourist businesses such as hotels and railways, these advertisements focused on landscape vistas conveniently accessible by rail, where the tourist could relax in beautiful, natural and timeless surroundings, punctuated only by visits to sublime natural wonders.[18]

The corollary to this escapist fantasy, similar to the depiction of the Scottish Highlands, was a view of an exclusively rural, depopulated place, without inconvenient locals either working or displaying visible signs of poverty, and did not always tally with the reality.[19] In contrast, more everyday advertisements aimed at the local Irish population retained a nineteenth-century sensibility to design, relying on literal line drawings of products and users, with blocks of explanatory text set in a jumble of sizes and fonts.[20] These advertisements were occasionally spiced with overt Neo-Celtic imagery and steadfastly ignored any developments in Modernist graphic design which may have filtered through from Britain, with photography not commonly used in Irish advertisements until the 1930s.[21]

As the Publicity Department developed its operations in the late 1920s, the staff were involved in the promotion of electrical products and house wiring,

Energy!

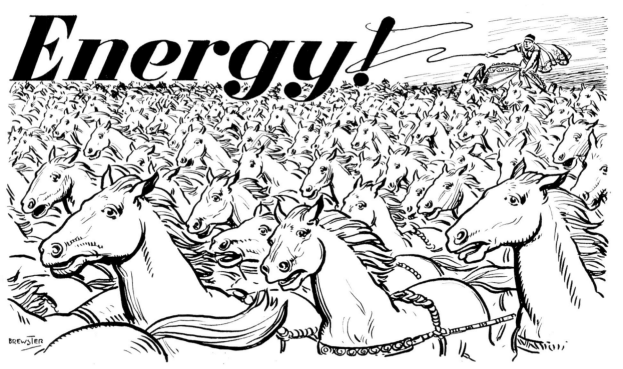

90,000 HORSE POWER

Of energy will be available from the Shannon Electrical Power Station next year for Irish Industry and Irish homes.

The American workman is the most prosperous on earth, because he has, on an average, three horse-power, the equivalent of thirty human slaves, helping him to produce.

No wonder he can toil less and be paid more than the workman of other lands. He is not a toiler, he is a director of machinery.

The Great Southern Railways are issuing return tickets at single fares (available for 3 days) from all stations to Limerick. Conducted tours daily by I.O.C. buses. Permits for private parties issued on application to The Guide Bureau, Strand Barracks, Limerick.

Wages and prosperity are determined by output, and the use of electric driven machinery is the key to the maximum of production with the minimum of effort. It is the secret of successful industrial organisation.

The Shannon is being harnessed to enable the Irish industrialist and the Irish worker to use that key.

Shannon electricity will lift the heavy work of industry from human shoulders to the iron shoulders of machines.

THE ELECTRICITY SUPPLY BOARD

Figure 66 Electricity Supply Board, '90,000 horses' newspaper advertisement, August 1928. (Image courtesy of the ESB Archives: MK.PA.1.42.)

the running of the sales showrooms, the organisation of lecturing tours on lighting systems and the preparation of a stream of books and pamphlets on electrical appliances and wiring.[22] Staff such as John Creagh and Laurence Joye were initially involved in giving tours of the Scheme to interested groups before the development of the dedicated Guide Bureau (see Fig. 63) , and started a campaign of public lectures in towns such as Waterford, Kilkenny, Arklow and Port Laoise in November 1928.[23] These lectures initially involved a talk on the construction of the Scheme, although they became swiftly concerned with selling the advantages of electrical power to potential consumers, particularly as the station went into operation and 'Shannon power' became available.[24] The success of the efforts of the Publicity Department can be seen from a comment in *The Irish Builder and Engineer* in 1929 that 'The propaganda of this body has been of particular appeal to those somewhat conservative souls whose placidity is so difficult to disturb.'[25] While later ESB advertising campaigns were aimed at a domestic market, representing the stylish middle–class Irish woman liberated from the drudgery of housework, the early advertisements retained a clear focus on the presentation of the Shannon Scheme to the general public, as well as the implications for farming and industry.[26]

The official ESB advertising campaign to promote the Shannon Scheme and electrical power can be divided into two phases – three initial advertisements published before the official formation of the Publicity Department in summer 1928; and a more consistent campaign of five advertisements published in the second half of 1928. This modest advertising campaign was described in the 1929 ESB Annual Report as being 'of a broadly propagandistic nature dealing with the possibilities of the Shannon Power Scheme' and Ned Lawler described the campaign in a letter to *Advertising World* as a 'considerable amount of propaganda and goodwill advertising'.[27] It is clear that the first priority of the Publicity Department was to provide a positive exposure of the Scheme to the general public, possibly in an attempt to move the focus away from its problematic financial aspect.

ESB advertising: initial advertisements

The initial campaign began with advertisements aimed at encouraging visitors to avail of rail and bus package deals to visit the construction works, as well

as general promotion of the idea of electricity as a source of power. Each of these advertisements was only published in the daily newspapers once, and was designed in a significantly different layout from the later, more co-ordinated series of advertisements.

The very first advertisement, published on the front page of *The Irish Times* on 20 June 1928, consisted of a drawing of the power station site above a detailed, centred layout of text which focuses on the packaged tours to the site, a layout that was used again in a second advertisement published the following week (see Fig. 64).[28] The drawing was unsigned and showed a view from the tail race bank, a viewpoint which was used by the Siemens photographer on a number of occasions, due to its convenient vantage point over the power house area. The style of the illustration is very clear and precise in its detail, although it is not directly based on any of the extant Siemens photographs of the Shannon Scheme.[29] This advertisement bears a direct relation to nineteenth-century letterpress advertising layouts, with a large amount of text arranged in a number of sizes and fonts, centred and in columns. The density of this text takes away from the emphasis on the headline, as the eye is distracted towards the detailed image so close above and the detailed text so close below. The references to the 'mighty project' and 'stupendous undertaking' emphasise the heroic nature of the scheme and the advertisement works on a direct visual level, demonstrating the size and complexity of the works in a rather literal fashion. The power station is framed like a landscape painting, presenting a 'view' for the prospective tourist, although in this case one constructed of concrete and rebar, rather than of trees and lakes. The form of the power station rears up in a massive, mountainous manner, again devoid of obvious human life.[30] The 'mighty project' seems to be building itself without human intervention, and both text and artwork try to present the Scheme as an example of the technological sublime. A development of the philosopher Edmund Burke's idea of 'the sublime', whereby the magnificence of vast natural landscapes dwarf and terrorise the viewer into an ecstasy of admiration, the technological sublime describes the evocation of similar feelings by man-made artefacts of the industrial world.

The next advertisement uses a rather different strategy to present the Scheme, showing a tidied-up image of the power house surrounded by examples of construction machinery, in front of a looming male silhouette

ELECTRICITY DOES THE HEAVY WORK

The Great Southern Railways are issuing return tickets at single fares (available for three days) from all stations to Limerick. Conducted tours daily by I.O.C. buses. Permits for private parties issued on application to the Guide Bureau, Strand Barracks, Limerick.

The Shannon Hydro-Electric Scheme could not be completed in the allotted space of three years without the use of electrically driven machinery.

Over two years ago a whole railway system, comprising 115 locomotives, 1,100 wagons, and 65 miles of tracks was transported to the Limerick docks.

Many difficulties had to be overcome. No crane on the quays was capable of unloading the large locomotives and other heavy machinery. An electric crane was specially erected to accomplish the task. It did so without effort.

In industry and in the home electricity does the heavy work easily and cheaply. It is the modern labour saver and youth saver. It converts the workman and housewife from labour slaves into directors of machinery.

The Shannon is being harnessed to bring YOU electricity, to help to do YOUR heavy work.

THE ELECTRICITY SUPPLY BOARD

Figure 67 Electricity Supply Board, 'Electricity Does The Heavy Work' newspaper advertisement, September 1928. (Image courtesy of the ESB Archives: MK.PA.1.43.)

grasping a fistful of thunderbolts (see Fig. 65). The symbolism of the thunderbolts is immediate, in the literal association of lightning with electricity common in other electrification projects of the time. Similar to the previous advertisements, the text 'See this Mighty Project in the Making' is emphasised but is linked directly with the image, as the giant silhouette is, presumably, using the lightning to build or forge part of the station. This figure of the heroic worker was not unknown in Ireland at the time, but would have been strongly connected to organised labour and the trade union movement, which represented a significant subsection of the urban Irish, although the Labour Party was not a particularly strong political force by the late 1920s.[33]

The Soviet Union had developed early links with the Irish nationalist revolutionary movement during the 1910s, and had been the only state to formally recognise the First Dáil and the 1919 Republic.[34] Irish artists and revolutionaries such as Harry Kernoff and Maud Gonne McBride were members of the Irish Friends of Soviet Russia, and the heroic industrial worker would have been a recognisable trope, if not a particularly popular one outside the labour movement.[35] The heroic silhouette of the male worker would have spoken clearly to an urban minority, particularly when juxtaposed with a construction scene, but P.J. Mathews has argued that the 'self-help' ethos of rural organisations such as the co-operative movement represented a type of collectivist tendency, which may have provided a significance for this advertisement to the rural farmer.[36] Repeating the rhetoric about the 'mighty project in the making' also focuses on the figure of the worker as a national force, implicitly creating an Irish project for Irish people while ignoring the crucial involvement of German engineering expertise.

ESB advertising: main advertising campaign

The main campaign of ESB advertisements ran for a little over five months, from the end of August 1928 to January 1929, and consisted of five different newspaper advertisements, placed in multiple Irish newspapers, including the daily national newspapers, forty provincial weekly newspapers, and a number of other publications such as *The Irish Builder and Engineer*, a bimonthly architectural and engineering publication.[37] These advertisements seem to have been designed and published in the newspapers one after the other, rather than

all at once, although some were repeated at a later date, and they have a level of sophistication and unity in the design and layout which was missing from the initial advertisements.

Each of the first three advertisements was published in a biweekly and then monthly pattern, mostly debuting in the national newspapers on a Thursday and appearing in the weekly provincial papers on Saturdays. The copywriting, design and publication of each advertisement happened in a sequential manner, with a regular cycle in the ESB Publicity Department allowing later advertisements to respond to feedback on the earlier ones, and a more sporadic pattern of publication in the trade magazines.[38]

Four of these advertisements include images signed by Gordon Brewster, the noted Dublin freelance illustrator, who produced lively illustrations and cartoons for the *Irish Independent*, the *Sunday Independent*, the *Evening Herald* and a number of commercial clients up until the 1940s, and would have been known to Lawler from his time at the *Irish Independent*.[39] The first two of these advertisements, published at the start and middle of September, continue to advertise rail deals to visit the Scheme, while the subsequent monthly advertisements move towards general propaganda for the Scheme and electrical power, working to familiarise the population with the idea of electricity, the main aim of the Publicity Department.

The first of these main Shannon Scheme advertisements is perhaps the best known, as it has been reprinted a number of times in different publications (see Fig. 66).[40] It has a more sophisticated layout than the earlier examples, with the top half dominated by a Brewster illustration, separated by a line of bold capital text from the lower, textual, part of the advertisement. The illustration shows a line drawing of horses rushing towards the spectator, pulling a chariot and charioteer all decorated with loose interlaced patterns, with the charioteer dressed in a Neo-Celtic tunic, cloak and headband.[41]

This image uses three interlinked metaphors, both visual and verbal, to make the Scheme accessible and desirable to the rural Irish reader, while simultaneously sidestepping any unappealing technological associations. The first metaphor uses horses and harnessing, a familiar idea in a land of small farmers, where fields were still rarely ploughed by tractor and the plough horse was a familiar sight.[42] The link between the physical power of a horse and that of electricity would also have been easily understandable to the farmer,

presenting a tantalising and extravagant level of horsepower.[43] Again, the idea of harnessing is very important, especially in respect to fears of electrical fires amongst an uneducated population: this is electricity tamed and under control. The next metaphor is that of the Shannon itself, which is particularly apt as this is a hydro–electric power station. The mythological associations of the River Shannon date back to the Gaelic epics, with Sionnan appearing in the story of the Well of Knowledge.[44] The movement of the horses in the image can be seen as a direct echo of the movement of river water, which is providing the electricity.

The text directly refers to 'harnessing the power of the Shannon', making use of the State's natural resources, as well as imaginatively linking the project to popular pride in 'the great river' of Ireland. It is these antiquarian links to a notably 'Irish' past that culminated in the inclusion of a Gaelic charioteer in the top right-hand corner of the image.[45] Not only was the river of water/

PROGRESS

By the Winter of 1930 a cheap and abundant supply of Electricity will be available in practically every town and village in the Saorstat.

The Shannon Power Scheme has made this possible.

But for the advent of the Shannon Scheme the vast majority of the towns and villages would never have Electricity.

The large towns might have installed their own plant and generated electricity from imported oil or coal. This would have cost them much money and would never have given them a cheap and abundant supply.

At the present time in towns with their own Electric Station only well-to-do people can afford to instal and use Electricity.

The Shannon Scheme makes it possible for every home to have Electricity.

Small villages are being catered for as well as the big towns.

To-day the Saorstat is the least electrified State in Europe. Next year it will have a supply as cheap and as widespread as the most modern State in Europe.

This is an achievement of which the country may well be proud. This is Progress!

THE ELECTRICITY SUPPLY BOARD

Figure 68 Electricity Supply Board, 'Progress' newspaper advertisement, September 1928. (Image courtesy of the ESB Archives: MK.PA.1.1.)

horses being tamed, but the horses were symbolically harnessed to the Irish nation, in much the same way that the electrical power of the Shannon was to be used by the Irish people. In a similar fashion to other newly independent countries, the importance of ancient myths and legends to the imagining of the Irish state meant that the upright Gaelic warrior of the popular imagination could be easily slotted into this essentialist metaphor.[46] This was particularly important in this interpretation of the Scheme as a heroic Irish project for the Irish people, emphasised by recognisably Irish Neo-Celtic imagery.

The Celtic charioteer would have been quite familiar as a symbol of cultural nationalist efforts throughout the late nineteenth and early twentieth century to revive various forms of Irish culture based on whatever fragments

of oral culture were to be found in remote areas, as well as medieval metalwork and illuminated manuscripts.[47] There is also a disconnect with the actual male Irish bodies on the Scheme itself, most of whom were labouring in decidedly unheroic conditions.

In direct contrast to the Neo-Celtic imagery of the illustration, the main text in the 90,000 horses advertisement discusses the benefits of this promised supply of energy to the Irish industrialist and the Irish worker. It refers directly to manufacturing principles developed by Henry Ford in his automobile assembly lines in the early 1900s, with 'the American workman' being described as 'a director of machinery' and discussing methods of creating prosperity and high wages. It seems divorced from the antiquarian and pastoral imagery, but it is tied into the idea of 'harnessing' the Shannon for industrial production. It makes a direct connection between the horse-power of the illustration, compared to the work of human slaves, stating that 'Shannon electricity will lift the heavy work of industry from human shoulders to the iron shoulders of machines', relating the image directly to the physical work of Irish industry.

The Government was specifically interested in supplying Shannon power to the Ford factory in Cork, as three years of supply negotiations culminated in an agreement to supply some sixteen million units of power in 1929.[48] The small numbers of business entrepreneurs and industrialists in the Free State would have been familiar with Ford's production methods and were noted at the time as being keen to capitalise on the expanded availability of electrical power to develop their factories.[49] However, the ESB Publicity Department employed a common strategy of collapsing past and present by harnessing the incongruous combination of a Neo-Celtic charioteer with an unashamedly Fordist text.[50]

The ESB changed their advertising focus around September 1928, from the general public to a smaller group of engineers and industrialists, who would form the basis of the ESB's industrial customers after the full operation of the Scheme in 1929. This is particularly noticeable in the choice of advertisements reproduced in *The Irish Builder and Engineer* from this point onwards, which concentrated on machinery, equipment and the rhetoric of progress, rather than Celtic or heroic symbols.

DIGGING 4,000 TONS A DAY

This machine is a Bucket Dredger used in digging the canal, which will carry the diverted waters of the Shannon to the Power Station. In the construction of this canal thirteen million tons of earth had to be excavated. The Bucket Dredger is operated by two men controlling four small electric motors totalling less than 200 horse power. It digs the earth, transports it, and fills it into railway wagons. Machines such as this using electric power have made possible the construction of the Shannon Works in three short years.

Such is the mighty performance of one of the giant excavators on the Shannon Works.

This single piece of electric driven machinery does the back breaking work of hundreds of navvies.

For centuries the world has wasted its most precious possession—human lives —in labour that electricity can do.

Even to-day in our country, on the farm, in the home, and in the factory, men and women are wearing out their lives doing the work electricity should do.

The Shannon is being harnessed to lighten human burdens, to brighten human lives.

THE ELECTRICITY SUPPLY BOARD

Figure 69 Electricity Supply Board, 'Digging 4,000 tons a day' newspaper advertisement, October 1928. (Image courtesy of the ESB Archives: MK.PA.1.44.)

The first of the *Irish Builder and Engineer* advertisements is laid out in a similar manner to the 90,000 horses one, although the balance between text and image has altered slightly, with a smaller image and the strapline placed further up the page (see Fig. 67). It depicts a scene at Limerick docks with rail engines being unloaded from a steamer, which would have been a common sight during the construction of the Scheme and may have been drawn from life or developed from Siemens photographs.[51] Also drawn by Gordon Brewster, it portrays a much more realistic scene of the work associated with the Shannon Scheme, as an overwhelming proportion of the equipment used in the Scheme was imported wholesale from Germany on regular steamers.[52] In tune with the written message that 'Electricity does the Heavy Work', two dockers take their ease in the foreground on the dockside as they watch the engine being unloaded by electric crane. The very literal visual message reinforced the text, which pointed out the extensive and efficient use of electrical machinery on the Scheme, replacing manual labour, and this was held up as a model for Irish industry. In terms heavily influenced by American progressive literature, it describes the benefits of electrical machinery to the workman and, notably, to the housewife. It is notable that, again, the German role in designing and importing these engines, let alone the power station itself was not acknowledged, with the focus remaining firmly on the progressive future of Irish industry.

It is also notable that the two (presumably Irish) dock workers are shown not actually working, but watching the arrival of this machinery, along with numbers of smaller figures in the background who are nearly all focused on the engine. There is no sense in either image or text that their already precarious docking work may be in any way threatened by the arrival of such sophisticated equipment. The advertisement promotes the idea that Irish workers will now be 'directors of machinery', promoting the idea that technological change would always bring increasing skill levels and professionalisation for workers, regardless of class or social concerns, rather than 'deskilling' manual workers even further.[53]

The next ESB advertisement, published at the end of September 1928, differed from its predecessors in being purely text-based (see Fig. 68). The entire advertisement seems to have been set quickly on a letterpress machine, and this return to simple text-only advertising makes it resemble not just Irish text-based product advertisements, but a political manifesto or effort at vote-

the actual work of the Scheme. The progressive-inspired text of previous advertisements had advocated the replacement of the human worker (equated with slavery) with machinery, but it only became visually explicit in the final three advertisements for the Scheme, with their literal replacement of canal-digging navvies with large pieces of construction equipment. This highlights the American progressivist influence in Ireland at the time, particularly as bucket excavators were unlikely to strike over conditions and wages in the way that the Shannon Scheme workers had done in 1925.[61] Of course, such excavators did not actually operate autonomously, but were driven by semi-skilled workers on higher pay rates than the navvies, and who were perceived to be climbing the skill ladder and becoming 'directors of machinery'. It is also notable that the vast majority of such semi-skilled workers on the Shannon Scheme were German, rather than Irish, owing to a great dearth of qualified men in Ireland and large numbers in Germany, many of whom may have worked with Siemens on previous projects.[62]

The advertisements moved from extending a specific invitation to the Irish public to visit the Scheme, to the broader promotion of electricity and, once the general public had been acclimatised to the idea of the Shannon Scheme as an Irish project, the ESB Publicity Department was able to promote an ideology of progress that is not often discussed in terms of late-1920s Ireland, particularly the replacement of the Irish worker by electrical machinery. Although the 90,000 horses advertisement is the most overt in its use of essentialist visual strategies, the other advertisements lean heavily on epochal ideas and concepts imported from America both for text and images. The ESB Publicity Department also made heavy use of modern newspaper distribution to circulate its message, as they aimed to present this grand epochal project as a naturalised, Irish one, despite the contradictions that posed at the time.

7

The National Imaginary: Irish Tourist Photographs

Now, when sitting down to write again of the Shannon Scheme, one feels a certain assurance that when reference is made to such items as the Power Station, the Weir and the Intake Building, of instance, a big number of readers will be able to visualise the location and formation of them without going into all the explanatory detail that was formerly necessary.[1]

The huge numbers of Irish tourists who visited the Shannon Scheme on organised tours during the construction did not just passively consume the spectacle of the ongoing works, but captured their own images of the project. The increasingly popular past-time of photography was enabled by the availability of small hand-held cameras, a development which started the democratisation of photography as a mass art form, rather than a more elite pursuit. These photographs were instrumental in shaping the popular view of the Scheme amongst the Irish public, particularly those who had absorbed the messages of the ESB advertisements and ventured by train or automobile to Limerick and then the site at Ardnacrusha, to see the 'mighty project' with their own eyes and lenses. The tourist photograph provided an easily recognisable format for the early-twentieth-century Irish tourist, which was used to tame and domesticate the technologically sophisticated construction works and power

station. Members of this Irish audience were keen to create their own images of the Shannon Scheme, to integrate it into the narrative of their own lives in an easily digestible format, one which also showed off their own skill and familiarity with another advanced technology of the time.

ESB Guide Bureau

The programme of guided tours run by the ESB's Guide Bureau was centrally important to the conceptualisation amongst the Irish public of the Shannon Scheme as a national endeavour. It built on the success of the Publicity Department providing private tours of the Scheme to groups such as the Institute of Civil Engineers, the Institute of Electrical Engineers, the Scientific and Engineering Society, engineering students from UCD, Trinity College and Cork technical schools and at least one group of teachers.[2] Led by John Creagh, the Guide Bureau was set up in June 1928 'to facilitate and conduct visitors to the works', expanding the earlier occasional tours into a daily schedule, in order to cope

Figure 71 Shannon Scheme postcard posted from Ardnacrusha to Dublin, 19 July 1930. (Image courtesy of Limerick City Museum: 2001:0259.)

with the influx of visitors enticed to the works by the ESB advertising campaign discussed in the previous chapter.[3] These tours were conducted from the Siemens offices at Strand Barracks in Limerick city, with the transport provided by the Irish Omnibus Company from Limerick to Killaloe, via O'Briensbridge, Parteen, Clonlara and the main site at Ardnacrusha itself.[4] The Guide Bureau operated this routine under the auspices of the Publicity Department from June 1928 to 1931, although hourly tours of the station complex itself continued for a number of years afterwards.[5] The formal organisation of the tour service coincided with the power house reaching an advanced state of construction and an increasing level of organisation within the ESB itself, as it prepared for the launch of the Scheme in 1929 and its subsequent take-over of control from Siemens.

From contemporary newspaper reports, the regular tours ran alongside group bookings from technically-orientated groups such as the Irish Technical Instruction Congress, the Institute of Electrical Engineers (back for a second visit in 1929) and the Association of University Electrical Engineers.[6] Business interests were also represented, with visits from the Dublin Chamber of Commerce, the Secretary and Works Manager of the Ford Works in Cork, and the *Irish Independent*, all with a view to installing Shannon current in their particular businesses.[7] An idea of the broad appeal of the Shannon Scheme as a tourist destination can be gathered by the numbers of American and German tourists noted in the newspapers as touring the Scheme, as well as notables such as Lord Leverhulme, the Archbishop of Westminster and the Chairman of the New York Power Board.[8] That said, the numbers of Irish visitors who visited using the specially discounted rail tickets were also very high, with the 1929 ESB Annual Report detailing some 85,000 visitors over the first ten months of operation, which was almost 3 per cent of the population of the Free State.[9] A *Limerick Leader* article also quotes the Guide Bureau as having logged 32,776 visitors in the month of September 1928, the highest number in the four months of operation at that point, presumably due to the effects of the national newspaper advertising campaign.[10]

The Scheme and the tourist gaze

The original series of ESB advertisements was aimed at the thousands of Irish visitors to the Shannon Scheme, as it was their physical engagement with the site

which would provide a visceral contact with the Scheme, as well as constructing it as an epic undertaking in their consciousness. The tourist was allowed into the construction site only under limited and controlled circumstances and the scale of the project would easily have dwarfed anything in the experience of the Irish public, both in terms of its physical size and the complexity of the engineering works. Their gaze was guided, focused and directed during the experience of the tour, as they were shepherded around a specific route through the works and particular aspects of the construction were pointed out to them.[11] Architect Harry Alberry recommended visiting with a motor car and a small party, describing his own visit in 1929: 'hundreds of happy holiday makers, *en route* for Limerick, clad in freshly tailored tweed suitings, or more filmy and more brilliant raiment, are anticipating acquaintance with the Free State's venture. Fortunately, the sun is shining.'[12] That the experience of the Scheme was largely visual is emphasised by a surviving postcard in the Limerick City Museum, from June 1930, which was posted from Ardnacrusha post office to an address in a Dublin suburb and bears the short message 'Here we are, a great sight to see the works.' (see Fig. 71) This emphasis on the visuality of the experience privileged the Scheme as a worthwhile 'sight' to see, and vindicated the effort and time spent by tourists spending their leisure time visiting the works.

One of the main effects of the public tours of the Shannon Scheme was to raise the status of the works to that of a national monument, a place to which it was worthwhile making a pilgrimage, like the Rock of Cashel, the lakes of Killarney or other spots on the tourist trail of Ireland, at least for the period of its construction. This was partly due to the spectacular scale of the works, but was emphasised by the whole apparatus of tourism, including the production of images both by the organising body and by the tourists themselves. One newspaper article recounted 'much surprised comment … concerning the immensity of the undertaking and the progress that has been made by the contractors'.[13] This discussion of the Scheme in the language of the sublime eased its inclusion in the pantheon of national monuments, as it was turned into an iconic site with a specific function in the national myth, in this case to emphasise the successful independence of the Irish Free State from Britain.[14]

Tourist sites are constructed as locations of authenticity, where tourists, taken out of their normal routine, can validate their own experiences as also being authentic, and the Shannon Scheme carried a particular piquancy in

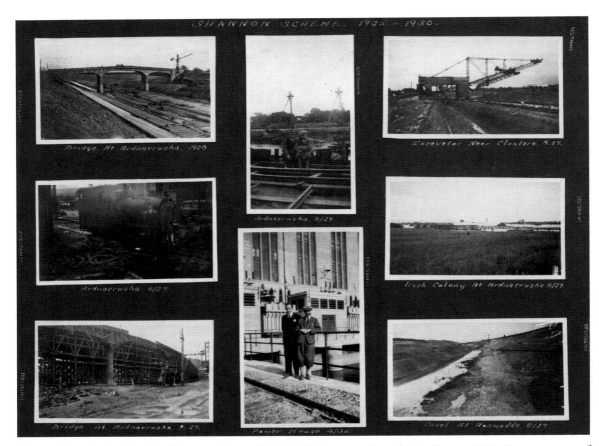

Figure 72 Malcolm Mitchell, 'Shannon Scheme 1925–1930', loose page from family album, *c.*1930. (Image courtesy of Limerick City Museum: 1993.0216 to 1993.0221.)

this respect.[15] Unlike the majority of tourist sites, which tend to be either ancient sites or places of spectacular natural beauty, the Shannon Scheme was unusual in that it was actually being constructed in front of the tourists' eyes. Rather than being a timeless reminder of their place in the world or of the gloriousness of national history, it was changing dynamically over time, with a visit in 1929 revealing a different sight from that seen in 1928. It is also unusual in that, for at least the first two years of the Guide Bureau's operation, it was also a place of large-scale building work, with attendant safety issues.[16] Although anything up to 4,000 workers were employed on the construction of the Scheme at any given time, the huge numbers involved in the construction

photographs (see Fig. 72, lower left). While there is no extant information on the camera (or cameras) used, the photographs are printed on Velox contact paper and vary slightly in size, indicating that they were probably taken with a Brownie-type camera and professionally developed, possibly in one of the chemists mentioned above. Of the twenty-five photographs present in the archive, fifteen are dated to specific months during this period (June and August 1927, Easter 1928, August 1928 and April 1930), with the rest dated to 1928, which reinforces the argument that they were taken on a small number of successive visits to the Scheme, as opposed to the regular documentation of the Siemens photographer, and then mounted as a discrete set of thematic pages within a larger album.

Within the photographs themselves, there is a wide range of exterior shots, including the steam engines used to ship cargo to and from the Limerick Docks (see Fig. 73, top right). The time span represents a broad period of construction and this is demonstrated by some repeated subjects, for example the bridge at Ardnacrusha village, which is shown supported by construction scaffolding in 1927, finished in 1928 and then again in 1930, with the head race flowing below (see Fig. 72, top left and bottom right, and Fig. 73, middle left). Additionally, two figures who are probably Mitchell and his older brother Robert appear in several of the photographs, posing in front of the power house, the dam and a steam engine (see Fig. 72, bottom centre, top centre and middle left). Their self-conscious posing in front of the Scheme exemplifies Bourdieu's description of the 'simulated naturalness, the theatrical attitude' of amateur photography.[39] The brothers, evidently photographic enthusiasts, are recording and emphasising their joint efforts as amateur photographers, repeatedly using the epochal 'truth-recording' function of photography to record their leisure-time pursuits, becoming subject, as well as objective force, self-consciously recording their presence at the Scheme at a specific moment in time. This inclusion of the Shannon Scheme as a backdrop to their photographs means that it has been included in the pantheon of places at which it is suitable to be photographed – the memorable places, which are usually restricted to either domestic sites or, more commonly, the location of holidays. The Shannon Scheme was not a place of natural beauty or ancient historic significance, and its inclusion within a photographic narrative of a family album would seem incongruous unless it is considered to be a

location of specific national importance.[40] The Mitchell brothers were using photography to purposefully insert themselves into a great national project, demonstrating a sensitivity to the epochal nature of the new nation.

The inclusion of the Shannon Scheme photographs in a family album further emphasises the successful naturalisation of the Scheme as a tourist destination. The Mitchell Shannon Scheme photographs are mounted on five pages of a larger album, which also contains other holiday photographs, naturalising the Shannon Scheme as another legitimate 'destination' for the Mitchells' tourism.[41] The album pages, however, have been separated from the binding on their donation to the museum and some of the photographs removed, implying that a later generation considered some of the photographs of continuing importance to the family, while others retain only 'historical' interest.[42] The donation of these photographs reinforces the Mitchell family's place in Irish history, linking them to the past and a sense of Irish identity.[43]

The second set of amateur photographs of the Shannon Scheme was taken by Ernest Bennis, also an enthusiastic amateur photographer in the Limerick area.[44] These consist of a set of nine Velox prints, 8.2 by 13cm in diameter, indicating that they were taken using a similar type of camera as that used for the Mitchell photographs and developed in a similar manner. The photographs are undated, but internal evidence suggests a date quite late in the construction of the Scheme, between May and September 1929.[45]

The subjects of the Bennis photographs are similar to the Mitchell ones, in that they form a survey of certain exterior points of the Scheme, with three views of the power house, two of the canals and two of large pieces of equipment. The steam engines are noticeably absent, but are replaced with parked rock drillers and a bank–building machine. In addition, there are no people in evidence in these photographs, giving the Scheme the feel of a deserted monument, rather than a place of active work, possibly due to the photographs being taken at the weekend or on a holiday, both prime times for tourists, if not for construction work. In contrast to the Mitchell photographs, though, the technical skill of the photographer is nowhere near as accomplished, with two of the photographs being underexposed and one being taken from an unusual angle down onto the penstocks between the power house and weir (see Fig. 74, middle). The choice of views would have been dictated, to an extent, by the safe paths through the site for the visitor

(e.g. the top middle photograph in Fig. 74 is taken from the north bank of the tail race, in a similar location to several Siemens photographs).[46] Bennis is attempting to mimic pictorialist conventions, although to be fair, these photographs are the earliest in the Bennis collection in the Limerick City Museum and may represent his first attempt at using a camera on a holiday excursion.

The absence of family members in the photographs may be because Ernest Bennis was concentrating on photography as a solitary hobby, rather than as part of a family-based activity. This is also reinforced by the large number of photographs donated to the Museum by his children, which cover locations of historic interest throughout Limerick and Clare. Bennis was also notable as a local historian and member of the Old Limerick Society during the 1940s and 1950s, evincing a developed interest in amateur enthusiasms.[47] The donation of the photographs to the Limerick City Museum again indicates their categorisation as photographs of historical, rather than familial, value, particularly in the light of subsequent recognition of the Shannon Scheme as a site of epochal historical importance to the Irish nation.[48]

A third set of photographs fits firmly into the category of holiday photographs. These consist of eight small photographs in a cardboard album, documenting a Gordon family visit to the Scheme in September 1928. These photographs were taken with a small-format camera, possibly a Leica, which produced contact prints of the same size (see Figs 75 and 76). This represents

Figure 75 Richard Gordon, inside cover and photograph of power house construction in Shannon Scheme album, September 1928. (Photographs courtesy of Nicola Gordon Bowe and the author.)

a smaller format than any of the photographs considered so far, but also one which was cheaper to buy and maintain than even the Box Brownie and suitable for the hobbyist, rather than the serious amateur.

The photographs cover a similar gamut of outdoor views of the Scheme to the other amateur photographs, showing the power house, the weir and a bridge under construction, but these are framed by two more traditional holiday photographs, showing a picnic lunch and a motor car in a hotel forecourt (see Fig. 76).[49] The inclusion of these two photographs helps create a narrative of a family visit to the Shannon, representing the journey, as well as the actual destination. The inclusion of the photographs in a palm-sized album also allows for easy viewing for an individual, as well as easy transportation of the album itself. In addition, the inclusion of the family photographs may have ensured that the album has been kept within the original family, rather than donated to a museum or archive.

The Shannon Scheme as tourist site

The amateur visions of the Shannon Scheme focus on both the creation of familial narratives and the technical improvement of the skills of the amateur photographer. They show a marked repetition of the same scenes around the Scheme, although this may be partially dictated by the locations open to tourists. They lack the consideration of the aesthetic evident in the Siemens

Figure 76 Richard Gordon, photograph of roadside picnic in Shannon Scheme album, September 1928. (Photographs courtesy of Nicola Gordon Bowe and the author.)

POWERING THE NATION

industrial photographs, as well as the professional level of attention to labelling and dating, but are still, in most cases, carefully assembled into albums in order to construct a narrative of the Scheme, naturalising it into the category of acceptable things to photograph.

From a wider point of view, all of these photographs share a common attitude to the Scheme, whereby it was included in the personal and family narratives of Irish people, like other tourist sites in their own or other countries. They accept the Shannon Scheme as an important Irish place, despite its lack of overtly Celtic, Gaelic or historical symbolism, and do not display concern about locating it alongside the pantheon of sublime tourist sights in their albums. I would argue that this inclusion of such a technological undertaking demonstrates a cautious acceptance of the idea that, to these amateur photographers at least, a vision of Ireland as a modern, and modernised, country was not impossible.

8

Artistic Visions: Paintings, Prints and Watercolours by Irish Artists

> Throughout these pictures there are the human figures, giving a sense of scale, certainly, for they are tiny in the landscape, and often impressionistic. But they are worth looking at hard. For they are men at work, and though they are dwarfed by the machines, they have dreamed them, and then designed and built them, and now control them.[1]

The reflections of Irish politician, journalist and veterinary surgeon Justin Keating on men at work in the landscape may be focused on his father's paintings of the Shannon Scheme, but they can be expanded to apply to the work produced by other Irish artists who made the effort to visit the construction site during the late 1920s. The Irish art world of the period was characterised by a general lack of interest in the avant-garde experiments of European Modernists, and a marked focus on attempts to develop a specifically 'Irish' form of art, which generally manifested itself in the use of academic British techniques of representation and working to represent the rural and the anachronistic. The political and newspaper coverage of the Scheme, however, attracted a small number of Irish artists down to the banks of the Shannon, partly due to the virtuoso displays of cutting-edge engineering skill on show, and largely due to a recognition of the national significance of the project. The uneasy relationship

of the large-scale building works with the idyllic countryside of the West of Ireland seemed to epitomise the tension between the epochal world of heavy engineering, and an essentialist focus on the Irishman in the landscape which was still developing in the new years of the Free State.

Seán Keating (1889–1977), George Atkinson (1880–1941) and Brigid O'Brien (later Ganly) (1909–2002) all produced work based on the Shannon Scheme between 1926 and 1928, in a range of mediums which included oil painting, etching and watercolour. All three were closely related as staff or students of the Dublin Metropolitan School of Art (DMSA) (the precursor to the current National College of Art and Design), which gives an indication of the small size and closeness of the Irish art world of the 1920s. They were also working under a relatively high level of autonomy compared to commissioned artists such as Scheuritzel, with the only direct link to the organisations involved with the Scheme formed by the *post facto* purchase of Keating's paintings by the ESB. As would have been normal for the time, these artists were working independently, often relying on teaching for a regular income and selling their work through a yearly calendar of exhibitions. However, all three were drawn to the feat of advanced engineering and high technology being carried out in the evocative and mythologised West of Ireland, each responding to it in their own individual ways.

Irish art and the myth of the West

As in many other European counties, the late nineteenth century saw a literary revival in Ireland which was largely concerned with the ideas about national identity and had a lasting influence on the professional visual art produced in the country.[2] In the early part of the century, extensive debate had centred around the possible formation of an 'Irish school' of art, what form that school could and should take, as well as the suitable level of influence of originally British approaches such as Arts and Crafts.[3] The dominant position in this artistic debate developed after independence as an emphasis on 'Irish' Ireland, symbolically shutting out any other possible interpretations of Irishness. The same conditions which allowed the West of Ireland to be considered a parochial backwater of the British Empire, allowed it to be seen as a reservoir of unsullied essentialist 'Irishness' by Irish writers and painters of the early twentieth century, untouched

by modern civilisation.[4] This was particularly true of the isolated islands of the western seaboard which retained daily use of the Irish language and pre-industrial folklore and ways of life, which were to become a source of inspiration to Irish painters such as Jack B. Yeats and Keating himself.[5] Although much of this way of life was specific to the post-Famine world and to the area, the 'anachronistic' rural community was hailed as an authentic remnant of a past otherwise lost to the modernised world, in order to create a link to a re-invented mythical vision of a lost past.[6] The noble peasant reappears continuously through the early work of Orpen, Yeats, Henry, Lamb and Keating, romanticising and heroicising the subsistence farmers and fishermen of the West of Ireland, and the distinctive Western landscape became heavily associated with Irish national identity.[7]

The Shannon river played a very specific role in mythologising the Irish landscape, emphasising its status as a geographic boundary to turn it into an imaginative boundary between the colonised, civilised East and the mythic West. As well as being a focus of ancient myths and legends, both Christian and pagan Gaelic, it worked as a liminal or boundary area within Irish nationalist ideology, as an entry zone to the 'authentic homeland beyond the reach of colonial transformations'.[8] This romanticisation of the unspoilt, poor land of the West of Ireland is central to understanding the search for an 'Irish school' of painting during the first decades of the twentieth century, as well as the problematic relationship that these artists had with their own modernity. As Ciarán Benson said in his article on Irish Modernism, 'the artist's role was the Romantic one of seer in solidarity with his people ... The artist's job was to create images which best represented the idea of what it was to be *truly* Irish.'[9] As well as a dependence on the landscape and people of the West as subjects, the 'national realist' school also depended heavily on traditional modes of representation, as seen in the illustrations to the *Saorstát Éireann Irish Free State Official Handbook* produced in 1932 to commemorate ten years of the new state, largely illustrated with picturesque landscapes, medieval metalwork and pages from illuminated manuscripts.[10] The first letter of each chapter was also illustrated as a terminal letter in the manner of the illuminated manuscripts produced by artists such as Sean O'Sullivan and Maurice MacGonigal. This approach was thorough enough that the letter O starting the chapter on the Shannon Scheme was based on one of the Siemens industrial photographs, but was re-framed as a woodcut for Irish consumption (see Fig. 6).[11]

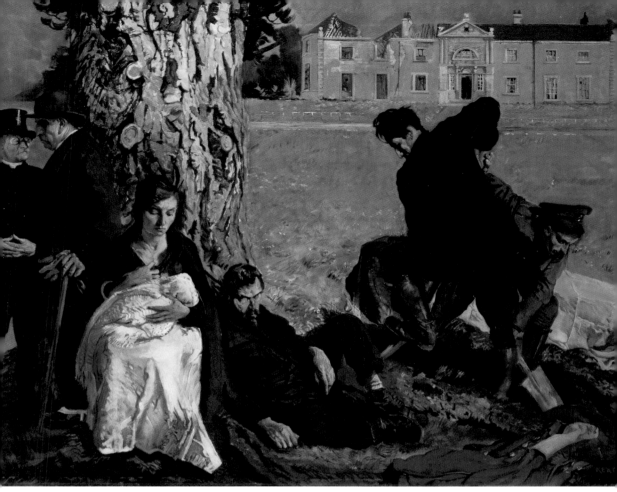

Figure 77 Seán Keating, *An Allegory*, oil on canvas, 102 by 130 cm, 1924. (Photograph courtesy of and © National Gallery of Ireland Presented, Friends of the National Collections of Ireland, 1952 / Image courtesy of DACS 2017 © Estate of Seán Keating.)

Painters such as Paul Henry had developed an oeuvre influenced by French *plein air* artists, which depicted 'noble peasants' at work, often digging for potatoes or hauling in fishing boats, notable for their romanticised depiction of subsistence agriculture.[12] The irony of such a focus on agricultural labour was that it excluded the largest labour force on the western seaboard, that of Limerick city, the third largest industrial centre in the new Free State. The major port at the mouth of the Shannon, Limerick, was a major processing centre for the agricultural products of the co-operative farms of the Golden Vale and the location of numerous strikes and the short-lived Limerick

Soviet of 1919.[13] It seems that Limerick as a location of industrial labour was generally ignored by the artists of Irish Ireland, as it was too industrialised to function within their imagining of the 'true, rural Ireland', despite its location in the West.

Seán Keating: politics, passion and heavy machinery

Few Irish artists of the early twentieth century are as discussed and debated as Seán Keating, whose influence was felt in both the art world itself and that of art education. Later the President of the Royal Hibernian Academy (RHA), he spent much of the 1920s creating controversial paintings with a political edge, while teaching in the Dublin Metropolitan School of Art. His involvement with the Shannon Scheme has been discussed by several eminent historians of Irish art, generally focusing on his allegorical painting *Night's Candles are Burnt Out* (1929) and a minor dispute about whether or not his Shannon Scheme paintings were produced on commission for the ESB.[14] He has been used repeatedly as an exemplar of the realist Irish artist discussed above, frequently contrasted with early abstract Modernists such as Mainie Jellet, who had returned from France in the early 1920s having trained with Cubists Lhote and Gleizes.[15] Although Keating was later described as 'a virulent anti-Modernist' and the opponent of 'every manifestation of modernism', it seems that he was only against Modernist stylistic use of abstraction, rather than being totally against the condition of modernity, a rather different proposition.[16] From a historiographical point of view, this extended focus on his position within later debates on Irish art has a tendency to accentuate his later views on High Modernism and the International Style, and to neglect the subtleties of his earlier paintings, particularly his landscapes.

Seán Keating, known for much of his early life as John Keating, was a Limerick native who attended the Dublin Metropolitan School of Art on a scholarship during the early 1910s, where he was heavily influenced by the Anglo-Irish portrait and later war painter Sir William Orpen.[17] Keating was a prolific painter, who exhibited regularly with the Royal Hibernian Academy from 1915 until his death in 1977 and worked as a teacher of painting at the Dublin Metropolitan School of Art from 1919 onwards.[18] Although many of his works were composed from sketches or from life, his technical approach

was unusually modern, particularly his use of photography and film cameras to capture poses which he would later develop into fully fledged paintings.[19] Despite this use of recorded images for compositional purposes, he remained a resolute draughtsman, retaining a thorough appreciation of the technical skill of drawing throughout his life.[20] Keating had a perpetual admiration for skill of any sort, which tied in with his respect for the craft of drawing.[21]

There is no doubt that Keating, in his early years particularly, had a very well-developed political sensibility and he was at the forefront of the efforts to create a self-consciously 'national' school of art in Ireland, reacting to and addressing the political issues of the day.[22] His work in the 1910s and early 1920s self-consciously constructed images of the fighters of the War of Independence as national heroes, and he has been described as almost 'the official artist of the Irish Free State', despite his only officially commissioned state art work coming two decades later.[23] Keating was also notable as a 'provocateur' for a number of articles on art published during the 1920s and 1930s, and his 1924 article 'The Slave Mind of Ireland' castigated the people of Ireland for their slowness in throwing off the psychological aspects of colonisation.[24]

This passionate embrace of a specifically rural interpretation of Irish national identity can also be seen in his 1922 painting *An Allegory*, which was first exhibited in the 1925 Royal Hibernian Academy show (see Fig. 77).[25] Keating uses an allegorical approach, composing a tableau in which every person has a symbolic meaning, which is not always interpreted in the same way.[26] He arranged six figures in the foreground of the painting, against the backdrop of a ruined 'Big House', symbolising not just literal property destruction, but the destruction of Ireland's Anglo-Irish inheritance. The two men on the right are the putative brothers, dressed in the uniforms of the opposing sides of the Civil War, working together to dig a grave for a tricolour-covered coffin, critiquing both sides of the Civil War in their wanton destruction of the very thing they fought for. The central couple symbolise the effect on the common people of Ireland: the mother with child and dispirited father. It is particularly significant that the father figure here is a self-portrait of Keating himself, whose accusing stare is the only figure looking out at the viewer.[27] The final two figures are those of a priest, twiddling his thumbs, and a suited man standing with his back to the rest of the tableau, a figure which can be interpreted as representing the additional failure of church and business

to support the Irish family.[28] The overall impression is one of Keating's anger and disillusionment at the internecine conflict of the Civil War and it has been described by his son Justin Keating as 'a very angry painting' and 'a ferocious denunciation of brother killing brother'.[29]

In addition to these deeply held nationalist beliefs, Keating's early interest in the Limerick docks seems to have sparked another aspect of his political idealism, holding political views which were decidedly on the left. His wife May was a friend of and had worked as secretary to Hanna Sheehy-Skeffington, suffragette and union organiser, and both women were members of the USSR Society (or Friends of the Soviet Union), a politically radical group in Dublin.[30] Although Keating does not seem to have been as radical as his wife, he is described by his son Justin as holding distinctly left-wing views throughout the period under discussion, which is supported by his call for an Irish 'Five Year Plan' in his 'Talk on the Future of Irish Art'.[31] Keating seems to have seen the emphasis on hard work and physical achievement of socialist

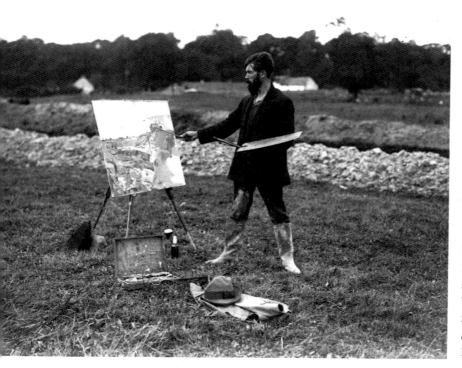

Figure 78 Photograph of Seán Keating painting 'Excavator at work. Lubecker with Stone Wagon and Wagon Train' at the Shannon Scheme excavations, c.1926. (Image © RTÉ Stills Library 0506-042.)

reorganisation, not only as a parallel to his own personal craftsmanlike ethos, but as a way to extricate his country from an otherwise inevitable decline.[32] His work has resonances with Soviet realism, particularly in his depiction of heroic allegorical figures representing different aspects of the national struggle and he is described by Bielenberg as 'the most powerful visual propagandist of the new regime'.[33] Indeed, Keating and his contemporaries are described by Barrett as 'crypto–socialist–realists' and by Kennedy as 'socialist realist', although for Keating, the national aspect of his work always seems to have been of the greatest importance.[34]

Keating's fascination with machinery and heavy engineering equipment provided him with an alternative to the atmosphere of despair and decline

Figure 79 Seán Keating, *Night's Candles are Burnt Out*, oil on canvas, 1929. (Image courtesy of Gallery Oldham © Estate of Seán Keating / DACS 2017.)

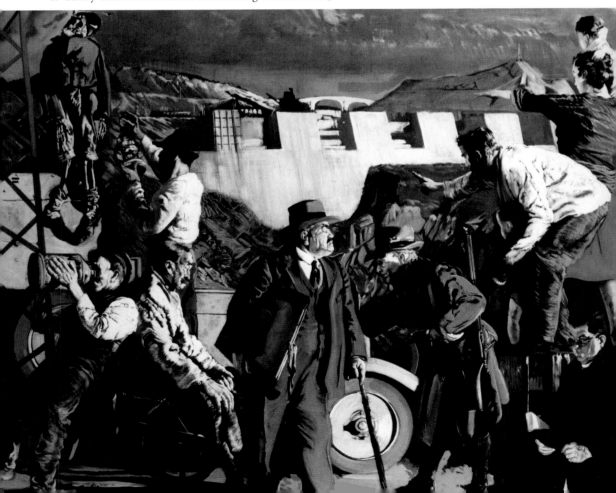

after the Civil War, and led him to the enormous construction site going up outside his home town and some unlikely additions to his growing collection of new Free State heroes.[35] He recognised the national importance of the Scheme from two perspectives: that of providing national inspiration to a disillusioned country, as well as the practical provision of much needed work, seeing the project as an Irish equivalent of the Russian Five Year Plan.[36] Despite several descriptions of Keating's Shannon Scheme work as a commission, the impetus for the project came directly from the artist himself, rather than from the Government or the ESB.[37] He managed to visit the Scheme on a number of occasions during the DMSA summer breaks and spent at least two weeks during the summer of 1926 living in the barracks with the workmen, setting up his easel at different points around the site to paint or sketch in a manner later compared by his son Michael to a freelance photographer documenting a project.[38] He is reported to have changed from paint to charcoal or pencil depending on the weather and he frequently had to repair to a large skip during heavy rain or ongoing blasting operations. One (possibly staged) photograph of him on the Scheme shows him working on a large canvas, while wearing wellington boots due to the poor terrain (see Fig. 78).[39] He also took a number of photographs and short clips with a cine camera, in order to capture scenes for later development in his studio, some of which are shown in his grandson's documentary film *Sean Keating: Where Do I Begin?*[40] This visit to the Scheme produced some twenty sketches in oil, watercolours and charcoal, which were reported to form the basis of a series of thirty large oil paintings, although he exhibited a mere three oil landscape paintings and three drawings of the power station site in the Royal Hibernian Academy of 1927.[41] He returned to the Scheme that summer, with the intention of working on a second series, although he only showed two further drawings of machinery in the RHA exhibition in 1928.[42] He then worked on the large allegorical canvasses, including *Night's Candles are Burnt Out* and *Der Übermann*, in his Dublin studio, which were not exhibited until 1929.[43] The majority of these works were purchased by the ESB in the mid-1930s, possibly at the instigation of Laurence Kettle, who was an ESB Board member by this time.[44] Keating's paintings of the Shannon Scheme were certainly not unknown to the Government in the late 1920s, as witnessed by a letter from Keating to Thomas Bodkin written in January 1927, which

invited Bodkin to a viewing of his Shannon work in his college rooms along with President Cosgrave and 'some of the ministers and others interested in the Shannon Scheme', who may have included Patrick McGilligan and Thomas McLaughlin.[45] This meeting predates formation of the ESB, as well as the 1928 exhibition of his landscape paintings at the RHA and the 1931 purchase of *Night's Candles are Burnt Out* by Gallery Oldham in the UK, but his Shannon Scheme paintings and drawings were in circulation for some years before gradually being purchased by the ESB.[46] Other drawings have also appeared for sale from private collections in recent years, which suggests that the ESB did not purchase every single work relating to the Scheme, but rather a representative selection.[47]

The best known of his Shannon Scheme paintings, *Night's Candles are Burnt Out* is a powerful allegorical composition which has been discussed at length by numerous art historians, both in terms of its depiction of Keating's hopes for the new Irish state and as a symbol of his status as the semi-official artist of the Irish Free State (see Fig. 79).[48] The canvas depicts the same cast of characters as *An Allegory*, but in radically different circumstances. Instead of the ruin of Ireland Past, the backdrop to this allegory is the monolithic sight of the half-built power house at Ardnacrusha, based on one of the oil sketches Keating had previously made on site around August or September 1927 (see Fig. 80).[49] The theme of creation, rather than destruction, pervades the painting, with the central figure grasping a drawing portfolio under his arm and the revitalised Keating family on the right pointing out the power house works and the future of light, in poses reminiscent of socialist realist paintings.[50] The relative positions and demeanour of the 'characters' from *An Allegory* have radically changed – one gunman is only present as a skeleton and the other now bows to his suited companion, who has variously been identified as a businessman or an engineer. The portfolio of technical drawings makes it more likely that this figure is actually an engineer, although given the nationalist tone of the painting and his suit (including fedora and two-tone shoes), he is more likely to be Irish than German. Regardless, he symbolised Keating's view of the increased importance of hard work and technical skill in the reconstruction of the new state, compared to the previous priority of the military. As both Bhreathnach-Lynch and Bielenberg point out, the earlier noble peasants and stoic gunmen have been superseded by a new class of hero – those of the

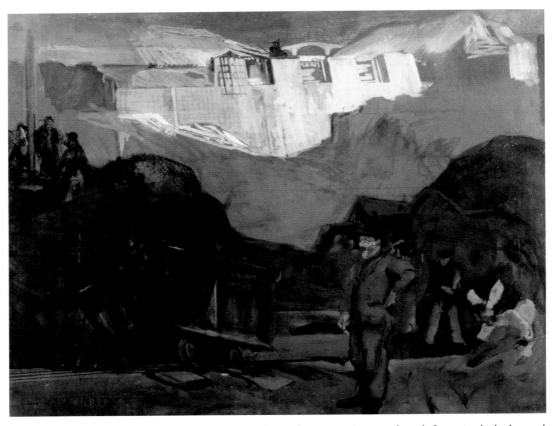

Figure 80 Seán Keating, *View of Dam from Power Station side with figures in the background*, oil on canvas, August or September 1927. (Image courtesy of the ESB Archives © Estate of Seán Keating / DACS 2017.)

engineer and entrepreneur, figures dedicated to creation and construction.[51] On the other hand, the priest is now marginalised, sitting reading by candle-light at the bottom right of the painting, seemingly oblivious to all that is going on around him. Keating's use of lighting as metaphor emphasised this irrelevance, with the priest's candle and the oil-lamp being removed from the derrick by a labourer, both superseded by electric light from the Shannon Scheme, a metaphorical version of Romeo's new dawn.[52] The three labourers are new additions to Keating's cast, who represented the effort and labour of Irishmen going into the construction of this Scheme, albeit currently *not*

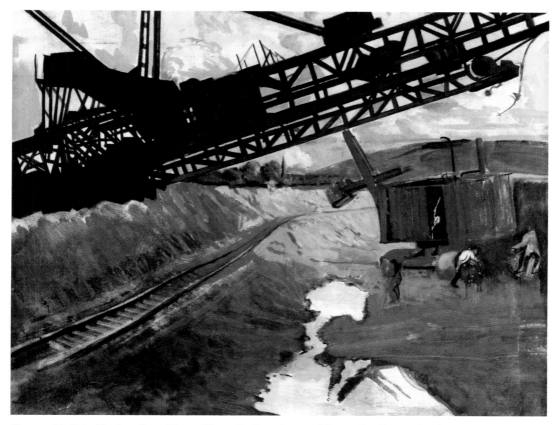

Figure 81 Seán Keating, *Site of Power House, Drilling Gang and Steam Shovel at Work*, oil on canvas, 1926 or 1927. (Image courtesy of the ESB Archives © Estate of Seán Keating / DACS 2017.)

working while they drink, rest and take down the oil lamp of the past. Partly due to Keating's theatrical staging of a disparate group of characters, which included the unlikely presence of small children on a construction site, it can also be read as a pause in the labour to take stock and consider the work in progress.

Keating seems to have spent a large amount of time talking to both Irish and German engineers on the Scheme and had been infected with their enthusiasm for the project, producing a positive statement of the possibilities of 1929 compared to his dispirited outlook of 1922. The painting did not

provoke a coherent critical response, with a variety of interpretations ranging from a celebration of 'the coming of electricity and a new day' in the *Irish Times*, to the *Irish Independent*, which missed the connection between candle, oil lamp and the title of the painting and saw it as 'bitterly satirical', with the family pointing out 'with angry insistence, the ravages of the mountain side'.[53] This 'problem picture' was also interpreted by London critics during its exhibition in the Royal Academy as a satire on German involvement in the Scheme, as well a direct attack on Britain, with the assumption that the skeleton represented the British Army. This was vehemently denied by Keating, who provided a different explanation: 'The allegory represents the dawn of a new Ireland, and the death of the stage Irishman, who is seen hanging on one of the power standards in the corner of the picture.'[54]

In contrast to his tightly staged allegories, Keating's landscapes of the Shannon Scheme are composed on a much larger scale. They comprise the majority of his paintings of the Shannon Scheme, but they have been almost ignored by art historians in favour of his allegorical works.[55] However, the landscape paintings in that collection follow the same pattern of loosely painted impressions of large pieces of excavation equipment in the muddy landscape of a construction site, carried out in a subdued palette and not always finished, bearing a striking resemblance to Orpen's landscape paintings of the First World War.[56] However, Keating's are landscapes of construction, rather than desolation, with a slapdash energy derived from both his style of working and the changeable conditions on the site, with drawings occasionally appearing on the reverse of canvasses.[57]

The unsigned painting *Site of Power House – Drilling Gang and Steam Shovel at Work* depicts a steam shovel on its caterpillar tracks attended by three workers, while an Absetzer spreading machine looms overhead (see Fig. 81).[58] From the position of the Absetzer, it is possible that it was being winched into place, as its function was to transport the rubble and earth from the excavators to a wagon train. The painting could have been produced during either of Keating's visits to the Scheme, as these machines were in constant use throughout both summers. Keating's fascination with machinery is responsible for the consideration of German construction machinery as a subject for an Irish painter, although there is no attempt here to provide any overt allegorical symbolism for the viewer. Instead, we are shown the work being carried

out by enormous pieces of machinery, which loom in the middle ground of a desolate landscape. The precious Irish countryside has been stripped away, layer by layer, to reveal levels and platforms of mud and earth, with only a small glimpse of the archetypal green landscape in the far distance. The majority of Keating's Shannon Scheme landscapes follow this pattern, with the traditional West of Ireland landscape being forcibly moulded into something new. The lack of sentimentality towards the landscape is striking, particularly when compared to Keating's emotional treatment of the same topic in his allegorical paintings, and the composition is often haphazard and unpolished. There are few human figures in these paintings, with some totally depopulated, whilst others featured anonymous groups of workmen in the foreground or background, such as the three workers in front of the steam shovel in this painting or the anonymous figures in the foreground of

Figure 82 George Atkinson, *Il Ponte Vecchio*, Florence, etching, 25.4cm x 30.5cm, 1914. (Image courtesy of Dublin City Gallery, The Hugh Lane: Reg. 415.)

View of Dam (see Fig. 80). There, a loosely rendered worker stands by a rock wagon with a hand on his hip, while the background is populated with even sketchier groups of workers. Most of the detail in the painting is actually in the power house concrete works in the background, presumably for later use as the backdrop to *Night's Candles*. It is this move of focus away from the detailed human figure that led a contemporary critic writing in *The Irish Times* to judge that: 'Mr. Keating's style is hardly suitable for that kind of work. His Shannon studies lack that decisive approach which is so characteristic of his figure paintings, making one feel that he is wasting his time in County Limerick.'[59] Such criticism may have been what prompted Keating to return to allegorical figures for his later exhibited paintings of the Scheme, which did end up having a much larger circulation. The landscape paintings represent a detour from the main trajectory of his portrait work, driven by his interest in the epochal nature of the Shannon Scheme. Keating is quoted by both his sons, Justin and Michael, as being fascinated by machinery, and Michael (who became an engineer himself) recounts bedtime stories about the technical challenges of the project garnered from the engineers on site, as well as the careful depiction of current engineering practice in his work. Keating is also reported to have been impressed by the work ethic and consideration for technique of the German workers, particularly when compared to his own approach to creative work and contrasted with that of the Irish workers on the Scheme.[60] It is apparent from the landscape paintings that Keating was struggling to depict his hopes for his country using an unfamiliar visual language, particularly in the hope that construction and engineering could bring a sense of positivity and progress to the new state. Justin Keating pointed out that it is the machines which are heroic in the landscape paintings, rather than the people.[61] Although his visual vocabulary was concerned specifically with 'the machine', Keating clearly saw the transformative power of modern technology, both from a practical point of view and as an epochal symbol for the modernisation of the nation in the future. Although the details of this future are never really worked out, it is implicit in both his overtly allegorical work, and in his machine landscapes, all of which show Ireland at a point of transformation, in the process of moving from one state to the next.

Bearing in mind Keating's sensitivity towards the political climate of progress, or at least aspiration towards it, in the late 1920s, it should not be

surprising that he has been considered by numerous art historians and critics to be a central propagandist for the Cumann na nGaedheal Government.[62] This view has been supported by the fact that the majority of his Shannon Scheme pictures have spent the last seventy years in the hands of a semi-state body set up by that Government. However, it is only on examination of the historical facts in recent years that it has emerged that the Shannon Scheme work was not actually a government commission, set up along the lines of work emanating from Soviet Russia during the same period, but an independent project carried out by an artist in his own working time.[63] Considering the implicit desire evident in Keating's allegorical paintings to record and memorialise what he considered to be a monumental event in the history of the country, it should be no surprise that the senior staff of the ESB, who certainly held a similar view of their own undertaking, would find the funds to purchase such work, even if they were not able to purchase it on its initial completion.[64] It is only with the passage of time and the passing of the events of the late 1920s into history that Keating's work has become considered to be the 'official' record of the Scheme, an irony that would not have been lost on Keating himself.

George Atkinson: civic responsibility and the academic landscape

Despite the notoriety surrounding Keating's paintings of the Shannon Scheme, he was the best known but not the only artist to produce work on the subject of the Shannon Scheme in the late 1920s. Irish printmaker George Atkinson (1880–1941), the headmaster of the Dublin Metropolitan School of Art, also produced a small series of etchings based on the Scheme. Atkinson came from a very different background, training and politics to Keating, and his work on the Scheme represents an entirely different aspect of the Irish art world of the late 1920s, one which has not been discussed nearly as exhaustively as the more colourful Keating's.

Atkinson also trained at the DMSA in the 1890s, and then attended the Royal College of Art (RCA) in London to develop his practice in etching, mezzotint and typography.[65] His long career in Dublin art education started with teaching hours in the Metropolitan School of Art in 1902, and he had

179

progressed to headmaster by 1918, later becoming the first director when the School became the National College of Art in 1936.[66] Atkinson is best known for his role as a central proponent of art education in Ireland in the early years of the twentieth century, particularly promoting the South Kensington system of teaching.[67] His tireless efforts kept the School running throughout the First World War, the War of Independence and the Civil War, and he managed to ensure continued funding from successive government departments with little conception of the requirements of an art school.[68] Art collector, lawyer and critic Thomas Bodkin described him in 1924 as someone who: 'has made an extensive study of methods and theories of art training, is an admirable organiser and possesses the rare qualification, eminently desirable in the management of a large school, of being a practitioner of many arts.'[69] He is particularly noted for his encouragement of the early design disciplines in the School of Art, very much informed by his training at the RCA, and sought to improve the quality and level of work being carried out in the area of 'cultivated ornament' in an Irish context.[70] This was reinforced by a number of his own projects, which included the 1923 commission of the official Cenotaph for deceased revolutionaries Michael Collins and Arthur Griffith outside Dáil Éireann, which took the form of a Neo-Celtic cross.[71] He was also heavily involved in the organisation of the *Aonach Tailteann* art competition in 1924, part of a self-conscious effort to encourage the development of an identifiable Irish style in Irish art, both fine and decorative.[72] His continual work on the development and promotion of Irish art can be seen from his involvement with the Royal Hibernian Academy and several prominent galleries, as well as numerous public lectures in the 1920s on the need for the improvement of Irish artistic standards.[73] Atkinson was forever thinking of the wider civic good, working to develop and promote both the fine and decorative arts in Ireland, and to form a 'bridgehead' between the older generation of academicians and the younger artists.[74]

All this activity in the service of the arts in Ireland seems to have left Atkinson, by the 1920s, with a decreasing amount of time for his own printmaking practice. Despite plaudits as 'a brilliant engraver' and 'accomplished etcher', as well as praise for reintroducing the technically difficult print form of mezzotint to Ireland, his artistic production dropped off dramatically after his appointment as headmaster of the DMSA in 1918 and he had not

exhibited at the Royal Hibernian Academy since 1923.[75] His exhibited works included a small number of painted portraits and etched book–plates, but mainly consisted of etchings and mezzotints of Irish and Italian landscapes, ranging from the Dublin Mountains to the palazzos of Venice.[76] The small 1914 etching *Il Ponte Vecchio, Florence* depicted the eponymous bridge in the lower half of the composition, finely delineated in strong sunlight; a typical example of his work from this period (see Fig. 82).[77] The composition is notable for having all the detail of the bridge in the lower half of the image, with the top half dedicated to a delicate study of billowing clouds, pierced by rays of sunshine. The tonal effects in the sky and water, as well as the shadowed buildings, are created by the careful patterning of parallel and interlocking lines and the overall effect is of a restrained study of a historic structure,

Figure 83 George Atkinson, *Shannon Scheme – Keeper Mountain*, etching on paper, 35cm by 41.5cm, *c.*1926/7. (Image courtesy of and © Crawford Art Gallery Collection, Cork: 277-PR.)

carried out in the academic tradition of romantic landscapes.[78] The use of etching provided much more of a technical challenge than a watercolour or drawing, showcasing the artist's technical skill, something which Atkinson considered to be hugely important.[79] Both technique and attitude were entirely consistent with Atkinson's South Kensington training, which was also a mainstay of the teaching at the Metropolitan School of Art for the first half of the twentieth century. It was this approach to art education which brought Atkinson and Keating to opposite sides of a conflict in the School in 1927, when a hugely critical report by French experts (precipitated by Keating) had recommended the dismissal of Atkinson and a large proportion of his staff, ironically including Keating himself.[80] Their shared respect for the acquisition and practice of technical skill, both in artistic and in general terms, was not enough to overcome their fundamental differences in approach and aesthetic.

Given these circumstances and his interest in romantic rural landscapes, the fact that George Atkinson also visited the Shannon Scheme site in the late 1920s is somewhat unexpected, although its timing in relation to the French Report may not be coincidence.[81] He produced three artist proof etchings of the Shannon Scheme, which were exhibited both together and separately at a number of venues in Dublin and London between 1927 and 1933, overlapping with the period and venues at which Keating's Shannon Scheme paintings were also on display.[82] There is no record of *The Excavations* or *The Culvert* being exhibited after 1933, and all three are now in the collection of the Crawford Art Gallery in Cork.[83] Based on internal evidence in the prints, Atkinson visited the Scheme in July or August 1926 when he drew the culverting of the Blackwater River in *The Culvert* and again around May 1927 when he drew the foundation excavations for the power house in *The Excavations*.[84] Due to the nature of the canal construction works, *Keeper Mountain* could have been sketched on either visit, although it is likely to be the earlier, given that the canal banks are graded, but not gravelled.[85]

Keeper Mountain focused on a section of the canal works, showing a head race canal bank under construction, with a small flow of water at the bottom and a bucket dredger and bucket chain excavator silhouetted on the horizon (see Fig. 83). The title refers to Keeper Hill in the distance, which is located in County Tipperary and can be seen from some sections of the head race. It is a rather desolate scene, devoid of any human habitation. Unlike Keating's

paintings, Atkinson treated machinery as an element in the landscape, rather than the focus of the image, concentrating instead on the bank of the canal. He rendered the lumps and bumps of the earthen bank using careful techniques of line work, so that the density of line built up a picture of light and shade. The image is constructed so that this bank and its delicate line work make up the bottom two thirds of the image, with the right bank with its fringe of trees receding into the vanishing point of the composition, focusing the eye on the eponymous 'mountain'. The sky is rendered in a carefully detailed treatment of line, not dissimilar to that of the *Ponte Vecchio* in Fig. 82. Unlike Keating's dynamic compositions, the print depicted a still, empty, somewhat oppressive landscape, which showcased Atkinson's considerable skill with line and his adherence to the conventions of academic landscapes.

The Excavations was created in a similar manner to *Keeper Mountain*, with a detailed study of the earthworks in the foreground receding into the distant countryside in the background, although here the horizon remained below the middle of the frame (see Fig. 84). The majority of the detail is focused on the lower half of the print, with the cable crane and four steam plumes outlined against a lightly rendered sky. The start of the metal formwork for the power house foundations sits in a muddy, confused landscape, all of which is again depicted through the skilful use of etched line. The bucket dredger on the right is still treated as a landscape element, not unlike the pit heads of nineteenth-century British industrial landscapes.[86] It is this print which garnered the most critical interest when it was exhibited with other Irish art in Brussels in 1930, as part of a concerted effort by the Irish Government to promote Irish art abroad.[87] An *Irish Independent* reviewer singled it out from Atkinson's other prints (two of the Shannon Scheme and one of the Rialto Bridge in Venice) to describe it as 'excellently worked out in detail', 'a splendid and comprehensive view of the scheme' giving 'a clear idea of the magnitude and nature of the works', indicating the public thirst for images of the Scheme.[88]

The Culvert is a rather more emphatically composed image, compared to the other prints, dominated by the foreshortened cylinder of the concrete culvert of the Blackwater river, with foreground earth and pipes rendered in a detailed, observant fashion (see Fig. 85). This observant gaze is extended to the texture of the culvert itself, as well as the scaffolding and the activity of a work

Figure 84 George Atkinson, *Shannon Scheme – The Excavations*, etching on paper, 50.2 x 64.4 cm, *c.*1927. (Image courtesy of and © Crawford Art Gallery Collection, Cork: 3027-PR.)

gang in the background, under a crumpled cloudy sky. The sky, particularly, is more densely rendered than usual, looking more like a creased fabric than the airy depictions of his other prints. Atkinson's careful line work details the organised chaos of a building site, using an architectural treatment for the culvert and using the workmen as scaling elements in the distance. Unlike the other two prints, these workmen do represent an element of movement and work being carried out, although they are relegated to a very minor position compared to the culvert itself.

The subject of all three prints is very much the landscape itself, with no heroic workers or overt political statements. They represent a more academic approach to the industrial landscape, but without Scheuritzel's very German

Figure 85 George Atkinson, *Shannon Scheme – The Culvert*, etching on paper, 45.5 x 50.4 cm, *c.*1926. (Image courtesy of and © Crawford Art Gallery Collection, Cork: 3026-PR.)

cultural celebration of technology and construction. They sit within a British tradition of landscape conventions applied to the industrial world, although any attempt to render the Scheme in a picturesque manner is undercut by the large-scale dreariness of the muddy landscapes. However, the very fact that Atkinson considered the Scheme important to be the subject of his return to printmaking from his institutional and organisational duties says something about his commitment to the new Ireland being shaped out of this muddy landscape.[89] His profile as the headmaster of the Metropolitan School of Art ensured that he could exhibit them extensively, and they played a role

in representing a quiet, unheroic but skilled Ireland abroad. These prints represent, in their own quiet, understated way, his civic commitment to the creation of a new Ireland in the late 1920s, as well as the role of the artist in this new state.

Brigid O'Brien Ganly: student work

In addition to the exhibited work of Keating and Atkinson, one of their students at the Metropolitan School of Art also visited the Scheme in the late 1920s. At this time, Rosaleen Brigid O'Brien (later known under her married name as Brigid Ganly) was an art student in her late teens, taking classes with Keating, Patrick Tuohy and Oliver Sheppard.[90] From an Anglo-Irish family of nationalists and artists, her father Dermod O'Brien was a noted landscape and portrait painter and president of the Royal Hibernian Academy.[91] Along with the rest of their family, they were both fixtures on the Dublin society circuit, attending balls and functions on a regular basis, alongside luminaries such as W.B. Yeats, Ministers McGilligan and Blythe, Gordon Campbell, Lennox Robinson, George Atkinson and Thomas Bodkin.[92] Having grown up in Cahermoyle House in west Limerick, O'Brien's family moved to Dublin in 1920, but retained strong family connections with Limerick.[93]

O'Brien had started as a day student at the Dublin Metropolitan School of Art in October 1925, at the age of sixteen, and attended for two full years until July 1927, before her return in November 1928 for a further year and her election to the RHA.[94] She continued to attend both day and evening classes at the DMSA from 1929 to 1933, alongside painting classes at the RHA Schools, while starting her long career of public exhibition at the RHA, the Water Colour Society of Ireland and the Oireachtas Art exhibitions.[95] She had shown promise in sculpture in her final year at the DMSA, winning the Taylor Scholarship for a male nude in 1929, but as a product of Atkinson's South Kensington influenced system, she also produced murals, designs for Cuala Industries embroideries, and illustrations for children's books by her uncle Conor O'Brien and her friend Sheila Pym in the late 1920s and early 1930s.[96] Her marriage to playwright Andrew Ganly seems to have curtailed the scope of her design work, if not her painting, and she was better known in her later years as a painter of portraits and still lifes.[97] Taught directly by

Keating in the late 1920s and early 1930s, she later expressed her high opinion of his drafting abilities and enthusiasm, if not his painting skills.[98]

The circumstances of O'Brien's visit to the Shannon Scheme are unclear, although she was not attending the DMSA in the 1927–8 academic year, and she was more than sufficiently well-connected to organise permits prior to the official opening of the Scheme to visitors in June 1928.[99] She exhibited a number of paintings of Cassis in the south of France at the RHA exhibitions of April 1928 and 1929, so she may have spent at least part of the previous winter in France with her family, but it is not inconceivable that the 20-year-old O'Brien may have stayed in Limerick and visited the Shannon Scheme site

Figure 86 Brigid O'Brien (Ganly), *Ardnacrusha Power Station under Construction*, watercolour, 1928. (This image is reproduced courtesy of the National Library of Ireland: PD 4258 TF.)

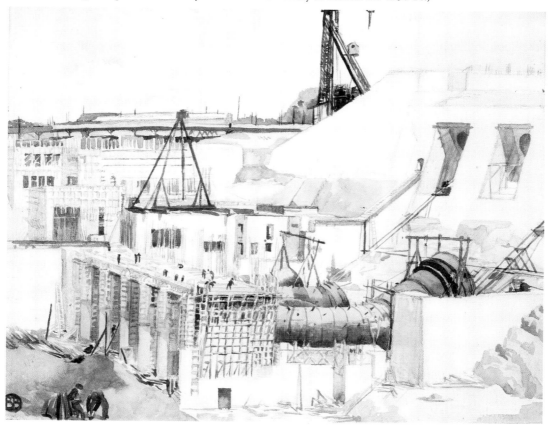

amid the constant newspaper coverage and stream of tour buses leaving the Strand for the construction site.[100] Both her headmaster Atkinson and tutor Keating had exhibited work on the Shannon Scheme in the two previous RHA shows, which the art student daughter of the RHA President would have been unlikely to miss.[101]

The two small watercolour drawings which have survived from O'Brien's visit to the Scheme – detailed studies carried out mostly in shades of blue and ochre – represent the only images of the Shannon Scheme known to be produced by a woman, significant for a project dominated by male engineers, photographers and artists. The first is a study of the construction of the turbine hall foundations, with half-built penstocks, and can be firmly dated to early July 1928 based on the progress of the works (see Fig. 86).[102] It shows the construction works in full sun, with the shadows on the bright concrete picked out in blue, and the ochre used for the metal of the penstocks, wooden formwork and the surrounding earth. It depicts a much more ordered scene than Keating's landscape paintings, with the rectangular structures of the turbine hall and control building foundations clad in gridded wooden formwork and stepping away from the viewer past the monolith of the intake building. It is similar to Atkinson's etchings, however, in its attention to precisely observed detail, even though it is unlikely that O'Brien would have had the technical knowledge to understand the actual function of cable cranes and the mechanics of pouring concrete. Its treatment of figures owes more to Atkinson than to Keating, with a number of tiny figures scattered over the power house foundation. The close observation, however, is also applied to the workmen in the bottom left-hand corner, who, rather than being relegated to ciphers, are depicted in motion, with one figure on the bottom left caught in the act of reaching down, perhaps to pick up something by his feet or tie a shoe lace.

The second watercolour shares the same colour palette, but depicts the canal construction on a cloudier day (see Fig. 87). This attention to weather and to skies in particular has been picked out as a feature of O'Brien's landscape work, and it effects the whole tone of the drawing.[103] Without the bright reflective concrete surfaces of the power station building, it is a somewhat darker scene, but retains a similar liveliness and energy. It depicts part of the canal construction work, with the caterpillar track base of a bucket excavator

or dredger in the foreground, and another bucket dredger in the background, along with the wooden forms for constructing one of the bridges, possibly at Clonlara in April 1928.[104] The heaped banks of the canal are rendered in a looser hand, as is the machinery and equipment, with the canal banks receding to a vanishing point on the right, making liberal use of landscape conventions. Again, the sky is rendered with some energy, and the workmen surrounding and climbing on the machinery base form elements within the landscape, rather than any detailed emphasis on an idealised worker.

In some ways, these two watercolours show the development from messy, mucky chaos, to precisely rendered construction that can also be seen in the much longer-term production of the Siemens industrial photographs. There is no more romanticisation of the landscape here than in O'Brien's paintings of France or Dublin, and little overt involvement in the dialogue of nationalism, other than the choice of subject. While the power house watercolour shows the influence of Atkinson's work, the canal drawing acknowledges a debt to Orpen, translated through the 'technical solidity and … decent craftsmanship' of Keating and her other young teachers at the DMSA.[105] At the age of twenty and still an art student, it is not surprising that O'Brien's work shows these formative influences clearly, exhibiting 'the academic virtues of solid draughtsmanship and practiced, unshowy technique' which would become characteristic of her later work.[106] There is no firm record that these watercolours were publicly exhibited in the 1920s, as both were acquired from the artist's estate in the mid-2000s.[107]

Keating, Atkinson, O'Brien: capturing technology at work in the West of Ireland

The artwork discussed in this chapter demonstrates the ability of three Irish artists to produce different representations of the same construction site, based on their individual interests, skills and background. Despite the fact that all three artists visited the Shannon Scheme site around the same time period, the work discussed represents their responses to and interpretations of the highly technological project under construction in the Irish countryside. While Keating produced highly passionate, personal allegories of the Irish political situation, as well as a series of paintings and drawings echoing the vigorous reconstruction

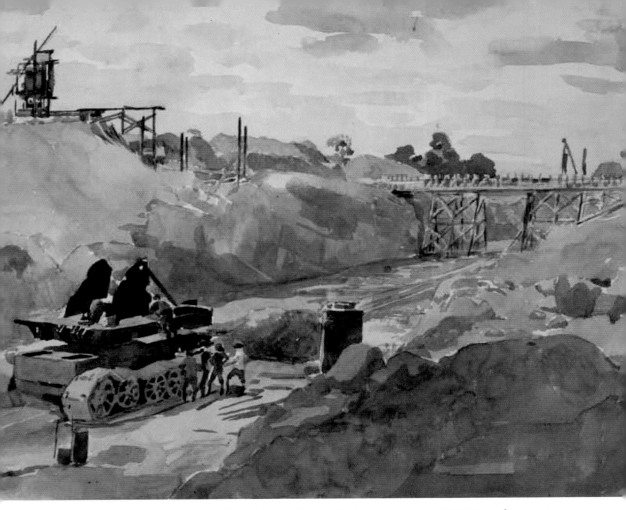

Figure 87 Brigid (O'Brien) Ganly, *Ard Na Crusha*, watercolour, *c.*1928. (Image from a private collection. Photograph courtesy of Whyte's and Sons Auctioneers.)

of his native soil, Atkinson responded in a more measured fashion. Atkinson continually promoted the role of the Irish artist in Irish society, supporting and advocating for Irish art and artists, regardless of stylistic or personal differences, and he shared Keating's sense of the importance of the Shannon Scheme to the new nation, enough to make it the centrepiece of his return to practice in the late 1920s. This tied in with his promotion of the printmaker as an artist in his own right, rather than purely as a way to distribute copies of paintings, with a clear sense of the technical possibilities of the medium.

Both Keating and Atkinson were exhibiting in Dublin galleries throughout

the late 1920s, as well as representing Ireland abroad, and they encountered a large number of artistic hopefuls as part of their teaching practice at the Metropolitan School of Art. Although O'Brien possessed advantages of both talent and family connections that would have set her apart from the 'finishing school' female art students grumbled about by Keating, she was at such an early stage in her career as a professional artist that it is not surprising that the influence of her teachers can be clearly seen in her Shannon Scheme drawings.[108] These teachers were almost exclusively older men, contemporaries of her father, at a time when women were not expected to pursue professional careers past marriage. The fact that the 20-year-old O'Brien managed to visit the Shannon Scheme site in 1928, whether through privileged personal connections or not, demonstrates a rare curiosity and wish to experiment with new topics. It may not have been overtly politically motivated, but the fact that the art school student managed to follow her teachers down to this 'nation building' site is significant in itself, as the Shannon Scheme had sufficiently captured the Irish imagination that a young artist was inspired by this subject matter, despite radical differences in the technical subject from the majority of Irish art work at that time and her own subsequent oeuvre.

There are a number of common themes between all three sets of artwork, as both the technological nature and Western site of the project attracted Irish artists to it. The essentialist myth of the West of Ireland and the role of traditional depictions of landscape are influential in the work of all three Irish artists, although Keating seems to have been responding more directly to the first, and Atkinson and O'Brien more directly to the second. Keating's strongest work remains focused on his energetic portrayal of the human figure and his allegorical paintings remain the most distinctive representation of physical labour on the Shannon Scheme, influenced both by his leftist Limerick position and his depiction of different sections of Irish society. His landscape paintings are less sure, continuing to use similar methods and techniques, but attempting to transfer his expressive, gestural style to the representation of machinery and equipment. Partly due to his extensive use of oil paint, his Shannon Scheme landscapes lack the detailed quality of the other two artists, who were working in print and watercolour. Both Atkinson and O'Brien share the ability to present more precise, detailed images of industrial construction, despite their lack of technical understanding of the actual machinery and

processes involved, with Atkinson in particular incorporating them into his detailed study of the landscape itself. Atkinson's interest in the Scheme seems to have come from his sense of civic duty to the new Ireland and Irish art, as well as a challenge to his professional position, while O'Brien was still at an impressionable age, influenced by her teachers and father's contemporaries to work on a topic very different from her own mature work.

All three artists demonstrate an interest in the depiction of industrial skill and technique, even if they don't clearly understand the specifics of the technology itself. This is evident both in the particular subject matter of a construction site, and in their differing approaches to the skill and craft of producing paintings, prints and drawings. All three seem to have had an appreciation for technique, or *Technik*, the way in which something can be created out of raw materials. All of the artists can be considered modern, in the sense that they were engaging with the modern world and modern topics, but it is important to note that all three were working from positions which rejected avant-garde Modernist experiments current in Europe in the late 1920s.[109]

Despite this rejection of aesthetic Modernism, all three artists, in their choice to produce artwork in the late 1920s on the Shannon Scheme, demonstrated a consciousness of the epochal nature of the project and its importance for the positioning of the new Ireland in the modern world. Keating, with his purposefully allegorical paintings, worked with the purpose of commemoration of the enterprise on the Shannon as a landmark for future generations, as well as a milestone of achievement in their own time. Atkinson, too, was concerned enough to return to active printmaking in order to document and commemorate this work of the new Free State, and O'Brien to use her personal connections to organise a visit or visits to the site, which is unusual both as a woman and as a student, although not as a member of the Dublin intelligentsia. The fact that all three artists produced and exhibited work based on the Shannon Scheme in the late 1920s meant that it was legitimised as a suitable 'Irish' topic within the Irish art establishment, which had substantial overlaps with that of politics, literature and the theatre. The appearance of artwork on the topic in the rarefied world of the Royal Hibernian Academy, the Oireachteas exhibitions and other 'national' exhibition venues meant that it was absorbed into the canon of suitable topics of Irish high culture,

moving the coverage of the Scheme out of the realm of popular culture of such as newspapers and letters, into discussions in the salons and exhibition halls of the new State. The focus of the artwork does not form a coherent response from a single background to the Shannon Scheme, but ranges from Keating's overtly political allegories to Atkinson's careful landscapes, followed by O'Brien's impressionable watercolours.

However, to return to the statement by Justin Keating at the start of the chapter, it is important to look carefully at this range of images, at both the landscape and the workers, as different influences on the artists propelled them towards different focuses: the body of the worker is well represented in Keating's allegorical paintings, along with that of the engineer, but dwindles in significance in the landscape paintings by all three artists. This switch of focus away from the heroic worker can be seen as a result of the scale of the work carried out on the Clare landscape, where the worker was literally dwarfed by the enormous size of the site, both around the power house and along the canals. As the worker was reduced in significance, the existing conventions of landscape representation came to the fore, as the artists struggled to capture such a large undertaking. However, the worker never quite disappeared from these landscapes, but moved through and around the changing countryside and can still be seen as a dynamic force, directing and controlling the machinery and equipment, as well as the changes in the landscape itself. The shift of focus away from the workers themselves to the equipment they operated and the effects of that equipment on the landscape of the West of Ireland reflects the contemporary shift of emphasis from manual hand work to mechanised work, which encouraged a wider focus and framing of images. All three artists clearly recognised the potential of the Shannon Scheme as important to the development of the new State, worth including in the remit of legitimate subjects for Irish art, even if their different approaches reflected the variety of styles and priorities of the Irish art world of the time.

9

Official Recognition:
The Commemorative Stamp

All concerned in this vast undertaking, which we can see to-day in almost its permanent shape, may well be proud of its successful progress. The country, too, will always take pride in the magnificent installation created by such arduous labour, so much skill in conception, and such tenacity in execution. It has been demonstrated in this convincing visible form that Saorstat Eireann can carry out, rapidly, efficiently and economically, a Hydro-Electric Scheme on a scale as large as any in Europe. Thereby has been laid a firm foundation for confidence, both at home and abroad, in our capacity to realise those economic developments of wide national scope and effect to which we all look forward.[1]

The idea of the Shannon Scheme as a great Irish project was emphasised in 1930 with the issue of a commemorative stamp by the Department of Posts and Telegraphs, roughly a year after the power station went into operation. The completed power station had been officially switched on by President Cosgrave in a ceremony in July 1929 and from October 1929 had been providing power to a slowly expanding backbone network across much of the country.[2] The official ceremony had included an official blessing by the Catholic

Bishop of Killaloe Dr Fogarty, ensuring the place of the Shannon Scheme as an undertaking approved by both Church and State.[3]

Stamps are part of a set of national symbols which any new nation-state is expected to acquire, to assert its legitimacy in the eyes of both its own citizens and the wider world. While flags and anthems are the focus of much ritualistic behaviour, it is the small, generally unconsidered items like coins and stamps which become part of the everyday lives of the citizens and play an important role in reinforcing national identity, which W.B. Yeats famously referred to as 'the silent ambassadors of national taste'.[4] The images carried on these tokens have very strong emotional associations for the citizens of a state, not least because of their connection with historical continuity, with the Free

Figure 88 Various artists, first definitive series of stamps, Irish Free State, 1922. (Image courtesy of An Post and the author.)

State definitive stamps issued in December 1922 purposefully marshalling antiquarian and political symbols such as shamrocks, Celtic crosses and the four heraldic provinces of Ireland, along with territorial assertions to the entire island of Ireland in order to legitimise the essentialist pedigree of the new State (see Fig. 88).[5]

Producing the Shannon Scheme commemorative stamp

Despite the remarkably fast production of the definitive stamps within a year of independence, the first Free State Government only issued three commemorative stamps during its ten-year tenure up to 1932.[6] The other two commemoratives issued during this decade were both for anniversaries: the 1929 centennial of Catholic Emancipation and the 1931 bicentennial of the Royal Dublin Society (RDS). Both stamps were designed by Irish academic artists (including George Atkinson), depicting a portrait of Daniel O'Connell for Catholic Emancipation and a rural 'Irish' labourer representing the ambiguous 'Royal' status of the RDS, rather than by any sort of 'British' urbanised science.[7] The early Free State stamps emphasise the state as agrarian, Catholic and Gaelic, with religious or rural images predominating and a definite lack of English language text, with the only Roman font used for clerical Latin.[8] Despite these overtly nationalistic visual messages, Irish stamps in this period were still actually reliant on colonial production infrastructure, with the original drawings transferred onto printing plates at the Royal Mint in London, and then printed in Dublin Castle on English paper by a printer on secondment from the Mint.[9]

Very little information about the commissioning process for the Shannon Scheme stamp has survived, but given the high proportion of early-twentieth-century Irish stamps which resulted from requests from organisations outside the Department of Posts and Telegraphs, it is entirely possible that the project was initiated by the ESB Publicity Department. Commemorative editions were seen as an unnecessary financial drain on the State, rather than as an opportunity for the formation or shaping of opinion.[10] The initial system of open competition had been abandoned after the 1922 definitive series, due to the large number of low-quality designs submitted, and subsequent stamp designs were commissioned straight from the artist by the Department of Posts and Telegraphs selection committees.[11] As late as 1942, the Department of

Figure 89 Edward Louis Lawrenson, *The Wooden Plough*, oil on canvas, 62.5 x 75 cms, *c.*1910s. (Image courtesy of Private Collection / Photo © The Maas Gallery, London / Bridgeman Images MAA619283.)

Posts and Telegraphs was being criticised for not organising 'a committee of people of taste and technical knowledge and a competition open to the world', although it was also commented that 'it is arguable that stamps should really only be designed by highly-trained engravers'.[12] The earlier issues of the Irish Free State were described in the 1960s as being 'designed purely for postal use, [paying] scant attention to potential philatelic revenue up till now'.[13]

The pool of Irish printmakers sufficiently experienced for the typographic technique of stamp printing was rather small and the choice of Anglo-Irish artist Edward Louis Lawrenson was probably based on his skill with and knowledge of printmaking techniques, as well as his interest in landscapes.[14] Particularly noted for his experimentation with coloured aquatints, Lawrenson was a well-known academic printmaker and a regular exhibitor at both the Royal Academy in London and the Royal Hibernian Academy, where he had shown a range of romantic compositions and Sussex landscapes (see Fig. 89).[15] After the Civil War, the subject of his prints changed to West of Ireland landscapes and his work was included in the exhibition of Irish Art shown in Brussels in 1930 that included one of Atkinson's views of the Shannon Scheme.[16] Newspaper coverage shows that the stamp was announced to the public in late June 1930, in conjunction with a proposed ceremony to celebrate the official handing-over of the Scheme to the ESB.[17] This ceremony was later cancelled, most likely for financial reasons, and the stamp was issued on 15 October of the same year, somewhat delayed by the discovery of a defect in the lettering which required the plate to be remade before production started.[18]

The large rectangular stamp itself is a departure from previous Free State issues, using agate, a shade of brown, an earthy, wholesome colour rather at odds with the industrial subject (see Fig 90).[19] Rather than the usual portrayal of the power house shown in the photographs and advertisements, Lawrenson drew the weir building, where the head race is diverted from the Shannon. The repetitive concrete forms of the sluice-gate flanges march across the stamp, which also clearly depicts the much-contested flat roofs that were eventually built on the weir complex. This departure seems to have confused a number of commentators, as the stamp is variously described as showing 'the great Power House of Ardnacrusha', 'a general view of the power station and weir' and 'the Shannon power house at Ardnacrusha', despite the fact that it doesn't show the power house at all.[20]

The image itself has been created with very fine detail, particularly in the use of line to depict the texture of the water, the clouds and the canal bank on the bottom left. Lawrenson's knowledge of typographic techniques were particularly pertinent here, as the typograph process is based on the use of rather thick line, rather than any sort of shaded image, and would have

required a familiarity with the quirks of the medium to provide the best-quality image once the original drawing was scaled down to the size of a stamp.[21] The image itself emphasised the modern technical construction of the weir, but was framed by the text necessary to turn an engraving into a stamp, and which told a very different story. Stamp design almost always includes the name of the country and the value of the stamp, bolstered here by the descriptive caption 'Forbairt Chomhacht na Sionainne', which translates into English as 'Shannon Power Development'.[22] The fact that all of the text, including the country name, was in the Irish language and set in an insular uncial font based on medieval Irish illuminated manuscripts, made a very strong statement of Irish cultural nationalism, overlying and laying claim to the more modern visual interpretation of the weir.[23] It also served as a linkage to the other Irish stamps in use in 1930, symbolically drawing the Shannon Scheme into the visual schema of a Gaelic Ireland.

Circulating the Shannon Scheme

The release of the Shannon Scheme stamp was an important moment in the representation of the Scheme, as it demonstrated a willingness by the Free State Government to include the Scheme in the official pantheon of icons of the new state. Although the commemorative stamp was only circulated from October 1930 to February 1931, the inclusion of this overtly modern Scheme on the everyday correspondence of the citizens of the State served to naturalise it as a legitimate symbol of the state, as well as signalling that Pearse's aspirational 'harnessing of the rivers' was becoming a reality and that the Irish Free State was taking her place amongst the nations.[24] The view of the Scheme is similar in some ways to the early ESB advertisements, with no humans in sight, giving the impression that this construction has sprung up by itself. Although the seemingly autonomous eruption of the Scheme in the advertisements had the effect of presenting a technological sublime, this is negated by the tiny scale of the stamp, a mere 4 by 2.4cm. This miniaturising of the 'mighty project' tamed it and brought it under control, particularly the unfamiliar Modernist edifice of the weir building surrounded by the Irish language set in an uncial typeface. By its inclusion of an untroubled river landscape, this stamp could also represent the end of the period of physical and metaphorical upheaval of the 1920s, with

the hard work over and the epochal place of both power station and nation assured.

It is also important that the Shannon Scheme stamp was circulated within the postal system, as it involves the stamp in the system of posted artefacts, whereby the act of posting pins the object to a specific place and time: 'I was here on this day' (see Fig. 91). This would have made the stamp more meaningful to the individuals who used it to create their own biography, both the person posting it and the one receiving. That the letter was posted using a commemorative rather than a definitive stamp would have added another layer of importance to its significance, as an individual biography was tied to a larger national event of significance, as well as to the larger imagined nation.[25]

Stamp collecting

Susan Pearce discusses how artefacts can become 'set apart' from their original mundane uses, and moved from the everyday world to the almost sacred, special place of the collection, where the sacrifice of their mundane usage allows them to dwell in a kind of object afterlife: 'They are wrenched out of their own true contexts and become dead to their living time and space in order that they may be given an immortality within the collection.'[26] In this manner, the collected object is only sustained by the conscious preservation by the collector, with its symbolic role hugely outweighing any remaining physical function. It is this creation of value and meaning which drives different types of collector, allowing them to assign and perpetuate abstract connotations about themselves or the world around them, turning their collection of stamps into 'reified thoughts and feelings'.[27]

The collected object can be divided into two different types: the souvenir and the collectible. These are not mutually exclusive categories, as one example of a stamp may be posted on a letter or postcard from Limerick and act as a souvenir, while another may have been bought as part of a set and put straight into an album and function as a collectible, as above. The souvenir is much more personal, as the postcard or letter sent by a friend, or a statue bought at a tourist site, carries with it the memory of the original visit or the absent friend, which can be revisited in the present by the owner. Souvenirs are very personal to the owner and may not have anything like the

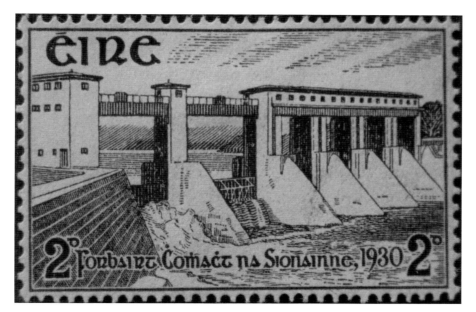

Figure 90 Edward Louis Lawrenson, 'Shannon Power Development', 2p stamp commemorating the completion of the Shannon Scheme, Irish Free State, 15 October 1930. (Image courtesy of An Post and the author.)

Figure 91 Shannon Scheme first day cover, 15 October 1930. (Image courtesy of David Feldman Stamp Auctions and An Post.)

same significance to another person, as the feelings which they evoke in the present build on the experience with which they were originally connected. Their close association with memory means that they become signifiers of 'origin stories', where beginnings are told and retold in an attempt to create a narrative of self.[28] They are particularly good at creating associations of the 'authentic' experience in the human desire for authenticity, a central part of the experience of the modernised world.

The role of the souvenir in internalising external experiences and places plays a very important role in the distribution and popularity of Shannon Scheme commemorative stamps, as they allow the owner to internalise the Scheme and assign it personal significance. Moving a place such as the Shannon Scheme from the realm of the nationally important to the personally important was an important step in creating a strong feeling about the Scheme among the population of Ireland and was largely dependent on the ability of that population to visit the site during the late 1920s and early 1930s. This is particularly significant in the use of the stamp as souvenir, particularly in the transformation of mass-produced images into personal possessions and 'memory texts', without individuals necessarily having visited the site in person.[29]

The Shannon Scheme First Day Cover (FDC) in Fig. 91 was posted and watermarked in Dublin and also sent to an address in Dublin, but the effort of creating a First Day Cover on the initial day of the stamp's sale means that its very inclusion in the collection of Irish stamps marks it out as an important souvenir of the Scheme and part of the imagined nation of Ireland. However, after its sale at public auction in 2011, it functions as a collectible, as it was part of a larger album containing Irish Free State stamps dating from 1922 to 1966, presumably collected by the Holy Ghost Father Revd P.J. O'Shea named on the FDC.[30] This album contains a presentation folder for the collection of Irish stamps given to the delegates of the Postal Union Congress in 1924, which cements the owner as a serious philatelic collector.[31] The role of the album in stamp collecting is central to the politics of collecting, whereby what gets collected can be read as indicative of cultural power and ideology among a specific population.[32] Collecting choices are more restricted than in the photographic album, where there is always the opportunity to make more of your own images, rather than relying on state apparatus to issue stamps and

change over time – in 1988, Rickards considered printed souvenirs to be on the borderline of ephemera[5] but, by 2000, they are included in the definition of ephemera as: 'manuscript and printed matter, records of the past and present (both humble and prestigious), items designed to be thrown away (bus tickets) and to be kept (cigarette cards), and documents of considerable importance (at least to the individual concerned) through to the most trivial.'[6] The value of ephemera lies in this very transience: the fact that things like bus tickets are not really expected to survive gives them an attraction to collectors, as they feel that they are protecting a fragile piece of the past, saving a vulnerable object from destruction.[7] Because each piece of ephemera relates to a specific time and place, that of its creation and use, it is seen by collectors to provide a direct, if tiny, connection to that past, particularly to the everyday and the mundane texture of life in a historical period.[8] Of course, ephemera also allow for a great deal of romanticisation, as each tiny piece makes up the fabric of a lived experience and allows the collector to dream about what that specific bus journey in 1910 was like, or what it might have been like to be on that holiday in 1930 and to pick out a postcard to send to a loved one. The very materiality

ADAIR ABBEY & RIVER, LIMERICK.

Figure 92 Valentine postcard, 'Adair [*sic*] Abbey & River, Limerick', late 1920s. (Image courtesy of Limerick City Museum: 1991.0070.)

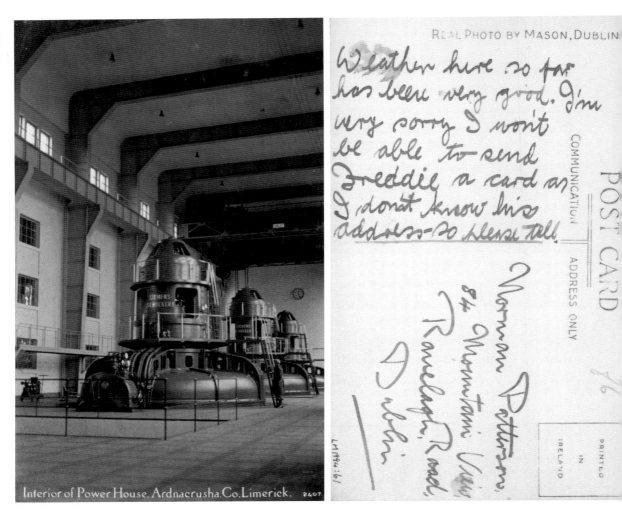

Figure 93 Mason, 'Interior of Power House, Ardnacrusha, Co. Limerick', 'Real Photo' postcard, front and reverse, early 1930s. (Image courtesy of Limerick City Museum: 1994.0061.)

of the object allows a consideration of the texture of everyday life in a way which political histories cannot, which is one reason why the study of ephemera is very useful in building up a picture of the unheroic and ordinary aspects of the past.[9] Ephemeral objects are also particularly useful because they are generally produced without a conscious consideration of their role as historical documents. Although this may be more true of some types of ephemera than others (e.g. archery scorecards are literally intended only to last for a day, whereas cigarette cards have an implicit role as collectibles, regardless of whether specific

POWERING THE NATION

examples actually do get collected or not) this lack of historical consciousness is obvious when compared to a medium like history painting, which has a definite conscious intent and consideration of how the subject and composition may be considered in the very long term, something which also applies to more self-conscious forms such as commemorative stamps.[10] In this way, ephemera are an important element of the condition of modernity, where tickets, receipts and short notes on postcards form a level of brief, speedy communication as part of the fast pace and anonymous nature of the modern world.

Souvenirs and collectibles

The role of ephemera, such as postcards, continues well after their original purpose has ended. These types of ephemera tend to be kept as souvenirs, or to be collected as part of a set, whether this is to be connected to the type of object or the place of origin. In contrast to the collection of souvenirs from visits to particular locations, the fetishistic collection is focused on the creation of meaning through the acquisition of ordered sets, rather than through a connection with a personal life history.[11] This type of collecting is particularly associated with album-based collectors, where the albums provide a ready-made ordering device, which also functions to highlight the blank spaces in the collection, which the collector then feels pressurised to fill. The emphasis here is on two different feelings, neither of which is particularly connected with the origin of the artefact, or the collector, for that matter. One is the thrill of the chase, or hunting for that rare example to fill in the last blank spot, while the other is associated with the longer-term satisfaction of having created a full set, ordered, understood and controlled, in a way which large parts of people's personal experience is not. It is the symbolic structure of this long-term meaning which can be shared by large numbers of people, and is particularly important to the museum collection, with its associations with definitiveness.[12] It is involved in the recognition of systems of knowledge and the classification of that knowledge, where the original use value or personal narratives are almost totally lost in favour of meaning created by the location within the collection.[13]

Souvenir and collectible: commercial picture postcards

The history of the picture postcard has also been intertwined with the act of marking a particular time and place through the postal system, although in this case it is much more closely related to tourism and the act of visiting a place outside the normal routine. Theories about the development of the picture postcard link it to Victorian illustrated stationery, court cards and German advertising cards, but all agree that by the end of the nineteenth century the European postal system was groaning under the weight of millions of postcards being sent from place to place. The production of the picture postcard as souvenir seems to have developed mostly in the German-speaking world, with German printers and publishers developing the novelty and souvenir aspects of the postcard, going far past its original use as a speedy format for communicating short messages.[14] The connection with travel and sightseeing became much more important during this period, linking in with the development of foreign travel as an affordable holiday for the middle-classes, with very early 'greetings from' (or 'grussaus') cards being issued in German-speaking countries from the 1890s.[15] Commercial companies in Germany printed souvenir postcards of tourist sights, famous buildings and special events in an increasingly large geographical area, experimenting with colour printing from the late 1890s. The craze for sending postcards was facilitated by the penny post in Britain and by similarly priced postage in other countries, as well as by the international efforts of the Universal Postal Union.[16]

This wide spread of the picture postcard was responsible for a significant development of the photograph as a common everyday item. This is particularly evident in the use of photographs of particularly scenic or historical places on postcards from the late nineteenth century, through which the visit of the tourist to the place was often marked by the purchase and possibly the posting of a related postcard. MacCannell discusses the mechanism by which the tourist sight (or site) is marked off, framed and enshrined in a photograph, professional or otherwise, but this process is carried further by the mechanical reproduction of the professional photograph into a postcard, which could then be sent out into the world, in order to represent the sight.[17] Picture postcards of a tourist site also work as markers for the site itself, guiding visitors to experience the location in a particular way, positioning it politically

and culturally as well as geographically.[18] They also act as collectibles, in some cases, although the lack of records kept by postcard manufacturers means that the possibility of completing a set was harder than with stamp collecting, where issues are carefully recorded by governmental sanction.

Although this chapter is looking at postcards and cigarette cards, both of which are fairly self-conscious types of ephemera, the particular circumstances in which they were produced in Ireland in the late 1920s and early 1930s mean that the examples discussed are not as self-conscious in their representation of Irishness as many later examples, carrying none of the intentional construction of a particular view of Irishness that typified post-War postcards produced by John Hinde, for example.[19] That is not to say that these examples are devoid of intentional strategies of representation, but that those strategies were much more firmly aimed at a contemporary audience, rather than at the possible collectors of future times. They functioned as a less official representation of the nation, reinforcing the landscape element of national identity and visualising the nation in rather literal terms. Postcards encouraged the assumption that the sender and receiver are sharing a 'moment' together, looking at the same scene, although Esther Milne points out that picture postcards are mostly mass manufactured and highly mediated, so the sender is choosing a pre-packaged 'moment', rather than making one of their own.[20] Like Schor's postcards of Paris, which show a neat, uncrowded city where only picturesque types of work are carried out, the Ireland of picture postcards, even in the 1920s, was a scenic, fertile country full of castles and abbeys, untroubled by any sights that would disrupt the romantic tourist vision (see Fig. 92).[21]

Shannon Scheme postcards

The production of picture postcards in Ireland in the late 1920s was very similar to that in the rest of the British Isles, with a small number of big publishers such as Valentine & Sons of Dundee being balanced by smaller Irish producers like Eason & Son and Mason, as well as large numbers of tiny issues by photographers, stationers, chemists and other local businesses. The Shannon Scheme was an obvious subject for reproduction, particularly considering the large numbers of people visiting the Scheme on organised tours. Postcard manufacturers are notorious for not keeping records of their issues, but a

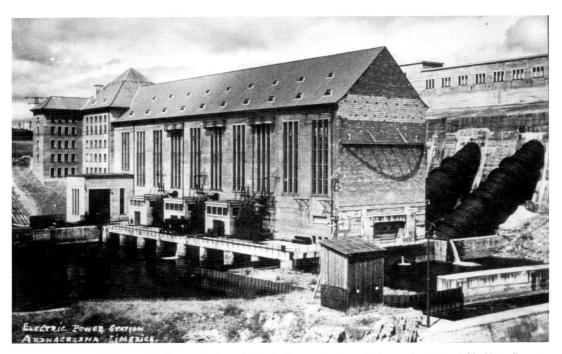

Figure 94 Eason & Son, 'Electric Power Station, Ardnacrusha, Limerick', 'Signal' series postcard, early 1930s. (Image courtesy of Limerick City Museum: 1995.0049.)

number of publishers, both British and Irish, were producing postcards of the Scheme in the very late 1920s and early 1930s.[22] These postcards are based on a number of different photographs, mostly exterior and aerial shots of the Scheme, which seem to have been taken by each company's own photographers. The majority of the postcards are printed using the technique of photogravure, which involves transferring the image onto a printing plate and using that to create a large number of prints. However, some are 'Real Photo' cards, which were direct photographic prints from the negative.[23]

The 'Real Photo' postcards were issued by both Mason and Eason & Son in an attempt to create a more directly 'truthful' representation of the Scheme, using the label of 'real' photographs to emphasise the direct reproduction of the scene through the camera and negative, directly onto the postcards themselves. The Dublin company of Thomas J. Mason had been an opticians and instrument makers since 1779, but branched out into the publication

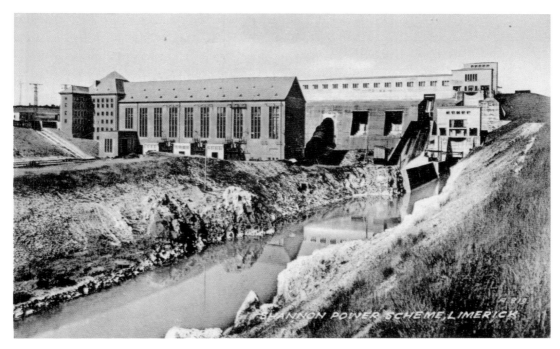

Figure 95 Valentine postcard, 'Shannon Power Scheme, Limerick', late 1920s. (Image courtesy of Limerick City Museum: 2000.0045.)

of postcards in 1931 (the company is still in existence as Mason Technology, laboratory equipment makers).[24] Many of the photographs were taken by the head of the company at the time, Thomas Mason, who had been amassing photographs of Irish historical, archaeological and ornithological interest since the late nineteenth century, some of which were later published as a book of photographs of Irish islands.[25] Mason was considered an expert photographer, receiving a membership of the Royal Irish Academy, despite his lack of formal training.[26] The Mason postcards seem to have been taken in the early 1930s, which ties in with the lifespan of the Mason postcard business, which operated from 1931 until silver shortages during the Second World War made it unviable.[27] Unusually for commercial postcards, these include an interior shot of the turbine hall, which emphasises the repeated rhythmic forms of the generators (see Fig. 93). It depicts an affinity for high technology unsurprising in someone embedded in the production of technological equipment.

The 'Signal' series of postcards was issued by Eason & Son, which had started life as an Irish subsidiary of W.H. Smith in the 1850s. Charles Eason, its Irish manager, took over in 1886 and developed the company into the existing chain of bookshops, newsagents and stationers.[28] The 'Signal' series was produced from 1905 onwards, and Eason also provided a service for the printing of postcards by the thousand for smaller companies and individuals within ten or twelve weeks of order.[29] Two Signal postcards both show the same image, a photograph of the power house complex taken from the east bank of the tail race, with and without a white border on the card (see Fig. 94). This image also seems to have been taken in the very early 1930s, judging from the finished state of the complex and the level of vegetation on the bank, and seems to have been composed to show off the turbine hall, with the ship lift and fish pass outside the composition.

The largest number of postcards was printed by Valentine & Sons, a Scottish firm specialising in greeting cards and illustrated envelopes, founded in Dundee in the 1840s. Valentine moved into postcard production in 1895 and opened a Dublin office in 1905. By 1914, the company had fifty machines printing postcards and had developed a reputation for the high quality of their photographic images, as well as being one of the main publishers of cards for small local concerns.[30] Six different images of the Shannon Scheme were reproduced on Valentine postcards, with one wide shot of the power house from the tail race being reproduced in black and white, sepia and retouched colour (see Fig. 95). The colour postcards are described as 'Collo colour' on the back, which refers to the German invention of collotype colour printing which Valentine had been using since 1895.[31] The walls of the power house building and parts of the intake building in Fig. 101 have been tinted to a strong shade of orange, presumably to look like brickwork, rather than the grey concrete that it actually is. This 'enhancing' of the station buildings is part of a long-standing postcard tradition of retouching photographs of tourist sights for increased aesthetic effect, a practice which later culminated in the virulent colouring of John Hinde's Irish postcards of the 1950s.[32] It also has the effect of creating a rather luridly coloured vision of the Shannon Scheme in order to make it more attractive as a tourist sight, and to emphasise, by inference, its national importance. The retouching of the building to faux brick could also be read as an attempt by Scottish Valentine to naturalise the

Scheme into a more familiar British material, despite the lengthy discussions of the architects about the relationship of the grey concrete to traditional Irish stone buildings.

Only a small number of the commercial postcards which were in circulation after the completion of the Shannon Scheme were ever posted, with many kept by collectors as part of a larger collection, such as that of Ernest Bennis, Limerick local historian, whose amateur photographs of the Scheme have been discussed previously.[33] Some of these played more of a souvenir role, such as the Mason postcard bearing a message about a lost postal address on the back (see Fig. 93). This inclusion of postcards depicting the Shannon Scheme in a collection of local historical material clearly places them as 'authentic artefacts', described by Pearce as legitimate for amateur collecting.[34] It is also positioning the postcard as a marker of intimacy between the sender and receiver, however separated in space and time they may be, so that they become more individual and personal, and better souvenirs.[35]

Collectibles: T.C. Carroll postcards

The production of views of the Shannon Scheme for purchase as a set in the late 1920s puts the postcard representation of the Shannon Scheme firmly into the category of the collectible, rather than the souvenir, in this case. These postcards were first produced by Siemens in sets of twelve, based on their industrial photographs taken during 1926 and 1927. It seems that they were issued in two sets of twelve, all labelled 'Siemens BauUnion G.m.B.H. KommGes. Limerick Ireland'. However, it seems that Siemens quickly moved away from issuing the postcards themselves, as Limerick stationer T.C. Carroll & Sons began the very successful sale of sets of eighteen Shannon Scheme postcards in 1928. These postcard sets reused a small number of the Siemens photographs (seven out of twenty-three different images) and were sold in two sets priced one shilling and sixpence in 1928 and 1929, the latter along with a promotional booklet explaining 'this Stupendous Undertaking', which was available for one shilling, or one shilling and twopence by post (see Fig. 96).

The postcards are all photogravure and each collection also holds a different decorative envelope, each of which seems to have held a random collection of cards, suggesting that different selections of postcards may have

Figure 96 T.C. Carroll & Sons, advertisement for Shannon Scheme booklet and postcards, *Limerick Leader*, May 1928 and June 1929. (Image courtesy of the National Library of Ireland and the *Limerick Leader*.)

been issued at different times.[36] The layout of the envelopes differs radically from the postcards inside, presenting rather conservative typeset layouts, with six different font faces in use, as well as a decorative border (see Fig. 97). The organisation of the postcards into randomised sets was obviously intended to function as part of a collection, as the buyer was encouraged to buy more envelopes of postcards, with the intention of creating a full set.[37]

The images on the postcards are taken from the Siemens industrial photographs, which were presumably endorsed by Siemens Ireland as a promotional device within Ireland.[38] They represent a wide range of photographs of the Scheme, from the early stages of canal construction in 1926 to the works in a state of completion in November 1929.[39] The majority of the photographs used are exterior photographs of the works, as well as photographs of the various types of canal-building machinery imported by Siemens-BauUnion (see Fig. 98 for example set of eighteen). From an aesthetic point of view, they do not present a particularly bright or appealing

Figure 97 T.C. Carroll & Sons, envelope for postcards of Shannon Scheme Views, 1929. (Image courtesy of the ESB Archives: PG.SS.PC.46.)

set of images, compared to other postcards of the time. Their value comes from their inclusion in a collectible set, as well as their commemorative connection to a specific historical moment. They portray a determinedly modern view of the Scheme, not shying away from depicting unglamorous swathes of mud and large pieces of industrial machinery, from bank builders to rock crushers, as well as numerous views of half-built buildings sitting in the middle of what is obviously a building site, which are typical of the broad exterior landscapes of the earlier Siemens photographs. These postcards may have been collected by the more technically-minded population of Ireland, but they seem to have been one of the more popular sets of collectible postcards of the day, based on the numbers donated to Irish archives and museums.[40] There are none of the more artistically Modernist composed shots of the interior of the building here, as the emphasis is on the spectacular nature of the construction work. The emphasis on machinery and equipment may seem an unusual subject for collectible postcards, but the Irish population (particularly those visiting

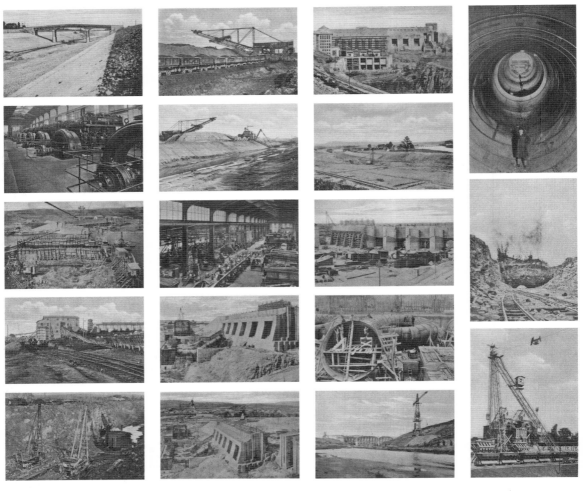

Figure 98 T.C. Carroll & Sons, collection of 18 Shannon Scheme Views, 1928. (Images courtesy of the ESB Archives: PG.SS.PC.4, 6-12, 18-19, 23, 25, 32, 37, 40, 42, 44 & 45.)

the Limerick area) would have been already familiar with the idea of the Shannon Scheme as a national monument and collected the postcards as a way of remembering this project of national importance. The dominance of machinery and sophisticated building forms in these postcards represent another view of the technological sublime, representing the awe and admiration for the project. This is particularly important because these postcards give the impression that the giant forms of the power station and weir were being

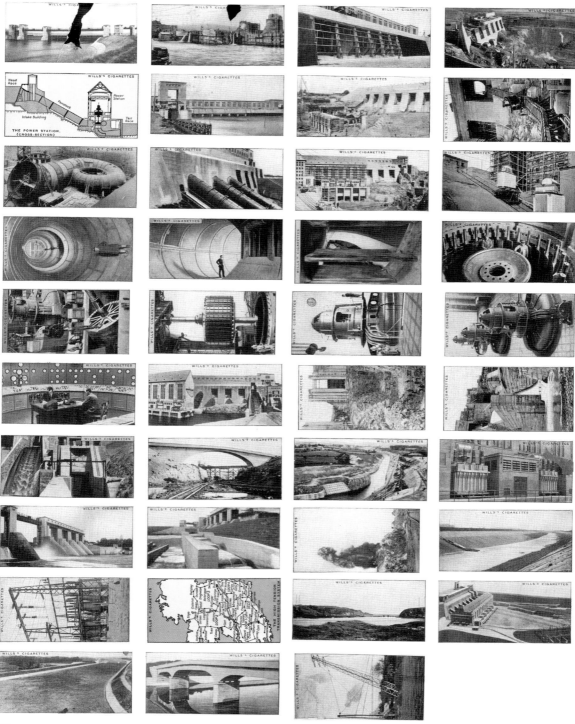

Figure 99 W.D. & H.O. Wills, 'Shannon Electric Power Scheme' cigarette card set, 1930. (Images courtesy of the ESB Archives.)

constructed by this machinery, rather than by the hand of human workers, who only appear as minute figures. This is partly an effect of the scaling down of the Siemens photographs, so that figures which were dominated by the technology in a 10" by 12" photographic print were reduced to insignificance in a picture postcard.

Collectibles: Shannon Scheme cigarette cards

The history of cigarette cards is even more tied up with the history of collecting than that of postcards, as these were some of the first types of printed ephemera produced specifically to be collected. They originated in the United States in the late nineteenth century as cardboard stiffeners for paper packets of cigarettes, which were initially just blank cardboard. By the 1880s, these stiffeners were being printed with advertisements for other tobacco products, which quickly developed into images of educational interest, complete with short edifying essays on the back. They flourished in fits and starts up until the 1960s, with interruptions to production caused by wartime paper shortages. By the heyday of the cards in the 1920s, tobacco companies were employing staffs of artists, writers and printers to produce the cards, which had developed a reputation for providing accurate snippets of general knowledge to the cigarette-smoking public.[41] The production of cigarette cards in Britain was started by an American company Allen & Ginter in 1875, and the expansion of the American Duke company into the British market prompted a short Tobacco War, which ended in the creation of the Imperial Tobacco Company conglomerate in 1905, which controlled cigarette production in Britain, due to the imposition of import tax on foreign (particularly American) brands.[42] By the late 1920s, companies such as Wills and Player had reintroduced cigarette cards in their products and interest in collecting them had prompted collector Colonel Bagnall to start up the London Cigarette Card Company, in order to facilitate trade in these specific ephemera; the organisation became a limited company in 1931.[43] The largest shareholder in the Imperial Tobacco Company, W.D. & H.O. Wills, had set up a manufacturing facility in Dublin in 1922, in order to service the Free State market. Wills produced a number of series of Irish interest (e.g. Irish sportsmen, Irish Holiday Resorts), as well as the general publication of cigarette cards depicting cinema stars, wild flowers, household hints and railway

locomotives. The range and breadth of the topics covered was eclectic, to say the least, although it did seem to tend towards topics which would lend themselves to a series, rather than one-off topics.[44] The cards were usually printed using lithography or photogravure, depending on whether a drawn or photographed image was used, with the backs printed by letterpress with type set on linotype machines, generally in a single colour. These cards fall much more firmly within the category of collectibles, as they have a passive function and were very specifically produced with the intention of being collected, unlike the more obvious functional role of postcards or stamps, both of which could also be sent through the post and used to communicate a message.

The Shannon Scheme series of cigarette cards was produced in the early 1930s by the British cigarette company Wills, as part of their commitment to illustrating Irish topics for a local audience. There are forty monochrome cards in the set, which reproduce at least eighteen of the Siemens photographs framed in white, each with a caption describing the image (see Fig. 99). Each of these photographs was chosen to form a definitive set of images, to represent the Shannon Scheme, presumably with the blessing of Siemens, as many of them reproduce Siemens industrial photographs. The reverse of each card carries a plain layout, with the title repeated and a short description of the photograph and its significance for the overall work (see Fig. 100). The text is laid out centrally, within a linear frame and doesn't contain any of the decorative elements of other cigarette card issues. This is possibly an attempt by Wills' designers to provide a more minimal look, to relate to the mainly photographic images printed on the cards, although what they have achieved is more Art Deco in style than Modernist, in a similar fashion to the 'modern' newspaper advertisements discussed previously. Apart from two diagrammatic illustrations and a photograph of a model, the cards are illustrated with a selection of Siemens photographs, with the emphasis again heavily on outdoor scenes of civil engineering construction. However, this selection of images differs from the postcards in that it includes a number of the higher contrast *Neue Sachlichkeit* influenced photographs. For example, card numbers 20 to 23 present photographs which use the repetitive circular shapes and arcs of the penstock and turbine construction to locate the figures of workers, often posing for effect. The difference between these images and the original photographs, though, is that they are so small that any sense of workers'

agency is lost, as they are reduced to ciphers a couple of millimetres high. The emphasis is returned to the shapes and forms of the machinery and the architecture of the power house and weir buildings, which render the cards into clearer, unambiguous representations of the technological sublime. The power station is again depicted as being constructed by machinery, without the human involvement.

For a Scheme that was all about superlatives in size and scale, though, the cigarette cards provide a tiny, pocket-sized compendium of authoritative modern technical information. The cigarette cards also position the Shannon Scheme firmly within the pantheon of collectible topics, as they form a finite numbered series, which was much easier to complete than even the T.C. Carroll postcards, with their lack of obvious numbering. They allowed the subject of the Scheme to be naturalised as something worth recording, included in the realm of the worthy snippets of educational information associated with 'cigarette card knowledge'.

Ephemera: The Shannon Scheme in miniature

One commonality between both souvenir and fetishistic collecting, both of which are present in the examples discussed here, is that the object loses its connection with its original moment of creation. In the case of the Shannon Scheme ephemera, this is doubly important, as most of these ephemera are depicting the act of creation of the Scheme itself, of the construction of a national undertaking almost considered to be a national monument.[45] So, the images on the postcards and cigarette cards may represent modern technology and construction methods but, by their very inclusion in the world of ephemera, that act of creation is reduced to the world of the everyday. This process is similar for the labour of creating all ephemera – it is diminished, as the origins of the ephemera become less and less important, either superseded by the personal memories of the owner or by the place within the collection. The Shannon Scheme becomes naturalised into the order of important things, as its inclusion within these systems of objects assumes that the historical significance of the Scheme is undisputed and secondary in importance to either the personal connection of the souvenir or of its place in the larger collection of Irish-themed cards.

One of the effects of this naturalisation is to obscure the political dimension of the ephemera, as it is placed alongside other parts of the collection, which may range from images of the Irish countryside to well-known sportspeople. The postcards and cigarette cards were both produced by private enterprise, but the cigarette cards and a large proportion of the postcards reproduced the imagery of the Scheme originally produced by the contracting company Siemens, with the intention of producing 'propaganda' for the German company, whereas they were used here to present the Scheme as an Irish project.[46] The intention of Siemens to use their photographs as propaganda for German industry has been overwhelmed here by the voracious desire of the Irish people for images of the Scheme which they could relate to, either as part of their personal biography, or as part of a larger interest in collecting.

These images are resolutely part of the modern world, both in terms of the systems of circulation involved in the postal service and in the distribution of packaged cigarettes. However, these photographs have been carefully chosen to give a specific impression of the construction, framing the construction machinery as more important than the workers involved. They present a view of the Scheme as a site of the technological sublime, but one which is thoroughly naturalised by its reproduction in miniature, where it can be neatly domesticated and controlled by inclusion into a collection. They represent a recognition that the modern world had come to Ireland, even if aesthetic Modernism had not.

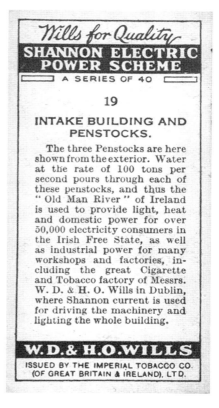

Fig. 100 W.D. & H.O. Wills, Reverse of 'Shannon Electric Power Scheme' cigarette card, 1930 (Image courtesy of the ESB Archives.)

11

The Shannon Scheme: Imagining a Technological Ireland

The representation of electrical technology in Ireland, as the new technology of the epoch, was influenced by a number of factors, as the cultural context of the new State, the relationship of technology to nationhood and the approach of specific German and Irish visual practitioners to their media and the subject all influenced the way in which the Shannon Scheme was presented in the 1920s and early 1930s. Different interpretations of Irishness have been associated with different segments of Irish society, but all struggled to represent the Shannon Scheme in a satisfactory manner, to bridge this gap between essential cultural background and epochal technology. These competing definitions of Irish identity are the legacy of a culture which was not as monolithic as political vested interests in subsequent decades would have people think. The Irish nation envisioned in the 1920s and 1930s by the Cumann na nGaedheal Government imagined a civil, democratic state; orderly and organised above all. The presentation of the Shannon Scheme as a naturalised Irish project was central to the survival not just of the political party, but of the Free State itself, based both on the huge financial investment and the reputational risk. The visual representations of the Scheme spiralled out through Siemens, the ESB, commercial companies and private individuals, until the power station took a place in the popular imagination of Ireland. What that place was, however, was nothing if not ambiguous, with the visual depiction of epochal modernisation

underestimated imagination of the people of Ireland that they could find a place within their national mythology for a hydro-electric power station, demonstrating an awareness of the epochal and technological in the early years of the State. It is only in recent years that this idea of a technological Ireland has become a possibility again, with 'the next industrial revolution' of digital technology welcomed into Ireland in recent decades. It is therefore important to challenge the purely teleological narrative of Irish national identity, given the multiple narratives, subjectivities and particularly multiple modernities implicit in this possibility, as well as the possibility of multiple meanings of technology in different national contexts. Rather than positioning the Scheme as a natural phenomenon, overall these images propose a much subtler discourse about the possibility of a modernised, but not Modern Ireland.[2]

It is ideas about technology and modernisation and their relationship to Irish national identity which underpin this study, considering how Geertz's formulation of essentialist and epochal movements can be balanced, forming a dialogue between two different expressions of these tendencies within Irish culture. The overall effect of the representation of the Shannon Scheme in the 1920s and early 1930s was as a step towards creating Pearse's vision of a free and productive Ireland, which 'would drain the bogs, would harness the rivers, would plant the wastes …',[3] in a pragmatic effort to reimagine electrical technology as harnessing the very landscape to the effort of Irish nation-building.

Endnotes

Introduction

1. P.H. Pearse, 'From a Hermitage', *CELT: Corpus of Electronic Texts* <http://www.ucc.ie/celt/published/E900007-005/text002.html> Accessed 12 January 2017.

2. 'The Remaking of Ireland', *The Nation and Athenaeum*, 5 July 1930, ESB Newspaper Clippings Book 15.

3. '"If St. Patrick Could Only See That!"', *Cincinnati Times-Star*, 17 March 1931, ESB Newspaper Clippings Book 16; '"If St. Patrick Could Only See That!"', *Indiana Journal*, 17 March 1931, ESB Newspaper Clippings Book 16; '"If St. Patrick Could Only See That!"', *Ashland Times-Gazette*, 16 March 1931, ESB Newspaper Clippings Book 16; '"If St. Patrick Could Only See That!"', *Augusta Chronicle*, 11 March 1931, ESB Newspaper Clippings Book 16; '"If St. Patrick Could Only See That!"', *Owatonna People's Press*, 17 March 1931, ESB Newspaper Clippings Book 15; '"If St. Patrick Could Only See That!"', *Oneonta Star*, 10 March 1931, ESB Newspaper Clippings Book 16; '"If St. Patrick Could Only See That!"', *Rochester Post Bulletin*, 17 March 1931, ESB Newspaper Clippings Book 16.

4. '"If St. Patrick Could Only See That!"', ESB Newspaper Clippings Book 16.

5. 'Run-of-the-river' hydroelectricity is based on the drop in the level of water in a river over a long distance, rather than conventional 'high fall' dams, which store a large 'pond' of water behind a barrier, creating a controlled artificial waterfall.

6. The current village of Ardnacrusha is on the north side of the power station and canal, more or less in the location of the main work camp. The original Ardnacrusha village on the 1842 Ordnance Survey Map lay to the south of the tail race canal, and is now called Parteen, not to be confused with nearby Parteen Bridge or Parteen-a-Lax at the end of the tail race canal. The weir at the top end of the head race canal was also named Parteen Weir or Parteen Villa, despite being some 14km away.

7. For more detailed historical discussion of the station, see: M. Manning and M. McDowell, *Electricity Supply in Ireland: The History of the E.S.B.* (Dublin: Gill & Macmillan, 1984), pp. 39–53; A. Bielenberg (ed.), *The Shannon Scheme and the Electrification of the Irish Free State: An Inspirational Milestone* (Dublin: The Lilliput Press, 2002); G. O'Beirne, *Siemens in Ireland 1925–2000: Seventy Five Years of Innovation* (Dublin: A&A Farmar, 2000), pp. 41–67; L. Schoen, 'Studies in the Development of Hydro-Electric Energy Utilisation: The Electrification of Ireland' (PhD Thesis, Technische Universität Berlin, 1979), pp. 61–226.

8. The Minister for Justice Kevin O'Higgins was assassinated by anti-Treaty forces in July 1927. 'Mr. O'Higgins Murdered', *The Irish Times*, 11 July 1927, p. 7; C. Meehan, *The Cosgrave Party:*

A History of Cumann na nGaedheal, 1923–33 (Dublin: Royal Irish Academy, 2010), pp. 91–112.

9 The 'semi-states' are wholly state-owned corporations or bodies, equivalent to British nationalised industries. They were generally set up to either develop natural resources (for example, Bord na Móna/Peat Board or Bord Gáis/Gas Board) or to provide services to the Irish people (for example, the state broadcaster RTÉ (Raidió Teilifís Éireann) or Aer Lingus, the national airline). Many of these semi-states have been nationalised in recent years, including Aer Lingus and Eir the telephone operator and ISP (Internet Service Provider), which started out as the semi-state telephone company Telecom Éireann.

10 'Filming the Shannon Scheme', *Cork Examiner*, 24 May 1929, ESB Newspaper Clippings Book 05. Although a number of short films of the Scheme exist from the period, particularly Pathé news reels, and a 1931 Abbey play set at a thinly disguised Shannon Scheme, I have chosen to concentrate on two-dimensional images, in order to provide a manageable topic for analysis. D. Johnston, 'Moon in the Yellow River – Photographs from Abbey Production 1931' (TCD Manuscripts: 10066/299/553-8, 1931); D. Johnston, 'Dramatic Works – the Moon in the Yellow River, Corrected Copy, 1947 Version' (TCD Manuscripts: 10066/4/1, 1947); D. Johnston, 'Misc. Papers' (TCD Manuscripts: 10066/4/6-11a, 1954); 'President Cosgrave', *British Pathé* <http://www.britishpathe.com/record.php?id=15158> Accessed 12 January 2017; 'The Shannon Scheme (Aka the Shallow Scheme)', *British Pathé* <http://www.britishpathe.com/record.php?id=16774> Accessed 12 January 2017; 'Preparing for Electricity Era', *British Pathé* <http://www.britishpathe.com/record.php?id=17030>

Accessed 12 January 2017; 'The King's Illness (Including the Shannon Scheme)', *British Pathé* <http://www.britishpathe.com/record.php?id=16779> Accessed 12 January 2017.

11 A. Bielenberg, 'Seán Keating, the Shannon Scheme and the Art of State-Building', in A. Bielenberg (ed.), *The Shannon Scheme and the Electrification of the Irish Free State: An Inspirational Milestone* (Dublin: The Lilliput Press, 2002), pp. 114–37; T. Cusack, 'Crossing the Shannon: Ireland's "Mighty Stream" and the Making of the Nation', *Visual Culture in Britain*, 3:1 (2002), pp. 77–97; A. McNight, 'Sean Keating and the Shannon Scheme' (BA Thesis, National College of Art and Design, 2001). It is also briefly considered in Kennedy's early essay on the visual culture of the Free State. See B.P. Kennedy, 'The Irish Free State 1922–49: A Visual Perspective', in B.P. Kennedy and R. Gillespie (eds), *Ireland: Art into History* (Dublin: Town House & Country House, 1994), pp. 147–50.

12 Manning and McDowell, *Electricity Supply in Ireland: The History of the E.S.B.*

13 Bielenberg, 'Seán Keating, the Shannon Scheme and the Art of State-Building', pp. 114–37; M. McCarthy, *High Tension: Life on the Shannon Scheme* (Dublin: The Lilliput Press, 2004). It is also briefly addressed in Meehan's political history of Cumann na nGaedheal. See Meehan, *The Cosgrave Party: A History of Cumann na nGaedheal, 1923–33*, pp. 91–112.

14 The architecture of the power station is briefly considered in H. Campbell, 'Modern Architecture and National Identity in Ireland', in J. Cleary and C. Connolly (eds), *The Cambridge Companion to Irish Culture* (Cambridge: Cambridge University Press, 2005), pp. 293–4; M. Dunn, 'Ardnacrusha – a Case Study', in R. Loeber et al. (eds), *Art and Architecture of Ireland Volume IV: Architecture* (Dublin: Royal Irish Academy, The Paul Mellon Centre and Yale

University Press, 2014), pp. 169–70; P. Larmour, *Free State Architecture: Modern Movement Architecture in Ireland, 1922–1949* (Kinsale: Gandon Editions, 2009), pp. 13–16; S. Rothery, *Ireland and the New Architecture 1900–1940* (Dublin: The Lilliput Press, 1991), pp. 142–5; E. Rowley, 'The Conditions of Architectural Modernism in Ireland, 1900–1970: Between Aspiration and Production', in E. Juncosa and C. Kennedy (eds), *The Moderns: The Arts in Ireland from the 1900s to the 1970s* (Dublin: Irish Museum of Modern Art, 2011), p. 422. The advertisements and newspaper coverage are considered in M. Kelly, 'The Role of Advertising in the Establishment and Early Development of a Semi-State Company' (MA Thesis, Dublin City University, 2003); M. Sutton, '"Harnessed in the Service of the Nation": Party Politics and the Promotion of the Shannon Hydroelectric Scheme 1924–32', in M. Farrell, J. Knirck and C. Meehan (eds), *A Formative Decade: Ireland in the 1920s* (Dublin: Irish Academic Press, 2015), pp. 86–107.

15 T. Garvin, *Preventing the Future: Why Was Ireland So Poor for So Long?* (Dublin: Gill & Macmillan, 2004); J. Lee, *The Modernisation of Irish Society* (Dublin: Gill & Macmillan, 1973); J. Lee, *Ireland 1912–1985 Politics and Society* (Cambridge: Cambridge University Press, 1989); O. MacDonagh, *Ireland: The Union and Its Aftermath* (Dublin: University College Dublin Press, 2003); A. Mitchell, *Labour in Irish Politics, 1890–1930: The Irish Labour Movement in the Age of Revolution* (Dublin: Irish University Press, 1974); T. Bartlett et al. (eds), *Irish Studies: An Introduction* (Dublin: Gill & Macmillan, 1988); D.G. Boyce and A. O'Day (eds), *The Making of Modern Irish History: Revisionism and the Revisionist Controversy* (London: Routledge, 1996); C. Carroll and P. King (eds), *Ireland and Post-Colonial Theory* (Cork: Cork University Press, 2003); C. Connolly (ed.), *Theorizing Ireland* (Basingstoke: Palgrave Macmillan, 2002); C. Curtain, M. Kelly and L. O'Dowd (eds), *Culture and Ideology in Ireland* (Galway: Galway University Press, 1984); S. Hutton and P. Stewart (eds), *Ireland's Histories: Aspects of State, Society and Identity* (London: Routledge, 1991).

16 R.F. Foster begins his survey of modern Ireland in 1600, working from the broader definition of 'modern'. See R. F. Foster, *Modern Ireland 1600–1972* (London: Allen Lane, 1988); C. Ó Gráda, *Ireland: A New Economic History 1780–1939* (Oxford: Clarendon Press, 1994); M. E. Daly, *Industrial Development and Irish National Identity 1922–1939* (Dublin: Gill & Macmillan, 1992).

17 'Generation Asset Map', *Electricity Supply Board* <https://www.esb.ie/our-businesses/generation-energy-trading-new/generation-asset-map> Accessed 12 January 2017.

18 D. Rushe, 'Remembering a Remarkable Project', *Irish Independent*, 25 September 1975, p. 6; M. Mulvihill, 'Turning the Infant State Electric', *The Irish Times*, 3 April 2004, p. A9; A. Bushe, 'Ardnacrusha: Dam Hard Job: 8.8 Million Cubic Metres of Earth and Rock', *Sunday Mirror*, 4 August 2002; A. Sherry, 'A Fascinating First Look inside Dublin's Awesome Port Tunnel', *Financial Times*, 16 November 2006; 'Dublin Port Tunnel', *Dublin North Central Matters*, Summer 2006, p. 5.

19 T. Hammons, 'Shannon Scheme for the Electrification of the Irish Free State', *IEEE Power Engineering Review*, 22:11 (November 2002), pp. 36–8; 'Building of the Month June 2009: Ardnacrusha Generating Station, Ballykeelaun Td., County Clare', *Buildings of Ireland: National Inventory of Architectural Heritage* <http://www.buildingsofireland.ie/Surveys/Buildings/BuildingoftheMonth/Archive/Name,1405,en.html> Accessed 12 January 2017.

20 'Interactive Services', *Interactive Services* <http://www.interactiveservices.com/> Accessed 12 January 2017; 'About Espatial', *eSpatial* <http://www.espatial.com/company/> Accessed 12 January 2017.

21 'Census of Population in Ireland', *Office of the Minister of State for Integration* <http://www.integration.ie/website/omi/omiwebv6.nsf/page/statistics-census2011-en> Accessed 12 January 2017.

22 This point was stressed by the conclusion of the high-profile RTÉ documentary *The Story of Ireland*, which includes a classroom of multi-national children learning Irish and playing hurling. *The Age of Nations* (Radio Teilifís Éireann, 2011), F. Keane (dir.).

23 For an example of this high-tech, international Ireland at work, see Mark Curran's photographic study of the Hewlett Packard plant in Leixlip, outside Dublin. M. Curran, *The Breathing Factory* (Heidelberg: Edition Braus, 2006).

Chapter 1

1 'Events of the Week – the Shannon Schemers', *An Phoblacht*, 9 October 1925, p. 3.

2 H. Bhabha, *The Location of Culture*, 2nd edn (London: Routledge, 1994), p. 81.

3 B. Anderson, *Imagined Communities*, 2nd edn (London: Verso, 1991), p. 5.

4 *Ibid.*, p. 5.

5 For example, Patrick Pearse's poetry about turning his back on life in service of the Irish dream of independence is nothing if not heartfelt, as well as a prediction of his actual death in the Easter Rising of 1916. See P.H. Pearse, 'Renunciation', *CELT: Corpus of Electronic Texts* <http://www.ucc.ie/celt/published/E950004-016/text001.html> Accessed 12 January 2017.

6 Anderson, *Imagined Communities*, p. 24. The history of clocks, longitude, summer time, transport timetables, time zones and personal chronometers also played an important role in sedimenting the structures of power and organisation within national, imperial and colonial boundaries during the eighteenth and nineteenth centuries.

7 Bhabha, *The Location of Culture*, p. 35.

8 This may be a simple replacement of the previous colony or jurisdiction with a nation of the same name (Peru), or with a radical redefinition of the values and make-up of the same territory (Southern Rhodesia becomes Zimbabwe).

9 There is an ongoing debate about whether or not Ireland can be considered a post-colonial nation. As this book is specifically concerned with the Irish Free State, the nation-state formed by the withdrawal of British administration from twenty-six of the thirty-two counties on the island of Ireland, it treats the Irish Free State as a post-colonial state, while acknowledging that it is one of multiple definitions. See T. Halloran, '"An Éirinneach Nó Sassanach Tú?" – Are You Irish or English?', *The Victorian Web* <http://www.victorianweb.org/history/halloran1.html> Accessed 12 January 2017, for a good overview of the topic.

10 S. Bhreathnach-Lynch, *Ireland's Art, Ireland's History: Representing Ireland 1845 to Present* (Omaha, NE: Creighton University Press, 2007); E. Morris, *Our Own Devices: National Symbols and Political Conflict in Twentieth-Century Ireland* (Dublin: Irish Academic Press, 2000); D.C. Swan, 'Vanishing Borders: The Representation of Political Partition in the Free State, 1922–1949', in L. King and E. Sisson (eds), *Ireland, Design and Visual Culture: Negotiating Modernity 1922–1992* (Cork: Cork University Press, 2011), pp. 133–47.

11 C. Ní Bheacháin, 'Seeing Ghosts: Political Ephemera and the Phantom Republic, 1921–32', *Seeing Things: Irish Visual Culture*

(unpublished conference paper, University of Limerick, 2007); C. Meehan, *The Cosgrave Party: A History of Cumann na nGaedheal, 1923–33* (Dublin: Royal Irish Academy, 2010), pp. 3–16. The anti-Treaty forces refused to recognise the legitimacy of the Dáil until 1927, largely due to the requirement to take an oath of allegiance to the British Crown, maintaining that the Republic was not subject to Crown authority.

12 F. McNally, 'Kenny Gets Ball Rolling in County Where Even the GAA Team Are Blueshirts', *The Irish Times*, 3 February 2011. Cumann na nGaedheal's successor party Fine Gael are still called Blueshirts on occasion, based on their association with the short-lived Army Comrades Association of 1932 and 1933, who wore blue paramilitary-style uniforms and were accused of Fascist tendencies. See J.M. Regan, *The Irish Counter Revolution 1921–1936* (Dublin: Gill & Macmillan, 1999), pp. 324–40. The current minority Fine Gael government is supported by Fianna Fail in Dáil votes, a situation that has been heralded as an end to Treaty politics, so far inaccurately. C. Browne, 'End of Civil War Politics Would Give Us a Real Choice between Left and Right', *Irish Independent*, 1 March 2016.

13 Bhabha, *The Location of Culture*, p. 34.

14 For example, figures such as socialist James Connolly and feminist Constance Markievicz have been appropriated by 'official' nationalist histories and their radical non-nationalist views played down, although this tendency has been balanced somewhat by the recognition of the role of women in the 1916 Rising commemorations in 2016. J. Horan, 'James Connolly', *Republican Sinn Féin* <http://www.rsf.ie/connolly.htm> Accessed 16 August 2005; S. Pašeta, 'Women and the Rising', *Inspiring Ireland* <http://inspiring-ireland.ie/1916/women-and-rising> Accessed 12 January 2017;

N. Murray, 'Women & the 1916 Rising: An Educational Resource', *Scoilnet* <https://www.scoilnet.ie/uploads/resources/16512/16188.pdf> Accessed 12 January 2017.

15 Bhabha, *The Location of Culture*, p. 42; L. Gibbons, 'A Race against Time: Racial Discourse and Irish History', in C. Hall (ed.), *Cultures of Empire: A Reader* (Manchester: Manchester University Press, 2000), pp. 214–15.

16 Bhabha, *The Location of Culture*, p. 201.

17 T. Adorno and M. Horkheimer, *Dialectic of Enlightenment: Philosophical Fragments*, E. Jephcott (trans.), 2nd edn (Stanford, CA: Stanford University Press, 2002), pp. 120–67.

18 B. Taylor, *Art and Literature under the Bolsheviks: Authority and Revolution 1924–1932* (London: Pluto Press, 1992). It is important to note that both the dynastic continuity of the Romanov heirs and the rapid economic development of the Soviet five-year plans posited themselves as 'timeless', while retaining a teleological view of their own progress.

19 C. Geertz, *The Interpretation of Cultures*, 2nd edn (New York, NY: Basic Books, 2000), p. 283.

20 N. Gordon Bowe, 'Symbols of Ireland', *Government of Ireland* <http://www.gov.ie/en/essays/symbols.html> Accessed 12 January 2017.

21 An Garda Siochána is the Irish police force, literally 'the guardians of the peace', and An Post is the Irish post office, literally 'the post'.

22 D. Keenan, 'DUP Cautions on PSNI Parade Plan', *The Irish Times*, 18 August 2010, p. 6.

23 Geertz, *The Interpretation of Cultures*, p. 239.

24 J. Sheehy, *The Celtic Revival: The Rediscovery of Ireland's Past 1830–1930* (London: Thames & Hudson, 1980), N. Gordon Bowe and E. Cumming, *The Arts & Crafts Movements in Dublin & Edinburgh, 1880–1930* (Dublin: Irish Academic Press, 1998). For examples from other European countries, see A. Yagou, 'Metamorphoses of Formalism: National

Identity as a Recurrent Theme of Design in Greece', *Journal of Design History*, 20:2 (2007), pp. 145–59; C. Ashby, 'Nation Building and Design: Finnish Textiles and the Work of the Friends of Finnish Handicrafts', *Journal of Design History*, 23:4 (2010), pp. 351–65.

25 Geertz, *The Interpretation of Cultures*, p. 240.

26 *Ibid.*, p. 241.

27 *Ibid.*, p. 242.

28 P. Sparke, *An Introduction to Design and Culture: 1900 to the Present*, 2nd edn (London: Routledge, 2004), p. 95. These strategies are either an essentialist re-appropriation of craft traditions, or an epochal emphasis on developing modern industries of production.

29 Geertz, *The Interpretation of Cultures*, p. 308. The influence of Geertz's thinking on Irish design history can be seen in King and Sisson's book, particularly L. King and E. Sisson, 'Materiality, Modernity and the Shaping of Identity: An Overview', in L. King and E. Sisson (eds), *Ireland, Design and Visual Culture: Negotiating Modernity 1922–1992* (Cork: Cork University Press, 2011), pp. 30–1.

30 E. Hobsbawm and T. Ranger (eds), *The Invention of Tradition*, 2nd edn (Cambridge: Cambridge University Press, 1983), p. 1.

31 *Ibid.*, p. 6.

32 H. Trevor-Roper, 'The Invention of Tradition: The Highland Tradition of Scotland', in E. Hobsbawm and T. Ranger (eds), *The Invention of Tradition* (Cambridge: Cambridge University Press, 1983), pp. 15–41.

33 L. Gibbons, *Transformations in Irish Culture* (Cork: Cork University Press, 1996), p. 13.

34 L.I.A. Gregory, *Gods and Fighting Men: The Story of the Tuatha De Danaan and of the Fianna of Ireland*, eBook edn (Salt Lake City, UT: Project Gutenberg, 2004).

35 S. Hayes O'Grady, *The Colloquy with the Ancients* (Cambridge, Ontario: In parentheses Publications, 1999).

36 L.P. Curtis, *Apes and Angels: The Irishman in Victorian Caricature*, Rev. edn (Washington, DC: Smithsonian Institute, 1997), pp. 29–57.

37 J. Lee, *Ireland 1912–1985 Politics and Society* (Cambridge: Cambridge University Press, 1989), p. 651; Gordon Bowe and Cumming, *The Arts & Crafts Movements in Dublin & Edinburgh, 1880–1930*, p. 78.

38 Sheehy, *The Celtic Revival: The Rediscovery of Ireland's Past 1830–1930*, pp. 147–75; N. Gordon Bowe, *Art and the National Dream: The Search for Vernacular Expression in Turn of the Century Design* (Dublin: Irish Academic Press, 1993), p. 185; D. Campion, 'Manifestations of a Nation, Ireland: Exhibitions and Symbols 1850–1950' (MA Thesis, V&A/RCA, 1989), pp. 55–68. The historical authenticity of the oral sagas is itself not uncontested, given the controversy surrounding sources such as James Macpherson's Ossianic cycle of poems. See Gibbons, 'A Race against Time: Racial Discourse and Irish History', p. 215.

39 T. Garvin, *1922: The Birth of Irish Democracy* (Dublin: Gill & Macmillan, 1996), p. 12; O. MacDonagh, *Ireland: The Union and Its Aftermath* (Dublin: University College Dublin Press, 2003), pp. 178–9.

40 The Congested Districts Board of the late nineteenth century focused mostly on public works, but as a way of alleviating rural poverty, rather than developing an industrial base in the West of Ireland.

41 This formation of antagonism to industry is very different from the situation in Germany, where industrialisation and modernisation developed alongside a drive towards the political unification of a number of fragmented territories.

42 The *Feis Ceoil* is an annual Irish music and dance competition, which was started in 1897 with the intention of promoting Irish culture.

The *Aonach Tailteann* was an attempt to create a Celtic version of the Greek Olympiad, recreating an ancient Irish sporting event in honour of Queen Tailtiu. The revived event ran in 1924, 1928 and 1932 and the name is currently being used for the Athletics Association of Ireland yearly competition. R.F. Foster, *Modern Ireland 1600–1972* (London: Allen Lane, 1988), pp. 446–56; Geertz, *The Interpretation of Cultures*, p. 243.

43 N. Gordon Bowe (ed.), *Art and the National Dream: The Search for Vernacular Expression in Turn of the Century Design* (Dublin: Irish Academic Press, 1993), p. 181.

44 S. Hutton and P. Stewart (eds), *Ireland's Histories: Aspects of State, Society and Identity* (London: Routledge, 1991), p. 2.

45 P. O'Malley, *Biting at the Grave: The Irish Hunger Strikes and the Politics of Despair* (Belfast: Blackstaff, 1990). Even Ireland's best-known socialist, James Connolly, felt that he had to portray radical socialism as the inheritor of an authentic Celtic past of communal tribal ownership of land. J. Connolly, *Labour in Irish History*, 12th edn (Dublin: New Books, 1973), pp. xvii–vxiii.

46 Foster, *Modern Ireland 1600–1972*; Lee, *Ireland 1912–1985 Politics and Society*; J. Smyth, 'Industrial Development and the Unmaking of the Irish Working Class', in S. Hutton and P. Stewart (eds), *Ireland's Histories: Aspects of State, Society and Ideology* (London: Routledge, 1991); R. Cullen Owens, *A Social History of Women in Ireland, 1870–1970* (Dublin: Gill & Macmillan, 2005).

47 The initial survey of Irish visual culture by Kennedy has since been expanded in several recent PhD theses and books on aspects of Irish national identity. See D.C. Swan, 'The Development of the Visual Imagery of the State in Ireland, North and South 1920–1960' (PhD

Thesis, National College of Art and Design, 2005); L. King, 'Traditions and Modernities: Aer Lingus and the Visualisation of Irish Identities 1951–1961' (PhD Thesis, Dublin City University, 2007); L. Godson, 'Ceremonial Culture in the Irish Free State, 1922–1939' (PhD Thesis, RCA, 2008); B.P. Kennedy, 'The Irish Free State 1922–49: A Visual Perspective', in B.P. Kennedy and R. Gillespie (eds), *Ireland: Art into History* (Dublin: Town House & Country House, 1994), pp. 132–52; L. King and E. Sisson (eds), *Ireland, Design and Visual Culture: Negotiating Modernity 1922–1992* (Cork: Cork University Press, 2011); J. Brück and L. Godson (eds), *Making 1916: Material and Visual Culture of the Easter Rising* (Liverpool: Liverpool University Press, 2015).

48 R. Buchanan, 'Declaration by Design: Rhetoric, Argument, and Demonstration in Design Practice', in V. Margolin (ed.), *Design Discourse: History, Theory, Criticism* (Chicago, IL: University of Chicago Press, 1989), pp. 105–8.

49 Anderson, *Imagined Communities*, pp. 163–85.

50 T. Edensor, *National Identity, Popular Culture and Everyday Life* (Oxford: Berg, 2002), pp. 5–7.

51 *Intermediate Certificate History Syllabus* (Dublin: The Stationary Office, 2000), p. 11; J. O'Callaghan, *Teaching Irish Independence: History in Irish Schools 1922–72* (Newcastle upon Tyne: Cambridge Scholars Publishing, 2009), pp. 55–69.

52 Ní Bheacháin, 'Seeing Ghosts: Political Ephemera and the Phantom Republic, 1921–32', p. 118; MacDonagh, *Ireland: The Union and Its Aftermath*.

53 The Treaty included a provision of an oath of allegiance to the British Crown as a condition of taking up a seat in the Oireachtas, which resulted in the anti-Treaty forces (later Fianna Fáil) boycotting the Dáil until Cumann na nGaedheal brought in specific legislation

making the oath a precondition for standing for election. See D. Ferriter, *The Transformation of Modern Ireland 1900–2000* (London: Profile Books, 2004), p. 310; MacDonagh, *Ireland: The Union and Its Aftermath*, pp. 121–2.

54 'Events of the Week – the Shannon Schemers', p. 3.

55 Dáil Éireann, 'Debate on Treaty', Vol. 3 (Dublin: The Stationery Office, 1921), p. 33.

56 S. Collins, *The Cosgrave Legacy* (Dublin: Blackwater Press, 1996), pp. 4–77; A. Jordan, *W. T. Cosgrave 1880–1965: Founder of Modern Ireland* (Dublin: Westport Books, 2006); Meehan, *The Cosgrave Party: A History of Cumann na nGaedheal, 1923–33*, pp. 16–22.

57 B.A. Reynolds, *William T. Cosgrave and the Foundation of the Irish Free State, 1922–25* (Kilkenny: Kilkenny People Printing, 1998).

58 Garvin, *1922: The Birth of Irish Democracy*, p. 153; M.E. Daly, *Industrial Development and Irish National Identity 1922–1939* (Dublin: Gill & Macmillan, 1992), p. 57; C. Ó Gráda, *Ireland: A New Economic History 1780–1939* (Oxford: Clarendon Press, 1994), pp. 385–6.

59 Daly, *Industrial Development and Irish National Identity 1922–1939*, pp. 15–16; MacDonagh, *Ireland: The Union and Its Aftermath*, pp. 144–5; E. O'Halpin, 'Politics and the State 1922–32', in T. Moody et al. (eds), *A New History of Ireland Volumes 7–8* (Oxford: Oxford University Press, 2003), p. 113.

60 Dáil Éireann, 'Seizure of Cattle by Military', Vol. 2 (Dublin: The Stationery Office, 1923), p. 1909. O'Halpin, 'Politics and the State 1922–32', p. 109; Meehan, *The Cosgrave Party: A History of Cumann na nGaedheal, 1923–33*, pp. 29–38; T. Boylan, C. Curtain and L. O'Dowd, 'Politics and Society and Post-Independent Ireland', in T. Bartlett et al. (eds), *Irish Studies: A General Introduction* (Dublin: Gill & Macmillan, 1988), pp. 152–73.

61 Foster, *Modern Ireland 1600–1972*, pp. 251–2; D. Johnson, *The Interwar Economy in Ireland* (Dublin: The Economic and Social History Society of Ireland, 1989), p. 22.

62 Daly, *Industrial Development and Irish National Identity 1922–1939*, p. 14. The largest areas for employment in the Free State in 1926 were 53 per cent in agriculture, 9.7 per cent in manufacturing and 3.0 per cent in construction. From D. Gillmor, 'Land and People, C.1926', in T. Moody et al. (eds), *A New History of Ireland Volumes 7–8* (Oxford: Oxford University Press, 2003), p. 68.

63 Ó Gráda, *Ireland: A New Economic History 1780–1939*, p. 386.

64 C. Meehan, 'Fine Gael's Uncomfortable History: The Legacy of Cumann na nGaedheal', *Éire-Ireland: a Journal of Irish Studies*, 43:3 & 4 (Fall/Winter 2008), p. 60.

65 O'Halpin, 'Politics and the State 1922–32', p. 115.

66 G. O'Beirne, *Siemens in Ireland 1925–2000: Seventy Five Years of Innovation* (Dublin: A&A Farmar, 2000), pp. 45–55; B. Delany, 'McLaughlin, the Genesis of the Shannon Scheme and the ESB', in A. Bielenberg (ed.), *The Shannon Scheme and the Electrification of the Irish Free State: An Inspirational Milestone* (Dublin: The Lilliput Press, 2002), pp. 11–27; M. Manning and M. McDowell, *Electricity Supply in Ireland: The History of the E.S.B.* (Dublin: Gill & Macmillan, 1984), pp. 18–38.

67 Garvin, *1922: The Birth of Irish Democracy*, p. 147.

68 *Ibid.*, p. 149.

69 Kennedy, 'The Irish Free State 1922–49: A Visual Perspective', pp. 134–38; Department of Finance, 'The Coinage of Saorstát Eireann' (Dublin: Stationery Office, 1928), p. 5; Sheehy, *The Celtic Revival: The Rediscovery of Ireland's Past 1830–1930*, p. 175; Campion, 'Manifestations

of a Nation, Ireland: Exhibitions and Symbols 1850–1950', p. 64; P. Caffrey, 'The Coinage Design Committee (1926–1928) and the Formation of a Design Identity in the Irish Free State', in L. King and E. Sisson (eds), *Ireland, Design and Visual Culture: Negotiating Modernity 1922–1992* (Cork: Cork University Press, 2011), pp. 75–89.

70 Morris, *Our Own Devices: National Symbols and Political Conflict in Twentieth-Century Ireland*, p. 2.

71 B. Hobson, *Saorstát Éireann Irish Free State Official Handbook* (Dublin: The Talbot Press, 1932), p. 15.

72 Sheehy, *The Celtic Revival: The Rediscovery of Ireland's Past 1830–1930*, pp. 170–3.

73 Hobson, *Saorstát Éireann Irish Free State Official Handbook*, pp. 9–12.

74 C. Graham (ed.), *In Search of Ireland: A Cultural Geography* (London: Routledge, 1997), p. 2.

75 T. Bennett et al., *New Keywords: A Revised Vocabulary of Culture and Society* (Oxford: Blackwell, 2005), p. 219; R. Williams, *Keywords: A Vocabulary of Culture and Society* (London: Fontana, 1988), pp. 208–9.

76 P. Greenhalgh, *The Modern Ideal: The Rise and Collapse of Idealism in the Visual Arts from the Enlightenment to Postmodernism* (London: V&A Publications, 2005), pp. 62–3.

77 D. MacCannell, *The Tourist: A New Theory of the Leisure Class*, 3rd edn (Berkeley, CA: University of California Press, 1999), p. 7.

78 MacCannell, *The Tourist: A New Theory of the Leisure Class*, p. 15.

79 T.P. Hughes, *Human-Built World: How to Think About Technology and Culture* (Chicago, IL: University of Chicago Press, 2005).

80 M. Berman, *All That Is Solid Melts into Air: The Experience of Modernity* (London: Verso, 1983), p. 152.

81 K. Fallan, *Design History: Understanding Theory and Method* (New York, NY: Berg, 2010), p. 114.

82 C. Wilk, *Modernism: Designing a New World 1914–1939* (London: V&A Publications, 2006), pp. 72–89.

83 T.J. Misa, P. Brey, and A. Feenberg (eds), *Modernity and Technology* (Cambridge, MA: The MIT Press, 2004), p. 5; Greenhalgh, *The Modern Ideal: The Rise and Collapse of Idealism in the Visual Arts from the Enlightenment to Postmodernism*, pp. 15–23.

84 Greenhalgh, *The Modern Ideal: The Rise and Collapse of Idealism in the Visual Arts from the Enlightenment to Postmodernism*, p. 14.

85 Wilk, *Modernism: Designing a New World 1914–1939*, p. 14.

86 E. Sisson, 'Experimentalism and the Irish Stage: Theatre and German Expressionism in the 1920's', in L. King and E. Sisson (eds), *Ireland, Design and Visual Culture: Negotiating Modernity 1922–1992* (Cork: Cork University Press, 2011), pp. 39–55.

87 Wilk, *Modernism: Designing a New World 1914–1939*, p. 17.

88 B. Wittrock, 'Modernity: One, None or Many? European Origins and Modernity as a Global Condition', *Daedalus*, 129:1 (Winter 2000), p. 33.

89 A. Gerschenkron, *Economic Backwardness in Historical Perspective: A Book of Essays* (Cambridge, MA: Belknap Press, 1962).

90 M. Sabatino, 'Ghosts and Barbarians: The Vernacular in Italian Modern Architecture and Design', *Journal of Design History*, 21:4 (2008), pp. 335–58.

91 M.Ö. Gürel, 'Consumption of Modern Furniture as a Strategy of Distinction in Turkey', *Journal of Design History*, 22:1 (2009), pp. 47–67.

92 E. Schatzberg, '*Technik* Comes to America: Changing Meanings of *Technology*', *Technology and Culture*, 47:3 (July 2006), pp. 488–502.

93 L. Marx, '*Technology*: The Emergence of a Hazardous Concept', *Social Research*, 64:3 (Fall 1997), p. 977.

Architecture (Dublin: Royal Irish Academy, The Paul Mellon Centre and Yale University Press, 2014), p. 13; H. Campbell and L. Cassidy, 'Architectural Education in the Nineteenth and Twentieth Centuries', in R. Loeber et al. (eds), *Art and Architecture of Ireland Volume IV: Architecture* (Dublin: Royal Irish Academy, The Paul Mellon Centre and Yale University Press, 2014), p. 128.

29 J. Sheehy, *The Celtic Revival: The Rediscovery of Ireland's Past 1830–1930* (London: Thames & Hudson, 1980), pp. 144–5; N. McCullough and V. Mulvin, *A Lost Tradition: The Nature of Architecture in Ireland* (Dublin: Gandon Editions, 1987); 'Nationality in Architecture, Mr. LF Giron's Presidential Address to the Architectural Association of Ireland, Delivered 19th November', *The Irish Builder and Engineer*, 29 November 1924, p. 1021; Oculus, 'Wynn's Hotel', *The Irish Builder and Engineer*, 5 February 1927, p. 73; 'The War Memorial Building, Trinity College Dublin', *The Irish Builder and Engineer*, 8 December 1928, p. 1022; P. Larmour, *Free State Architecture: Modern Movement Architecture in Ireland, 1922–1949* (Kinsale: Gandon Editions, 2009), pp. 7, 13; Loeber and Campbell, 'Architectural Profession', p. 11; F. O'Dwyer, 'Gothic Revival', in R. Loeber et al. (eds), *Art and Architecture of Ireland Volume IV: Architecture* (Dublin: Royal Irish Academy, The Paul Mellon Centre and Yale University Press, 2014), p. 106; P. Larmour, 'Hiberno-Romanesque Revival', in R. Loeber et al. (eds), *Art and Architecture of Ireland Volume IV: Architecture* (Dublin: Royal Irish Academy, The Paul Mellon Centre and Yale University Press, 2014), pp. 107–8.

30 Central Statistics Office, 'Numbers of Persons in Each Occupational Group in Saorstát Éireann, 18th April 1926', *Central Statistics Office Ireland* (Dublin: Central Statistics Office Ireland, 1928); E. Rowley, 'Office of Public Works (OPW), 1922–2000', in R. Loeber et al. (eds), *Art and Architecture of Ireland Volume IV: Architecture* (Dublin: Royal Irish Academy, The Paul Mellon Centre and Yale University Press, 2014), p. 45; Rowley, 'Concrete', pp. 72–3; Rowley, 'Factories in the Twentieth Century', p. 256; C. Rynne, *Industrial Ireland: An Archaeology* (Cork: Collins Press, 2006), pp. 173–4; F. McSweeney, R.C. Cox and S. De Courcy, 'Construction Materials', in R.C. Cox (ed.), *Engineering Ireland* (Cork: The Collins Press, 2006), p. 181. Larmour identifies a bare handful of 'proto-modern' grain silos, granaries and grandstands built in the 1900s and 1910s. See Larmour, *Free State Architecture: Modern Movement Architecture in Ireland, 1922–1949*, pp. 8–12; E. Rowley, 'The Conditions of Architectural Modernism in Ireland, 1900–1970: Between Aspiration and Production', in E. Juncosa and C. Kennedy (eds), *The Moderns: The Arts in Ireland from the 1900s to the 1970s* (Dublin: Irish Museum of Modern Art, 2011), p. 422; Rothery, *Ireland and the New Architecture 1900–1940*, pp. 140–1.

31 'Modern Architecture of the North', *The Irish Builder and Engineer*, 21 March 1925, pp. 221–2; 'Architectural Engineering', *The Irish Builder and Engineer*, 6 March 1926, p. 187; W.J.H. Leverton, 'The Architectural Treatment of Reinforced Concrete', *The Irish Builder and Engineer*, 18 September 1926, pp. 715–16; H. Robertson, 'Modern French Architecture', *The Irish Builder and Engineer*, 16 April 1927, pp. 263–9; P.L. Dickinson, 'Some Aspects of the New Architecture', *The Irish Builder and Engineer*, 16 March 1929, p. 223; P.L. Dickinson, 'Internationalism in Architecture', *The Irish Builder and Engineer*, 11 October 1930, p. 894; Rothery, *Ireland and the New Architecture 1900–1940*, pp. 96–100.

32 For example, Michael Scott's house 'Geragh' in Sandycove or Alan and Mairín Hope's house 'Meander' in Foxrock, both south county Dublin. Rothery, *Ireland and the New Architecture 1900–1940*, p. 144; S. Rothery, 'Ireland and the New Architecture 1900–1940', in A. Becker, J. Olley and W. Wang (eds), *20th Century Architecture: Ireland* (Munich: Prestel, 1997), p. 20; Larmour, *Free State Architecture: Modern Movement Architecture in Ireland, 1922–1949*, pp. 44–57.

33 Barry Byrne had been trained by Frank Lloyd Wright in the US and sent drawings over for the church, and the construction was overseen by Irish architect J.R. Boyd Barrett. See Rothery, *Ireland and the New Architecture 1900–1940*, pp. 20, 106–7; 'Exterior of Church of Christ the King, Turners Cross', *Turners Cross* <http://www.turnerscross.com/church/exterior.php> Accessed 12 January 2017; Rothery, *Ireland and the New Architecture 1900–1940*, pp. 157–68; Larmour, *Free State Architecture: Modern Movement Architecture in Ireland, 1922–1949*, pp. 17–19; Rowley, 'The Conditions of Architectural Modernism in Ireland, 1900–1970: Between Aspiration and Production', pp. 436–7; Campbell, Rowley, and Ryan, 'Modernism', p. 113.

34 R. Loeber, 'Chapter Introduction – Protagonists', p. 9.

35 M. Robertson, *Laymen and the New Architecture* (London: John Murray, 1925), pp. 163–5.

36 Loeber and Campbell, 'Chapter Introduction – Building Materials, Construction and Interior Decoration', p. 53; P. Arnold, 'Stone Construction', in R. Loeber et al. (eds), *Art and Architecture of Ireland Volume IV: Architecture* (Dublin: Royal Irish Academy, The Paul Mellon Centre and Yale University Press, 2014), p. 60; Rynne, *Industrial Ireland: An Archaeology*, pp. 149–61; McSweeney, Cox, and De Courcy, 'Construction Materials', pp. 173–80.

37 T. Hand and P. Wyse Jackson, 'Stone Types and Production', in R. Loeber et al. (eds), *Art and Architecture of Ireland Volume IV: Architecture* (Dublin: Royal Irish Academy, The Paul Mellon Centre and Yale University Press, 2014), p. 59; G. O'Neill, 'Slate', in R. Loeber et al. (eds), *Art and Architecture of Ireland Volume IV: Architecture* (Dublin: Royal Irish Academy, The Paul Mellon Centre and Yale University Press, 2014), pp. 70–1; Rynne, *Industrial Ireland: An Archaeology*, pp. 161–2.

38 'Invoice Nr. AZ for costs incurred on account of the experiments carried out with models of the weir for the Shannon, Ireland, December 1926' in Siemens-Schuckertwerke, 'Correspondence January–March 1927' (Siemens Archive: 2281, 1927).

39 Ambistones, or AMBI blocks, were the product of a block-making system developed by German manufacturing company AMBI Maschinenbau. An illustrated advertisement from 1924 mentions that they had twelve branches in Germany and nineteen agencies abroad. By a later 1926 advertisement, they also had an Irish agent, P.G. O'Rourke in Dublin. 'Ambistone Advertisement', *The Irish Builder and Engineer*, 13 November 1926, p. 865; 'Ambistone Advertisement', *The Irish Builder and Engineer*, 19 April 1924, p. 335. The cement used was imported from Britain, according to 'Topical Touches', *The Irish Builder and Engineer*, 4 September 1926, p. 665.

40 'Memo from Resident Engineer's Office Re Painting of External Woodwork in the Power Station' in Shannon Power Development, 'Power House Design: Architectural and Buildings' (National Archives of Ireland: SS 495, 1928); 'Minutes of the Meeting about the architectural construction of the Power House held on the Building Site on the 7.11.28.' in Shannon Power Development, 'Power House

Design: Architectural and Buildings'. Larmour assumes that the architect of the building was Hans Hertlein, but the correspondence refers only to Herr Dohme as being in charge of the negotiations on form, visiting the site during July 1928. Wilhelm Dohme was the Head of the Siemens Head Office Architecture and Building Construction Bureau and an experienced designer of power stations and other industrial buildings. Larmour, *Free State Architecture: Modern Movement Architecture in Ireland, 1922–1949*, p. 13; Dohme, *Kraftswerkhochbauten*.

41 '"Killaloe Slates" Advertisement', *The Irish Builder and Engineer*, 18 January 1930, p. 43.

42 Shannon Power Development, 'Power House Design: Architectural and Buildings'.

43 Ludin in Mende, '"Denkmäler Von Adel Und Kraft": Wassermühlen Und Wasserkraftwerke Zwischen Nutzung Und Erhalt', pp. 222–3.

44 H. Adams, *The Education of Henry Adams* (Raleigh, NC: Hayes Barton Press, 1999), pp. 291–9; D.E. Nye, *Electrifying America: Social Meanings of a New Technology* (Cambridge, MA: The MIT Press, 1991), p. 142.

45 'Ardnacrusha Control Building', *European Building*, October 1996, pp. 37, 39; 'Ardnacrusha Control Building', *Irish Architect*, 118, June 1996, pp. 11–14; W. Schivelbusch, *The Railway Journey: The Industrialization and Perception of Time and Space* (Berkeley, CA: University of California Press, 1987), pp. 43–4.

46 R. Hayward, *Where the River Shannon Flows* (London: George G. Harrap & Co. Ltd., 1949), p. 271.

47 'Approaching Completion: Rapid Progress of the Shannon Scheme: Final Stages of Work: The Navigation Lock', *Irish Independent*, 9 May 1929, p. 2, ESB Newspaper Clippings Book 05.

48 'Specifications for the 38kV Switch House and the Building between the Power House and the 38kV Switch House' in Shannon Power Development, 'Power House Design: Architectural and Buildings'.

49 'Progress of the Shannon Hydro-Electric Works: Special to the "Irish Builder and Engineer"', *The Irish Builder and Engineer*, 18 August 1928, pp. 697–8, ESB Newspaper Clippings Book 02; R.D. Gauld, 'The Progress of the Shannon Hydro-Electric Works', *The Irish Builder and Engineer*, 29 May 1926, pp. 414–18; 'The Progress of the Shannon Hydro-Electric Scheme', *The Irish Builder and Engineer*, 15 October 1927, pp. 753–4; 'The Shannon Scheme: An Incursion of Engineers', *The Irish Builder and Engineer*, 2 October 1926, pp. 745–6; 'The Shannon Scheme: Another Stage Reached', *The Irish Builder and Engineer*, 3 August 1929, pp. 689–90; 'Topical Touches', p. 601.

50 'Engineering News: The Institution of Civil Engineers in Ireland and the Shannon Scheme', *The Irish Builder and Engineer*, 3 May 1924, p. 406; 'Topical Touches', *The Irish Builder and Engineer*, 4 October 1924, p. 845; 'Untitled', *The Irish Builder and Engineer*, 8 January 1927, pp. 17–18; 'The State and Architecture', *The Irish Builder and Engineer*, 18 August 1928, pp. 709–10.

51 'Engineering Section: Economics of the Shannon Scheme', *The Irish Builder and Engineer*, 13 June 1925, p. 490; 'Topical Touches'.

Chapter 3

1 Letter from Siemens Head Office Berlin to Professor Rishworth, 31 August 1928, in Shannon Power Development, 'Power House Design: Architectural and Buildings' (National Archives of Ireland: SS 495, 1928).

2 A. Yaneva, *Mapping Controversies in Architecture* (Farnham: Ashgate, 2012).

3 K. Baynes and F. Pugh, *The Art of the Engineer: Two Hundred Years in the Development of Drawings for the Design of Transport on Land, Sea and Air* (Cardiff: Welsh Arts Council, 1978), p. 2.

4 K. Henderson, *On Line and on Paper: Visual Representations, Visual Culture, and Computer Graphics in Design Engineering* (Cambridge, MA: The MIT Press, 1999), p. 30; M. Frascari, J. Hale and B. Starkey (eds), *From Models to Drawings: Imagination and Representation in Architecture* (London: Routledge, 2007), p. 5.

5 P.J. Booker, *A History of Engineering Drawing* (London: Chatto & Windus, 1963), p. xv; L. Purbrick, 'Ideologically Technical: Illustration, Automation and Spinning Cotton around the Middle of the Nineteenth Century', *Journal of Design History*, 11:4 (1998), p. 281; L. Brasseur, *Visualising Technical Information: A Cultural Critique* (Amityville, NY: Baywood Publishing Company, 2003), pp. 47–55; M. Carpo, *Architecture in the Age of Printing: Orality, Writing, Typography and Printed Images in the History of Architectural Theory*, S. Benson (trans.) (Cambridge, MA: The MIT Press, 2001), pp. 7–9.

6 B. Starkey, 'Post-Secular Architecture: Material, Intellectual, Spiritual Models', in M. Frascari, J. Hale and B. Starkey (eds), *From Models to Drawings: Imagination and Representation in Architecture* (London: Routledge, 2007), pp. 231–3.

7 Baynes and Pugh, *The Art of the Engineer: Two Hundred Years in the Development of Drawings for the Design of Transport on Land, Sea and Air*, pp. 2–3, 9–10; Purbrick, 'Ideologically Technical: Illustration, Automation and Spinning Cotton around the Middle of the Nineteenth Century', p. 281.

8 Starkey, 'Post-Secular Architecture: Material, Intellectual, Spiritual Models', p. 234.

9 Baynes and Pugh, *The Art of the Engineer: Two Hundred Years in the Development of Drawings for the Design of Transport on Land, Sea and Air*, p. 6; Booker, *A History of Engineering Drawing*, p. 86; H. Powell and D. Leatherbarrow (eds), *Masterpieces of Architectural Drawing* (London: Orbis Publishing, 1982).

10 K. Gispen, 'The Long Quest for Professional Identity: German Engineers in Historical Perspective, 1850–1990', in P. Meiksins and C. Smith (eds), *Engineering Labour: Technical Workers in Comparative Perspective* (London: Verso, 1996), pp. 133–41; C. Smith and P. Whalley, 'Engineers in Britain: A Study in Persistence', in P. Meiksins and C. Smith (eds), *Engineering Labour: Technical Workers in Comparative Perspective* (London: Verso, 1996), pp. 35–7; Baynes and Pugh, *The Art of the Engineer: Two Hundred Years in the Development of Drawings for the Design of Transport on Land, Sea and Air*, p. 9; W. König, 'Science-Based Industry or Industry-Based Science? Electrical Engineering in Germany before World War I', *Technology and Culture*, 37:1, January 1996, p. 78; J. Dooge, 'Engineering Training and Education', in R.C. Cox (ed.), *Engineering Ireland* (Cork: Collins Press, 2006), pp. 40–50.

11 Baynes and Pugh, *The Art of the Engineer: Two Hundred Years in the Development of Drawings for the Design of Transport on Land, Sea and Air*, pp. 4–5.

12 A. Pérez-Gómez, 'Questions of Representation: The Poetic Origin of Architecture', in M. Frascari, J. Hale and B. Starkey (eds), *From Models to Drawings: Imagination and Representation in Architecture* (London: Routledge, 2007), p. 12; Brasseur, *Visualising Technical Information: A Cultural Critique*, pp. 47–55; Purbrick, 'Ideologically Technical: Illustration, Automation and Spinning Cotton around the Middle of the Nineteenth Century', p. 289.

13 The drawings discussed in this chapter are from sources including the ESB archive in Dublin, the Siemens Archive in Munich and the Shannon Power Development papers in the National Archives of Ireland, as well as Ardnacrusha power station, where the original

finished drawings are still used as references for civil engineering staff.

14 Powell and Leatherbarrow (eds), *Masterpieces of Architectural Drawing*, pp. 50–5.

15 Electricity Supply Board, *The Shannon Hydro-Electric Power Station: Reprinted from the Engineer* (Dublin: Electricity Supply Board, 1928); Purbrick, 'Ideologically Technical: Illustration, Automation and Spinning Cotton around the Middle of the Nineteenth Century', p. 275; Brasseur, *Visualising Technical Information: A Cultural Critique*, pp. 41–7, 56–64.

16 T. Porter, *The Architect's Eye: Visualization and Depiction of Space in Architecture* (London: E&FN Spon, 1997), pp. 104–6.

17 W. Dohme, *Kraftswerkhochbauten* (Berlin: Siemens-Schuckertwerke, 1925), p. 12.

18 Siemens–Schuckertwerke, 'The Shannon Scheme 1924 Drawings SSW' (Siemens Archive: 11139, 1924); S.S.J. Purser Griffith, *Notes on the Siemens-Schuckert Shannon Power Scheme as Expounded to the Dáil by the Minister for Industry and Commerce on the 19th December 1924* (Dublin: Saorstát Eireann, 1925).

19 Dáil Éireann, 'The Shannon Power Scheme – Statement by the Minister for Industry and Commerce', Vol. 9 (Dublin: The Stationery Office, 1924).

20 Starkey, 'Post-Secular Architecture: Material, Intellectual, Spiritual Models', p. 234.

21 Purser Griffith, *Notes on the Siemens-Schuckert Shannon Power Scheme as Expounded to the Dáil by the Minister for Industry and Commerce on the 19th December 1924*, pp. 7–8; W. Borgquist et al., *The Electrification of the Irish Free State: The Shannon Scheme: Report of the Experts Appointed by the Government*, 1925, McGilligan Papers, UCD Archive: P35/22.

22 Powell and Leatherbarrow (eds), *Masterpieces of Architectural Drawing*, p. 187. The drawings in Ardnacrusha power station include both positive and negative blueprints produced by Siemens Head Office, although there seems to be no trace of the original drawings in the Siemens Archive.

23 Booker, *A History of Engineering Drawing*, pp. 133, 71.

24 'Subject: Generating Station, Ardnacrusha. Description of the works for the construction of the Power House, dated Siemensstadt 25th Jan.28', letter from Wilhelm Fleischer to Dr P.W. Sothman, 26 March 1928 in Shannon Power Development, 'Power House Design: Architectural and Buildings'.

25 Baynes and Pugh, *The Art of the Engineer: Two Hundred Years in the Development of Drawings for the Design of Transport on Land, Sea and Air*, p. 9.

26 'Minutes of Meeting 25th November, 1925' in Shannon Power Development, 'Minutes of Meetings and Conferences' (National Archives of Ireland: SS 166, 1929).

27 'Power House Design', Letter from Rishworth to Siemens Limerick, 22 November 1926, in Shannon Power Development, 'Power House Design: Architectural and Buildings'.

28 'Shannon Scheme Ireland, Water Power Plant, Power Station and Intake Building', Letter from Wallem to Rishworth, 31 August 1928, in Shannon Power Development, 'Power House Design: Architectural and Buildings'.

29 'Power Station Buildings', Letter from Prendergast to Rishworth, 19 February 1927, in Shannon Power Development, 'Power House Design: Architectural and Buildings'.

30 'Power House Design', Letter from Rishworth to McGilligan, 21 September 1927, in Shannon Power Development, 'Power House Design: Architectural and Buildings'.

31 'Re: Power House Architecture', Letter from Ott & Uitting to Rishworth, 5 November 1927, in Shannon Power Development, 'Power House Design: Architectural and Buildings'.

32 'Re: Architecture Power Station', Letter from Ott & Uitting to Rishworth, 5 November 1927, in Shannon Power Development, 'Power House Design: Architectural and Buildings'.

33 Letter from Bach & Goffin to Prendergast & Rishworth, 31 May 1928, in Shannon Power Development, 'Power House Design: Architectural and Buildings'.

34 're: Power House', Letter from Bach & Goffin to Prendergast & Rishworth, 26 May 1928, in Shannon Power Development, 'Power House Design: Architectural and Buildings'.

35 're: Steel Superstructure of Power House', Letter from Bach & Goffin to Prendergast & Rishworth, 31 May 1928, in Shannon Power Development, 'Power House Design: Architectural and Buildings'. Dohme had previously expressed his preference for having all participants in a design process in one location, literally 'am Reißbrett' or 'at the drawing board', viewing development work by letter to be 'ein kümmerlicher Ersatz' or 'a miserable substitute'. Dohme, *Kraftswerkhochbauten*, p. 5.

36 'Power House Buildings', Letter from Rishworth to the Secretary, Department of Industry and Commerce, 26 June 1928, in Shannon Power Development, 'Power House Design: Architectural and Buildings'.

37 'Re: Power House', Letter from the Secretary, Department of Industry and Commerce to Rishworth, 5 July 1928, in Shannon Power Development, 'Power House Design: Architectural and Buildings'.

38 Letter from Gordon Campbell, Secretary, Department of Industry and Commerce to Rishworth, 25 June 1928, in Shannon Power Development, 'Power House Design: Architectural and Buildings'; 'Power House Buildings', Letter from Rishworth to the Secretary, Department of Industry and Commerce, 26 June 1928, in Shannon

Power Development, 'Power House Design: Architectural and Buildings'; 'Re: Power House', Letter from Gordon Campbell to Siemens Ireland, 3 July 1928, in Shannon Power Development, 'Power House Design: Architectural and Buildings'.

39 're: Steel Superstructure of Power House', Letter from Bach & Goffin to Prendergast & Rishworth, 31 May 1928, in Shannon Power Development, 'Power House Design: Architectural and Buildings'; 're: Power House. Your Letter of the 3.7.28', Letter from Uitting to Rishworth, 6 July 1928, in Shannon Power Development, 'Power House Design: Architectural and Buildings'; 're: Power House. Construction of Roof', Letter from Bach to Rishworth, 2 August 1928, in Shannon Power Development, 'Power House Design: Architectural and Buildings'; 're: Power House. Construction of Roof', Letter from Bach to Rishworth, 3 August 1928, in Shannon Power Development, 'Power House Design: Architectural and Buildings'; 'Shannon Scheme Ireland, Water Power Plant, Power Station and Intake Building', Letter from Wallem to Rishworth, 31 August 1928, in Shannon Power Development, 'Power House Design: Architectural and Buildings'.

40 'Power House – Roofs of Intake and Minor Buildings', Letter from Rishworth to Campbell, 17 September 1928, in Shannon Power Development, 'Power House Design: Architectural and Buildings'.

41 Dohme, *Kraftswerkhochbauten*, p. 5.

42 J.K. Brown, 'Design Plans, Working Drawings, National Styles: Engineering Practice in Great Britain and the United States, 1775–1945', *Technology and Culture*, 41:2, April 2000, pp. 195–238.

43 'Shannon Scheme Ireland, Water Power Plant, Power Station and Intake Building', Letter

from Wallem to Rishworth, 31 August 1928, in Shannon Power Development, 'Power House Design: Architectural and Buildings'.

44 'Power House – Roofs of Intake and Minor Buildings', Letter from Rishworth to Campbell, 17 September 1928, in Shannon Power Development, 'Power House Design: Architectural and Buildings'.

45 Powell and Leatherbarrow (eds), *Masterpieces of Architectural Drawing*, p. 50.

Chapter 4

1 'Das Shannon-Kraftwerk: Ein Grosswerk Deutscher Technik', *Berliner Volkzeitung*, 14 March 1929. Siemens Archive: 4068 German Newspapers. Original text reads: 'Noch im diese Jahre geht ein Grosswerk deutscher Technik im Ausland, das im Auftrage Irlands hergestellte Shannon-Kraftwerk, seiner Vollendung entgegen. In seinem baulichen Teil durch die Siemens-Bauunion bereits im wesentlichen fertiggestellt, wird es gegenwärtig von den Siemens-Schuckert-Werken mit den elektrischen Maschinen und Apparaten ausgestattet. Unser Bild gibt eine Gesamtansich der Baustelle, in deren Mittelpunkt die gewaltige Betonsperrmauer steht, die den Oberwasserkanal abschliesst und das noch im Bau begriffene Wasserschloss beträgt.'

2 Siemens-Schuckertwerke, 'Propaganda February–May 1927' (Siemens Archive: 2086, 1927).

3 A. Sekula, 'Reading an Archive: Photography between Labour and Capital', in J. Evans and S. Hall (eds), *Visual Culture: The Reader* (Milton Keynes: Open University, 1999), p. 191.

4 Siemens-Schuckertwerke, 'Lichtbilder W.R. Shannon Irland: Hafen, Strand Barracks, Verschiedenes 1926–1930' (Siemens Archive: A700, 1930).

5 'Re: Propaganda', Letter from Siemens Dublin to Siemens Head Office, 6 May 1927, in Siemens-Schuckertwerke, 'Propaganda February–May 1927'.

6 'Photoapparat und Zubehör', Typed copies of letter sent to Werkstätte für Chemie & Photographie, L.G. Kleffel & Sohn, Grass & Worff, 12 May 1927, in Siemens-Schuckertwerke, 'Propaganda February–May 1927'; 'Betr.: AZA/Wo. Photoapparat und Zubehör', Letter from L.G. Kleffel & Sohn to Siemens-Schuckertwerke, 13 May 1927, in Siemens-Schuckertwerke, 'Propaganda February–May 1927'; 'Betr. AZA/WO Photoapparat und Zubehör', Letter from Grass & Worff to Siemens Berlin, 16 May 1927, in Siemens-Schuckertwerke, 'Propaganda February–May 1927'; 'Betr. AZA/WO Photoapparat und Zubehör', Letter from Werkstatte fur Chemie und Photographie to Siemens Berlin, 17 May 1927, in Siemens-Schuckertwerke, 'Propaganda February–May 1927'; 'Betr. Photoapparat und Zubehör', Letter from L.G. Kleffel & Sohn to Siemens-Schuckertwerke, 20 May 1927, in Siemens-Schuckertwerke, 'Propaganda February–May 1927'.

7 Shannon Power Development files also include a letter from Sothmann to the Department of Industry & Commerce dated August 1928, requesting the appointment of an official photographer and the purchase of two cameras, one of which was to be used at Ardnacrusha to provide a record of Siemens workmanship, should any disputes arise, as well as providing a 'valuable historical record'. A March 1929 letter from Wilhelm Fleischer, a Norwegian mechanical engineer working for the ESB in Limerick, states that he had taken 131 photographs with 17 'films and prints' not yet sent in. These photographs have not been identified in any archive, and Fleischer proposed retaining the negatives to allow him to easily supply reprints, although he resigned and

returned to Norway in July 1929. See Letter from Sothmann, Chief Electrical Engineer to Establishment Officer, Department of Industry & Commerce, 28 August 1928, in Shannon Power Development, 'Supplies: Instruments and Technical Equipment' (National Archives of Ireland: SS 5027, 1928); 'Ardnacrusha, Erection Work. Photographs for Fleischer's reports sent to Dr. Sothmann, Nos. 1–131 inclusive', Letter from Wilhelm Fleischer to Mr. Flanagan, Shannon Power Development, 8 March 1929, in Shannon Power Development, 'Staff: Hans Jenny & Wilhelm Fleischer' (National Archives of Ireland: SS 5029, 1929); Letter from Shannon Power Develeopment to Messrs. Lafayette, Westmoreland Street, Dublin, 7 November 1929, in Shannon Power Development, 'Staff: Hans Jenny & Wilhelm Fleischer'.

8 The prints were identified as silver gelatin using the method outlined in B. Coe and M. Haworth-Booth, *A Guide to Early Photographic Processes* (London: Victoria & Albert Museum, 1983), pp. 14, 22–3.

9 'Re: Propaganda', Letter from Siemens Dublin to Siemens Head Office, 6 May 1927, in Siemens-Schuckertwerke, 'Propaganda February–May 1927'. On comparison with other correspondence in the Siemens Archive, the signature on the letter seems to have been initialled by Herr Dr Ott (see 'Betr. Krafthous Elektrishers Teil', Memo from Dr Ott, Herr Wechler and Herr Uitting to A.Z.A Berlin, 28 June 1927, in Siemens-Schuckertwerke, 'Correspondence June–August 1927' (Siemens Archive: 2051, 1927) for Ott's signature).

10 Herr Wechler decided to stay on after the completion of the Scheme and was facilitated by the ESB, which put him in charge of its new accounting department. Although he gained some later notoriety as a member of the Nazi Party, he lived in Dublin until his death in 1943. See D. O'Donoghue, 'Heil Hibernia', *Sunday Business Post*, 6 May 2001, p. 64; G. O'Beirne, *Siemens in Ireland 1925–2000: Seventy Five Years of Innovation* (Dublin: A&A Farmar, 2000). At least two other engineers involved with the project owned cameras, the German Herr Uitting, working for Siemens, and the Norwegian Wilhelm Fleischer working for Shannon Power Development, although only one of Uitting's photographs has survived in the Haselbeck collection in the ESB Archive, and none of Fleischer's. S. O'Brien, 'Interview with Patricia Haselbeck, Grand-Daughter of Franz Haselbeck' (Hunt Museum, Limerick, 2010), Shannon Power Development, 'Staff: Hans Jenny & Wilhelm Fleischer'.

11 The iconic photograph of Brunel in front of the Great Eastern ocean liner was taken by photographer Robert Howlett in 1857, moving photography out of the studio and onto the industrial site. See P. Fara, 'Engineering Fame: Isambard Kingdom Brunel', *Endeavour*, 30:3, September 2003, pp. 90–1; R. Sachsse, 'Made in Germany as Image in Photography and Design', *Journal of Popular Culture*, XXXIV:3, 2000, pp. 43–58; R. Hoozee (ed.), *British Vision: Observation and Imagination in British Art 1750–1950* (Ghent: Mercatorfonds, Museum voor Schone Kunsten, 2008), pp. 92–3.

12 The Harland & Wolff shipyard in Belfast employed a professional photographer to record the construction of its ships, which included the Titanic and its sister liners Olympic and Britannic. During the 1920s, their photographer was Robert Welch, who ran a photographic business in Belfast and produced a large number of photographs of the flora, fauna, antiquities, towns and industries of Ulster. He was particularly noted for his photographs of natural history, having received an honorary

Material Memories: Design and Evocation (Oxford: Berg, 1999), p. 222.

Chapter 5

1 Letter from Edith Meissner to Hannelore Thierauf, Irish Tourist Board, 16 June 1992 in 'Edith Meissner' (ESB Archive: 1992).

2 A. Sekula, 'Reading an Archive: Photography between Labour and Capital', in J. Evans and S. Hall (eds) *Visual Culture: The Reader* (Milton Keynes: Open University, 1999), p. 183. The Rampf photographs were donated to the ESB Archive by his daughter Edith Meissner in 1992 via the Irish Tourist Board, and the Haselbeck photographs were donated by his granddaughter Patricia Haselbeck in 2010.

3 M. Maguire, 'Socialists, Savages and Hydroelectric Schemes: A Historical Anthropological Account of the Construction of Ardnacrusha', *Irish Journal of Anthropology*, 3, 1998, pp. 61–5; M. McCarthy, 'The Shannon Scheme Strike', *Old Limerick Journal*, 4, 1980, pp. 21–6; M. McCarthy, *High Tension: Life on the Shannon Scheme* (Dublin: The Lilliput Press, 2004), pp. 16–45, 60–3; Report on the Labour Situation on the Shannon in S. Schuckertwerke, 'Correspondence 1925 October–November' (Siemens Archive, 1925).

4 McCarthy, *High Tension: Life on the Shannon Scheme*, pp. 65–75; Shannon Power Development, 'Minutes of Meetings and Conferences' (National Archives of Ireland: SS 166, 1929).

5 C.F. Sabel, *Work and Politics: The Division of Labour in Industry* (Cambridge: Cambridge University Press, 1982), p. 23.

6 McCarthy, *High Tension: Life on the Shannon Scheme*, pp. 65–75; 'The Shannon Scheme: Rapid Progress Made', *Irish Independent*, 20 August 1926, p. 4.

7 Landed Estates Database, 'House: Doonass', *NUI Galway* <http://landedestates.nuigalway. ie/LandedEstates/jsp/property-show. jsp?id=2034> Accessed 12 January 2017.

8 'The Camps on the Building Sites of the Shannon Scheme', *Siemens: Progress on the Shannon*, 1:4, January 1927, p. 16.

9 T. Benton, 'Building Utopia', in C. Wilk (ed.), *Modernism 1914–1939: Designing a New World* (London: V&A Publications, 2006).

10 'The Camps on the Building Sites of the Shannon Scheme', pp. 14–16.

11 Maguire, 'Socialists, Savages and Hydroelectric Schemes: A Historical Anthropological Account of the Construction of Ardnacrusha', pp. 65–6; M. McCarthy, 'How the Shannon Workers Lived', in A. Bielenberg (ed.), *The Shannon Scheme and the Electrification of the Irish Free State: An Inspirational Milestone* (Dublin: Lilliput Press, 2002), pp. 51–66; McCarthy, *High Tension: Life on the Shannon Scheme*, pp. 77–92.

12 'The Camps on the Building Sites of the Shannon Scheme', pp. 13–16.

13 Letter from Edith Meissner to Hannelore Thierauf, Irish Tourist Board, 16 June 1992 in 'Edith Meissner'. Rampf is listed in the Siemens files as a dredger operator, with a visa expiring on 24 May 1929. McCarthy, *High Tension: Life on the Shannon Scheme*, p. 276.

14 B. Coe and M. Haworth-Booth, *A Guide to Early Photographic Processes* (London: Victoria & Albert Museum, 1983), p. 16.

15 M. Alvarado, 'Photographs and Narrativity (1979–80)', in M. Alvarado, E. Buscombe and R. Collins (eds), *Representation and Photography: A Screen Education Reader* (Hampshire: Palgrave, 2001), pp. 151–2.

16 Letter from Edith Meissner to Hannelore Thierauf, Irish Tourist Board, 16 June 1992 in 'Edith Meissner'.

17 E. Edwards, 'Photographs as Objects of Memory', in J. Aynsley, C. Breward and M. Kwint (eds), *Material Memories: Design and Evocation* (Oxford: Berg, 1999), p. 233.

18 McCarthy, *High Tension: Life on the Shannon Scheme*, pp. 110–26, 240–55; R. Volti, *An Introduction to the Sociology of Work and Occupation* (Thousand Oaks, CA: Sage, 2012), p. 141.

19 Volti, *An Introduction to the Sociology of Work and Occupation*, p. 142.

20 *Ibid.*, p. 134.

21 E. Wenger, *Communities of Practice: Learning, Meaning and Identity* (Cambridge: Cambridge University Press, 1998), pp. 1–2.

22 *Ibid.*, pp. 51–6.

23 Meissner's annotation reads 'Abschied von meinen Stubenkollegen Engel aus Berlin! Und so wohne ich allein' which translates as 'Farewell to my colleague Engel from Berlin! And now I am living alone.' Franz Engel is listed in the Siemens files as an excavation foreman. McCarthy, *High Tension: Life on the Shannon Scheme*, p. 275.

24 H. Alberry 'Great Undertakings: A Visit to the Shannon Scheme', *The Irish Builder and Engineer*, 8 June 1929, p. 498.

25 Alberry, 'Great Undertakings: A Visit to the Shannon Scheme', pp. 73–9.

26 P. Haselbeck Flynn, *Fond Memories Bring the Light …: The Photography of Franz Sebastian Haselbeck 1885–1973* (Limerick: Hunt Museum, 2010), p. 31; S. O'Brien, 'Interview with Patricia Haselbeck, Grand-Daughter of Franz Haselbeck' (Hunt Museum, Limerick, 2010); P. Haselbeck Flynn, *Franz S. Haselbeck's Ireland: Selected Photographs* (Cork: Collins Press, 2013), pp. 1-3. He is recorded in the 1911 census as Francis Haselbeck, a 26-year-old Church of Ireland photographer, living with his mother and five younger siblings at 77 Colooney Street (now Wolfe Tone Street) in Limerick city centre. 'Residents of a House 77 in Colooney Street (Limerick Urban No. 4, Limerick)', National Archives of Ireland <http://www.census.nationalarchives.ie/reels/nai002759206/> Accessed: 12 January 2017.

27 Metropolitan School of Art, 'Index Register of Payments by Students, School of Art, for the Session 1903–04' (NIVAL: NCAD College Register 1903–04, 1904); L. Anthony, 'Reference Letter for F. Haselbeck' (ESB Archive Haselbeck Collection: 1912). Franz is recorded here as Frederick.

28 The employment situation in Limerick in the 1910s and 1920s is discussed in M. Mastriani, 'From Crubeens to Computer Chips: Limerick's Industrial Development, 1914–2003', in D. Lee (ed.), *Made in Limerick: History of Industries, Trade and Commerce Vol. I* (Limerick: Limerick Civic Trust, 2003), pp. 72–3.

29 Of over a thousand glass negatives in the collection, twenty-four negatives and seventy-five prints clearly depict elements of the Shannon Scheme. Some of the images are present as both negative and print, giving a total of seventy-three different images. Several of these are reproduced in Haselbeck Flynn, *Franz S. Haselbeck's Ireland: Selected Photographs*, pp. 108–15.

30 Haselbeck Flynn, *Fond Memories Bring the Light …: The Photography of Franz Sebastian Haselbeck 1885–1973*; Haselbeck Flynn, *Franz S. Haselbeck's Ireland: Selected Photographs*, pp. 108-115.

31 R.A. Stebbins, *Amateurs: On the Margin between Work & Leisure* (London: SAGE Publications, 1979), pp. 36–7.

32 E. Lingo and S. Tepper, 'Looking Back, Looking Forward: Arts-Based Careers and Creative Work', *Work and Occupations*, 40:4, 2013, pp. 340–51.

33 J. Turpin, *A School of Art in Dublin since the 18th Century: A History of the National College of Art and Design* (Dublin: Gill & Macmillan, 1995).

34 See Chapter 4, and Siemens Photograph No. 1331, page 23, Siemens Album A705, Siemens Archive, which shows the 'topping out' ceremony, the traditional builder's rite on the placing of the last beam in a new structure.

35 Wenger, *Communities of Practice: Learning, Meaning and Identity*, pp. 73–9.

Chapter 6

1 'The Future of Electricity', *Dundalk Democrat*, 15 September 1928, ESB Newspaper Clippings Book 02.

2 Dáil Éireann, 'Orders of the Day. Money Resolution – Electricity Supply Bill, 1927', Vol. 19 (Dublin: The Stationery Office, 1927); L. Schoen, 'The Irish Free State and the Electricity Industry, 1922–1927', in A. Bielenberg (ed.), *The Shannon Scheme and the Electrification of the Irish Free State: An Inspirational Milestone* (Dublin: The Lilliput Press, 2002), pp. 44–5.

3 A. Forty, *Objects of Desire: Design and Society since 1750* (London: Thames & Hudson, 1986), pp. 182–206.

4 Electricity Supply Board, 'Annual Report and Accounts of the Electricity Supply Board (for the Year 1st April 1928 to 31st March 1929)' (ESB Archive: 1929), p. 12; A. Webb, 'Free State Seeks Electricity Users: Needs Treble Present Number to Make the $20,000,000 Shannon Project Pay', *New York Times*, 25 March 1928, p. 57.

5 There is some dispute as to whether Lawler was appointed before or after Stephen Tallents to the British Empire Marketing Board, making him the first Public Relations Officer to a public utility in the British Isles. E. Gunning, *Public Relations: A Practical Handbook* (Dublin: Gill & Macmillan, 2003), p. 4. Delany states that 'Lawlor [*sic*]' was appointed before Tallents, based on a reference to Michael Colley, who states that he was appointed 'months' before Tallents, although Colley does not give a source for this information. B. Delany, 'McLaughlin, the Genesis of the Shannon Scheme and the ESB', in A. Bielenberg (ed.), *The Shannon Scheme and the Electrification of the Irish Free State: An Inspirational Milestone* (Dublin: The Lilliput Press, 2002), p. 18; M. Colley, *The Communicators: The History of the Public Relations Institute of Ireland* (Dublin: Public Relations Institute of Ireland, 1993), p. 17. Oram also describes Lawler's appointment as 'the first such appointment in a public utility in Europe'. See H. Oram, *The Advertising Book: The History of Advertising in Ireland* (Dublin: MO Books, 1986), p. 49.

6 Oram, *The Advertising Book: The History of Advertising in Ireland*, pp. 45, 48–9.

7 'The Whispering Gallery: Advertising the Shannon Scheme', *Advertising World*, November 1931, p. 344, ESB Newspaper Clippings Book 18.

8 Electricity Supply Board, 'Annual Report and Accounts of the Electricity Supply Board (for the Year 1st April 1928 to 31st March 1929)'; M. Manning and M. McDowell, *Electricity Supply in Ireland: The History of the E.S.B.* (Dublin: Gill & Macmillan, 1984), pp. 77–9.

9 Thirty-two staff were employed in Sales, Contracts and Public Relations (excluding electricians) by March 1929. See Electricity Supply Board, 'Annual Report and Accounts of the Electricity Supply Board (for the Year 1st April 1928 to 31st March 1929)', p. 21. Frank Brandt exhibited three paintings in the 1920 Oireachtas Art Exhibition and married the better known artist Muriel Brandt in 1935. See T. Snoddy, *Dictionary of Irish Artists: 20th Century* (Dublin: Merlin Publishing, 2002), p. 46; Oram, *The Advertising Book: The History of Advertising in Ireland*, pp. 50, 71, 74; A. Stewart, *Royal Hibernian Academy List of Exhibitors: Vol. 1 A-G* (Dublin: Manton Publishing, 1985), p. 80.

10 The first Irish radio station 2RN only began broadcasting in 1926 and was yielding miniscule advertising revenues during the late 1920s. Oram,

The Advertising Book: The History of Advertising in Ireland, pp. 4, 29; T.R. Nevett, Advertising in Britain: A History (London: Heinemann, 1982), p. 4; M. McCarthy, 'Advertising Ireland: Newspaper Advertisements, 1922–60', Inventing and Reinventing the Gendered Consumer from the Early Modern to Postmodern Periods (University of Limerick, 2010); J. Horgan, Irish Media: A Critical History since 1922 (London: Routledge, 2001), pp. 20–1.

11 Nevett, Advertising in Britain: A History, pp. 156–8; Oram, The Advertising Book: The History of Advertising in Ireland, p. 4.

12 C. Kenny, 'O Say Can You See? Irish Advertising Agents Look to America, 1895–1936', Irish Communications Review, 15:1, 2016, pp. 12–41; Nevett, Advertising in Britain: A History, p. 150; M. Tungate, Adland: A Global History of Advertising (London: Kogan Page Publishers, 2007), pp. 25–7; B. Whelan, 'American Influences on Irish Advertising and Consumerism 1900–1960: Fashioning Irishwomen', Journal of Historical Research in Marketing, 6:1, 2014, pp. 163–5.

13 F. Corr, The Publicity Club of Ireland 1923–1998 (Dublin: MO Publications, 1998), pp. 5, 13.

14 'Publicity for Ireland: Advertisers' Dublin Visit', Irish Independent, 18 October 1930, p. 11, ESB Newspaper Clippings Book 16; M.A. Lavery, 'Some "Don'ts" for Advertisers: Advertising to the Irish Provinces: How to Reach the Agricultural Market', Advertiser's Weekly, 17 October 1930, p. 26, ESB Newspaper Clippings Book 16.

15 I. Furlong, Irish Tourism 1880–1980 (Dublin: Irish Academic Press, 2009), pp. 38–41; E. Zuelow, Making Ireland Irish: Tourism and National Identity since the Irish Civil War (Syracuse, NY: Syracuse University Press, 2009), p. 7.

16 Furlong, Irish Tourism 1880–1980, p. 46.

17 J.P. O'Brien, '"Ireland of the Welcomes": Tourist Development in the Irish Free State', Advertiser's Weekly, 17 October 1930, p. 18, ESB Newspaper Clippings Book 16; Furlong, Irish Tourism 1880–1980, p. 46; W. Nutting, Ireland Beautiful (Garden City, NY: Garden City Publishing Co, 1925), pp. 63–6.

18 B. O'Connor, 'Myths and Mirrors: Tourist Images and National Identity', in B. O'Connor and M. Cronin (eds), Tourism in Ireland: A Critical Analysis (Cork: Cork University Press, 1993), pp. 70–4; A. Mehegan, '"Pictures from the Wilds": Trains, Travels and Tourists in County Donegal, 1890–1914' (MA Thesis, National College of Art & Design, 2003), pp. 71–81, 143–4.

19 K. Haldane Grenier, Tourism and Identity in Scotland, 1770–1914: Creating Caledonia (Hampshire: Ashgate, 2005), pp. 93–134; Zuelow, Making Ireland Irish: Tourism and National Identity since the Irish Civil War, pp. 4–5; Furlong, Irish Tourism 1880–1980, p. 49; R. Lenman, 'British Photographers and Tourism in the Nineteenth Century', in D. Crouch and N. Lübbren (eds), Visual Culture and Tourism (Oxford: Berg, 2003), pp. 94–6.

20 S.J. Eskilson, Graphic Design: A New History (London: Laurence King, 2007), p. 58; C. Kenny, '"The Advertising Problem": An Irish Solution of 1910', Journal of Historical Research in Marketing, 6:1, 2014, p. 118.

21 Lavery, 'Some "Don'ts" for Advertisers: Advertising to the Irish Provinces: How to Reach the Agricultural Market', p. 24, ESB Newspaper Clippings Book 16. The earliest photographic advertisement I found in my survey of the Limerick Leader 1924–1932 was an advertisement for Sweet Afton cigarettes, published on Saturday 16 July 1927, p. 2, although the majority of advertisements remained drawn by hand through the period surveyed.

22 'Shannon Scheme and an Experimental Farm', Limerick Leader, 12 November 1928, p. 11, ESB

Newspaper Clippings Book 02; 'The Shannon Scheme: 500 Louth People See the Big Work: A Successful Excursion', *Dundalk Democrat*, 18 May 1929, ESB Newspaper Clippings Book 05; 'Electric Lighting: In the Home, Shop and Factory: Why a Two-Part Tariff Is Necessary: Lectures in Tralee', *Kerryman*, 8 March 1930, ESB Newspaper Clippings Book 12; Electricity Supply Board, 'Annual Report and Accounts of the Electricity Supply Board (for the Year 11th August 1927 to 31st March 1928)' (ESB Archive: 1929).

23 Prior to the organisation of the daily travel deal advertised in these posters, permits to view the Scheme could be acquired from the Resident Engineer, J. Prendergast, at Strand Barracks, and were only issued for Thursday and Saturday afternoons, and Sundays. *Limerick City Directory 1928* (Limerick: George McKern & Sons, 1928), p. 108. 'Funeral of L T Joye', *Irish Independent*, 13 March 1939, p. 5; 'Mr. Laurence T. Joye', *The Irish Press*, 11 March 1939, p. 7; 'Col. L.T. Joye: Funeral Tribute', *Sunday Independent*, 12 March 1939; 'Exhibition of Model, Town Hall, Waterford', *Waterford Star*, October 1929; 'Shannon Scheme Model: Kells Firm's Enterprise Appreciated', *Meath Chronicle*, 9 November 1929, p. 1, ESB Newspaper Clippings Book 10; '"Irish Independent's" Shannon Scheme Model', *Irish Independent*, 8 May 1929, p. 3, ESB Newspaper Clippings Book 05; 'Visit to Shannon Scheme Works: Kilkenny Mayor's Generous Hospitality: Enjoyable and Instructive Outing', *Kilkenny People*, 13 July 1929, ESB Newspaper Clippings Book 06; 'Shannon Scheme Visitors, 32,076', *Irish Independent*, 6 October 1928, p. 7, ESB Newspaper Clippings Book 02; S. O'Brien, 'Interview with Lar Joye, Grand-Son of Laurence Joye' (National Museum, Collins Barracks, 2010).

24 'Electricity Board's Campaign: Lectures in the Free State', *The Irish Times*, 23 November 1928,

p. 11, ESB Newspaper Clippings Book 03; 'Shannon Scheme: Important Lecture at Sligo Congress: Economic Features and Advantages', *Cork Examiner*, 13 June 1929, ESB Newspaper Clippings Book 05; 'Shannon Scheme Lecture', *Evening Mail*, 17 October 1929, ESB Newspaper Clippings Book 06; 'The Shannon Scheme: Kells Lecture on Topical Subject', *Drogheda Independent*, 16 November 1929, ESB Newspaper Clippings Book 10.

25 'The Shannon Scheme: Another Stage Reached', *The Irish Builder and Engineer*, 3 August 1929, p. 690.

26 M. Kelly, 'The Role of Advertising in the Establishment and Early Development of a Semi-State Company' (MA Thesis, Dublin City University, 2003), pp. 43–4.

27 Electricity Supply Board, 'Annual Report and Accounts of the Electricity Supply Board (for the Year 11th August 1927 to 31st March 1928)', p. 18; 'The Whispering Gallery: Advertising the Shannon Scheme', p. 344, ESB Newspaper Clippings Book 18.

28 The second advertisement appeared in *The Irish Times* and the *Irish Independent* on 26 July, and the *Cork Examiner* on 27 July 1928.

29 The closest match is Siemens industrial photograph number 809, which was taken the previous February and shows the concrete construction of the station at a similar stage, as well as the wooden shuttering on the entrance holes for the first two penstocks, and at the bottom of the image, the arches which will become the outflow channels under the turbine hall.

30 There are actually at least four tiny figures included near the bottom of the outflow channel arches, but they would have been barely visible when reproduced at the scale of a newspaper, if at all.

31 D.E. Nye, *American Technological Sublime* (Cambridge, MA: The MIT Press, 1994), p.

116; T.P. Hughes, *Human-Built World: How to Think About Technology and Culture* (Chicago, IL: University of Chicago Press, 2005), pp. 26–36, 144–72.

32 Nye, *American Technological Sublime*, pp. 133–42; H. Adams, *The Education of Henry Adams* (Raleigh, NC: Hayes Barton Press, 1999), pp. 291–9.

33 The Labour Party had bowed to nationalism in the elections of 1918 and 1921 in making the decision to 'step back' and allow the election essentially to be fought along Treaty lines. This allowed 1916 revolutionary James Connolly to be assimilated into the nationalist pantheon of dead heroes, his Marxist writings and theories played down or forgotten. In combination with infighting within the Irish Congress of Trade Unions, organised labour slipped from the public eye in the late 1910s and early 1920s, a position that it subsequently found extremely difficult to change. N. Puirséil, *The Irish Labour Party 1922–73* (Dublin: University College Dublin Press, 2007), pp. 9–13; D. Howell, *A Lost Left: Three Studies in Socialism and Nationalism* (Manchester: Manchester University Press, 1986), pp. 17–154; T. Brown, *Ireland: A Social and Cultural History 1922–2002*, 2nd edn (London: Harper Perennial, 1985), pp. 91–5; S. Hutton, 'Labour in the Post-Independence Irish State', in S. Hutton and P. Stewart (eds), *Ireland's Histories: Aspects of State, Society and Identity* (London: Routledge, 1991), pp. 52–6.

34 A. Mitchell, *Labour in Irish Politics, 1890–1930: The Irish Labour Movement in the Age of Revolution* (Dublin: Irish University Press, 1974), p. 36.

35 An IFSR delegation visited Russia in 1930, which included Kernoff, Gonne McBride, Charlotte Despard and Hanna Sheehy-Skeffington, whom May Keating worked for as a secretary, although she was not part of the Russian trip. Kernoff exhibited Russian propaganda posters in Daniel Egan's Dublin gallery in October 1930. V. Bonnell, *Iconography of Power. Soviet Political Posters under Lenin and Stalin* (Berkeley, CA: University of California Press, 1999), pp. 23–63; É. O'Connor, *Seán Keating – Art, Politics and Building the Irish Nation* (Dublin: Irish Academic Press, 2013), pp. 92–3.

36 P.J. Mathews, *Revival: The Abbey Theatre, Sinn Féin, the Gaelic League and the Co-Operative Movement* (Cork: Cork University Press, 2003), pp. 2–9.

37 Electricity Supply Board, 'Annual Report and Accounts of the Electricity Supply Board (for the Year 11th August 1927 to 31st March 1928)'.

38 This is borne out by an unaddressed letter in the ESB Archive, which requests the repetition of 'the last advertisement in this week's issue of your paper'. Unaddressed letter from E.A. Lawler, 11 November 1928, ESB Newspaper Clippings Book 19 (December 1931 to July 1932) (ESB Archive: 1932).

39 Brewster had trained at the Dublin Metropolitan School of Art, initially as a day student, but continued sporadic evening classes after beginning work as an illustrator for his father at Independent Newspapers. He exhibited two works in the RHA annual show in 1916 and one in 1917, with his address given as Independent Newspapers Art Department. Metropolitan School of Art, 'Index Register of Payments by Students, School of Art, for the Session 1904–05' (NIVAL: NCAD College Register 1904–05, 1905); Metropolitan School of Art, 'Index Register of Payments by Students, School of Art, for the Session 1905–06' (NIVAL: NCAD College Register 1905–06, 1906); Metropolitan School of Art, 'Index Register of Payments by Students, School of Art, for the Session 1906–07' (NIVAL: NCAD College Register 1906–07, 1907); Metropolitan School of Art, 'Index Register of Payments by

Students, School of Art, for the Session 1908–09' (NIVAL: NCAD College Register 1908–09, 1908); Metropolitan School of Art, 'Index Register of Payments by Students, School of Art, for the Session 1909–10' (NIVAL: NCAD College Register 1909–10, 1910); Metropolitan School of Art, 'Index Register of Payments by Students, School of Art, for the Session 1911–12' (NIVAL: NCAD College Register 1911–12, 1912); Snoddy, *Dictionary of Irish Artists: 20th Century*, pp. 50–1; Oram, *The Advertising Book: The History of Advertising in Ireland*, pp. 50, 71, 74; G. Brewster, 'The Gordon Brewster Collection' (National Library of Ireland: PD 2199, 1946); Stewart, *Royal Hibernian Academy List of Exhibitors: Vol. 1 A-G*, p. 81.

40 For example, see H. Campbell, 'Irish Identity and the Architecture of the New State', in A. Becker, J. Olley and W. Wang (eds), *20th Century Architecture: Ireland* (Munich: Prestel, 1997), p. 84; Colley, *The Communicators: The History of the Public Relations Institute of Ireland*, p. 16.

41 For example, see M.A. Hutton, *The Táin*, 2nd edn (Dublin: The Talbot Press, 1924); H. O'Kelly, 'Reconstructing Irishness: Dress in the Celtic Revival, 1880–1920', in J. Ash and E. Wilson (eds), *Chic Thrills: A Fashion Reader* (Berkeley, CA: University of California Press, 1993), pp. 75–83.

42 R.F. Foster, *Modern Ireland 1600–1972* (London: Allen Lane, 1988), p. 538.

43 The horse has been used as symbol for power and energy in a number of contexts, including by the Italian Futurist Umberto Boccioni, although in his 1910 painting *The City Rises* it is more a symbol of the metaphorical energy of the modern city, than the literal energy of electricity.

44 E. O'Curry, *On the Manners and Customs of the Ancient Irish, Vol. 2* (Dublin: Williams and Norgate, 1873), p. 144.

45 Although the charioteer in this advertisement does contain a symbolic reference to Roman charioteers such as Ben Hur, the eponymous hero of the film shown in Irish cinemas the previous November, his headband and the scrolling decoration on his chariot and cloak allowed him to be much more closely identified with figures from Celtic legends such as Cúchulainn and the Red Branch Knights. 'Advertisement for Ben Hur', *Limerick Leader*, 26 November 1927, p. 1; Kelly, 'The Role of Advertising in the Establishment and Early Development of a Semi-State Company', pp. 43–4.

46 M. Macdonald, 'Anima Celtica: Embodying the Soul of the Nation in 1890s', in T. Cusack and S. Bhreathnach-Lynch (eds), *Art, Nation and Gender: Ethnic Landscapes, Myths and Mother-Figures* (Aldershot: Ashgate, 2003), pp. 29–37; C. Ashby, 'Nation Building and Design: Finnish Textiles and the Work of the Friends of Finnish Handicrafts', *Journal of Design History*, 23:4, 2010, pp. 360–1.

47 J. Sheehy, *The Celtic Revival: The Rediscovery of Ireland's Past 1830–1930* (London: Thames & Hudson, 1980); N. Gordon Bowe and E. Cumming, *The Arts & Crafts Movements in Dublin & Edinburgh, 1880–1930* (Dublin: Irish Academic Press, 1998); J. Lee, *Ireland 1912–1985 Politics and Society* (Cambridge: Cambridge University Press, 1989), p. 651; Foster, *Modern Ireland 1600–1972*, pp. 446–56; Brown, *Ireland: A Social and Cultural History 1922–2002*, pp. 45–78; F. Kinahan, 'Douglas Hyde and the King of the Chimps: Some Notes on the De-Anglicizing of Ireland', in T.J. Edelstein, R. Born and S. Taylor (eds), *Imagining an Irish Past: The Celtic Revival 1840–1940* (Chicago, IL: The David and Alfred Smart Museum of Art, University of Chicago, 1992), pp. 64–79.

48 Letter from Lindsay Crawford, Free State Trade Agent, New York to Gordon Campbell, 16 April 1926 in P. McGilligan, 'Letters' (McGilligan Papers, UCD Archive: P35/29, 1926); letter from Thomas McLaughlin to Patrick McGilligan, 23 December 1929 in P. McGilligan, 'Progress of Works; Quarterly Reports' (McGilligan Papers, UCD Archive: P35/51, 1929); 'Shannon Power in Cork: Electricity for Ford Works', *The Irish Times*, 18 December 1929; 'Shannon Scheme: Laying Cables to the Fordson Factory', *Cork Examiner*, 18 December 1929; 'Shannon to Flow That Fords May Go: Famous River to Build Famous Cars in Cork Factory after Tonight', *Boston Transcript*, 10 February 1930.

49 Henry Ford was the son of a Corkman, and the Irish division of the Ford company opened a factory in Cork in 1917, which resumed Fordson tractor production after the hiatus of the Civil War in 1929. 'Electrifying Shannon Gives Free State Vim: Crop of New Factories Arise Following the Lead of Henry Ford in Cork', *Christian Science Monitor*, 11 May 1929.

50 This same strategy is pointed out in later Irish advertisements in L. King, '(De)Constructing the Tourist Gaze: Dutch Influences and Aer Lingus Tourism Posters, 1950–1960', in L. King and E. Sisson (eds), *Ireland, Design and Visual Culture: Negotiating Modernity 1922–1992* (Cork: Cork University Press, 2011), p. 186.

51 It does not precisely match with any of the Siemens photographs of German steamers unloading at Limerick docks, although several photographs in Siemens album A700 show very similar scenes taken in March 1926. See unnumbered photographs on pages 8–10, and photograph numbers 116–122, on pages 10 to 13 Siemens-Schuckertwerke, 'Lichtbilder W.R. Shannon Irland: Hafen, Strand Barracks, Verschiedenes 1926–1930' (Siemens Archive: A700, 1930).

52 Letter from Siemens Berlin to Siemens H.O. Dublin, 28 May 1927, in Siemens-Schuckertwerke, 'Propaganda February–May 1927' (Siemens Archive: 2086, 1927); R.D. Gauld, 'The Progress of the Shannon Hydro-Electric Works', *The Irish Builder and Engineer*, 29 May 1926, p. 414.

53 D.J. Lee, 'Skill, Craft and Class: A Theoretical Critique and a Critical Case', *Sociology*, 15, 1981, pp. 56–8; D. Spencer, 'Braverman and the Contribution of Labour Process Analysis to the Critique of Capitalist Production – Twenty-Five Years On', *Work Employment Society*, 14, 2000, pp. 223–4.

54 Similar advertisements were run in the Irish newspapers by Cumann na nGaedheal during the 1927 General Election campaign, using text-only advertisements to exhort voters to return the sitting government to office. For example, see 'Cumann na nGaedheal election advertisement', *The Irish Times*, 7 June 1927, p. 4.

55 'Progress Advertisement', *The Irish Times*, 27 September 1928, p. 8; 'Progress Advertisement', *The Irish Builder and Engineer*, 5 January 1929.

56 The image in the 'Digging 4,000 tons a day' advertisement is very similar to Siemens photograph no. 383, taken on 21 November 1926, and the image in the 'Building by Electricity' advertisement is very similar to Siemens photograph no. 292, taken on 30 July 1926, both of which are found in Siemens Album A703.

57 P. Ó Duibhir, 'Death in a Sweetshop', *National Library of Ireland* <https://blog.nli.ie/index. php/2013/03/25/death-in-a-sweetshop/> Accessed 12 January 2017; Brewster, 'The Gordon Brewster Collection'.

58 Kelly, 'The Role of Advertising in the Establishment and Early Development of a Semi-State Company', p. 43.

59 Despite an overall unemployment rate of 6 per cent in the 1926 Census, male navvies had a 37.5 per cent unemployment rate and 'general and undefined labourers' were on 32.5 per cent and 34 per cent for male and female workers respectively, the highest percentages outside of industrial workers (43 per cent and 36.2 per cent for male and female workers) and female spinners, piecers and carders (35 per cent). 24.6 per cent of dock labourers were already out of work at this point. See Central Statistics Office, 'Males and Females in Saorstát Éireann on 18th April, 1926, Classified by Individual Occupations and by Industrial Status', *Central Statistics Office Ireland* (Dublin: Central Statistics Office Ireland, 1928), pp. 20, 22.

60 M. McCarthy, 'How the Shannon Workers Lived', in A. Bielenberg (ed.), *The Shannon Scheme and the Electrification of the Irish Free State: An Inspirational Milestone* (Dublin: Lilliput Press, 2002), p. 51.

61 Whelan, 'American Influences on Irish Advertising and Consumerism 1900–1960: Fashioning Irishwomen', pp. 163–5.

62 G. O'Beirne and M. O'Connor, 'Siemens-Schuckert and the Electrification of the Irish Free State', in A. Bielenberg (ed.), *The Shannon Scheme and the Electrification of the Irish Free State: An Inspirational Milestone* (Dublin: The Lilliput Press, 2002), p. 84; Manning and McDowell, *Electricity Supply in Ireland: The History of the E.S.B.*, p. 46.

Chapter 7

1 'Final Stages of Shannon Power Development: Good Progress Made During Winter', *Cork Examiner*, 1 June 1929, p. 15, ESB Newspaper Clippings Book 5.

2 'Shannon Scheme's Progress: Civil Engineers Visit: Clare Transformation Story', *Irish Independent*, 13 May 1927, p. 10; 'Teachers' Excursion to Ardnacrusha', *Connacht Tribune*, 30 July 1927, p. 2; 'Engineers Visit the Shannon Scheme', *Limerick Leader*, 14 May 1927, p. 5; 'Engineering Students Visit Shannon Scheme', *Limerick Leader*, 8 June 1927, p. 3; Shannon Power Development, 'Minutes of Meetings and Conferences' (National Archives of Ireland: SS 166, 1929); Shannon Power Development, 'Engineering & Scientific Assoc. Of Ireland Shannon Visit' (National Archives of Ireland: SS 5062, 1929); 'The Shannon Scheme: An Incursion of Engineers', *The Irish Builder and Engineer*, 2 October 1926, pp. 745–6.

3 Electricity Supply Board, 'Annual Report and Accounts of the Electricity Supply Board (for the Year 11th August 1927 to 31st March 1928)' (ESB Archive: 1929); 'Shannon Scheme Visitors', *Limerick Leader*, 6 October 1928, p. 7.

4 Electricity Supply Board, 'Annual Report and Accounts of the Electricity Supply Board (for the Year 11th August 1927 to 31st March 1928)'.

5 Electricity Supply Board, 'Annual Report and Accounts of the Electricity Supply Board (for the Year 11th August 1927 to 31st March 1928)'; 'Visitors to Shannon Scheme', *Kerryman*, 15 August 1931, ESB Newspaper Clippings Book 17; 'Visitors to Shannon Scheme', *Kilkenny People*, 22 August 1931, ESB Newspaper Clippings Book 17.

6 'Shannon Scheme in Detail: Unique Experience for 200 Visitors', *Irish Independent*, 14 June 1928, p. 13; 'Managed Like a Village: President at Shannon Works: National Effects of Shannon Scheme', *Irish Independent*, 10 September 1928, p. 7, ESB Newspaper Clippings Book 02; 'Shannon Scheme Visitors', p. 7; 'Engineers to Visit Shannon Scheme', *Limerick Leader*, 2 June 1929, p. 3; 'The Shannon Scheme: Engineers to Visit Power Development Works', *The Irish Builder and Engineer*, 18 September 1926, p. 725; 'Engineering Section: Southern Officials Visit

Shannon Works', *The Irish Builder and Engineer*, 8 January 1927, p. 24.

7 'Still They Come: More Shannon Scheme Visitors', *Limerick Leader*, 3 November 1928, p. 3, ESB Newspaper Clippings Book 02; 'Pictorial Review. Dublin Chamber of Commerce Visit to Shannon Scheme', *Irish Independent*, 4 October 1928, p. 3, ESB Newspaper Clippings Book 02.

8 'French Engineers to See Shannon Works and Drumm Train', *Irish Independent*, 3 July 1928, p. 8; 'To Visit Limerick and Ardnacrusha', *Limerick Leader*, 15 June 1929, p. 7; 'Distinguished Visitors to the Shannon Scheme', *Limerick Leader*, 7 September 1929, p. 7; 'German Boy Scouts on Visit to Limerick', *Limerick Leader*, 30 August 1930, p. 7; 'Cardinal Bourne at Ardnacrusha', *Irish Independent*, 3 March 1931, p. 8; 'Tourists and Shannon Scheme', *Cork Examiner*, 6 August 1931, ESB Newspaper Clippings Book 17; 'German Visitors at Shannon Scheme', *Nenagh Guardian*, 22 August 1931, ESB Newspaper Clippings Book 17; 'Ardnacrusha Visit: Mr. F.P. Walsh Inspects Shannon Power Station', *The Irish Press*, 11 August 1932, ESB Newspaper Clippings Book 19.

9 Electricity Supply Board, 'Annual Report and Accounts of the Electricity Supply Board (for the Year 11th August 1927 to 31st March 1928)'; 'Cheap Trips to the Shannon: Guides to Explain the Scheme', *The Irish Times*, 20 June 1928, p. 7; Central Statistics Office, 'Population of Saorstát Éireann and of Each Province at Each Census since 1881 and the Numbers of Marriages, Births and Deaths Registered in Each Intercensal Period since 1871', *Central Statistics Office Ireland* (Dublin: Central Statistics Office Ireland, 1928).

10 'Shannon Scheme Visitors', p. 7.

11 Urry discusses how the tourist gaze is directed and focused on 'out of the ordinary' features of the landscape. See J. Urry, *The Tourist Gaze* (London: Sage, 1990), p. 3.

12 H. Alberry, 'Great Undertakings: A Visit to the Shannon Scheme', *The Irish Builder and Engineer*, 8 June 1929, p. 496. Alberry was born in Liverpool, but practised in Ireland and is best known for the refit of Leinster House as a permanent home for the Oireachtas in the early 1920s, as well as writing for *The Irish Builder and Engineer* under the pseudonym of Oculus. See 'Allberry, Harry', *Dictionary of Irish Architects 1720–1940* <http://www.dia.ie/architects/view/23> Accessed 12 January 2017; S. Rothery, *Ireland and the New Architecture 1900–1940* (Dublin: The Lilliput Press, 1991), pp. 103–8.

13 'Shannon Scheme Visitors: 10,000 Excursionists to Limerick', *The Irish Times*, 25 July 1928, p. 5.

14 See Edensor's discussion of the iconic tourist sites as ideologically loaded national landscapes in T. Edensor, *National Identity, Popular Culture and Everyday Life* (Oxford: Berg, 2002), pp. 45–8.

15 D. Crouch and N. Lübbren (eds), *Visual Culture and Tourism* (Oxford: Berg, 2003), p. 11.

16 Thirty-three workers were killed in accidents during the construction works, with another fourteen killed in related accidents and nineteen in the sinking of the steamer SS *Arabia*. M. McCarthy, *High Tension: Life on the Shannon Scheme* (Dublin: The Lilliput Press, 2004), p. 110.

17 Edensor, *National Identity, Popular Culture and Everyday Life*, pp. 69–70.

18 S.F. Mills, 'Open-Air Museums and the Tourist Gaze', in D. Crouch and N. Lübbren (eds), *Visual Culture and Tourism* (Oxford: Berg, 2003), p. 77.

19 D. MacCannell, *The Tourist: A New Theory of the Leisure Class*, 3rd edn (Berkeley, CA: University of California Press, 1999), pp. 5–7.

20 MacCannell, *The Tourist: A New Theory of the Leisure Class*, pp. 36, 62.

21 Sivert points out a similar process at work with the Tennessee Valley Authority dams in the 1930s, where the dams acted as visual arguments for the benefits of governmental intervention in underdeveloped rural areas, partly through the provision of electricity, but largely through the promotion of the dams as tourist destinations. L. Sivert, 'The Industrial Pastoral in the Tennessee Valley Authority', in M. Aitchison (ed.), *The Architecture of Industry: Changing Paradigms in Industrial Building and Planning* (Farnham: Ashgate, 2014), pp. 45–7.

22 Alberry, 'Great Undertakings: A Visit to the Shannon Scheme', p. 498.

23 Mills, 'Open-Air Museums and the Tourist Gaze', p. 81.

24 R. Balm and B. Holcomb, 'Unlosing Lost Places: Image Making, Tourism and the Return to Terra Cognita', in D. Crouch and N. Lübbren (eds), *Visual Culture and Tourism* (Oxford: Berg, 2003), p. 162.

25 P.D. Osborne, *Travelling Light: Photography, Travel and Visual Culture* (Manchester: Manchester University Press, 2000), pp. 83–4.

26 Edensor, *National Identity, Popular Culture and Everyday Life*, p. 86; 'Holidays! See Ireland First. Limerick', *The Irish Times*, 7 July 1928, p. 4.

27 Alberry, 'Great Undertakings: A Visit to the Shannon Scheme', pp. 496–8.

28 R.A. Stebbins, *Amateurs: On the Margin between Work & Leisure* (London: SAGE Publications, 1979), p. 261.

29 J. Evans, 'Introduction to Part II: Regulating Photographic Meanings', in J. Evans and S. Hall (eds), *Visual Culture: The Reader* (London: SAGE Publications, 1999), pp. 130–1.

30 B. Coe and P. Gates, *The Snapshot Photograph: The Rise of Popular Photography 1888–1939* (London: Ash & Grant, 1977), p. 17.

31 Coe and Gates, *The Snapshot Photograph: The Rise of Popular Photography 1888–1939*, pp. 10–11; A. Sekula, 'Reading an Archive: Photography between Labour and Capital', in J. Evans and S. Hall (eds), *Visual Culture: The Reader* (Milton Keynes: Open University, 1999), p. 191; A. Pollen, 'Lost and Found', (MA Thesis, University of Brighton, 2006), pp. 63–6. R.A. Stebbins, *Amateurs: On the Margin between Work & Leisure* (London: SAGE Publications, 1979), p. 20; G. Batchen, *Each Wild Idea: Writing, Photography, History* (Cambridge, MA: The MIT Press, 2001), p. 57.

32 P. Bourdieu, 'The Social Definition of Photography', in J. Evans and S. Hall (eds), *Visual Culture: The Reader* (Milton Keynes: Open University, 1999), p. 167.

33 Coe and Gates, *The Snapshot Photograph: The Rise of Popular Photography 1888–1939*, pp. 22–35.

34 'Laird's Photographic Chemists', *Limerick Leader*, 20 June 1925, p. 1; 'John Laird & Co.: The Rexall Pharmacy', *Limerick Leader*, 21 July 1926, p. 2; 'Liston's Chemist, O'Connell Street', *Limerick Leader*, 24 September 1927, p. 3.

35 E. Chandler, 'History of the Dublin Camera Club', *Dublin Camera Club* <http://www.dublincameraclub.ie/images/DCC/History/DCC_History_byEddieChandler.pdf> Accessed 12 January 2017.

36 O.S. Merne, *The Story of the Photographic Society of Ireland, 1854–1954* (Dublin: The Photographic Society of Ireland, 1954), pp. 21–3.

37 'Stokes Album' (National Library of Ireland Manuscripts: ALB 235, *c.*1930); 'Ternan Album' (National Library of Ireland Manuscripts: ALB 162, *c.*1930); C. Bruton, 'Shannon Scheme Construction Photos 1928/29 C16/517–C16/534' (Irish Architectural Archive: 2006/138/1–18, 2006). Some of the Bruton photographs were exhibited in *The Moderns*

exhibition in the Irish Museum of Modern Art, 2010–11 and are republished without comment in the illustrations of L. Gibbons, 'Mirrors of Memory: Ireland, Photography and the Modern', in E. Juncosa and C. Kennedy (eds), *The Moderns: The Arts in Ireland from the 1900s to the 1970s* (Dublin: Irish Museum of Modern Art, 2011), pp. 432–5.

38 Malcolm Mitchell is registered in the 1911 census as 4 years of age, living with his parents, younger brother and a female servant in Kilrush, Co. Clare. His father Frederick's occupation is given as Commercial Clerk – Flour, and the family religion is Church of Ireland, which puts Mitchell into Limerick's commercial middle class. Mitchell would have been between 20 and 23 when the Shannon Scheme photographs were taken and his albums were later labelled with his address as 'Malbay', 25 Belfield Park, Ennis Road, Limerick. 'Residents of a House 1 in Kilrush (Pt. of) Rural (Limerick North, Limerick)', National Archives of Ireland <http://www.census.nationalarchives.ie/reels/nai002745089/> Accessed: 12 January 2017. Limerick's social structure in the early twentieth century is discussed in T. Keane, 'Class, Religion and Society in Limerick City, 1922–1939' (PhD Thesis, Mary Immaculate College, University of Limerick, 2015).

39 Bourdieu, 'The Social Definition of Photography', p. 166.

40 D.E. Nye, *American Technological Sublime* (Cambridge, MA: The MIT Press, 1994).

41 L. Wright, 'Representations of Leisure: Snapshot Imagery and Memory', in B. Snape and D. Smith (eds), *Recording Leisure Lives: Holidays and Tourism in 20th Century Britain* (Eastbourne: Leisure Studies Association, 2011), pp. 168–72.

42 This is in contrast to Pollen's photograph albums, which lost their private meaning after the death of the photographer's son and their subsequent move into the area of commercial commodity in a car boot sale. See Pollen, 'Lost and Found', pp. 14–25, 40–6, 99–102.

43 E. Edwards, 'Photographs as Objects of Memory', in J. Aynsley, C. Breward and M. Kwint (eds), *Material Memories: Design and Evocation* (Oxford: Berg, 1999), p. 233.

44 Ernest H. Bennis was registered in the 1911 census as resident at 23 Ascot Terrace (O'Connell Avenue) with his wife, daughter, a visitor and a female servant. He is recorded as a 42-year-old Quaker merchant and marriage registrar, which would have put him in his late sixties at the time the Shannon Scheme photographs were taken. He is noted as having died in 1956 in E.H. Bennis, 'Reminiscences of Old Limerick', *Old Limerick Journal*, 36 (1999), p. 55. He also briefly appears in the 1887 register of the Metropolitan School of Art as an 18-year-old, although he only paid for one month of tuition. Metropolitan School of Art, 'Index Register of Payments by Students, School of Art, for the Session 1887–88' (NIVAL: NCAD College Register 1887–88, 1887); 'Residents of a House 23 in Ascot Terrace (Limerick No. 4 Urban, Limerick)', National Archives of Ireland <http://www.census.nationalarchives.ie/reels/nai002758312/> Accessed: 12 January 2017.

45 The finishing on the power house is similar to Siemens photograph no. 1200, which is dated 24/5/1929. The next Siemens photograph no. 1283 of the power house shows similar finishing, but with the tail race full of water.

46 The same location is also used in Siemens industrial photographs nos. 488 (11.4.27), 639 (n.d., but taken 9 or 10.27), 962 (28.7.28), 1009 (7.11.28), 1046 (27.11.28), 1088 (16.1.29), 1137 (4.3.29), 1200 (24.5.29), 1244 (11.7.29), 1283 (26.8.29), 1338 (5.10.29), 1390 (11.12.29), 1417 (23.1.30), as well as Seán Keating's painting *Night's Candles are Burnt Out*, discussed in Chapter 8.

41 'Shannon Scheme: Mr. John Keating's Sketches', p. 7; Royal Hibernian Academy of Arts, *Royal Hibernian Academy of Arts Catalogue 1927* (Dublin: Royal Hibernian Academy of Arts, 1927), pp. 16, 21; 'Royal Hibernian Academy: Portraits in Favour', *The Irish Times*, 11 April 1927, p. 8; Stewart, *Royal Hibernian Academy List of Exhibitors 1826–1979: Vol. 2 G-M*, p. 140.

42 'Royal Hibernian Academy: Annual Exhibition Second Notice', *The Irish Times*, 9 April 1928, p. 6; 'Shannon Scheme on Canvas: A Series of Oil Paintings', *The Irish Times*, 25 August 1927, p. 5; Royal Hibernian Academy of Arts, *Royal Hibernian Academy of Arts Catalogue 1928* (Dublin: Royal Hibernian Academy of Arts, 1928), p. 19; Stewart, *Royal Hibernian Academy List of Exhibitors 1826–1979: Vol. 2 G-M*, p. 140.

43 A. Jarman, *Royal Academy Exhibitors 1905–1970: Volume III E-Lawl*, 2nd edn (Wiltshire: Hilmartin Manor Press, 1985), p. 166. 'The Key Men' is often connected to the Shannon Scheme, but was painted in the 1940s, based on the building of the second Irish hydroelectric power station at Poulaphouca in Wicklow, alongside the painting of dumper trucks mentioned in note 16 above.

44 Bielenberg, 'Seán Keating, the Shannon Scheme and the Art of State-Building', p. 127.

45 T. Bodkin, 'Correspondence with John Keating: Re Shannon Scheme Series' (Bodkin Papers, Trinity College Dublin: Ms. 6941/444, 1927).

46 J. White, *Seán Keating P.R.H.A. 1889–1977* (Dublin: Royal Hibernian Academy, 1989); Bielenberg, 'Seán Keating, the Shannon Scheme and the Art of State-Building', p. 135; O'Connor, *Seán Keating in Context: Responses to Culture and Politics in Post-Civil War Ireland*, p. 20; O'Connor, *Seán Keating – Art, Politics and Building the Irish Nation*, p. 175.

47 'Details of Lot 139: Seán Keating – Bank Building Machine at Blackwater Aquaduct', *James Adam Salesrooms* <http://www.adams.ie/5374/S-an-Keating-PPRHA-HRA-HRSA-1889-1977-Bank-Building-Machine-at-Blackwater-Aquaduct-Watercolour-16-5-x-24cm-6-5-x-9-5-5374?ipp=10&keyword=-&view=lot_detail> Accessed 12 January 2017; 'Seán Keating: Bunkhouse at Shannon, Ardnacrusha Works', *Whyte's, Fine Art Auctioneers and Valuers, Dublin*: 20 November 2010 (2006).

48 Kennedy, 'The Irish Free State 1922–49: A Visual Perspective', p. 147; Kennedy, *Irish Art and Modernism 1880–1950*, pp. 320–1; Cusack, 'Crossing the Shannon: Ireland's "Mighty Stream" and the Making of the Nation', pp. 77–97; Bhreathnach-Lynch, 'Framing Ireland's History: Art, Politics, and Representation', pp. 49–50; Bhreathnach-Lynch, 'Landscape, Space and Gender: Their Role in the Construction of Female Identity in Newly Independent Ireland', pp. 82–4; Kennedy, *Great Irish Artists: From Lavery to Le Brocquy*, p. 98; Kennedy, *Irish Painting*, pp. 34, 119.

49 The concrete shuttering on the power house was at an intermediate stage between Siemens photograph No. 603, approx. August 1927 and photograph No. 639, taken 29 September 1927.

50 O'Connor, *Seán Keating in Context: Responses to Culture and Politics in Post-Civil War Ireland*, p. 20; Barrett, 'The Visual Arts and Society, 1921–1984', p. 605; Ferriter, *The Transformation of Modern Ireland 1900–2000*, p. 316. Keating reused the family group on the frontispiece of Joseph Hanly's 1932 book *The National Ideal: A Practical Exposition of True Nationality appertaining to Ireland*, this time pointing to symbolic hammer, sickle and cross. See O'Connor, *Seán Keating – Art, Politics and Building the Irish Nation*, pp. 89–90, 92.

51 Bielenberg, 'Keating, Siemens & the Shannon Scheme', p. 45; Bhreathnach-Lynch,

'Framing Ireland's History: Art, Politics, and Representation', p. 50.

52 The title is based on a couplet from Shakespeare's 'Romeo and Juliet', where the titular couple discuss whether or not the new day is breaking. 'Night's candles are burnt out, and jocund day Stands tiptoe on the misty mountain tops.'
W. Shakespeare, 'Romeo and Juliet: Entire Play', *MIT: The Complete Works of William Shakespeare* <http://shakespeare.mit.edu/romeo_juliet/full.html> Accessed 12 January 2017.

53 'Harnessing the Shannon: Progress of the Super-Power Scheme: Supplies Available in Early Winter', *Birmingham Daily Mail*, 23 July 1929, p. 6, ESB Newspaper Clippings Book 06; 'Our London Letter: Saorstat Art', *Irish Independent*, 4 May 1929, p. 6.

54 'The Problem Picture: End of the Stage Irishman', *The Irish Times*, 6 May 1929, p. 6, ESB Newspaper Clippings Book 05.

55 They are discussed very briefly in Crookshank and The Knight of Glin, *Ireland's Painters 1600–1940*, p. 281 and in more detail in O'Connor, *Seán Keating – Art, Politics and Building the Irish Nation*, pp. 165, 74. It is difficult to determine precisely which paintings and drawings were exhibited in the Royal Hibernian Academy in 1928 and 1928, as the titles recorded in the RHA List of Exhibitors and the RHA catalogues do not match with those in current use with the works in the ESB collection. Royal Hibernian Academy of Arts, *Royal Hibernian Academy of Arts Catalogue 1927*, pp. 16, 21; Royal Hibernian Academy of Arts, *Royal Hibernian Academy of Arts Catalogue 1928*, p. 19; Stewart, *Royal Hibernian Academy List of Exhibitors 1826–1979: Vol. 2 G-M*, p. 140.

56 Foster, Fraser Jenkins and Upstone (eds), *William Orpen: Politics, Sex & Death*.

57 O'Connor, *Seán Keating – Art, Politics and Building the Irish Nation*, p. 174.

58 Some of the titles retain approximations of the German names for the equipment, for example, Lufflebagger for a Löffelbagger, rather than a bucket excavator.

59 'Royal Hibernian Academy: Portraits in Favour', p. 8.

60 Keating, *Sean Keating: Where Do I Begin?*

61 Keating, 'Sean Keating at Ardnacrusha', p. 53.

62 White, *John Keating: Paintings – Drawings*, p. 7; Dunne, 'RHA and Keating: Overdrawn on the Image Bank', NIVAL: Seán Keating file; Kennedy, *Irish Painting*, p. 34; Bielenberg, 'Keating, Siemens & the Shannon Scheme', p. 47; Cullen, *Visual Politics: The Representation of Ireland 1750–1930*, pp. 168–9; Cusack, 'Crossing the Shannon: Ireland's "Mighty Stream" and the Making of the Nation', pp. 91–2; Bhreathnach-Lynch, 'Crossing the Rubicon: Seán Keating's an Allegory', p. 125.

63 Bielenberg, 'Seán Keating, the Shannon Scheme and the Art of State-Building', p. 135.

64 Details of the gradual purchase of Keating's Shannon Scheme painting by the ESB are detailed in O'Connor, *Seán Keating – Art, Politics and Building the Irish Nation*, p. 175.

65 Atkinson was born in 1880 in Cork, the son of a Protestant timber mill owner. 'Residents of a House 27.1 in Harcourt Street (Fitzwilliam, Dublin)', *National Archives of Ireland* <http://www.census.nationalarchives.ie/reels/nai000186952/> Accessed 12 January 2017; 'Residents of a House 32 in Southern Road (Cork Urban No. 5, Cork)', *National Archives of Ireland* <http://www.census.nationalarchives.ie/reels/nai000531683/> Accessed 12 January 2017.

66 J. Turpin, 'The Metropolitan School of Art (Part 2)', *Dublin Historical Record*, 38:2, 1985, pp. 43–4; J. Turpin, *A School of Art in Dublin since the 18th*

Century: A History of the National College of Art and Design (Dublin: Gill & Macmillan, 1995), p. 195.

67 The Dublin Metropolitan School of Art had received its certificates from the Science and Art Department in South Kensington since the 1870s, concentrating on drawing from the antique, landscapes and ornament. See J. Turpin, 'The South Kensington System and the Dublin Metropolitan School of Art 1877–1900', *Dublin Historical Record*, 36:2, March 1983, pp. 42–64; Turpin, *A School of Art in Dublin since the 18th Century: A History of the National College of Art and Design*, p. 169.

68 O'Connor, *Seán Keating in Focus*, p. 17; T. Mulhall, 'The Twenties', *Artinform*, 1:1, 1973, pp. 7–8.

69 T. Bodkin, 'Dublin', *The Studio*: 87, 1924, p. 46.

70 Turpin, *A School of Art in Dublin since the 18th Century: A History of the National College of Art and Design*, pp. 208–9.

71 The Cenotaph also bore two decorative panels bearing medallions of Collins and Griffith, carried out by the sculptor Albert Power, who also taught at the Metropolitan School of Art. See Turpin, *A School of Art in Dublin since the 18th Century: A History of the National College of Art and Design*, p. 237; N. Gordon Bowe and E. Cumming, *The Arts & Crafts Movements in Dublin & Edinburgh, 1880–1930* (Dublin: Irish Academic Press, 1998), p. 93; A. Dolan, *Commemorating the Irish Civil War: History and Memory, 1923–2000* (Cambridge: Cambridge University Press, 2003), pp. 7–9; Bhreathnach-Lynch, *Ireland's Art, Ireland's History: Representing Ireland 1845 to Present*, p. 166.

72 M. Cronin, 'The State on Display: The 1924 Tailteann Art Competition', *New Hibernia Review*, 9:3, Fall 2005, pp. 50–1; Bodkin, 'Dublin', p. 226.

73 Atkinson had been elected a member of the Royal Hibernian Academy in 1914 and later became its treasurer; organised the exhibition for Dublin Civic Week in 1927, along with fellow artists Paul Henry and Leo Whelan; was a signatory to Lady Gregory's petition for Hugh Lane's French paintings to be returned to Dublin in 1917; sat on the Art Advisory Committee of the Dublin Municipal Gallery of Modern Art, the Board of Governors of the National Gallery of Ireland and advised the Crawford Gallery in his native Cork on purchases to be made using the Gibson Bequest money of 1919: L.I.A. Gregory, 'Hugh Lane's French Pictures' (O'Brien Papers, National Library of Ireland: MS 36,888, 1917); Kennedy, *Irish Art and Modernism 1880–1950*, pp. 84–5; 'Paintings, Drawings and Engravings: The Metropolitan School of Art', *The Irish Times*, 20 September 1927, p. 11; 'Municipal Gallery of Modern Art: Advisory Committee', *The Irish Times*, 6 October 1928, p. 8; 'National Gallery of Ireland: Mrs. William O'Brien's Gift', *The Irish Times*, 8 December 1932, p. 4. Lectures included venues such as the Royal Dublin Society, the Central Catholic Library, the Dublin Literary Society and the Dublin Writers Club: 'The Art of Etching: Mr. George Atkinson's Lecture', *The Irish Times*, 19 January 1924, p. 6; 'Good Art and Bad Art', *The Irish Times*, 28 March 1924, p. 2; 'Standards in Art: Meaning of Their Collapse', *The Irish Times*, 24 March 1927, p. 10; 'Dublin Writers Club: Mr. G. Atkinson's Lecture', *The Irish Times*, 21 November 1929, p. 6; 'Obituary: Mr. George Atkinson, R.H.A.', *The Irish Times*, 25 March 1941, p. 8; Bodkin, 'Dublin', p. 46.

74 A. Griffith, 'A History of Fine Art Printmaking in Ireland During the Twentieth Century', (PhD Thesis, Trinity College, Dublin, 2010); Mulhall, 'The Twenties', p. 8.

75 Bodkin, 'Dublin', p. 46; J. Crampton Walker, *Irish Life and Landscape* (Dublin: Talbot Press,

1926), p. 96; 'Obituary: Mr. George Atkinson, R.H.A.', p. 8.

76 A. Stewart, *Royal Hibernian Academy List of Exhibitors 1826–1979: Vol. 1 A-G* (Dublin: Manton Publishing, 1985), p. 23.

77 'Leopold Friedrich I Franz Nikolaus Fürst Von Anhalt-Dessau', *The Peerage* <http://thepeerage.com/p11200.htm#i111999> Accessed 12 January 2017; 'Atkinson, George (1880–1941): Ponte Vecchio, Etching on Paper', *Dublin City Gallery, The Hugh Lane* <http://emuseum.pointblank.ie/online_catalogue/work-detail.php?objectid=15> Accessed 12 January 2017.

78 F. Klingender, *Art and the Industrial Revolution* (London: Noel Carrington, 1947), pp. 65–9.

79 Turpin, *A School of Art in Dublin since the 18th Century: A History of the National College of Art and Design*, p. 245.

80 *Ibid.*, pp. 261–72; O'Connor, *Seán Keating in Focus*, pp. 15–18; O'Connor, *Seán Keating – Art, Politics and Building the Irish Nation*, pp. 198–219.

81 Atkinson's name is not among the permits to visit the Scheme that have survived in the National Archives of Ireland, but as headmaster of the Dublin Metropolitan School of Art, he would have been sufficiently well connected to organise permission to visit the works.

82 Normally an etching would be printed as a numbered edition, with each print noted as 1/30, 2/30, etc., but these etchings are not numbered. As only one print of each seems to exist, this indicates that they are artist's proofs, now usually marked as AP. Royal Hibernian Academy of Arts, *Royal Hibernian Academy of Arts Catalogue 1927*, p. 26; Stewart, *Royal Hibernian Academy List of Exhibitors 1826–1979: Vol. 1 A-G*, p. 23; 'Arts and Crafts: Aonach Tailteann Exhibition', *Irish Independent*, 6 August 1928, p. 9; 'Arts and Crafts: Aonach Tailteann Exhibition', p. 9; 'The Pageantry of Civic Week: Historical and Military Spectacles', *The Irish Times*, 17 September 1927, p. 13; 'Industries Needed: A Matter for Amazement: On the Shannon: A Fine People', *Limerick Leader*, 15 February 1930, p. 42, ESB Newspaper Clippings Book 12; 'Critics Comments', *Irish Independent*, 20 September 1928, p. 3; 'Tailteann Games Art Awards', *The Irish Times*, 6 September 1928, p. 4; 'Our London Letter: Saorstat Art', p. 6; P. McGilligan, 'Memoranda on Compensation for Existing Electricity Undertakings, the Shannon Control Board and the Sale of Electricity and the Activities of the E.S.B. in the Early Years of Its Existence.' (McGilligan Papers, UCD Archive: P35/45, 1931); 'Etchings and Drypoint: Attractive Exhibition', *The Irish Times*, 11 June 1933, p. 3; J.C. Walker and D. Egan, 'Exhibition of Irish Landscapes, Arranged by J. Crampton Walker & Daniel Egan, in the Angus Gallery 36 St. Stephen's Green N, July 17th – August 12th 1933' (O'Brien Papers, National Library of Ireland: MS 36890, 1933).

83 *Keeper Mountain* was donated to the Crawford by fellow Anglo-Irish Corkman Lennox Robinson, who had been on the Board of the Abbey Theatre from 1923 onwards, as well as being a prolific playwright and producer. The two men would have met professionally around this time, if not beforehand, as Atkinson made masks for a production of the W.B. Yeats play *The King of the Great Clock Tower*, which Robinson produced in 1934. L. Robinson, *Ireland's Abbey Theatre – a History 1899–1951* (London: Sidgwick and Jackson, 1951), p. 163; 'Lennox Robinson', *Irish Playography* <http://www.irishplayography.com/person.aspx?personid=9692> Accessed 12 January 2017. The other two prints were in the possession of the family until the 2010s, when they were also donated to the Crawford collection. S. O'Brien (2010) Email from W.B. Atkinson, 'Re: Photos of Etchings'.

in Bengal, in Aden, in the Yemen and in South Africa during the Second Boer War, achieving a rank of 2nd Lieutenant by 1893. He left the service in 1900, although he is not on the list of those wounded during the Boer War. He then returned to his art education, first studying painting at the Académie Colarossi in Paris and then taking private lessons in the Netherlands with Alphonse Mucha and American artist George Hitchcock. See British War Office, 'The Monthly Army List, for January, 1893', (London: War Office, 1893); British War Office, 'Boer War Casualties 1899–1902', (London: The Naval and Military Press, 1902); Metropolitan School of Art, 'Index Register of Payments by Students, School of Art, for the Session 1880–81' (NIVAL: NCAD College Register 1880–81, 1881); 'Deaths – Lawrenson', *The Times*, 28 December 1940, p. 1; J. Crampton Walker, *Irish Life and Landscape* (Dublin: Talbot Press, 1926), p. 129; T. Snoddy, *Dictionary of Irish Artists: 20th Century* (Dublin: Merlin Publishing, 2002), pp. 342–3.

16 A. Stewart, *Royal Hibernian Academy List of Exhibitors: Vol. 2 H-M* (Dublin: Manton Publishing, 1985), pp. 413–14; A. Jarman (ed.), *Royal Academy Exhibitors 1905–1970: Vol. V Lawr-Sher*, 2nd edn (Wiltshire: Hilmarton Manor Press, 1987), pp. 4–5; 'Irish Watercolour Society: Annual Exhibition in Mills' Hall', *The Irish Times*, 1 May 1930; *Exposition D'art Irlandais, 10 Mai – 8 Juin 1930* (Brussels: Musées Royaux des Beaux-Arts de Belgique, Musée d'Art Ancien, 1930), pp. 33, 44.

17 'Shannon Scheme Celebration: Commemorative Postage Stamp Issued', *Limerick Echo*, 28 June 1930, ESB Newspaper Clippings Book 15; 'New Free State Stamp: To Mark Completion of Shannon Scheme', *The Irish Times*, 24 June 1930, p. 8, ESB Newspaper Clippings Book 15; 'New Free State Stamp to Mark Completion

of Shannon Scheme', *Meath Chronicle*, 28 June 1930, ESB Newspaper Clippings Book 15; 'New Stamp: To Mark Shannon Scheme Completion', *Limerick Leader*, 28 June 1930, ESB Newspaper Clippings Book 15.

18 'Shannon Stamp', *Cork Examiner*, 11 October 1930, ESB Newspaper Clippings Book 16; 'Shannon Scheme Stamps', *Limerick Leader*, 20 October 1930, p. 3; 'New Postage Stamps: Shannon Scheme Issue', *The Times*, 21 October 1930, p. 12; Department of the Taoiseach, 'Special Postage Stamp 1930' (National Archives of Ireland: S8 317, 1930).

19 D. Feldman, *Stamps of Ireland: Illustrated Catalogue* (Dublin: David Feldman Ltd., 1974), p. 36; 'New Postage Stamps: Shannon Scheme Issue', p. 12.

20 M.G. Palmer, 'Irish Politics Quiet During Recess of Dail: Cosgrave Forces Cold to Fianna Fail Success', *New York Times*, 29 June 1930, p. 49; 'Shannon Scheme Stamps', p. 3; 'New Free State Stamp: To Mark Completion of Shannon Scheme', p. 8, ESB Newspaper Clippings Book 15.

21 Morris, *Our Own Devices: National Symbols and Political Conflict in Twentieth-Century Ireland*, p. 78.

22 The dots over some of the consonants in the stamp are lenited 'h's common in Irish before the spelling reform of the 1950s, so I have rendered the caption using modern Irish orthography intended for use with Roman fonts. M. Ó Laoire, 'The Standardization of Irish Spelling: An Overview', *Journal of the Simplified Spelling Society*, 22:2, 1997, pp. 19–23.

23 C. Bell and M.A. Bolger, 'Divided by a Common Typeface', *ISType–Mono* (Istanbul, 2014).

24 Department of Foreign Affairs, 'Shannon Scheme Stamps, Presentation to H.M. The King' (National Archives of Ireland: GR/1181-1, 1931); Feldman, *Handbook of Irish Philately*, p. 82; P.H. Pearse, 'From a Hermitage', *CELT:*

Corpus of Electronic Texts <http://www.ucc.ie/celt/published/E900007-005/text002.html> Accessed 12 January 2017.

25 E. Edwards, 'Photographs as Objects of Memory', in J. Aynsley, C. Breward and M. Kwint (eds), *Material Memories: Design and Evocation* (Oxford: Berg, 1999), p. 233.

26 S.M. Pearce, *On Collecting: An Investigation into Collecting in the European Tradition* (London: Routledge, 1995), p. 24.

27 *Ibid.*, p. 25.

28 *Ibid.*, p. 244; S. Stewart, *On Longing: Narratives of the Miniature, the Gigantic, the Souvenir, the Collection* (Durham, NC: Duke University Press, 2007), p. xii.

29 Stewart, *On Longing: Narratives of the Miniature, the Gigantic, the Souvenir, the Collection*, pp. 135–8; Edwards, 'Photographs as Objects of Memory', pp. 232–3.

30 David Feldman International Auctioneers, 'Lot 40263', *David Feldman International Auctioneers* <http://www.davidfeldman.com/auctions/browse-lots/aucP/all_previous/item/131955/> Accessed 12 January 2017. A First Day Cover is the philatelic term for an envelope posted on the first day of issue for a particular stamp, carrying a franked copy of that stamp. They are prized by collectors and national post services often issue specially designed envelopes for use as first day covers.

31 The Universal Postal Union was a Swiss organisation set up in the 1870s to arrange the validity of stamps across national boundaries. F. Staff, *The Picture Postcard & Its Origins* (London: Lutterworth Press, 1966), pp. 64–6.

32 Pearce, *On Collecting: An Investigation into Collecting in the European Tradition*, p. 33.

33 J. Armstrong, 'Irish Stamps Can Make First-Class Prices', *The Irish Times*, 16 July 1999, p. C2; 'Commemoratives 1929–1959', *Raven Stamps* <http://www.irstamps.com/retail/commems1929-1959.html> Accessed 12 January 2017.

Chapter 10

1 Reverse side text from 'The Power Station To-Day', cigarette card no. 29, from the W.D. & H.O. Wills set *Shannon Power Electric Scheme*, early 1930s.

2 P.B. Meggs and A.W. Purvis, *Meggs' History of Graphic Design*, 4th edn (Hoboken, NJ: John Wiley & Sons, 2006), pp. 134–5.

3 M. Rickards and M. Twyman, *The Encyclopedia of Ephemera: A Guide to the Fragmentary Documents of Everyday Life for the Collector, Curator and Historian* (London: The British Library, 2000), p. v.

4 Rickards and Twyman, *The Encyclopedia of Ephemera: A Guide to the Fragmentary Documents of Everyday Life for the Collector, Curator and Historian*.

5 M. Rickards, *Collecting Printed Ephemera* (Oxford: Phaidon, 1988), p. 13.

6 Rickards and Twyman, *The Encyclopedia of Ephemera: A Guide to the Fragmentary Documents of Everyday Life for the Collector, Curator and Historian*, p. v.

7 Rickards, *Collecting Printed Ephemera*, pp. 15–16.

8 Rickards and Twyman, *The Encyclopedia of Ephemera: A Guide to the Fragmentary Documents of Everyday Life for the Collector, Curator and Historian*, p. vi.

9 E. Breisach, *Historiography: Ancient, Medieval & Modern*, 2nd edn. (Chicago, IL: University of Chicago Press, 1994), pp. 417–19.

10 Rickards, *Collecting Printed Ephemera*, p. 18.

11 S.M. Pearce, *On Collecting: An Investigation into Collecting in the European Tradition* (London: Routledge, 1995), p. 32.

12 Pearce, *On Collecting: An Investigation into Collecting in the European Tradition*, pp. 260, 85.

13 *Ibid.*, p. 301; S. Stewart, *On Longing: Narratives of the Miniature, the Gigantic, the Souvenir, the Collection* (Durham, NC: Duke University Press, 2007), pp. 151–4.

14 Pearce, *On Collecting: An Investigation into Collecting in the European Tradition*, p. 301; Stewart, *On Longing: Narratives of the Miniature, the Gigantic, the Souvenir, the Collection*, pp. 151–4.

15 Pearce, *On Collecting: An Investigation into Collecting in the European Tradition*, p. 301; Stewart, *On Longing: Narratives of the Miniature, the Gigantic, the Souvenir, the Collection*, pp. 151–4.

16 F. Staff, *The Picture Postcard & Its Origins* (London: Lutterworth Press, 1966), p. 46; Rickards and Twyman, *The Encyclopedia of Ephemera: A Guide to the Fragmentary Documents of Everyday Life for the Collector, Curator and Historian*, p. 248.

17 Staff, *The Picture Postcard & Its Origins*, pp. 50–8.

18 E. Milne, *Letters, Postcards, Email: Technologies of Presence* (New York: Routledge, 2010), pp. 315–42; Staff, *The Picture Postcard & Its Origins*, pp. 64–6.

19 D. MacCannell, *The Tourist: A New Theory of the Leisure Class*, 3rd edn (Berkeley, CA: University of California Press, 1999), pp. 44–5.

20 J.-M. Garcia-Fuentes, 'Guidebooks, Postcards and Panoramas: The Building of Monserrat through Modern Mass Media', *Memory Studies*, 9:1 (2015), pp. 63–74; MacCannell, *The Tourist: A New Theory of the Leisure Class*, p. 41.

21 J. Carville, *Photography and Ireland* (London: Reaktion Books, 2011), pp. 9–12; D. McGonagle, 'Foreward', in D. Lee (ed.), *Hindesight: John Hinde Photographs and Postcards by John Hinde 1935–1971* (Dublin: Irish Museum of Modern Art, 1993), p. 12.

22 Milne, *Letters, Postcards, Email: Technologies of Presence*, p. 363.

23 F.E. Dixon, 'The Printers and Publishers of Irish Postcards' (National Library of Ireland Manuscripts: Ms 24,585, 1979).

24 N. Schor, '*Cartes Postales*: Representing Paris 1900', *Critical Inquiry*, 18:2 (Winter 1992), p. 222; Carville, *Photography and Ireland*, pp. 60–8.

25 Dixon, 'The Printers and Publishers of Irish Postcards'.

26 *Ibid.*

27 *Ibid.*

28 R. Doyle, 'Saga of a Scientific Family by a Seventh Generation Son', *The Irish Times*, 22 October 2003, p. B2; S. O'Brien (2010) Email from S. Mason, 'Re: History of Mason Company'; S. Mason, *The Mason Family Business: A Brief History 1780–1980* (Dublin: Mason Technology, 1980), p. 2.

29 S. Rouse, *Into the Light : An Illustrated Guide to the Photographic Collections in the National Library of Ireland* (Dublin: National Library of Ireland, 1998); Mason, *The Mason Family Business: A Brief History 1780–1980*, p. 12; T.H. Mason, *The Islands of Ireland* (London: B.T. Batsford, 1936).

30 Dixon, 'The Printers and Publishers of Irish Postcards'; Mason, *The Mason Family Business: A Brief History 1780–1980*, p. 16.

31 Mason, *The Mason Family Business: A Brief History 1780–1980*, p. 13; S. O'Brien, (2010) Telephone Discussion with Stan Mason, Director of Mason Technology.

32 'About Eason: Eason & Sons', eason.ie | Ireland's Largest Book & Stationery Retailer <http://www.easons.com/t-about.aspx> Accessed 12 January 2017.

33 Dixon, 'The Printers and Publishers of Irish Postcards'; L.M. Cullen, *Eason & Son: A History* (Dublin: Eason & Son, 1989), p. 346; N. Kissane, *Ex Camera 1860–1960: Photographs from the Collections of the National Library of Ireland* (Dublin: National Library of Ireland, 1990), pp. x–xi.

34 Staff, *The Picture Postcard & Its Origins*, p. 58; Dixon, 'The Printers and Publishers of Irish Postcards'; A.W. Coysh, *The Dictionary of Picture*

Postcards in Britain 1894–1939 (Woodbridge, Suffolk: Antique Collectors Club, 1984), p. 275; Kissane, *Ex Camera 1860–1960: Photographs from the Collections of the National Library of Ireland*, p. xi.

35 Staff, *The Picture Postcard & Its Origins*, p. 58.

36 There are thirty-five different T.C. Carroll postcards in the Limerick City Museum collection, twenty-seven in the ESB archive and eighteen in the Irish Architectural Archive, although overlaps between the collections mean that there are forty different images in total. These can be dated to either 1928 or 1929 from the manufacturer's numbers printed in the stamp box on the cards, although the numbers indicate that several of the cards were reprinted two or three times, some during both years.

37 T.C. Carroll closed in 1968 and efforts to locate a surviving archive have not been successful. Carville, *Photography and Ireland*, pp. 9–12; Dixon, 'The Printers and Publishers of Irish Postcards'; Lee, *Hindesight: John Hinde Photographs and Postcards by John Hinde 1935–1971*.

38 Several of the earlier postcards also had 'Siemens-Bauunion G.m.B.H. Komm. Ges. Limerick, Ireland' printed on the reverse.

39 The earliest photograph is on Siemens postcard 3, showing a general view of the employee housing at Ardnacrusha, reproducing Siemens photograph 182 taken on 24 April 1926, and the latest is the T.C. Carroll postcard W 91 29 of Clonlara Bridge, which reproduces Siemens photograph 1043 taken on 27 November 1929. Siemens-Schuckertwerke, 'Lichtbilder W.R. Shannon Irland: Hafen, Strand Barracks, Verschiedenes 1926–1930' (Siemens Archive: A700, 1930); Siemens-Schuckertwerke, 'Lichtbilder W.R. Shannon Irland: Obergraben – Cloonlara 1926–1930' (Siemens Archive: A703, 1930).

40 Irish archives holding examples of these postcards include the ESB Archive, Limerick City Museum, the Irish Architectural Archive and the National Library of Ireland Ephemera Collection.

41 E.H. Bennis, 'Reminiscences of Old Limerick', *Old Limerick Journal*, 36 (1999), pp. 55–60.

42 Pearce, *On Collecting: An Investigation into Collecting in the European Tradition*, p. 291.

43 Milne, *Letters, Postcards, Email: Technologies of Presence*, pp. 363–4.

44 L. Ryan, 'Limerick Burial Register Online', *Limerick City Council* <http://www.limerickcity.ie/Press/Pressreleasesarchive/2009/LimerickBurialRegisterOnline/> Accessed 17 May 2012.

45 The National Monuments Act was passed in 1930 and protected a large number of monuments, including Iron and Bronze Age sites or medieval ecclesiastical settlements.

46 D. Bagnall, *Collecting Cigarette Cards and Other Trade Issues*, 2nd edn (Drayton, Somerset: London Cigarette Card Company, 1978), p. 41; M. Murray, *The Story of Cigarette Cards* (London: Murray Cards, 1987), p. 21; G. Howsden, *Collecting Cigarette & Trade Cards* (London: New Cavendish Books, 1995), pp. 7, 15; Rickards and Twyman, *The Encyclopedia of Ephemera: A Guide to the Fragmentary Documents of Everyday Life for the Collector, Curator and Historian*, p. 96. Despite the decided German interest in postcards and the crucial German involvement with the Scheme, no postcards of the Scheme have surfaced in Germany so far, probably because of the strong attachment of postcards to their geographical area of origin, at least before they get posted (e.g. there would be very little reason for a shop in Berlin to sell postcards of a building in Ireland).

Chapter 11

1 For Gabriel Hayes' 1942 realist sculptural reliefs of Irish industry, which include a panel on the

Shannon Scheme, see A. Rolfe and R. Ryan, *The Department of Industry and Commerce, Kildare Street, Dublin* (Dublin: The Office of Public Works, 1992), pp. 26–35. Seán Keating's 1939 mural of the Shannon Scheme in Michael Scott's Modernist Irish Pavilion at the New York World's Fair is discussed in *Building on the Edge of Europe* (Dublin: Royal Institute of the Architects of Ireland, 1996), pp. 48–9; A. McMonagle, 'Seán Keating: The Man', *Seán Keating and the E.S.B.* (Dublin: RHA Gallagher Gallery/ESB Touring Exhibitions Service, 1987), p. 10; E. Rowley, 'The Conditions of Architectural Modernism in Ireland, 1900–1970: Between Aspiration and Production', in E. Juncosa and C. Kennedy (eds), *The Moderns: The Arts in Ireland from the 1900s to the 1970s* (Dublin: Irish Museum of Modern Art, 2011), pp. 442–3. The ESB collection also contains a 1945 watercolour of a bomb splinter shield over one of the turbines in the turbine hall by Muriel Brandt, artist and wife of the ESB Publicity Department illustrator Frank Brandt. T. Snoddy, 'Muriel Brandt' in *Dictionary of Irish Artists: 20th Century* (Dublin: Merlin Publishing, 2002), pp. 45–7; A. Stewart, Royal Hibernian Academy List of Exhibitors: Vol 1 A–G (Dublin, Manton Publishing, 1985), p. 72; T. de Vere White, 'Muriel Brandt: An Appreciation', *The Irish Times*, 13 June 1981 (NIVAL: Muriel Brandt file).

2 H. Campbell, 'Irish Identity and the Architecture of the New State', in A. Becker, J. Olley and W. Wang (eds), *20th Century Architecture: Ireland* (Munich: Prestel, 1997), p. 85.

3 P.H. Pearse, 'From a Hermitage', *CELT: Corpus of Electronic Texts* <http://www.ucc.ie/celt/published/E900007-005/text002.html> Accessed 12 January 2017.

Bibliography

Primary Sources

Archives

'Other Family Correspondence' (O'Brien Papers, National Library of Ireland: MS 36798/3, 1862–1969).

'(Rosemary) Brigid O'Brien (Mrs. Andrew Ganly) to her parents, Dermod and Mabel O'Brien' (O'Brien Papers, National Library of Ireland: MS 36790, 1920–33).

'Edith Meissner' (ESB Archive: 1992).

'Stokes Album' (National Library of Ireland Manuscripts: ALB 235, c.1930).

'Ternan Album' (National Library of Ireland Manuscripts: ALB 162, c.1930).

Anthony, L., 'Reference letter for F. Haselbeck' (ESB Archive Haselbeck Collection: 1912).

Bodkin, T., 'Correspondence with John Keating: re Shannon Scheme series' (Bodkin Papers, Trinity College Dublin: Ms. 6941/444, 1927).

Borgquist, W., Meyer-Peter, E., Norberg Schultz, T., and Rohn, A.E., 'The Electrification of the Irish Free State: The Shannon Scheme: Report of the Experts Appointed by the Government', The Stationary Office: Dublin, 1925 (ESB Archive).

Brewster, G., 'The Gordon Brewster Collection' (National Library of Ireland: PD 2199, 1946).

Bruton, C., 'Shannon Scheme Construction Photos 1928/29 C16/517 - C16/534' (Irish Architectural Archive: 2006/138/1–18, 2006).

Department of Foreign Affairs, 'Shannon Scheme stamps, Presentation to H.M. the King' (National Archives of Ireland: GR/1181–1, 1931).

Department of the Taoiseach, 'Illustrated Record of Progress' (National Archives of Ireland: S8 305, 1930).

Department of the Taoiseach, 'Special Postage Stamp 1930' (National Archives of Ireland: S8 317, 1930).

Dixon, F.E., 'The Printers and Publishers of Irish Postcards' (National Library of Ireland Manuscripts: MS 24,585, 1979).

Electricity Supply Board, 'Annual Report and Accounts of the Electricity Supply Board (For the year 1st April 1928 to 31st March 1929)' (ESB Archive: 1929).

Electricity Supply Board, 'Annual Report and Accounts of the Electricity Supply Board (For the year 11th August 1927 to 31st March 1928)' (ESB Archive: 1929).

Electricity Supply Board, The Shannon Hydro-Electric Power Station: Reprinted From The Engineer (Dublin: Electricity Supply Board, 1928). ESB Archive.

Gregory, L.I.A., 'Hugh Lane's French Pictures' (O'Brien Papers, National Library of Ireland: MS 36,888, 1917).

Johnston, D., 'Moon in the Yellow River – Photographs from Abbey production 1931' (TCD Manuscripts: 10066/299/553–8, 1931).

Johnston, D., 'Dramatic Works – The Moon in the Yellow River, corrected copy, 1947 version' (TCD Manuscripts: 10066/4/1, 1947).

Johnston, D., 'Misc. Papers' (TCD Manuscripts: 10066/4/6–11a, 1954).

Keating, J., 'Report made to Mr. Joseph O'Neill at his request in 1925' (National Archives of Ireland: S 3458, 1925).

McGilligan, P., 'Letters' (McGilligan Papers, UCD Archive: P35/29, 1926).

McGilligan, P., 'Siemens: Progress on the Shannon' (McGilligan Papers, UCD Archive: P35/143, 1929).

McGilligan, P., 'Progress of Works; Quarterly Reports' (McGilligan Papers, UCD Archive: P35/51, 1929).

McGilligan, P., 'Memoranda on compensation for existing electricity undertakings, the Shannon Control Board and the sale of electricity and the activities of the E.S.B. in the early years of its existence.' (McGilligan Papers, UCD Archive: P35/45, 1931).

Metropolitan School of Art, 'Index Register of Payments by Students, School of Art, for the Session 1880–81' (NIVAL: NCAD College Register 1880–81, 1881).

Metropolitan School of Art, 'Index Register of Payments by Students, School of Art, for the Session 1887–88' (NIVAL: NCAD College Register 1887–88, 1887).

Metropolitan School of Art, 'Index Register of Payments by Students, School of Art, for the Session 1903–04' (NIVAL: NCAD College Register 1903–04, 1904).

Metropolitan School of Art, 'Index Register of Payments by Students, School of Art, for the Session 1904–05' (NIVAL: NCAD College Register 1904–05, 1905).

Metropolitan School of Art, 'Index Register of Payments by Students, School of Art, for the Session 1905–06' (NIVAL: NCAD College Register 1905–06, 1906).

Metropolitan School of Art, 'Index Register of Payments by Students, School of Art, for the Session 1906–07' (NIVAL: NCAD College Register 1906–07, 1907).

Metropolitan School of Art, 'Index Register of Payments by Students, School of Art, for the Session 1908–09' (NIVAL: NCAD College Register 1908–09, 1908).

Metropolitan School of Art, 'Index Register of Payments by Students, School of Art, for the Session 1909–10' (NIVAL: NCAD College Register 1909–10, 1910).

Metropolitan School of Art, 'Index Register of Payments by Students, School of Art, for the Session 1911–12' (NIVAL: NCAD College Register 1911–12, 1912).

Metropolitan School of Art, 'Index Register of Payments by Students, School of Art, for the Session 1912–13' (NIVAL: NCAD College Register 1912–13, 1913).

Metropolitan School of Art, 'Index Register of Payments by Students, School of Art, for the Session 1913–14' (NIVAL: NCAD College Register 1913–14, 1914).

Metropolitan School of Art, 'Index Register of Payments by Students, School of Art, for the Session 1914–15' (NIVAL: NCAD College Register 1914–15, 1915).

Metropolitan School of Art, 'Index Register of Payments by Students, School of Art, for the Session 1925–26' (NIVAL: IE/NIVAL CR/CR51/321, 1926).

Metropolitan School of Art, 'Index Register of Payments by Students, School of Art, for the Session 1926–27' (NIVAL: IE/NIVAL CR/CR52/329, 1927).

Metropolitan School of Art, 'Index Register of Payments by Students, School of Art, for the Session 1928–29' (NIVAL: IE/NIVAL CR/CR55/426 1929).

Metropolitan School of Art, 'Index Register of Payments by Students, School of Art, for the Session 1929–30' (NIVAL: IE/NIVAL CR/CR56/317, 1930).

Metropolitan School of Art, 'Index Register of Payments by Students, School of Art, for the Session 1930–31' (NIVAL: IE/NIVAL CR/CR57/270, 1931).

Metropolitan School of Art, 'Index Register of Payments by Students, School of Art, for the Session 1931–32' (NIVAL: IE/NIVAL CR/CR58/330, 1932).

Metropolitan School of Art, 'Index Register of Payments by Students, School of Art, for the Session 1932–33' (NIVAL: IE/NIVAL CR/CR60/348, 1933).

Purser Griffith, S.S.J., *Notes on the Siemens-Schuckert Shannon Power Scheme as expounded to the Dáil by the Minister for Industry and Commerce on the 19th December 1924* (Dublin: Saorstát Eireann, 1925). ESB Archive.

Schuckertwerke, S., 'Correspondence 1925 October-November' (Siemens Archive: 2280, 1925).

Shannon Power Development, 'Power House Design: Architectural and Buildings' (National Archives of Ireland: SS 495, 1928).

Shannon Power Development, 'Supplies: Instruments and Technical Equipment' (National Archives of Ireland: SS 5027, 1928).

Shannon Power Development, 'Minutes of Meetings and Conferences' (National Archives of Ireland: SS 166, 1929).

Shannon Power Development, 'Staff: Hans Jenny & Wilhelm Fleischer' (National Archives of Ireland: SS 5029, 1929).

Shannon Power Development, 'Engineering & Scientific Assoc. of Ireland Shannon Visit' (National Archives of Ireland: SS 5062, 1929).

Siemens-Bauunion, 'Bemerkenswerke Bauausführungen 1930–1933' (Siemens Archive: 68.L1.233, 1933).

Siemens-Schuckertwerke, 'The Shannon Scheme 1924 Drawings SSW' (Siemens Archive: 11139, 1924).

Siemens-Schuckertwerke, 'Correspondence January–March 1927' (Siemens Archive: 2281, 1927).

Siemens-Schuckertwerke, 'Propaganda February–May 1927' (Siemens Archive: 2086, 1927).

Siemens-Schuckertwerke, 'Correspondence June–August 1927' (Siemens Archive: 2051, 1927).

Siemens-Schuckertwerke, 'German Newspapers' (Siemens Archive: 4086, 1929).

Siemens-Schuckertwerke, 'Development of the Shannon Water Power in Ireland: A Guide to the Building Sites' (Siemens Archive: 16263, 1929).

Siemens-Schuckertwerke, 'Lichtbilder W.R. Shannon Irland: Hafen, Strand Barracks, Verschiedenes 1926–1930' (Siemens Archive: A700, 1930).

Siemens-Schuckertwerke, 'Lichtbilder W.R. Shannon Irland: Tail Race, Ardnacrusha Mappe No. 1 1926–1930' (Siemens Archive: A701, 1930).

Siemens-Schuckertwerke, 'Lichtbilder W.R. Shannon Irland: Obergraben - Cloonlara 1926–1930' (Siemens Archive: A703, 1930).

Walker, J.C. and Egan, D., 'Exhibition of Irish Landscapes, arranged by J. Crampton Walker & Daniel Egan, in the Angus Gallery 36 St. Stephen's Green N, July 17th – August 12th 1933' (O'Brien Papers, National Library of Ireland: MS 36890, 1933).

Audio-Visual

Keating, D., *Sean Keating: Where Do I Begin?* (Radio Teilifís Éireann, 1995).

The Age of Nations (Radio Teilifís Éireann, 2011), Keane, F. (dir.).

Newspaper Articles

'Music-Loving Duke Dead; Frederick II., Ruler of Duchy of Anhalt, Maintained Court Theatre', *New York Times,* 23 April 1918, p. 13.

'Nationality in Architecture, Mr. LF Giron's Presidential address to the Architectural Association of Ireland, delivered 19th November', *The Irish Builder and Engineer,* 29 November 1924, p. 1021.

'Ambistone advertisement', *The Irish Builder and Engineer,* 19 April 1924, p. 335.

'Engineering News: The Institution of Civil Engineers in Ireland and the Shannon Scheme', *The Irish Builder and Engineer,* 3 May 1924, p. 406.

'Topical Touches', *The Irish Builder and Engineer,* 4 October 1924, p. 845.

'The Art of Etching: Mr. George Atkinson's Lecture', *The Irish Times,* 19 January 1924, p. 6.

'Good Art and Bad Art', *The Irish Times,* 28 March 1924, p. 2.

'Events of the Week – The Shannon Schemers', *An Phoblacht,* 9 October 1925, p. 3.

'Engineering Section: The Shannon Scheme', *The Irish Builder and Engineer,* 24 January 1925, p. 66.

'Topical Touches', *The Irish Builder and Engineer*, 17 October 1925, p. 837.

'Modern Architecture of the North', *The Irish Builder and Engineer*, 21 March 1925, p. 221.

'Engineering Section: Economics of the Shannon Scheme', *The Irish Builder and Engineer*, 13 June 1925, p. 490.

'Laird's Photographic Chemists', *Limerick Leader*, 20 June 1925, p. 1.

'Topical Touches', *The Irish Builder and Engineer*, 17 April 1926, p. 281.

'Engineering Section: The Shannon Scheme', *The Irish Builder and Engineer*, 15 May 1926, p. 399.

'Architectural Engineering', *The Irish Builder and Engineer*, 6 March 1926, p. 187.

'Ambistone advertisement', *The Irish Builder and Engineer*, 13 November 1926, p. 865.

'The Shannon Scheme: An Incursion of Engineers', *The Irish Builder and Engineer*, 2 October 1926, p. 745–6.

'The Shannon Scheme: Rapid Progress Made', *Irish Independent*, 20 August 1926, p. 4.

'The Shannon Scheme: Engineers to Visit Power Development Works', *The Irish Builder and Engineer*, 18 September 1926, p. 725.

'John Laird & Co.: The Rexall Pharmacy', *Limerick Leader*, 21 July 1926, p. 2.

'Topical Touches', *The Irish Builder and Engineer*, 7 August 1926, p. 601.

'Topical Touches', *The Irish Builder and Engineer*, 4 September 1926, p. 665.

'Mr. O'Higgins Murdered', *The Irish Times*, 11 July 1927, p. 7.

'Shannon Scheme: Electricity Suppliers Visit: Efficiency and Vastness', *Irish Independent*, 7 October 1927, p. 9.

'Excavation work on the Shannon Canal', *The Irish Builder and Engineer*, 14 May 1927, p. 357.

'Engineering Section: Shannon Scheme Crushing Plant', *The Irish Builder and Engineer*, 23 July 1927, p. 548.

'The Progress of the Shannon Hydro-Electric Scheme', *The Irish Builder and Engineer*, 15 October 1927, p. 753–4.

'Untitled', *The Irish Builder and Engineer*, 8 January 1927, p. 17–18.

'Advertisement for Ben Hur', *Limerick Leader*, 26 November 1927, p. 1.

'Shannon Scheme's Progress: Civil Engineers Visit: Clare Transformation Story', *Irish Independent*, 13 May 1927, p. 10.

'Teachers' Excursion to Ardnacrusha', *Connacht Tribune*, 30 July 1927, p. 2.

'Engineers Visit the Shannon Scheme', *Limerick Leader*, 14 May 1927, p. 5.

'Engineering Students Visit Shannon Scheme', *Limerick Leader*, 8 June 1927, p. 3.

'Engineering Section: Southern Officials Visit Shannon Works', *The Irish Builder and Engineer*, 8 January 1927, p. 24.

'Liston's Chemist, O'Connell Street', *Limerick Leader*, 24 September 1927, p. 4.

'Shannon Scheme: Mr. John Keating's Sketches', *The Irish Times*, 25 January 1927, p. 7.

'Royal Hibernian Academy: Portraits in Favour', *The Irish Times*, 11 April 1927, p. 8.

'Shannon Scheme on Canvas: A Series of Oil Paintings', *The Irish Times*, 25 August 1927, p. 5.

'Paintings, Drawings and Engravings: the Metropolitan School of Art', *The Irish Times*, 20 September 1927, p. 11.

'Standards in Art: Meaning of their Collapse', *The Irish Times*, 24 March 1927, p. 10.

'The Pageantry of Civic Week: Historical and Military Spectacles', *The Irish Times*, 17 September 1927, p. 13.

'Topical Touches', *The Irish Builder and Engineer*, 13 October 1928, p. 857.

'The War Memorial Building, Trinity College Dublin', *The Irish Builder and Engineer*, 8 December 1928, p. 1022.

'The State and Architecture', *The Irish Builder and Engineer*, 18 August 1928, p. 709–10.

'Shannon Scheme Nears Completion: Power Station

Erection', *Connacht Tribune,* 14 January 1928, p. 12.

'Progress advertisement', *The Irish Times,* 27 September 1928, p. 8.

'Shannon Scheme Visitors', *Limerick Leader,* 6 October 1928, p. 7.

'Shannon Scheme in Detail: Unique Experience for 200 Visitors', *Irish Independent,* 14 June 1928, p. 13.

'French Engineers to see Shannon Works and Drumm Train', *Irish Independent,* 3 July 1928, p. 8.

'Cheap Trips to the Shannon: Guides to Explain the Scheme', *The Irish Times,* 20 June 1928, p. 7.

'Shannon Scheme Visitors: 10,000 Excursionists to Limerick', *The Irish Times,* 25 July 1928, p. 5.

'Holidays! See Ireland First. Limerick', *The Irish Times,* 7 July 1928, p. 4.

'Royal Hibernian Academy: Annual Exhibition Second Notice', *The Irish Times,* 9 April 1928, p. 6.

'Municipal Gallery of Modern Art: Advisory Committee', *The Irish Times,* 6 October 1928, p. 8.

'Arts and Crafts: Aonach Tailteann Exhibition', *Irish Independent,* 6 August 1928, p. 9.

'Critics Comments', *Irish Independent,* 20 September 1928, p. 3.

'Tailteann Games Art Awards', *The Irish Times,* 6 September 1928, p. 4.

'Clever Artists: Hibernian Academy Pictures', *Irish Independent,* 3 April 1928, p. 3.

'Nine Arts Ball: Brilliant Spectacle at the Metropole', *Irish Independent,* 18 February 1928, p. 8.

'How the Shannon Scheme is Progressing: Vast Works Taking Shape: 5,000 Men Engaged', *Clare Champion,* 8 September 1928. ESB Newspaper Clippings Book 02.

'How The Shannon Scheme Is Progressing: Vast Works Taking Shape: 5,000 Men Working In Shifts To Finish The Work By The Spring', *The Irish Times,* 28 August 1928, p. 5. ESB Newspaper Clippings Book 02.

'Progress of the Shannon Hydro-Electric Works: Special to the "Irish Builder and Engineer"', *The Irish Builder and Engineer,* 18 August 1928, p. 697–8. ESB Newspaper Clippings Book 02.

'What Mr. Cosgrave Will See On The Shannon', *The Irish Times,* 8 September 1928. ESB Newspaper Clippings Book 02.

'Electricity in the Irish Free State', *Electrical Review,* 5 October 1928. ESB Newspaper Clippings Book 02.

'The Future of Electricity', *Dundalk Democrat,* 15 September 1928. ESB Newspaper Clippings Book 02.

'Shannon Scheme and an Experimental Farm', *Limerick Leader,* 12 November 1928, p. 2. ESB Newspaper Clippings Book 02.

'Shannon Scheme Visitors, 32,076', *Irish Independent,* 6 October 1928, p. 7. ESB Newspaper Clippings Book 02.

'Managed Like A Village: President At Shannon Works: National Effects of Shannon Scheme', *Irish Independent,* 10 September 1928, p. 7. ESB Newspaper Clippings Book 02.

'Still They Come: More Shannon Scheme Visitors', *Limerick Leader,* 3 November 1928, p. 3. ESB Newspaper Clippings Book 02.

'Pictorial Review. Dublin Chamber of Commerce Visit to Shannon Scheme', *Irish Independent,* 4 October 1928, p. 3. ESB Newspaper Clippings Book 02.

'Electricity Board's Campaign: Lectures in the Free State', *The Irish Times,* 23 November 1928, p. 11. ESB Newspaper Clippings Book 03.

'Topical Touches', *The Irish Builder and Engineer,* 3 August 1929.

'The Shannon Scheme: Another Stage Reached', *The Irish Builder and Engineer,* 3 August 1929, p. 689–90.

'Exhibition of Model, Town Hall, Waterford', *Waterford Star,* October 1929.

'Progress Advertisement', *The Irish Builder and Engineer,* 5 January 1929, p. 36.

'Engineers to Visit Shannon Scheme', *Limerick Leader,* 2 June 1929, p. 3.

'To Visit Limerick and Ardnacrusha', *Limerick Leader,* 15 June 1929, p. 7.

'Distinguished Visitors to the Shannon Scheme',

Horgan, J., *Irish Media: A Critical History Since 1922* (London: Routledge, 2001).

Howell, D., *A Lost Left: Three Studies in Socialism and Nationalism* (Manchester: Manchester University Press, 1986).

Howsden, G., *Collecting Cigarette & Trade Cards* (London: New Cavendish Books, 1995).

Hughes, T.P., *Human-Built World: How to Think About Technology and Culture* (Chicago, IL: University of Chicago Press, 2005).

Hutton, M.A., *The Táin* 2nd edn (Dublin: The Talbot Press, 1924).

Independent House, *The Production of a Newspaper* (Dublin: Independent House, 1929).

Jarman, A., *Royal Academy Exhibitors 1905–1970: Volume III E-Lawl* 2nd edn (Wiltshire: Hilmartin Manor Press, 1985).

Johnson, D., *The Interwar Economy in Ireland* (Dublin: The Economic and Social History Society of Ireland, 1989).

Jordan, A., *W.T. Cosgrave 1880–1965: Founder of Modern Ireland* (Dublin: Westport Books, 2006).

Kennedy, B.P., *Irish Painting* (Dublin: Town House and Country House, 1993).

Kennedy, S.B., *Irish Art and Modernism 1880–1950* (Belfast: The Institute of Irish Studies, Queen's University of Belfast, 1991).

Kennedy, S.B., *Great Irish Artists: From Lavery to Le Brocquy* (Dublin: Gill & Macmillan, 1997).

Kennedy, S.B., *Paul Henry: Paintings, Drawings, Illustrations* (New Haven, CT: Yale University Press, 2007).

Kissane, N., *Ex Camera 1860–1960: Photographs from the Collections of the National Library of Ireland* (Dublin: National Library of Ireland, 1990).

Klingender, F., *Art and the Industrial Revolution* (London: Noel Carrington, 1947).

Larmour, P., *Free State Architecture: Modern Movement Architecture in Ireland, 1922–1949* (Kinsale: Gandon Editions, 2009).

Latour, B., *Pandora's Hope: Essays on the Reality of Science Studies* (Cambridge, MA: Harvard University Press, 1999).

Lee, D., *Hindesight: John Hinde Photographs and Postcards by John Hinde 1935–1971* (Dublin: Irish Museum of Modern Art, 1993).

Lee, J., *The Modernisation of Irish Society* (Dublin: Gill & Macmillan, 1973).

Lee, J., *Ireland 1912–1985 Politics and Society* (Cambridge: Cambridge University Press, 1989).

Lucic, K., *Charles Sheeler and the Cult of the Machine* (London: Reaktion Books, 1991).

MacCannell, D., *The Tourist: A New Theory of the Leisure Class* 3rd edn (Berkeley, CA: University of California Press, 1999).

MacDonagh, O., *Ireland: The Union and its Aftermath* (Dublin: University College Dublin Press, 2003).

MacGonigal, C., *Postart: An Exhibition of Postage Stamp Artwork* (Dublin: An Post, 1991).

Mackay, J.A., *Eire: The Story of Ireland and Her Stamps* (London: Philatelic Publishers, 1968).

Maguire, W.A., *A Century in Focus: Photography & Photographers in the North of Ireland* (Belfast: Blackstaff Press, 2000).

Manning, M. and McDowell, M., *Electricity Supply in Ireland: The History of the E.S.B.* (Dublin: Gill & Macmillan, 1984).

Mason, S., *The Mason Family Business: A Brief History 1780–1980* (Dublin: Mason Technology, 1980).

Mason, T.H., *The Islands of Ireland* (London: B.T. Batsford, 1936).

Mathews, P.J., *Revival: The Abbey Theatre, Sinn Fein, the Gaelic League and the Co-operative Movement* (Cork: Cork University Press, 2003).

McCarthy, M., *High Tension: Life on the Shannon Scheme* (Dublin: The Lilliput Press, 2004).

McConkey, K., *A Free Spirit: Irish Art 1860–1960* (London: Antique Collectors Club & Pyms Gallery, 1990).

McCullough, N. and Mulvin, V., *A Lost Tradition: The Nature of Architecture in Ireland* (Dublin: Gandon Editions, 1987).

Meehan, C., *The Cosgrave Party: A History of Cumann*

na nGaedheal, 1923–33 (Dublin: Royal Irish Academy, 2010).

Meggs, P.B. and Purvis, A.W., *Meggs' History of Graphic Design* 4th edn (Hoboken, NJ: John Wiley & Sons, 2006).

Merne, O.S., *The Story of the Photographic Society of Ireland, 1854–1954* (Dublin: The Photographic Society of Ireland, 1954).

Miller, L., *The Dolmen Book of Irish Stamps* (Dublin: The Dolmen Press, 1986).

Milne, E., *Letters, Postcards, Email: Technologies of Presence* (New York: Routledge, 2010).

Mitchell, A., *Labour in Irish Politics, 1890 – 1930: The Irish Labour Movement in the Age of Revolution* (Dublin: Irish University Press, 1974).

Morris, E., *Our Own Devices: National Symbols and Political Conflict in Twentieth-Century Ireland* (Dublin: Irish Academic Press, 2000).

Murray, M., *The Story of Cigarette Cards* (London: Murray Cards, 1987).

Nevett, T.R., *Advertising in Britain: A History* (London: Heinemann, 1982).

Nolan, M., *Visions of Modernity: American Business and the Modernization of Germany* (Oxford: Oxford University Press, 1994).

North, M., *Material Delight and the Joy of Living: Cultural Consumption in the Age of Enlightenment in Germany* (Hampshire: Ashgate, 2003).

Nutting, W., *Ireland Beautiful* (Garden City, NY: Garden City Publishing Co, 1925).

Nye, D.E., *Electrifying America: Social Meanings of a New Technology* (Cambridge, MA: The MIT Press, 1991).

Nye, D.E., *American Technological Sublime* (Cambridge, MA: The MIT Press, 1994).

Nye, D.E., *America as Second Creation: Technology and Narratives of New Beginnings* (Cambridge, MA: The MIT Press, 2003).

O'Beirne, G., *Siemens in Ireland 1925–2000: Seventy Five Years of Innovation* (Dublin: A&A Farmar, 2000).

O'Callaghan, J., *Teaching Irish Independence: History in Irish Schools 1922–72* (Newcastle upon Tyne: Cambridge Scholars Publishing, 2009).

O'Connor, É., *Seán Keating in Focus* (Limerick: The Hunt Museum, 2009).

O'Connor, É., *Seán Keating in Context: Responses to Culture and Politics in Post-Civil War Ireland* (Dublin: Carysfort Press, 2009).

O'Connor, É., *Seán Keating – Art, Politics and Building the Irish Nation* (Dublin: Irish Academic Press, 2013).

O'Curry, E., *On the Manners and Customs of the Ancient Irish, Vol. 2* (Dublin: Williams and Norgate, 1873).

Ó'Gráda, C., *Ireland: A New Economic History 1780–1939* (Oxford: Clarendon Press, 1994).

O'Malley, P., *Biting at the Grave: The Irish Hunger Strikes and the Politics of Despair* (Belfast: Blackstaff, 1990).

Oram, H., *The Advertising Book: The History of Advertising in Ireland* (Dublin: MO Books, 1986).

Osborne, P.D., *Travelling Light: Photography, Travel and Visual Culture* (Manchester: Manchester University Press, 2000).

Pearce, S.M., *On Collecting: An Investigation into Collecting in the European Tradition* (London: Routledge, 1995).

Porter, T., *The Architect's Eye: Visualization and Depiction of Space in Architecture* (London: E&FN Spon, 1997).

Puirséil, N., *The Irish Labour Party 1922–73* (Dublin: University College Dublin Press, 2007).

Regan, J.M., *The Irish Counter Revolution 1921–1936* (Dublin: Gill & Macmillan, 1999).

Reynolds, B.A., *William T. Cosgrave and the Foundation of the Irish Free State, 1922–25* (Kilkenny: Kilkenny People Printing, 1998).

Rickards, M., *Collecting Printed Ephemera* (Oxford: Phaidon, 1988).

Rickards, M. and Twyman, M., *The Encyclopedia of Ephemera: A Guide to the Fragmentary Documents of Everyday Life for the Collector, Curator and Historian* (London: The British Library, 2000).

Rieger, B., *Technology and the Culture of Modernity in Britain and Germany, 1890–1945* (Cambridge: Cambridge University Press, 2005).

Robertson, M., *Laymen and the New Architecture* (London: John Murray, 1925).

Robinson, L., *Palette and Plough: A Pen-and-Ink Drawing of Dermod O'Brien PRHA* (Dublin: Browne and Nolan, 1948).

Robinson, L., *Ireland's Abbey Theatre – A History 1899–1951* (London: Sidgwick and Jackson, 1951).

Rolfe, A. and Ryan, R., *The Department of Industry and Commerce, Kildare Street, Dublin* (Dublin: The Office of Public Works, 1992).

Rothery, S., *Ireland and the New Architecture 1900–1940* (Dublin: The Lilliput Press, 1991).

Rouse, S., *Into the Light: An Illustrated Guide to the Photographic Collections in the National Library of Ireland* (Dublin: National Library of Ireland, 1998).

Royal Hibernian Academy of Arts, *Royal Hibernian Academy of Arts Catalogue 1927* (Dublin: Royal Hibernian Academy of Arts, 1927).

Royal Hibernian Academy of Arts, *Royal Hibernian Academy of Arts Catalogue 1928* (Dublin: Royal Hibernian Academy of Arts, 1928).

Rubenstein, M., *Public Works: Infrastructure, Irish Modernism, and the Postcolonial* (Notre Dame, IN: University of Notre Dame Press, 2010).

Rushmore, D.B. and Lof, E.A., *Hydro-Electric Power Stations* 2nd edn (New York, NY: John Wiley & Sons, 1923).

Ryan, T., *R. Brigid Ganly HRHA: Retrospective Exhibition* (Dublin: Gorry Gallery, 1987).

Rynne, C., *Industrial Ireland: An Archaeology* (Cork: Collins Press, 2006).

Sabel, C.F., *Work and Politics: The Division of Labour in Industry* (Cambridge: Cambridge University Press, 1982).

Schivelbusch, W., *The Railway Journey: The Industrialization and Perception of Time and Space* (Berkeley, CA: University of California Press, 1987).

Schwartz, F.J., *The Werkbund: Design Theory and Mass Culture before the First World War* (New Haven, CT: Yale University Press, 1996).

Scott, D., *European Stamp Design: A Semiotic Approach to Designing Messages* (London: Academy Editions, 1995).

Sheehy, J., *The Celtic Revival: The Rediscovery of Ireland's Past 1830–1930* (London: Thames & Hudson, 1980).

Sichel, K., *From Icon to Irony: German and American Industrial Photography* (Boston, MA: Boston University Art Gallery, 1995).

Siemens, *Der Siemens-Konzern im Bilde: Siemens & Halske Aktien-Gesellschaft. Siemens-Schuckertwerke Aktien-Gesellschaft.* (Berlin: Siemens, 1925).

Siemens Archiv, *Siemens Erinnerungstatten: 20 Zeichnungen von Anton Scheuritzel* (Berlin: Siemens Archiv, 1939).

Singer, H.W., *Das Graphische Werk des Maler-Radierers Anton Scheuritzel: Ein Beschreibendes in Chronologisch Geordnetes Verzeichnis mit 81 Abbildungen* (Berlin: August Scherl GMBH, 1920).

Snoddy, T., *Dictionary of Irish Artists: 20th Century* (Dublin: Merlin Publishing, 2002).

Sparke, P., *An Introduction to Design and Culture: 1900 to the Present* 2nd edn (London: Routledge, 2004).

Staff, F., *The Picture Postcard & Its Origins* (London: Lutterworth Press, 1966).

Stebbins, R.A., *Amateurs: On the Margin Between Work & Leisure* (London: SAGE Publications, 1979).

Stewart, A., *Royal Hibernian Academy List of Exhibitors: Vol. 1 A–G* (Dublin: Manton Publishing, 1985).

Stewart, A., *Royal Hibernian Academy List of Exhibitors 1826–1979: Vol. 2 G–M* (Dublin: Manton Publishing, 1985).

Stewart, A., *Royal Hibernian Academy List of Exhibitors 1826–1979: Vol. 1 A–G* (Dublin: Manton Publishing, 1985).

Stewart, A., *Royal Hibernian Academy List of Exhibitors 1826–1979: Vol. 3 N–Z* (Dublin: Manton Publishing, 1985).

Stewart, A., *Royal Hibernian Academy List of Exhibitors:*

Vol. 2 H–M (Dublin: Manton Publishing, 1985).

Stewart, A., *Irish Art Societies and Sketching Clubs Index of Exhibitors 1870–1980: Vol 1 A–L* (Dublin: Four Courts Press, 1997).

Stewart, A., *Irish Art Societies and Sketching Clubs Index of Exhibitors 1870–1980: Vol 1 M–Z* (Dublin: Four Courts Press, 1997).

Stewart, S., *On Longing: Narratives of the Miniature, the Gigantic, the Souvenir, the Collection* (Durham, NC: Duke University Press, 2007).

Struck, H., *Die Kunst des Radierens* (Berlin: Paul Cassirer, 1908).

Taylor, B., *Art and Literature Under the Bolsheviks: Authority and Revolution 1924–1932* (London: Pluto Press, 1992).

Tungate, M., *Adland: A Global History of Advertising* (London: Kogan Page Publishers, 2007).

Turpin, J., *A School of Art in Dublin Since the 18th Century: A History of the National College of Art and Design* (Dublin: Gill & Macmillan, 1995).

Urry, J., *The Tourist Gaze* (London: Sage, 1990).

Volti, R., *An Introduction to the Sociology of Work and Occupation* (Thousand Oaks, CA: Sage, 2012).

Walker, D., *Modern Art in Ireland* (Dublin: Lilliput Press, 1997).

Wenger, E., *Communities of Practice: Learning, Meaning and Identity* (Cambridge: Cambridge University Press, 1998).

White, J., *John Keating: Paintings – Drawings* (Dublin: Municipal Gallery of Modern Art, 1963).

White, J., *Seán Keating P.R.H.A. 1889–1977* (Dublin: Royal Hibernian Academy, 1989).

Wilde, A., Wilde, J., and Weski, T., *Albert Renger-Patzsch: Photographer of Objectivity* (London: Thames & Hudson, 1997).

Wilk, C., *Modernism: Designing a New World 1914–1939* (London: V&A Publications, 2006).

Williams, R., *Keywords: A Vocabulary of Culture and Society* (London: Fontana, 1988).

Witkovsky, M.S., *Foto: Modernity in Central Europe, 1918–1945* (London: Thames & Hudson, 2007).

Yaneva, A., *Mapping Controversies in Architecture* (Farnham: Ashgate, 2012).

Zöbl, D., *Siemens in Berlin: Spaziergänge durch die Geschichte der Elektrifizierung* (Berlin: Verlag für Berlin-Brandenburg, 2008).

Zuelow, E., *Making Ireland Irish: Tourism and National Identity Since the Irish Civil War* (Syracuse, NY: Syracuse University Press, 2009).

Book Sections

'The News in Pictures', in *The Midland Tribune, 1881–1981: 100 Years of a Family Newspaper* (Birr: Midland Tribune, 1981), p. 13.

Alvarado, M., 'Photographs and Narrativity (1979–80)', in Alvarado, M., Buscombe, E., and Collins, R. (eds), *Representation and Photography: A Screen Education Reader* (Hampshire: Palgrave, 2001), pp. 148–63.

Amhoff, T., 'The Electrification of the Factory or the Flexible Layout of Work(s)', in Lloyd Thomas, K., Amhoff, T., and Beech, N. (eds), *Industries of Architecture* (London: Routledge, 2015), pp. 259–70.

Arnold, P., 'Stone Construction', in Loeber, R., et al. (eds), *Art and Architecture of Ireland Volume IV: Architecture* (Dublin: Royal Irish Academy, The Paul Mellon Centre and Yale University Press, 2014), pp. 59–61.

Balm, R. and Holcomb, B., 'Unlosing Lost Places: Image Making, Tourism and the Return to Terra Cognita', in Crouch, D. and Lübbren, N. (eds), *Visual Culture and Tourism* (Oxford: Berg, 2003), pp. 157–73.

Barrett, C., 'The Visual Arts and Society, 1921–1984', in Moody, T., et al. (eds), *A New History of Ireland Volumes 7–8* (Oxford: Oxford University Press, 2003), pp. 596–9.

Benton, T., 'Building Utopia', in Wilk, C. (ed.), *Modernism 1914–1939: Designing a New World* (London: V&A Publications, 2006), pp. 158–223.

Bhreathnach-Lynch, S., 'Framing Ireland's History: Art, Politics, and Representation', in Steward, J.C. (ed.), *When Time Began To Rant and Rage: Figurative Painting from Twentieth Century Ireland* (London: Merrell Holberton Publishers, 1998), pp. 40–51.

Bhreathnach-Lynch, S., 'Landscape, Space and Gender: Their Role in the Construction of Female Identity in Newly Independent Ireland', in Adams, S. and Gruetzner-Robins, A. (eds), *Gendering Landscape Art* (Manchester: Manchester University Press, 2000), pp. 76–86.

Bielenberg, A., 'Keating in Perspective', in McMonagle, A. (ed.), *Keating and Ardnacrusha: Art and Archive Exhibition at UCC May 2000* (Cork: University College Cork, 2000), p. 4.

Bielenberg, A., 'Seán Keating, the Shannon Scheme and the Art of State-Building', in Bielenberg, A. (ed.), *The Shannon Scheme and the Electrification of the Irish Free State: An Inspirational Milestone* (Dublin: The Lilliput Press, 2002), pp. 114–37.

Bourdieu, P., 'The Social Definition of Photography', in Evans, J. and Hall, S. (eds), *Visual Culture: The Reader* (Milton Keynes: Open University, 1999), pp. 162–80.

Boylan, T., Curtain, C., and O'Dowd, L., 'Politics and Society and Post-Independent Ireland', in Bartlett, T., et al. (eds), *Irish Studies: A General Introduction* (Dublin: Gill & Macmillan, 1988), pp. 152–73.

Buchanan, R., 'Declaration by Design: Rhetoric, Argument, and Demonstration in Design Practice', in Margolin, V. (ed.), *Design Discourse: History, Theory, Criticism* (Chicago, IL: University of Chicago Press, 1989), pp. 91–109.

Caffrey, P., 'The Coinage Design Committee (1926–1928) and the Formation of a Design Identity in the Irish Free State', in King, L. and Sisson, E. (eds), *Ireland, Design and Visual Culture: Negotiating Modernity 1922–1992* (Cork: Cork University Press, 2011), pp. 75–89.

Campbell, H., 'Irish Identity and the Architecture of the New State', in Becker, A., Olley, J., and Wang, W.

(eds), *20th Century Architecture: Ireland* (Munich: Prestel, 1997), pp. 82–8.

Campbell, H., 'Modern Architecture and National Identity in Ireland', in Cleary, J. and Connolly, C. (eds), *The Cambridge Companion to Irish Culture* (Cambridge: Cambridge University Press, 2005), pp. 285–303.

Campbell, H. and Cassidy, L., 'Architectural Education in the Nineteenth and Twentieth Centuries', in Loeber, R., et al. (eds), *Art and Architecture of Ireland Volume IV: Architecture* (Dublin: Royal Irish Academy, The Paul Mellon Centre and Yale University Press, 2014), pp. 127–9.

Campbell, H., Rowley, E., and Ryan, R., 'Modernism', in Loeber, R., et al. (eds), *Art and Architecture of Ireland Volume IV: Architecture* (Dublin: Royal Irish Academy, The Paul Mellon Centre and Yale University Press, 2014), pp. 112–14.

Carlson, M., 'The Realistic Theatre and Bourgeois Values, 1750–1900', in Williams, S. and Hamburger, M. (eds), *A History of German Theatre* (Cambridge: Cambridge University Press, 2008), pp. 92–119.

Dawson, B., 'Interview with Brigid Ganly', in Kennedy, C. and Winters, M. (eds), *Brigid Ganly* (Dublin: Hugh Lane Municipal Gallery of Modern Art, 1998), pp. 16–30.

Delany, B., 'McLaughlin, the Genesis of the Shannon Scheme and the ESB', in Bielenberg, A. (ed.), *The Shannon Scheme and the Electrification of the Irish Free State: An Inspirational Milestone* (Dublin: The Lilliput Press, 2002), pp. 11–27.

Dooge, J., 'Engineering Training and Education', in Cox, R. C. (ed.), *Engineering Ireland* (Cork: Collins Press, 2006), pp. 36–54.

Dunn, M., 'Ardnacrusha – A Case Study', in Loeber, R., et al. (eds), *Art and Architecture of Ireland Volume IV: Architecture* (Dublin: Royal Irish Academy, The Paul Mellon Centre and Yale University Press, 2014), pp. 169–70.

Edwards, E., 'Photographs as Objects of Memory', in Aynsley, J., Breward, C., and Kwint, M. (eds),

Material Memories: Design and Evocation (Oxford: Berg, 1999), pp. 221–36.

Eskildsen, U., 'Photography and the Neue Sachlichkeit Movement', in Mellor, D. (ed.), *Germany – The New Photography 1927–33* (London: The Arts Council of Great Britain, 1978), pp. 101–12.

Evans, J., 'Introduction to Part II: Regulating Photographic Meanings', in Evans, J. and Hall, S. (eds), *Visual Culture: The Reader* (London: SAGE Publications, 1999), pp. 128–37.

Gibbons, L., 'A Race Against Time: Racial Discourse and Irish History', in Hall, C. (ed.), *Cultures of Empire: A Reader* (Manchester: Manchester University Press, 2000), pp. 207–23.

Gibbons, L., 'Mirrors of Memory: Ireland, Photography and the Modern', in Juncosa, E. and Kennedy, C. (eds), *The Moderns: The Arts in Ireland from the 1900s to the 1970s* (Dublin: Irish Museum of Modern Art, 2011), pp. 330–417.

Gillmor, D., 'Land and People, *c.*1926', in Moody, T., et al. (eds), *A New History of Ireland Volumes 7–8* (Oxford: Oxford University Press, 2003), pp. 62–85.

Gispen, K., 'The Long Quest for Professional Identity: German Engineers in Historical Perspective, 1850–1990', in Meiksins, P. and Smith, C. (eds), *Engineering Labour: Technical Workers in Comparative Perspective* (London: Verso, 1996), pp. 132–67.

Hand, T. and Wyse Jackson, P., 'Stone Types and Production', in Loeber, R., et al. (eds), *Art and Architecture of Ireland Volume IV: Architecture* (Dublin: Royal Irish Academy, The Paul Mellon Centre and Yale University Press, 2014), pp. 57–9.

Hutton, S., 'Labour in the Post-Independence Irish State', in Hutton, S. and Stewart, P. (eds), *Ireland's Histories: Aspects of State, Society and Identity* (London: Routledge, 1991), pp. 52–79.

Jobling, P. and Crowley, D., 'A Medium for the Masses II: Modernism and Documentary in Photojournalism', in Jobling, P. and Crowley, D. (eds), *Graphic Design: Reproduction and Representation since 1800* (Manchester: Manchester University Press, 1996), pp. 171–244.

Keating, J., 'The Slave Mind of Ireland', in O'Connor, É. (ed.), *Seán Keating in Context: Responses to Culture and Politics in Post-Civil War Ireland* (Dublin: Carysfort Press, 2009), pp. 71–4.

Keating, S., 'Talk on the Future of Irish Art', in O'Connor, É. (ed.), *Seán Keating in Context: Responses to Culture and Politics in Post-Civil War Ireland* (Dublin: Carysfort Press, 1931), pp. 27–8.

Keisch, C., 'Symbolist Fantasies', in Hartley, K., et al. (eds), *The Romantic Spirit in German Art 1790–1990* (Stuttgart: Oktagon Verlag, 1995), pp. 312–15.

Kennedy, B.P., 'The Irish Free State 1922–49: A Visual Perspective', in Kennedy, B.P. and Gillespie, R. (eds), *Ireland: Art into History* (Dublin: Town House & Country House, 1994), pp. 132–52.

Kinahan, F., 'Douglas Hyde and the King of the Chimps: Some Notes on the De-Anglicizing of Ireland', in Edelstein, T.J., Born, R., and Taylor, S. (eds), *Imagining an Irish Past: The Celtic Revival 1840–1940* (Chicago, IL: The David and Alfred Smart Museum of Art, University of Chicago, 1992), pp. 64–79.

King, L., '(De)constructing the Tourist Gaze: Dutch Influences and Aer Lingus Tourism Posters, 1950–1960', in King, L. and Sisson, E. (eds), *Ireland, Design and Visual Culture: Negotiating Modernity 1922–1992* (Cork: Cork University Press, 2011), pp. 167–87.

King, L. and Sisson, E., 'Materiality, Modernity and the Shaping of Identity: An Overview', in King, L. and Sisson, E. (eds), *Ireland, Design and Visual Culture: Negotiating Modernity 1922–1992* (Cork: Cork University Press, 2011), pp. 29–35.

Larmour, P., 'Hiberno-Romanesque Revival', in Loeber, R., et al. (eds), *Art and Architecture of Ireland Volume IV: Architecture* (Dublin: Royal Irish Academy, The Paul Mellon Centre and Yale University Press, 2014), pp. 106–8.

Lee, D., 'The Munster Soviets and the Fall of The House

of Cleeve', in Lee, D. (ed.), *Made in Limerick: History of Industries, Trade and Commerce Vol. I* (Limerick: Limerick Civic Trust, 2003), pp. 286–306.

Lenman, R., 'British Photographers and Tourism in the Nineteenth Century', in Crouch, D. and Lübbren, N. (eds), *Visual Culture and Tourism* (Oxford: Berg, 2003), pp. 91–107.

Loeber, R., 'Chapter Introduction – Protagonists', in Loeber, R., et al. (eds) *Art and Architecture of Ireland Volume IV: Architecture* (Dublin: Royal Irish Academy, The Paul Mellon Centre and Yale University Press, 2014), pp. 9–10.

Loeber, R. and Campbell, H., 'Architectural Profession', in Loeber, R., et al. (eds) *Art and Architecture of Ireland Volume IV: Architecture* (Dublin: Royal Irish Academy, The Paul Mellon Centre and Yale University Press, 2014), pp. 11–14.

Loeber, R. and Campbell, H., 'Chapter Introduction – Building Materials, Construction and Interior Decoration', in Loeber, R., et al. (eds) *Art and Architecture of Ireland Volume IV: Architecture* (Dublin: Royal Irish Academy, The Paul Mellon Centre and Yale University Press, 2014), pp. 53–4.

Macdonald, M., 'Anima Celtica: Embodying the Soul of the Nation in 1890s', in Cusack, T. and Bhreathnach-Lynch, S. (eds), *Art, Nation and Gender: Ethnic Landscapes, Myths and Mother-Figures* (Aldershot: Ashgate, 2003), pp. 29–37.

Mastriani, M., 'From Crubeens to Computer Chips: Limerick's Industrial Development, 1914–2003', in Lee, D. (ed.), *Made in Limerick: History of Industries, Trade and Commerce Vol. I* (Limerick: Limerick Civic Trust, 2003), pp. 69–88.

McCarthy, M., 'How the Shannon Workers Lived', in Bielenberg, A. (ed.), *The Shannon Scheme and the Electrification of the Irish Free State: An Inspirational Milestone* (Dublin: Lilliput Press, 2002), pp. 48–72.

McGonagle, D., 'Foreward', in Lee, D. (ed.), *Hindesight: John Hinde Photographs and Postcards by John Hinde 1935–1971* (Dublin: Irish Museum of Modern Art, 1993), pp. 11–12.

McMonagle, A., 'Seán Keating: The Man', *Seán Keating and the E.S.B.* (Dublin: RHA Gallagher Gallery/ESB Touring Exhibitions Service, 1987), pp. 7–16.

McMonagle, A., 'Keating's Biographical Details', in McMonagle, A. (ed.), *Keating and Ardnacrusha: Art and Archive Exhibition at UCC May 2000* (Cork: University College Cork, 2000), pp. 6–8.

McSweeney, F., Cox, R.C., and De Courcy, S., 'Construction Materials', in Cox, R.C. (ed.), *Engineering Ireland* (Cork: The Collins Press, 2006), pp. 169–85.

Mende, M., 'The Berlin AEG Turbine Fitting Shop by Peter Behrens and Karl Bernhard', in Lourenço, P.B., et al. (eds), *Structural Analysis of Historical Constructions: Possibilities of Numerical and Experimental Techniques* (New Delhi: MacMillan, 2007), pp. 251–60.

Mills, S.F., 'Open-Air Museums and the Tourist Gaze', in Crouch, D. and Lübbren, N. (eds), *Visual Culture and Tourism* (Oxford: Berg, 2003), pp. 75–89.

Misa, T.J., 'The Compelling Tangle of Modernity and Technology', in Misa, T.J. (ed.), *Modernity and Technology* (Cambridge, MA: The MIT Press, 2004), pp. 1–30.

Molderings, H., 'Urbanism and Technological Utopianism: Thoughts on the photography of Neue Sachlichkeit and the Bauhaus', in Mellor, D. (ed.), *Germany – The New Photography 1927–33* (London: The Arts Council of Great Britain, 1978), pp. 87–94.

Nadel-Klein, J., 'Occidentalism as a Cottage Industry: Representing the Autochthonous "Other" in British and Irish Rural Studies', in Carrier, J.G. (ed.), *Occidentalism: Images of the West* (Oxford: Clarendon Press, 1995), pp. 109–34.

Nash, C., 'Embodying the Nation': The West of Ireland Landscape and Irish Identity', in O'Connor, B. and Cronin, M. (eds), *Tourism in Ireland: A Critical Analysis* (Cork: Cork University Press, 1993), pp. 86–112.

O'Beirne, G. and O'Connor, M., 'Siemens-Schuckert and the Electrification of the Irish Free State', in Bielenberg, A. (ed.), *The Shannon Scheme and the Electrification of the Irish Free State: An Inspirational Milestone* (Dublin: The Lilliput Press, 2002), pp. 73–99.

O'Byrne, R., 'Irish Modernism: The Early Decades', in Juncosa, E. and Kennedy, C. (eds), *The Moderns: The Arts in Ireland from the 1900s to the 1970s* (Dublin: Irish Museum of Modern Art, 2011), pp. 8–22.

O'Connell, D., 'Introduction', in Kennedy, C. and Winters, M. (eds), *Brigid Ganly* (Dublin: Hugh Lane Municipal Gallery of Modern Art, 1998), pp. 4–14.

O'Connor, B., 'Myths and Mirrors: Tourist Images and National Identity', in O'Connor, B. and Cronin, M. (eds), *Tourism in Ireland: A Critical Analysis* (Cork: Cork University Press, 1993), pp. 68–85.

O'Dwyer, F., 'Gothic Revival', in Loeber, R., et al. (eds) *Art and Architecture of Ireland Volume IV: Architecture* (Dublin: Royal Irish Academy, The Paul Mellon Centre and Yale University Press, 2014), pp. 103–06.

O'Halpin, E., 'Politics and the State 1922–32', in Moody, T., et al. (eds), *A New History of Ireland Volumes 7–8* (Oxford: Oxford University Press, 2003), pp. 86–126.

O'Kelly, H., 'Reconstructing Irishness: Dress in the Celtic Revival, 1880–1920', in Ash, J. and Wilson, E. (eds), *Chic Thrills: A Fashion Reader* (Berkeley, CA: University of California Press, 1993), pp. 75–83.

O'Neill, G., 'Slate', in Loeber, R., et al. (eds), *Art and Architecture of Ireland Volume IV: Architecture* (Dublin: Royal Irish Academy, The Paul Mellon Centre and Yale University Press, 2014), pp. 70–2.

Oltra, G.N., 'The Design of the Spanish Postage Stamp under Franco: the National Iconographic Scheme', in Glynne, J., Hackney, F., and Minton, V. (eds), *Networks of Design: Proceedings of the 2008 Annual International Conference of the Design History Society (UK) University College Falmouth 3–6 September* (Boca Raton, FL: Universal Publishers, 2009), pp. 340–4.

Pérez-Gómez, A., 'Questions of Representation: The Poetic Origin of Architecture', in Frascari, M., Hale, J., and Starkey, B. (eds), *From Models to Drawings: Imagination and Representation in Architecture* (London: Routledge, 2007), pp. 11–22.

Peschen, G. and Heinisch, T., 'Berlin at the Turn of the Century: A Historical and Architectural Analysis', in Burchhardt, L. (ed.), *The Werkbund: Studies in the History and Ideology of the Deutscher Werkbund 1907–1933* (London: The Design Council, 1980), pp. 35–48.

Posener, J., 'Between Art and Industry: The Deutsche Werkbund', in Burchhardt, L. (ed.), *The Werkbund: Studies in the History and Ideology of the Deutscher Werkbund 1907–1933* (London: The Design Council, 1980), pp. 7–15.

Prendergast, F., 'The Decline of Traditional Limerick Industries', in Lee, D. (ed.), *Made in Limerick: History of Industries, Trade and Commerce Vol. I* (Limerick: Limerick Civic Trust, 2003), pp. 1–22.

Rothery, S., 'Ireland and the New Architecture 1900–1940', in Becker, A., Olley, J., and Wang, W. (eds), *20th Century Architecture: Ireland* (Munich: Prestel, 1997), pp. 17–21.

Rowley, E., 'The Conditions of Architectural Modernism in Ireland, 1900–1970: Between Aspiration and Production', in Juncosa, E. and Kennedy, C. (eds), *The Moderns: The Arts in Ireland from the 1900s to the 1970s* (Dublin: Irish Museum of Modern Art, 2011), pp. 418–95.

Rowley, E., 'Office of Public Works (OPW), 1922–2000', in Loeber, R., et al. (eds), *Art and Architecture of Ireland Volume IV: Architecture* (Dublin: Royal Irish Academy, The Paul Mellon Centre and Yale University Press, 2014), pp. 45–7.

Rowley, E., 'Concrete', in Loeber, R., et al. (eds), *Art and Architecture of Ireland Volume IV: Architecture* (Dublin: Royal Irish Academy, The Paul Mellon

Index

Note: Page references in italics refer to pictures and illustrations.